Oil Paintings in Public Ownership in East Sussex

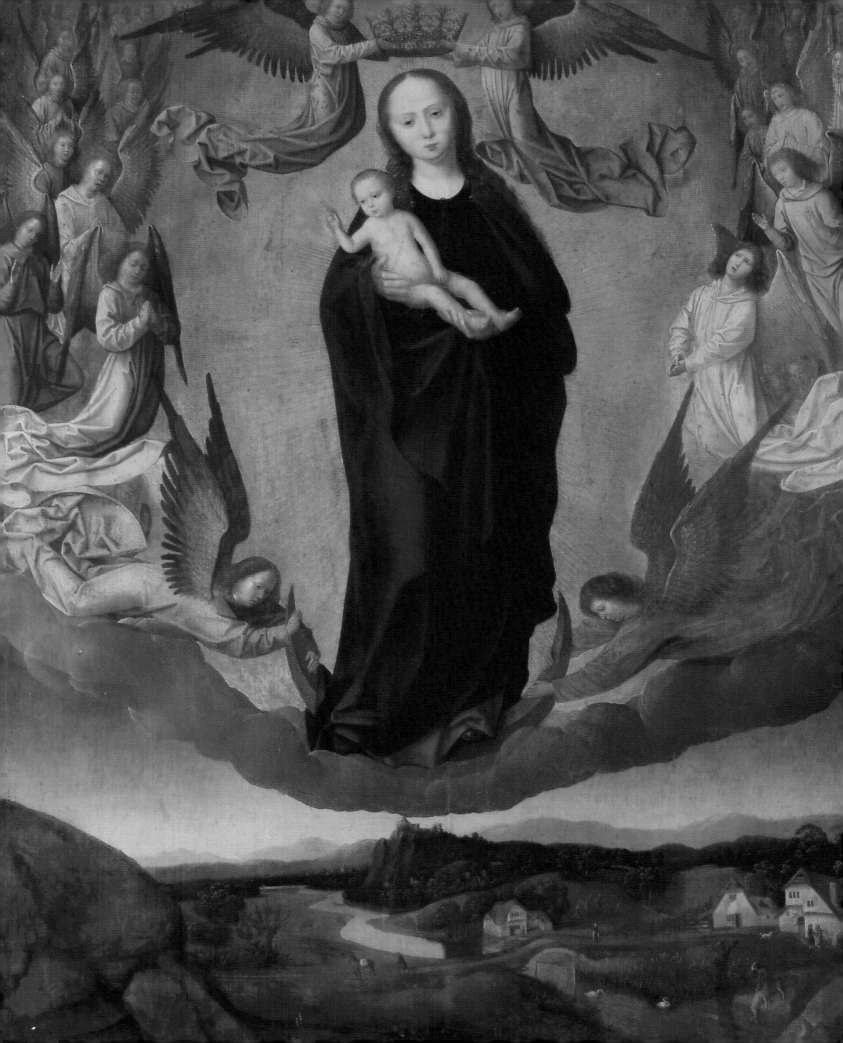

Oil Paintings in Public Ownership in East Sussex

The Public Catalogue Foundation

First published in 2005 by the Public Catalogue Foundation, St Vincent House, 30 Orange Street, London, WC2H 7HH

ISBN 1–904931–08–1 (hardback)
ISBN 1–904931–09–X (paperback)

East Sussex photography:
www.ajphotographics.com

Designed by Jeffery Design, London

Distributed by the Public Catalogue Foundation, St Vincent House, 30 Orange Street, London, WC2H 7HH
Telephone 020 7747 5936

Printed and bound in the UK by Butler & Tanner Ltd, Frome, Somerset

Cover image:

Burleigh, C. H. H. 1869–1956
Brighton Front (detail) c.1920
Brighton and Hove Museums and Art Galleries
(see p. 51)

Image opposite title page:

Cornelis, Albert c.1500–1532
The Assumption of the Virgin (detail)
Brighton and Hove Museums and Art Galleries
(see p. 65)

Back cover images (from top to bottom):

Hennessy, William J. 1839–1917
The Woodcutter c.1900
Brighton and Hove Museums and Art Galleries
(see p. 98)

Low, Diana 1911–1975
Grandparents on the Beach
Rye Art Gallery (see p. 361)

British (English) School
William the Conqueror c.1580
English Heritage, Battle Abbey (see p. 3)

Contents

Foreword

East Sussex has always seemed to me, a Man of Kent, a quiet county, quiet and ancient. So I suppose I should have expected the surprise I got. Hard on the heels of our West Sussex catalogue, East Sussex unexpectedly becomes the largest in our series to date: some 2800 paintings from 25 sites. Half of these paintings come from Brighton and Hove. The collection in Brighton is richer even than one would expect, to which is now added the Hove collection of 20th century British painting – less well known than it merits and a collection future generations will wonder at. And, as if enough is not enough, the Towner in Eastbourne brings the contemporary world into focus with its admirable collection.

Yet, despite the extraordinary wealth of its collections, East Sussex has been no less difficult to fund than the other counties. This is due less to any lack of generosity on the part of its citizens than to the fact that, with only three full-time staff, the PCF simply cannot (yet) find the resources to ask those citizens for support in a sufficiently timely manner. Nor have national institutions – or government – supported us as I feel they should. This makes the contributions of Christie's, our National Sponsor, and Hiscox plc, the Stavros S. Niarchos Foundation, the Garfield Weston Foundation and the John S. Cohen Foundation so enormously admirable.

So it is thanks, as ever, to the few that this catalogue has seen the light of day. I would like to record our enormous gratitude to our Patron, Mrs Phyllida Stewart-Roberts OBE, Lord Lieutenant of the County, whose energy has been unflagging; to Martin Armstrong who has demonstrated that spontaneous kindness that makes him so loved by his friends; to Deborah Gage who has been 'there' for us, whether in Kenya, New York or London; and to Andrew Rudebeck, for taking time off from stained glass to support our venture. All of them have put in sterling work to enable the county's oil paintings to be recorded.

The main financial burden has been assumed by a small number of institutions and companies and I happily therefore express our deep thanks to Philip Richards at RAB Capital, to Michael Rudman at the Spencer Wills Trust and to Peter Stormonth Darling. East Sussex County Council's support, at a time when their resources are under very great pressure, is particularly welcome. Finally our county launch would not have been possible without the generous help of Adams & Remers, Cripps Portfolio and Gorringes.

All of us at the PCF are indebted to all of those listed above and to the many others too numerous to mention in the space available. Finally, my thanks go to Sonia Roe, our Editor, who has over the last six months single-handedly brought this substantial volume of paintings to publication.

Fred Hohler, Chairman

The Public Catalogue Foundation

The United Kingdom holds in its galleries and civic buildings arguably the greatest publicly owned collection of oil paintings in the world. However, an alarming four in five of these paintings are not on view. Whilst many galleries make strenuous efforts to display their collections, too many paintings across the country are held in storage, usually because there are insufficient funds and space to show them. Furthermore, very few galleries have created a complete photographic record of their paintings, let alone a comprehensive illustrated catalogue of their collections. In short, what is publicly owned is not publicly accessible.

The Public Catalogue Foundation, a registered charity, has three aims. First, it intends to create a complete record of the nation's collection of oil, tempera and acrylic paintings in public ownership. Second, it intends to make this accessible to the public through a series of affordable catalogues and, after a suitable delay, through a free Internet website. Finally, it aims to raise funds through the sale of catalogues in gallery shops for the conservation and restoration of oil paintings in these collections and for gallery education.

The initial focus of the project is on collections outside London. Highlighting the richness and diversity of collections outside the capital should bring major benefits to regional collections around the country. The benefits also include a revenue stream for painting preservation and gallery education, as well as the digitisation of collections' paintings, thereby allowing them to put the images on the Internet if they so desire. These substantial benefits to galleries around the country come at no financial cost to the collections themselves.

The project should be of enormous benefit and inspiration to students of art and to members of the general public with an interest in art. It will also provide a major source of material for scholarly research into art history.

Financial Supporters

The Public Catalogue Foundation would like to express its profound appreciation to the following organisations and individuals who have made the publication of this catalogue possible.

Donations of £5000 or more

East Sussex County Council
Hiscox plc
Stavros S. Niarchos Foundation

RAB Capital
Garfield Weston Foundation

Donations of £1000 or more

Adams & Remers
Mr Ian Askew
Mrs T. Brotherton-Ratcliffe
The John S. Cohen Foundation
Cripps Portfolio Ltd
The Friends of the Royal Pavilion, Art
 Gallery and Museums, Brighton
Deborah Gage (Works of Art) Ltd
Gorringes

Mr & Mrs Derek Hunnisett
The Hans and Märit Rausing
 Charitable Trust
The Regency Society of Brighton and
 Hove
Mrs Andrew Stewart-Roberts OBE
Mr Peter Stormonth Darling
The Walland Trust Fund

Other Donations

Mr & Mrs John Barkshire
Consuelo & Anthony Brooke
Lord De La Warr
Lord Gage
Tim & Violet Hancock
John & Elisabeth Heskett
Mr Richard Hoare
Mr Garrett Kirk, Jr

Lady Lloyd
Mr & Mrs William Mellen
Mr Beville Pain
Mr & Mrs Andrew Rudebeck
Mr Richard Sachs
The Swan Trust
Mr Glen Swire
David & Jennifer Tate

National Supporters

The John S. Cohen Foundation
Hiscox plc

Stavros S. Niarchos Foundation
Garfield Weston Foundation

National Sponsor

Christie's

Acknowledgements

The Public Catalogue Foundation would like to thank the individual artists and copyright holders for their permission to reproduce for free the paintings in this catalogue. Exhaustive efforts have been made to locate the copyright owners of all the images included within this catalogue and to meet their requirements. Copyright credit lines for copyright owners who have been traced are listed in the Further Information section.

The Public Catalogue Foundation would like to express its great appreciation to the following organisations for their great assistance in the preparation of this catalogue:

Bridgeman Art Library
Flowers East
Marlborough Fine Art
National Association of Decorative and Fine Art Societies (NADFAS)
National Gallery, London
National Portrait Gallery, London
Royal Academy of Arts, London
Tate

The participating collections included in the catalogue would like to express their thanks to the following organisations which have so generously enabled them to acquire paintings featured in this catalogue:

Contemporary Art Society
Friends of Ditchling Museum
Friends of Hove Museum
Friends of the Royal Pavilion, Art Gallery and Museums
Friends of the Towner
MLA/V&A Purchase Grant Fund
National Art Collections Fund (the Art Fund)
National Heritage Memorial Fund (NHMF)
Quentin Bell Commemoration Fund

Catalogue Scope and Organisation

Medium and Support

The principal focus of this series is oil paintings. However, tempera and acrylic are also included as well as mixed media, where oil is the predominant constituent. Paintings on all forms of support (e.g. canvas, panel etc) are included as long as the support is portable. The principal exclusions are miniatures, hatchments or other purely heraldic paintings and wall paintings *in situ*.

Public Ownership

Public ownership has been taken to mean any paintings that are directly owned by the public purse, made accessible to the public by means of public subsidy or generally perceived to be in public ownership. The term 'public' refers to both central government and local government. Paintings held by national museums, local authority museums, English Heritage and independent museums, where there is at least some form of public subsidy, are included. Paintings held in civic buildings such as local government offices, town halls, guildhalls, public libraries, universities, hospitals, crematoria, fire stations and police stations are also included. Paintings held in central government buildings as part of the Government Art Collection and MoD collections are not included in the county-by-county series but should be included later in the series on a national basis.

Geographical Boundaries of Catalogues

The geographical boundary of each county is the 'ceremonial county' boundary. This county definition includes all unitary authorities. Counties that have a particularly large number of paintings are divided between two or more catalogues on a geographical basis.

Criteria for Inclusion

As long as paintings meet the requirements above, all paintings are included irrespective of their condition and perceived quality. However, painting reproductions can only be included with the agreement of the participating collections and, where appropriate, the relevant copyright owner. It is rare that a collection forbids the inclusion of its paintings. Where this is the case and it is possible to obtain a list of paintings, this list is given in the Paintings Without Reproductions section. Where copyright consent is refused, the paintings are also listed in the Paintings Without Reproductions section. All paintings

in collections' stacks and stores are included, as well as those on display. Paintings which have been lent to other institutions, whether for short-term exhibition or long-term loan, are listed under the owner collection. In addition, paintings on long-term loan are also included under the borrowing institution when they are likely to remain there for at least another five years from the date of publication of this catalogue. Information relating to owners and borrowers is listed in the Further Information section.

Layout

Collections are grouped together under their home town. These locations are listed in alphabetical order. In some cases collections that are spread over a number of locations are included under a single owner collection. A number of collections, principally the larger ones, are preceded by curatorial forewords. Within each collection paintings are listed in order of artist surname. Where there is more than one painting by the same artist, the paintings are listed chronologically, according to their execution date.

The few paintings that are not accompanied by photographs are listed in the Paintings Without Reproductions section.

There is additional reference material in the Further Information section at the back of the catalogue. This gives the full names of artists, titles and media if it has not been possible to include these in full in the main section. It also provides acquisition credit lines and information about loans in and out, as well as copyright and photographic credits for each painting. Finally, there is an index of artists' surnames.

Key to Painting Information

Almost all paintings are reproduced in the catalogue. Where this is not the case they are listed in the Paintings Without Reproductions section. Where paintings are missing or have been stolen, the best possible photograph on record has been reproduced. In some cases this may be black and white. Paintings that have been stolen are highlighted with a red border. Some paintings are shown with conservation tissue attached to parts of the painting surface.

Adam, **Patrick William** 1854–1929
Interior, Rutland Lodge: Vista through Open Doors 1920
oil on canvas 67.3 × 45.7
LEEAG.PA.1925.0671.LACF

Artist name This is shown as surname first. Where the artist is listed on the Getty Union List of Artist Names (ULAN), ULAN's preferred presentation of the name is always given. In a number of cases the name may not be a firm attribution and this is made clear. Where the artist name is not known, a school may be given instead. Where the school is not known, the painter name is listed as *unknown artist*. If the artist name is too long for the space, as much of the name is given as possible followed by (...). This indicates the full name is given at the rear of the catalogue in the Further Information section.

Painting title A painting followed by *(?)* indicates that the title is in doubt. Where the alternative title to the painting is considered to be better known than the original, the alternative title is given in parentheses. Where the collection has not given a painting a title, the publisher does so instead and marks this with an asterisk. If the title is too long for the space, as much of the title is given as possible followed by *(...)* and the full title is given in the Further Information section.

Medium and support Where the precise material used in the support is known, this is given.

Artist dates Where known, the years of birth and death of the artist are given. In some cases one or both dates may not be known with certainty, and this is marked. No date indicates that even an approximate date is not known. Where only the period in which the artist was active is known, these dates are given and preceded with the word *active*.

Execution date In some cases the precise year of execution may not be known for certain. Instead an approximate date will be given or no date at all.

Dimensions All measurements refer to the unframed painting and are given in cm with up to one decimal point. In all cases the height is shown before the width. Where the painting has been measured in its frame, the dimensions are estimates and are marked with (E). If the painting is circular, the single dimension is the diameter. If the painting is oval, the dimensions are height and width.

Collection inventory number In the case of paintings owned by museums, this number will always be the accession number. In all other cases it will be a unique inventory number of the owner institution. (P) indicates that a painting is a private loan. Details can be found in the Further Information section. The ❋ symbol indicates that the reproduction is based on a Bridgeman Art Library transparency (go to www.bridgeman.co.uk) or that the Bridgeman administers the copyright for that artist.

Facing page: Tyler, Philip, b.1964, *Daedalus Weeps* (detail), 1995, Brighton and Hove Museums and Art Galleries (see p. 183)

THE PAINTINGS

English Heritage, Battle Abbey

Alleyne, Francis (circle of) active 1774
Sir Thomas Webster, First Bt?
oil on canvas 29.2 x 24.1
88227220

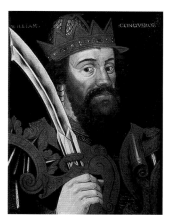

British (English) School
William the Conqueror c.1580
oil on panel 146.1 x 109.2 (E)
88055642

British (English) School
Whistler Webster, Second Bt, Aged 15 c.1725
oil on canvas 127.0 x 101.6
88227216

British (English) School
A Webster in the Uniform of the Rifle Brigade c.1850
oil on canvas 44.5 x 34.3
88227215

Fuller, Issac (style of) c.1606–1672
Thomas Jordan
oil on canvas 76.2 x 63.5
88227206

Gauffier, Louis 1761–1801
Godfrey Webster, Fourth Bt 1796
oil on canvas 175.3 x 132.1 (E)
88227203

Hoppner, John 1758–1810
Thomas Chaplin
oil on canvas 76.2 x 63.5
88227211

Hoppner, John (circle of) 1758–1810
Lady Elizabeth Webster
oil on canvas 76.2 x 63.5
88227204

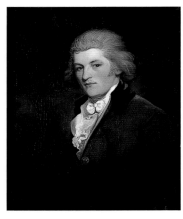

Hoppner, John (follower of) 1758–1810
Charles, Fourth Duke of Richmond
oil on canvas 76.2 x 63.5
88227205

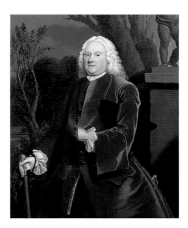

Hudson, Thomas (circle of) 1701–1779
Sir Thomas Webster, First Bt 1730
oil on canvas 127.0 x 101.6
88227207

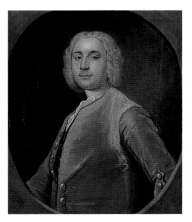

Hudson, Thomas (circle of) 1701–1779
Captain Edward Webster c.1740
oil on canvas 76.2 x 63.5
88227218

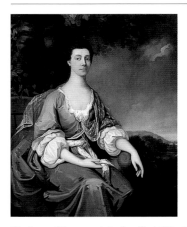

Hudson, Thomas (circle of) 1701–1779
Lady Martha Whistler Webster
oil on canvas 127.0 x 101.6
88227219

Hudson, Thomas (circle of) 1701–1779
Sir Whistler Webster, Second Bt
oil on canvas 127 x 110 (E)
88227217

Humphry, Ozias (circle of) 1742–1810
Lady Martha Whistler Webster
oil on canvas 76.2 x 63.5
88227212

Kneller, Godfrey (circle of) 1646–1723
Sir Godfrey Webster
oil on canvas 127.0 x 101.6
88227208

Legrand, Pierre Nicolas 1758–1829
Lady Charlotte Webster
oil on canvas 76.2 x 63.5
88227213

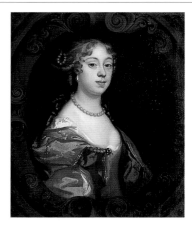

Lely, Peter (circle of) 1618–1680
Abigail Jordan (Later Lady Webster)
oil on canvas 76.2 x 63.5
88227210

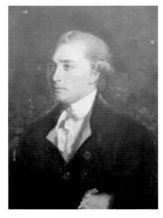

Stuart, Gilbert (follower of) 1755–1828
Sir Godfrey Vassal Webster, Fifth Bt
oil on canvas 76.2 x 63.5
88227214

Wilkins, Francis William 1800–1842
The Battle of Hastings 1820
oil on canvas 518.2 x 960.1
88227225

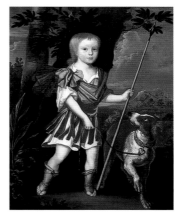

Wright, John Michael (follower of)
1617–1694
Sir Thomas Webster, First Bt, Aged 3 1680
oil on canvas 109.2 x 88.9
88227209

Battle Library

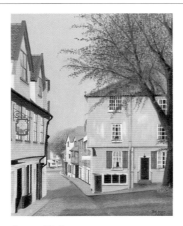

Avery, Ted
A Yellow House and Pub Lining a Street in Battle 1996
oil on canvas 48.5 x 40.0
UNC3

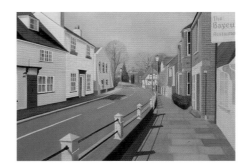

Avery, Ted
View of Mount Street, Battle 1996
oil on canvas 45.5 x 60.0
UNC2

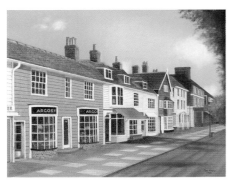

Avery, Ted
View of Shops in Tenterden 1996
oil on canvas 43 x 52
UNC1

Bexhill Museum

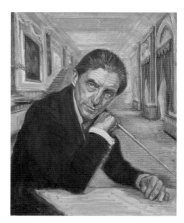

Burston, Samuel
Sir John Barbirolli
oil on canvas 50 x 40
BEXHM:2002.28.1

Graves, Charles A. 1834/1835–1918
*View from the Lawn, The Firs, Bexhill, Sussex
1891* 1891
oil on canvas 34 x 60
BEXHM:LP113

Graves, Charles A. 1834/1835–1918
View from Millfield, Bexhill 1896 1896
oil on canvas 29 x 60
BEXHM:LP 114

Graves, Charles A. 1834/1835–1918
High Street, Old Bexhill in 1898 1898
oil on canvas 41 x 56
BEXHM:LP108

Graves, Charles A. 1834/1835–1918
View from Millfield, Bexhill 1899 1899
oil on canvas 35 x 60
BEXHM:LP112

Graves, Charles A. 1834/1835–1918
Millfield, Bexhill 1904 1904
oil on canvas 44 x 72
BEXHIM:LP 115

Hacker, Enid
Hoad & Son Downs Mill, Bexhill-on-Sea
oil on board 46 x 61
BEXHM:1989.132

Hatfield, L. S.
*On the 5.15pm St Pancras to St Albans
(Blackout Train Scene)* 1941
oil on board 30.5 x 40.5
BEXHM:1992.417

A. J.
Industrial Scene 1964
oil on board 122 x 77
BEXHM:2004.197

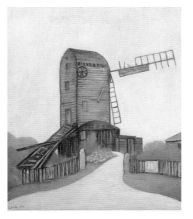

Lowry, Laurence Stephen 1887–1976
Old Windmill, Bexhill (Hoad's Mill) 1960
oil on canvas 78.5 x 68.5
BEXHM:1999.18

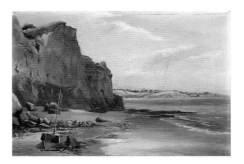

Oliver, M.
Galley Hill 1888
oil on canvas 23 x 33
BEXHM:LP94

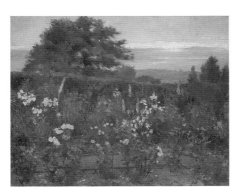

Sargent, Henry 1891–1983
Garden Scene
oil on canvas 45 x 55
BEXHM:2004.198

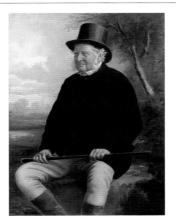

unknown artist
Arthur Sawyer Brook, 'Squire of Bexhill'
oil on board 60.5 x 46.7
BEXHM:LP 120

unknown artist
J. C. Thompson
oil on canvas 90 x 69
BEXHM:2004.196

Brighton and Hove Museums and Art Galleries

In 1850 the Brighton Town Commissioners purchased the Royal Pavilion and its estate from the Crown and a year later a group of Brighton artists, who had formed the Brighton and Sussex Society of Fine Arts, used available space in the upper rooms to establish an annual exhibition of paintings in oil and watercolour. An entrance fee of one shilling was charged and the takings were partly used by the Pavilion Committee to purchase pictures from the exhibition, the intention being that the pictures should form the nucleus of a public picture gallery. Over three years just over £181 was raised and used to purchase pictures by local artists including R. H. Nibbs, members of the prolific Earp dynasty of Brighton painters, and William John Leathem.[1] As well as purchasing pictures, the Committee also accepted gifts for the Pavilion gallery, located in rooms over the King's Apartments. In 1858 the Athenaeum Club presented Sir Thomas Lawrence's studio copy of a portrait of George IV. The picture was hung in the Banqueting Room.

By 1860 the nucleus of a permanent collection had been acquired and two local artists, Montague Penley and George de Paris, both members of the Pavilion Committee, were asked to assist in classifying the burgeoning collection, which, like other Victorian museum collections, consisted of contemporary British pictures, especially those with local links or by local artists.[2] There was little or no interest in contemporary Continental work. The local artists who formed the Fine Arts Sub Committee bought very conservatively, favouring large pictures in accord with academic taste. This pattern remained constant throughout the 19th century and Brighton's picture collection reflects national trends with appealing landscapes, social realism, paintings illustrating British history, and sentimental genre works. By August 1861 new picture galleries had been fitted up on the first floor of the Pavilion. The re-named Brighton Art Society appears to have used this space as well as the Great Kitchen for a display of no fewer than 500 oils and watercolours.[3] These loan exhibitions continued until 1865. On 9 November 1861 the Brighton and Sussex Museum was formally opened in the Royal Pavilion by Sir Richard Owen. As was common at the time, the museum was largely devoted to geology and natural history, but the Pavilion picture gallery continued to display paintings, some on loan, some already belonging to the town. In 1866 further rooms above the entrance hall were adapted for use as a gallery to display municipally owned pictures.

Accommodation in the Pavilion for the growing art collections and museum specimens was always inadequate and as early as 1856 moves were afoot to appropriate buildings formerly used as stables and coach houses for Queen Adelaide for use as a museum, library and art gallery. In 1873 the new Museum, Art Gallery and Library was opened in Church Street. Its building was the culmination of that Victorian belief that the cultivation of the mind was as important as law and order and working drains. The top-lit art gallery is one of the earliest purpose-built municipal picture galleries in the country. It was designed by the Borough Surveyor, Philip Lockwood, in a style reminiscent of a covered market or railway station. It was the largest space within the new

[1] *Proceedings of the Pavilion Committee*, vol. 1, 12 February 1855, p.363.
[2] Ibid., vol. 3. 16 January 1860.
[3] *Brighton Herald*, 22 August 1861.

museum. The opening display consisted of loans, but the *Brighton Herald* was already campaigning for the permanent collection to be displayed in the picture gallery in order to attract other gifts and bequests. The new gallery, confusingly, continued to be referred to as the 'Royal Pavilion Gallery' until about 1896. The Pavilion itself continued to exhibit paintings of primarily local interest in a variety of locations. In 1877 a supplementary museum was opened in the Pavilion displaying, amongst much else, prints illustrating the history and development of Brighton.

A pattern soon emerged in the new picture gallery by which loan and sale collections of watercolours were displayed in the spring and oils in the autumn. Pictures from the permanent collection were also displayed. The picture gallery was free except during the first three weeks of each exhibition, when a charge was made from Monday to Wednesday with Thursday to Saturday as free days. It was thought that this arrangement would result in the 'encouragement of artists by the sale of their works and the cultivation of refinement amongst the people'.[4] Pictures continued to be acquired, still mainly from local artists. In June 1891 the Town Council resolved that monies received from admission to the gallery should be used to purchase one picture annually for the permanent collection. The long duration of the sale exhibitions made it increasingly difficult to display the town's pictures and there was a pressing need for further space, an issue which was finally addressed by the provision of three new temporary exhibition galleries in 1902. By 1907 the permanent collection of oil paintings was hung in chronological order in the picture gallery with other pictures displayed elsewhere in the building. The £100 per year which had been granted annually by the Corporation for the purchase of pictures from the autumn exhibition was raised to £150 by 1910.

The provision of dedicated temporary exhibition galleries only briefly ameliorated the ever-present problem of lack of space. In April 1910 the Fine Art Sub Committee reported that very large pictures were being stored at the Madeira Drive shelter hall on the seafront. In the same year, nineteen pictures of an unspecified nature were given on 'permanent loan' to the education committee for hanging on the walls of a hostel in Beaconsfield Villas, Brighton. Occasionally pictures were even given away. A large canvas entitled *Christ Rejected*, attributed to Benjamin West, was decreed to be too large for the picture gallery and was given in 1910 to the Boston Museum of Fine Arts.

Although a large topographical collection of prints and drawings related to the history of Brighton had been acquired by the 1870s, it was not until the opening of the purpose-built museum and art gallery that gifts and bequests of importance began to be made. Paintings by Hendrik van Balen, Jan van Goyen (unfortunately stolen) and other masters were generally gifts from members or associates of the Fine Arts Committee. In May 1897 the Reverend Francis John Ottley bequeathed sixteen Dutch pictures; of outstanding importance was the gift by Henry Willett in 1903 (confirmed by a codicil to his will in 1905) of nearly sixty pictures. Willett's taste encompassed early Italian and Netherlandish schools, including *The Raising of Lazarus* by Jan Lievens, which once hung in Rembrandt's house.

It is unfortunate that Willett sold his more important works before his death and Brighton thus failed to acquire pictures by Giotto, Ghirlandaio

[4] Ibid., 28 May 1874.

and Roger Van der Weyden, amongst others. Willett had a passionate belief in the educational role of museums. Influenced by his friend John Ruskin, he wanted his collection to appeal to as broad an audience as possible. He favoured pictures from which visitors could derive pleasure by recognising and understanding figures and stories. In a catalogue of 1903 Willett wrote: 'The love of novelty, and the desire to escape from the monotony of life, are the motives which influence most people in entering a Picture Gallery. And if a short visit should afford a respite from "Anxious Self, Life's cruel Taskmaster", and permit any overburdened mind to regain its elasticity by obtaining fresh ideas and pleasant thoughts, an idle half-hour among pictures will not really be wasted'. [5]

Donations, bequests and purchases continued to enrich the collections, often in unpredictable ways, in the 20th century. In 1916 the Simpkins Bequest brought into the museum a collection of pictures which admirably reflect academic taste of the mid to late Victorian period with works by Alma-Tadema, John Brett, Luke Fildes, Frederick Goodall, John Linnell and Edward Poynter, amongst others. The Tessier Bequest of 1923 includes Dutch pictures by Van Bassen and Van der Velde amongst a more miscellaneous group of English and French paintings. The bequest strengthened the already considerable holdings of 17th century Dutch and Netherlandish schools. The weakness in works by Italian artists was partially remedied by C. F. N. Bergh's bequest in 1969 of a sum of money to be devoted to the purchase of 17th and 18th century oil paintings. As no nationality was prescribed, a group of some fourteen Italian oil sketches was acquired between 1970 and 1972.

Brighton Museum and Art Gallery has a strong collection of early 20th century British pictures. These have largely been donated but mention should be made of the pioneering series of exhibitions inaugurated by Henry Roberts, appointed Chief Librarian and Curator in 1906. From the *Exhibition of the Work of English Post-Impressionists, Cubists and Others* held in 1913–1914, Roberts purchased Robert Bevan's *The Cab Yard, Night*, the only painting bought by a public collection in the artist's lifetime. Three years earlier Roberts had put on an exhibition of Modern French artists. The exhibition included works by the French Impressionists and Post-Impressionists including Monet, Renoir, Sisley and Cézanne. The deeply conservative Fine Arts Sub Committee made only one purchase: the safe, uncontroversial and rather over-wrought *Swans at Play* by the now largely forgotten Gaston de Latouche, for which £320 was paid. For the same sum they could have acquired a Monet.[6] In subsequent years pictures by Mark Gertler, Harold Gilman, Charles Ginner, Ivon Hitchens, Sir John Lavery, Glyn Philpot, Walter Sickert, Edward Wadsworth and Rex Whistler were acquired. The museum has a particularly strong collection of works by Philpot, built up over many years through the generosity of members of the artist's family, many of whom have had connections with Brighton and Sussex.

The most important bequest of the late 20th century was that of Paul Heyer (1937–1997), a native of Brighton who set up an architectural practice in New York. Heyer assembled an important collection of contemporary American art, mostly dating from the 1970s and 1980s and in 1997 eleven works from his collection were, quite unexpectedly, bequeathed to Brighton Museum. The

[5] Henry Willett, *Catalogue (Imperfectly Descriptive) of a Collection of Pictures Lent to the Picture Gallery Brighton*, February 1903.
[6] Philip Vainler, 'Brighton's Early Art Exhibitions', *Royal Pavilions and Museums Review*, No. 2, 1988, pp.3–4.

acrylic and oil paintings in the bequest are by Frank Stella, Jules Olitski and Larry Poons, artists who developed and expanded the ideas of the New York school of Abstract Expressionism.

In 1997 the creation of the Brighton and Hove Unitary Authority resulted in the integration of the picture collections of both Hove Museum and Art Gallery and Brighton Museum. A museum collection of scientific specimens was first formed in Hove in 1900 and housed in various temporary locations. In 1908 a museum was formed in the upper rooms of Hove Library, but very rapidly outgrew its available space. In 1927 the museum collections were moved to Brooker Hall, a large Italianate villa built in 1877, which opened as Hove Museum and Art Gallery. At the museum's opening in 1927 the picture collection was largely on loan, but gifts and bequests were rapidly accepted, most notably from the Contemporary Art Society which presented pictures to Hove in 1940 and 1949. In 1975 the decision was made to concentrate on British 20th century paintings and drawings and since then an interesting group of pictures has been acquired, almost all of which are representational. The works include pictures by members of the Camden Town School as well as paintings by Hilda Carline, Duncan Grant, Henry Lamb, Bernard Meninsky and Gilbert Spencer.

Brighton and Hove City Council, Royal Pavilion, Library and Museums Service has benefited from the extraordinary generosity of the many benefactors who have donated or bequeathed works of art. Where pictures have been purchased, the support of outside funding bodies has been essential and the long-standing contributions of the Friends of the Royal Pavilion, Art Gallery and Museums, the Friends of Hove Museum, the National Art Collections Fund, the Contemporary Art Society and the Victoria & Albert Museum Purchase Grant Fund are here gratefully acknowledged. In addition, I should like to thank the following colleagues and volunteers who have contributed in many different ways in the preparation of this catalogue: Janet Brough, Jessica Campbell, Katy Gibson, Jenny Hand, and Lavender Jones.

Preston Manor

In 1932 Sir Charles and Lady Thomas-Stanford gave Preston Manor, together with its grounds and historic contents, to the Corporation of Brighton. The pictures in the gift include family portraits, landscapes, souvenirs of Madeira and Norway (where the Stanfords owned property), topographical paintings of Preston and its village, and sporting and equestrian pictures which reflect Ellen Stanford's passion for hunting and the turf. Amongst the portraits are works by Etty, Orpen and Sir J. J. Shannon, whilst in the drawing room is a group of landscapes of the 18th and 19th centuries by Alexander Nasmyth, Abraham Pether, Thomas Sidney Cooper, William Shayer and J. Clayton Adams. These artists, many of whom exhibited at the Royal Academy or the Royal Society of British Artists, represent an interesting document of late Victorian and Edwardian taste. Once hung in the drawing room, but now in the hall, is the most important painting at Preston Manor, *The Virgin and Child*, by Nicolas Poussin with Daniel Seghers. The picture was bought at Christie's by Vere Benett-Stanford, Ellen Stanford's first husband.

In 1939 Preston Manor received an important bequest of furniture, silver and pictures from Theresa Macquoid, widow of Percy Macquoid (1852–1925),

an artist, decorator and pioneer furniture historian, from whose collection the bequest came. The pictures are a mixed bag but include paintings which Macquoid believed to be by such masters as Holbein, Mabuse and Van Orley, but which are now, unfortunately, ascribed to anonymous painters of the Antwerp, Flemish and Netherlandish schools.

David Beevers, Keeper of Fine Art, Royal Pavilion, Libraries and Museums, Brighton and Hove

Aachen, Hans von (style of) 1552–1615
Nativity c.1590
oil on wood panel 51 x 39
FA000073

Adams, John Clayton 1840–1906
On the Llugwy, North Wales 1899
oil on canvas 79 x 118
FAPM090020

Adams, John Clayton 1840–1906
The Meadow Pool 1899
oil on canvas 73 x 119
FAPM090027

Adams, Norman b.1927
The Whole: The Word 1964
oil on canvas 87.0 x 91.5
FAH1994.55

Aelst, Willem van 1627–after 1687
Still Life with Carnations 1682
oil on canvas 49.5 x 40.2
FA000108

Aitken, J.
Christmas Time 1858
oil on canvas 25.0 x 20.3
FA000818

Aldridge, Eileen 1916–1990
The Downs near Brighton 1962
oil on canvas 71.5 x 91.5
FA000307

Allinson, Adrian Paul 1890–1959
Winter Magic
oil on canvas 67 x 91
FA000889

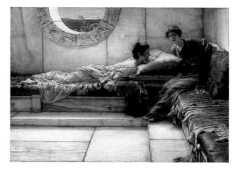

Alma-Tadema, Lawrence 1836–1912
The Secret 1887
oil on wood panel 40.4 x 54.9
FA000038

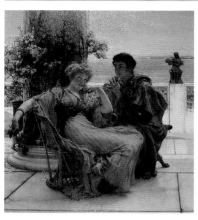

Alma-Tadema, Lawrence 1836–1912
Courtship (The Proposal) 1892
oil on canvas 39.2 x 35.5
FA000037

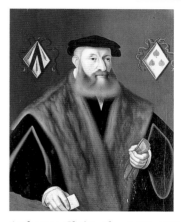

Alsloot, Denys van before 1573–1625/1626
Winter Landscape with Distant Village c.1610
oil on wood panel 44.3 x 58.7
FA000063

Amberger, Christoph c.1505–1561/1562
Portrait of a Man
oil on wood panel 78.3 x 63.0
FAH1945.62

Amshewitz, John Henry 1882–1942
Head of a Man 1910
oil on board 32.5 x 27.5
FA001005

Amshewitz, John Henry 1882–1942
The Revilers 1928
oil on canvas 58.6 x 61.7
FA000579

Andrews, H. d.1868
*The Duke and Duchess of Marlborough
Hawking at Blenheim*
oil on canvas 110.5 x 174.0
FA000723

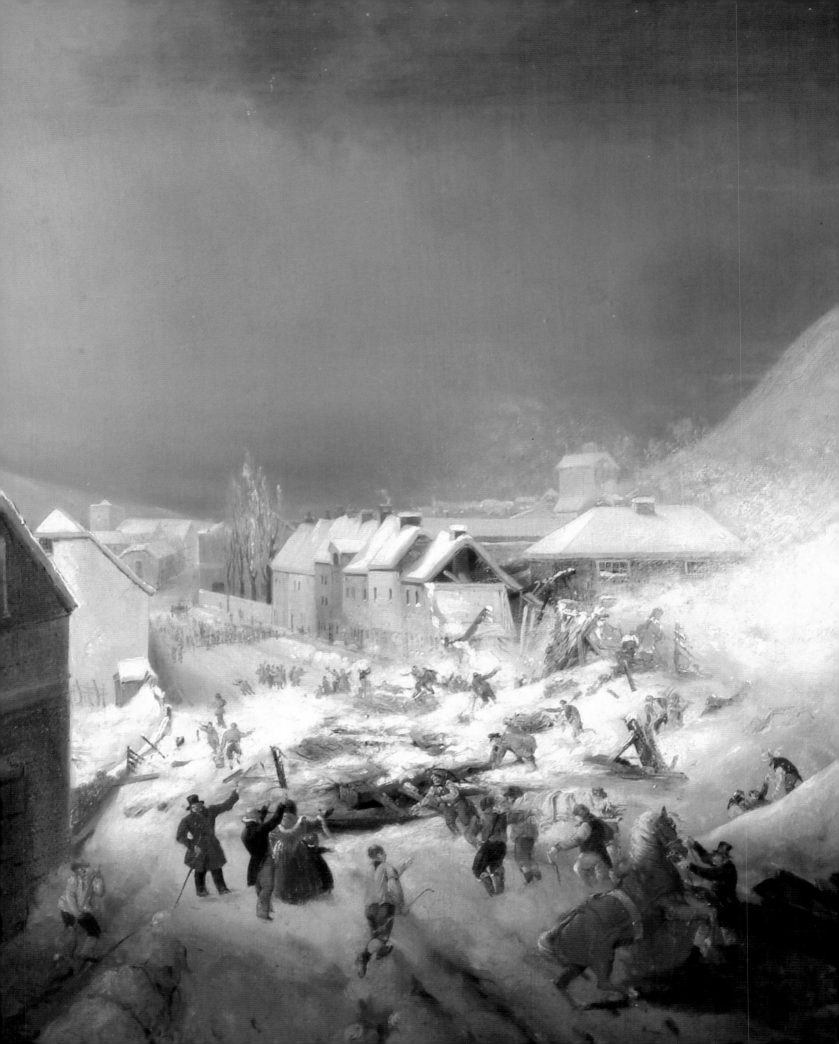

Andsell, Richard 1815–1885
Portrait of a Gentleman
oil on canvas 63.2 x 49.8
FAH1933.8

Annan, Dorothy 1908–1983
Girl with an Apple 1943
oil on board 81.5 x 56.3
FA000278

Anrooy, Anton Abraham van 1870–1949
Rhododendrons 1947
oil on canvas 61.0 x 48.3
FAH1963.57

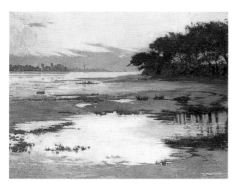

Appleton, Honor 1879–1951
Poole Harbour
oil on canvas 76.0 x 99.5
FAH1957.51

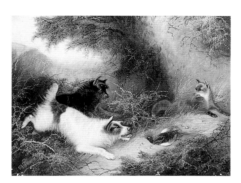

Armfield, Edward 1817–1896
Disturbed at Dinner
oil on canvas 71.1 x 91.5
FA000693

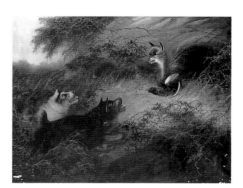

Armfield, Edward 1817–1896
Disturbed at Dinner (Large)
oil on canvas 101.6 x 127.2
FA000706

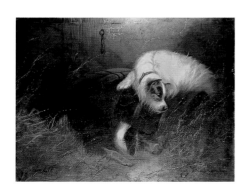

Armfield, Edward 1817–1896
On the Watch
oil on canvas 71.1 x 91.5
FA000695

Armfield, Edward 1817–1896
The Otter Hunt
oil on canvas 101.9 x 127.3
FA000705

Armitage, Edward 1817–1896
Samson and the Lion 1881
oil on canvas 330 x 199
FA001177

Facing page: unknown artist, *The Avalanche at Lewes, 1836* (detail), Lewes Castle and Museum, (p. 349)

Armstrong, John b.1937
Groyne at Hove Beach 1974
oil on hardboard 91 x 91
FAH1982.3

Ashford, William 1746–1824
Dublin from Phoenix Park 1797
oil on canvas 129.0 x 162.8
FA000620

Ashford, William 1746–1824
Dublin Harbour from Howth 1797
oil on canvas 129 x 191
FA000643

Ashton, C. H.
Pastoral Lovers 1896
oil on canvas 85.0 x 74.8
FA000875

Attree, J.
St Peter's Church, Brighton 1846
oil on wood panel 20.4 x 25.3
FA000628

Aumonier, James 1832–1911
Sketch for Sunday Evening
oil on canvas 37.5 x 64.8
FAH1936.50(a)

Austrian School
An Architectural Fantasy c.1720
oil on canvas 60.6 x 50.7
FA000069

Austrian School
Study for a Painted Ceiling c.1725
oil on wood panel 49.8 x 40.0
FA000074

Backhuysen, Ludolf I (attributed to)
1630–1708
Fishing Boats
oil on canvas 49.5 x 60.2
FA000200

Balen, Hendrik van I 1575–1632 **&**
Brueghel, Jan the elder 1568–1625
Pluto and Persephone c.1610
oil on wood panel 39.4 x 53.0
FA000060

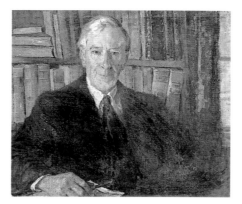

Barker, Adeline Margery b.1907
Reverend Edward Tickner Edwardes c.1940
oil on canvas 64.0 x 72.5
FA000309

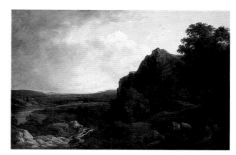

Barker, Benjamin II 1776–1838
Landscape 1807
oil on canvas 116.5 x 172.5
FA000031

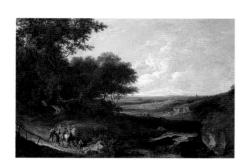

Barker, Benjamin II 1776–1838
Landscape with Waterfall
oil on canvas 60 x 85
FAH1927.47

Barrett, Jerry 1814–1906
Connoisseurs Studying Sculpture
oil on canvas 94 x 83
FA000931

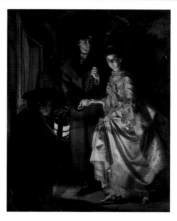

Barrett, Jerry 1814–1906
*Sheridan Assisting Miss Linley on Her Flight
from Bath*
oil on canvas 104 x 81
FA000212

Barrington, Trend
Hangleton Manor 1969
oil on canvas 45.6 x 61.0
FAH1970.40

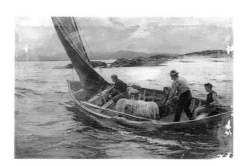

Bartlett, William H. 1858–1932
Bound for the Island Home 1904
oil on canvas 105.7 x 156.2
FA000131

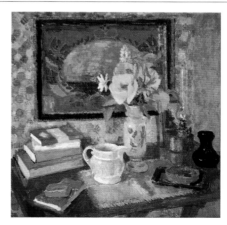

Bas, Edward le 1904–1966
The Bedside Table c.1940–1943
oil on board 59.5 x 61.0
FA000672

Bassen, Bartholomeus van c.1590–1652
Interior of an Imaginary Church 1627
oil on canvas 99.0 x 123.2
FA000002

Bateman, James 1893–1959
Thames Wharf c.1929–1930
oil on canvas 56 x 71
FA000683

Battersby, Martin 1914–1982
Oedipus and the Sphinx c.1965
oil on canvas 127 x 183
FA000090

Bauchant, André 1873–1958
Paysage montagneux 1929
oil on canvas 50.5 x 61.5
FA000315

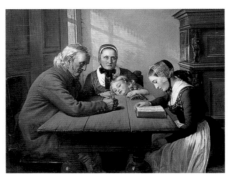

Baumann, Elisabeth 1819–1881
Sunday Evening 1858
oil on canvas 127 x 162
FAH1975.2

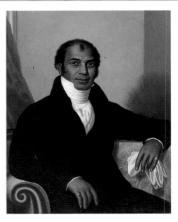

Baynes, Thomas Mann 1794–1854
Sake Deen Mahomed
oil on canvas 91.5 x 71.0
FA000732

Bazzani, Giuseppe 1690–1769
St Margaret of Cortona
oil on canvas 85.7 x 67.0
FA000387

Beale, Mary (attributed to) 1633–1699
Portrait of a Lady as St Agnes c.1670
oil on canvas 43.8 x 37.0
FAPM090012

Beard, E. 1878–1949
Pontus et aer 1909
oil on canvas 68.6 x 88.6
FA000967

Beaubrun family, (attributed to) active 16th
C–17th C
Henrietta Anne, Duchess of Orleans (1644–1670)
oil on canvas 130 x 98
FAH1945.73

Beaumont, Claudio Francesco 1694–1766
The Banquet of Alexander and Roxana c.1740
oil on canvas 58.0 x 70.5
FA000078

Beaumont, George Howland 1753–1827
Castel Gandolfo, Lake Albano
oil on canvas 97.7 x 135.7
FA001001

Beavis, Richard 1824–1896
The Shore at Scheveningen 1875
oil on canvas 30.3 x 61.0
FA000236

Beechey, William 1753–1839
William Porden c.1807
oil on canvas 75.0 x 62.3
FA000968

Beers, Jan van 1852–1927
Lady of the Directoire
oil on wood panel 24.0 x 18.4
FA000737

Beert, Osias the elder c.1580–1624
Still Life with Nautilus Cup, Fruit, Nuts and Wine c.1610
oil on wood panel 56.3 x 75.8
FA000061

Beeton, W. & Hargitt, Edward 1835–1895
Riding in Hyde Park 1864
oil on canvas 86.2 x 111.7
FA000134

Begeyn, Abraham 1637/1638–1697
Landscape with Sheep
oil on canvas 54 x 65
FAH1942.15

Bell, E.
Hove Town Hall Fire 1966
oil on canvas 46.0 x 55.8
FAH1966.151

Bell, Julian b.1952
Castle Hill on the Sussex Downs
oil on canvas 30.5 x 76.5
FA001197

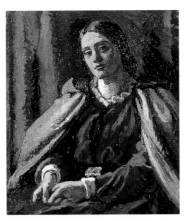

Bell, Vanessa 1879–1961
The Red Dress 1929
oil on canvas 73.3 x 60.5
FA000394

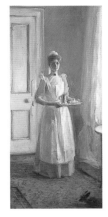

Belleroche, Albert de 1864–1944
The Servant
oil on canvas 85.8 x 38.8
FA000166

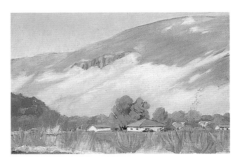

Bennett, E. A.
*Afrikaner Farmstead on the Road to
Hartebeestpoort* 1956
oil on paper 16.5 x 23.5
FA001121

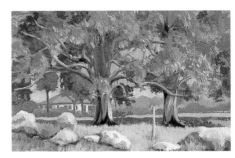

Bennett, E. A.
Avenue of Gum Trees, Rivonia, Transvaal 1956
oil on paper 19.7 x 28.4
FA001123

Bennett, E. A.
*Native House on Road to
Hartebeestpoort* 1958
oil on paper 16.2 x 25.3
FA001122

Bennett, E. A.
*Village Scene with Church at Centre and
Surrounded by Trees*
oil on paper 22.9 x 30.5
FA001119

Bennett, E. A.
Woodland Scene
oil on paper 26.2 x 36.4
FA001120

Bennett, James 1808–1888
Kemptown Park from Coes Field 1837
oil on board 16.4 x 26.0
FA001124

Bennett, James 1808–1888
The Manor House, Preston, Sussex c.1841
oil on canvas 37 x 57
FAPM090070
STOLEN

Bennett, James 1808–1888
Lover's Walk, Preston 1845
oil on canvas 19.0 x 26.5
FAPM090077

Bennett, James 1808–1888
The Manor House, Preston Place, Sussex 1845
oil on canvas 58 x 87
FAPM090082

Bennett, James 1808–1888
Hove, from the top of Holland Road c.1849
oil on board 17.6 x 25.8
FAH1930.84

Bennett, James 1808–1888
Country Scene
oil on canvas 86.8 x 122.8
FA001214

Bennett, James 1808–1888
Poynings
oil on board 18.5 x 27.3
FA000897

Bennett, James 1808–1888
Preston Park
oil on canvas 58.5 x 89.3
FA000844

Bennett, James 1808–1888
Preston Village and Manor
oil on canvas 58.5 x 88.9
FA000691

Bennett, James 1808–1888
Preston Village with the Railway
oil on canvas 58.4 x 89.0
FA000690

Bennett, James 1808–1888
Seascape
oil on canvas 30.8 x 38.3
FA000999

Bennett, James 1808–1888
The Pump House, Brighton, in 1825
oil on canvas 39.4 x 59.5
FA000206

Bennett, James 1808–1888
The Windmill
oil on board 18.6 x 27.1
FA001225

Bennett, James 1808–1888
View of Preston, near Brighton
oil on wood panel 14.5 x 24.8
FA000827

Berg, Adrian b.1929
Brighton Terrace 1990
oil on canvas 30.5 x 20.3
FAH1993.47

Bevan, Robert Polhill 1865–1925
The Cab Yard, Night c.1909–1910
oil on canvas 63.5 x 70.0
FA000121

Bevan, Robert Polhill 1865–1925
Rosemary la vallée 1916
oil on canvas 49.3 x 61.5
FAH1988.14

Bindon, Jack Armfield 1910–1985
St John's Church, Palmeira Square
acrylic on board 70 x 56
FAH1994.19

Facing page: Davie, Alan, b.1920, *Crazy Ikon (op. no. 258) (detail)*, 1959, Aldrich Collection, University of Brighton, (p. 198)

Birch, Samuel John Lamorna 1869–1955
Lingering Snows 1906
oil on canvas 125.9 x 151.5 (E)
FA000600

Birch, William Henry David 1895–1968
A Sussex Panorama c.1941
oil on canvas 95.8 x 383.6
FA000696

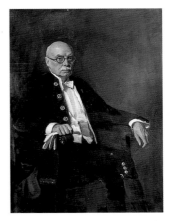

Birley, Oswald Hornby Joseph 1880–1952
William Henry Abbey 1935
oil on canvas 140 x 103
FA000927

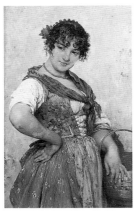

Blaas, Eugen von 1843–1931
Venetian Girl 1883
oil on wood panel 41.0 x 26.5
FA000557

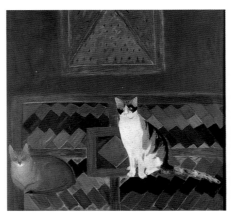

Blackadder, Elizabeth V. b.1931
Two Cats on a Kelim 1978
oil on canvas 90.5 x 90.5
FAH1985.30

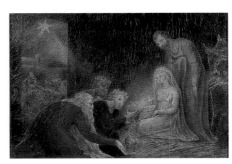

Blake, William 1757–1827
The Adoration of the Kings 1799
tempera on canvas 25.7 x 37.0
FA000034

Blanche, Jacques-Emile 1861–1942
Still Life: Fish on a Silver Plate 1908
oil on canvas 52 x 84
FAH1981.11

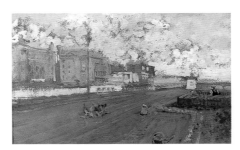

Blanche, Jacques-Emile 1861–1942
Brighton Front 1928
oil on board 28.5 x 45.0
FA000750

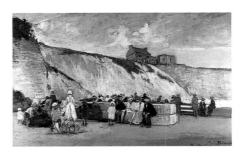

Blanche, Jacques-Emile 1861–1942
Black Rock, Brighton 1938
oil on canvas 61.0 x 96.5
FA000020

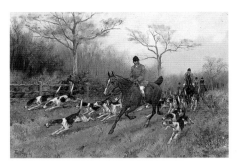

Blinks, Thomas 1860–1912
*Huntsmen and Hounds in a Wooded
Landscape* 1885
oil on canvas 24.3 x 34.7
FAPM090089

Block, Eugène-François de 1812–1893
The Signal 1874
oil on canvas 32.9 x 24.8
FA000259

Blyth, Beatrix
Woolbridge, Dorset
oil on hardboard 45.5 x 76.2
FAH1972.10

Bomberg, David 1890–1957
Players (formerly Fiesta) c.1920
oil on paper 30.8 x 41.3
FA100368

Bond, William H. 1861–1918
Old Shoreham Bridge 1904
oil on canvas 60 x 91
FA000325

Bone, Herbert Alfred 1853–1931
Mistress of the Moat 1898
oil on canvas 70.9 x 91.7
FA000376

Bonheur, Rosa 1822–1899
The Stag 1875
oil on canvas 21.7 x 16.4
FA000258

Bonheur, Rosa 1822–1899
Shepherd of the Pyrenees 1888
oil on canvas 60.5 x 81.0
FA000323

Bonington, Richard Parkes 1802–1828
Tomb in the Church of Saint Omer
oil on wood panel 19.2 x 14.6
FAH1922.26

Borcht, Peter van der (attributed to)
c.1540–1608
A Rest on the Flight into Egypt
oil on copper panel 25.8 x 35.1
FA000102

Borione, Bernard Louis b.1865
Cardinal at Coffee
oil on canvas 40.2 x 32.2
FA000437

Borione, Bernard Louis b.1865
Cavalier with Mandoline
oil on canvas 46.3 x 33.2
FA000563

Bottomley, Albert Ernest 1873–1950
Clay Hall Farm c.1934–1935
oil on board 63.6 x 76.5
FA000273

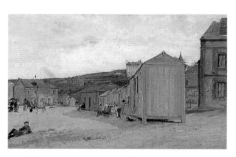

Boudin, Eugène Louis (after) 1824–1898
Trouville
oil on canvas 28.5 x 45.0
FA000268

Bowes, John 1899–1974
Cliffs and Forest
oil on canvas 41.0 x 61.8
FA000331

Boxall, William 1800–1879
Henry Graves 1829
oil on wood panel 32.2 x 24.4
FA000992

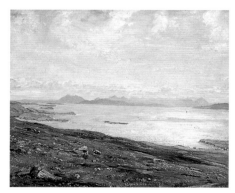

Boyle, Mark b.1934
Moorland Lake
oil on canvas 56.7 x 67.0
FA000405

Brangwyn, Frank 1867–1956
Queen Elizabeth Going aboard the 'Golden Hind' at Deptford c.1905
oil on wood panel 41 x 61
FA000336 🏵

Brangwyn, Frank 1867–1956
Ancona c.1937
oil on canvas 126.4 x 127.0
FA000136

Bratby, John Randall 1928–1992
Fishing Boat at Dungeness, RX67 c.1965
oil on canvas 132 x 81
FA000652

Breanski, Alfred de 1852–1928
View of Burnham Beeches
oil on canvas 30.4 x 35.7
FAH1927.75

Breanski, Gustave de c.1856–1898
Seascape
oil on canvas 77 x 118
FAH1931.54

Breanski, Gustave de c.1856–1898
Seascape with Fishing Boat
oil on canvas 78.5 x 119.5
FAH1932.92

Brett, John 1830–1902
Watergate, Cornwall 1881
oil on canvas 17.1 x 35.0
FA000043

Bridges, Thomas 1871–1939
House at Neuilly
oil on wood panel 30 x 41
FAH1939.173

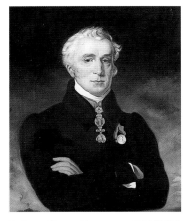

Briggs, Henry Perronet 1791/1793–1844
*The Duke of Wellington Wearing the Order of
the Golden Fleece* 1837
oil on canvas 76.9 x 64.0
FAH1946.68

British (English) School
Memento mori c.1580
oil on wood panel 54.0 x 43.5
FA000101

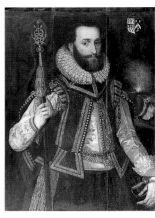

British (English) School
Portrait of a Gentleman in a Lace Ruff c.1600
oil on wood panel 103.5 x 80.0
FA000211

British (English) School
Portrait of a Young Man and Woman c.1600
oil on wood panel 39.5 x 55.8
FA000183

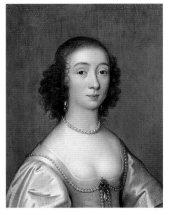

British (English) School
Lady Elizabeth Fane c.1640
oil on panel 38 x 30
FAPM090044

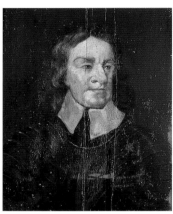

British (English) School
Oliver Cromwell c.1650
oil on wood panel 49.5 x 43.0
FA000433

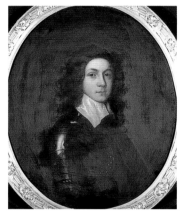

British (English) School
Man in Armour: Francis Boyle, Viscount Shannon 1660
oil on canvas 77 x 62
FAPM090078

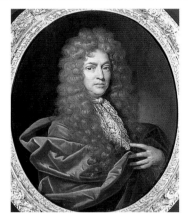

British (English) School
Lord Fairfax c.1660
oil on canvas 81.0 x 65.6
FA000144

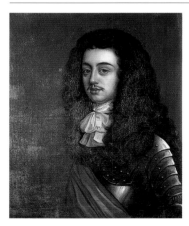

British (English) School
Sir Anthony Shirley (1624–1683) c.1660
oil on canvas 74.5 x 62.0
FAPM090040

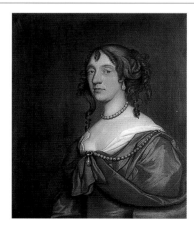

British (English) School
Portrait of a Woman c.1660–1665
oil on canvas 72 x 63
FAPM090053

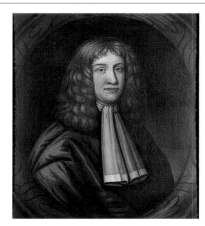

British (English) School
Portrait of a Man c.1670
oil on canvas 68 x 59
FAPM090051

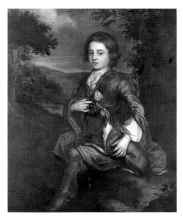

British (English) School
Portrait of a Boy with Dog c.1680
oil on canvas 119.5 x 97.0
FA000180

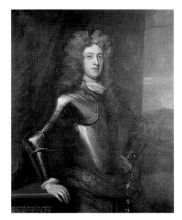

British (English) School 17th C
Henry Cavendish
oil on canvas 122.5 x 94.0
FAPM090006

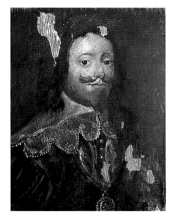

British (English) School
Charles I c.1700
oil on wood panel 19.6 x 14.6
FA000812

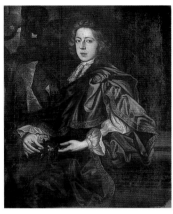

British (English) School
Portrait of a Young Man c.1700
oil on canvas 127.0 x 102.5
FA000127

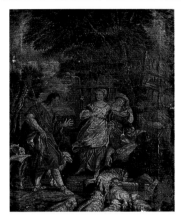

British (English) School
Shepherds c.1730
oil on canvas 50.0 x 39.5
FA000805

British (English) School
Angel and Figures by Ruins c.1750
oil on canvas 80.7 x 101.0
FA000242

British (English) School
Italianate Landscape c.1750
oil on canvas 89 x 119
FA000230

British (English) School
Portrait of a Man c.1750
oil on canvas 76.2 x 63.1
FA000187

British (English) School
Soldier with Decapitated Head c.1750
oil on canvas 95 x 163
FA000928

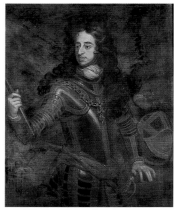

British (English) School
William IV, Prince of Orange c.1750
oil on canvas 123.0 x 98.8
FA000124

British (English) School
Village Scene 1760
oil on canvas 35.7 x 44.6
FA000824

British (English) School
Moonlit Shore with Figures c.1760
oil on canvas 84.0 x 135.2
FA000231

British (English) School
Outskirts of a Town c.1765
oil on canvas 78 x 112
FA000210

British (English) School
Italianate Landscape with Ruins c.1770
oil on canvas 132 x 108
FAPM090005

British (English) School
Italian Seaport c.1770
oil on canvas 54.0 x 61.2
FA000539

British (English) School
Shepherdess and Classical Ruins c.1770
oil on canvas 101.2 x 80.8
FA000244

British (English) School
Ecce Homo c.1775
oil on copper 22.4 x 17.0
FA000526

British (English) School
Woody Landscape c.1775
oil on wood panel 53.5 x 75.6
FA000145

British (English) School
Anne of Cleves (copy of Hans Holbein the younger) c.1780
oil on canvas 72.5 x 54.0
FAPM090042

British (English) School
Diana Sleeping c.1780
oil on canvas 64.9 x 81.2
FA000228

British (English) School
Landscape c.1780
oil on canvas 44.8 x 66.4
FA000814

British (English) School
Portrait of a Lady c.1780
oil on canvas 53.5 x 43.6
FA000185

British (English) School
'The Mole' at Algiers c.1780
oil on canvas 100 x 123
FAPM090003

British (English) School
HRH George Prince of Wales c.1785
oil on canvas 61 x 51
FA000746

British (English) School
Landscape with Church c.1790
oil on canvas 53.5 x 75.0
FA000289

British (English) School
Smoker Miles c.1790
oil on canvas 43.5 x 38.0
FA000811

British (English) School
Western Side of the Steyne, North of Castle Square, Brighthelmston 1797
oil on paper laid on canvas 38.5 x 98.5
FA001207

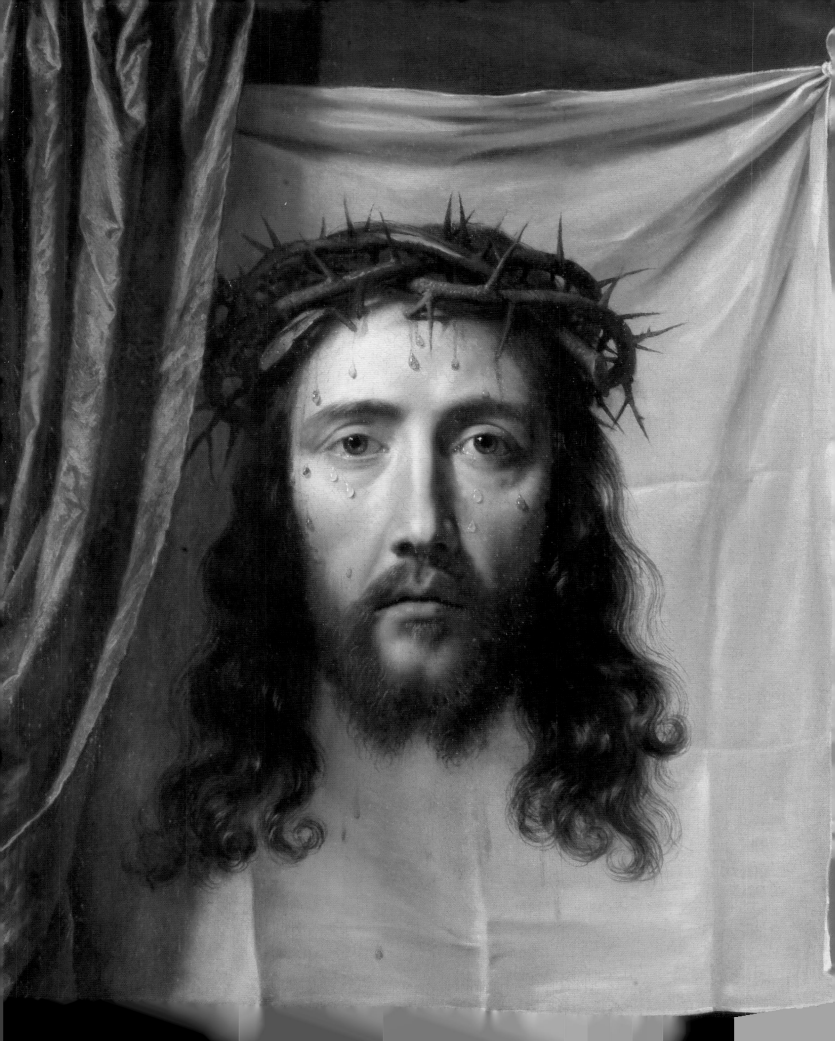

British (English) School
Western Side of the Steyne, South of Castle Square, Brighthelmston 1797
oil on paper laid on canvas 38.5 x 98.5
FA001208

British (English) School 18th C
Figures in Landscape
oil on canvas 51 x 61
FA000981

British (English) School 18th C
Landscape
oil on canvas 40 x 62
FA000982

British (English) School 18th C
Landscape
oil on canvas 20 x 25
FA000994

British (English) School 18th C
Mary Western?
oil on canvas 124 x 99
FAPM090039

British (English) School 18th C
Mythological Scene
oil on panel 20.0 x 25.4
FA001057

British (English) School 18th C
Rear Admiral Smith Callis
oil on canvas 124 x 99
FAPM090038

British (English) School late 18th C
Prince Charles
oil on wood panel 39.5 x 31.0
FAPM090054

British (English) School
Bramber Castle c.1800
oil on canvas 46 x 61
FA000900

Facing page: Champaigne, Philippe de, 1602–1674, *St Veronica's Veil* (detail), c.1640, Brighton and Hove Museums and Art Galleries, (p. 56)

British (English) School
Castle in a Landscape c.1800
oil on canvas 43 x 59
FA000886

British (English) School
Lake of Geneva c.1800
oil on canvas 88.6 x 121.3
FA000130

British (English) School
Lot Made Drunk by His Daughters c.1800
oil on canvas 53 x 70
FA000532

British (English) School
Mounted Figure c.1800
oil on canvas 37.0 x 44.5
FAPM090080

British (English) School
Pastoral Scene c.1800
oil on canvas 32 x 43
FAPM090023

British (English) School
Peasants in a Woodland Clearing c.1800
oil on canvas 91.5 x 72.0
FA000846

British (English) School
Seascape c.1800
oil on canvas 14.8 x 19.3
FA000473

British (English) School
View of a Cathedral City c.1800
oil on canvas 30.8 x 43.5
FA000821

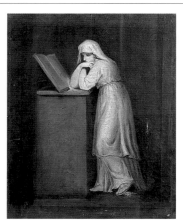

British (English) School
Woman in White Reading c.1800
oil on canvas 56 x 44
FA000535

British (English) School
Woodcutters in a Forest c.1800
oil on canvas 63.8 x 80.2
FA000738

British (English) School
Mary Tourle c.1802
oil on canvas 75.5 x 61.0
FAPM090062

British (English) School
William Stanford (1764–1841) 1808
oil on canvas 77 x 63
FAPM090061

British (English) School
Child and Angel c.1810
oil on canvas 51.0 x 37.5
FA000828

British (English) School
Portrait of a Law Officer c.1810
oil on canvas 92 x 71
FA000904

British (English) School
S. Ridley 1820
oil on canvas 77 x 64
FA000849

British (English) School
Brighton Beach c.1820
oil on canvas 105.5 x 147.6
FA000135

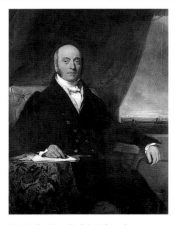

British (English) School
Captain Samuel Brown c.1820
oil on canvas 134.5 x 104.0
FA000669

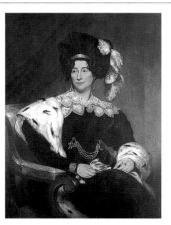

British (English) School
Lady Mary Brown c.1820
oil on canvas 135 x 104
FA000125

British (English) School
Lakeland Landscape c.1820
oil on canvas 25.1 x 31.4
FA000474

British (English) School
Portrait of a Bather c.1820
oil on canvas 103.0 x 78.8
FA000795

British (English) School
Seascape c.1820
oil on canvas 14.1 x 18.8
FA000629

British (English) School
Thomas Crosweller Junior (1788–1837) c.1820
oil on canvas 76.3 x 63.6
FA000191

British (English) School
*Thomas Crosweller Senior, Coach Proprietor
(1764–1829)* c.1820
oil on canvas 74.5 x 63.5
FA000321

British (English) School
William Giles Senior, Town Crier c.1820
oil on canvas 57 x 47
FA000867

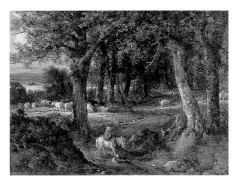

British (English) School
A Woodland Scene 1825
oil on canvas 21.0 x 26.5
FAPM090028

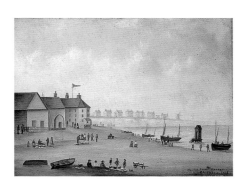

British (English) School
The Old Fish Market, Brighton 1825
oil on board 30.2 x 40.5
FA000991

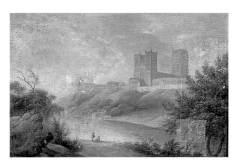

British (English) School
Durham c.1825
oil on canvas 30.0 x 43.5
FA000856

British (English) School
John Ade 1827
oil on board 30.8 x 26.2
FA000874

British (English) School
Fishing Scene c.1830
oil on wood panel 21.0 x 28.2
FA000944

British (English) School
James Crosweller (1788–1837) c.1830
oil on canvas 76.5 x 63.0
FA000892

British (English) School
Joseph Henry Good c.1830
oil on canvas 77 x 64
FA000730

British (English) School
Mrs Joseph Henry Good c.1830
oil on canvas 77 x 64
FA000731

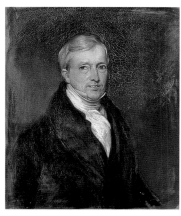

British (English) School
Smith Hannington c.1830
oil on canvas 74 x 65
FA000921

British (English) School
The Raising of Lazarus c.1830
oil on canvas 50.5 x 62.0
FA000531

British (English) School
Windmill by the Coast c.1830
oil on canvas 25.5 x 36.3
FA000819

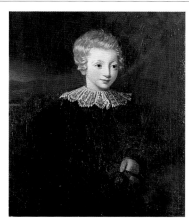

British (English) School
Captain MacDonald as a Child, Aged 4 c.1832
oil on canvas 75.5 x 62.5
FAPM090056

British (English) School
View of a Seaside Town: Rottingdean 1837
oil on canvas 43.0 x 61.5
FAPM090002

British (English) School
Brighton Beach c.1840
oil on board 33.2 x 48.3
FA001096

British (English) School
Christiana Delores MacDonald c.1840
oil on canvas 74.5 x 62.5
FAPM090007

British (English) School
Gentleman Seated c.1840
oil on canvas 57 x 45
FA000536

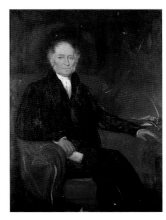

British (English) School
Henry Pegg c.1840
oil on canvas 119 x 87
FA001183

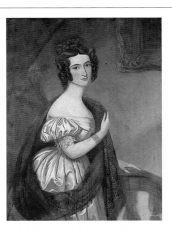

British (English) School
Portrait Reputed to be of Mrs Varnham c.1840
oil on canvas 111 x 84
FAPM090004

British (English) School
The Reverend James Vaughan c.1840
oil on canvas 61.0 x 51.3
FA000806

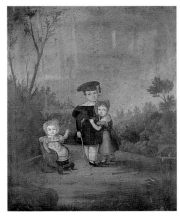

British (English) School
Three Children c.1840
oil on canvas 73 x 62
FA000860

British (English) School
Chain Pier 1841
oil on canvas 15.1 x 20.0
FA000948

British (English) School
Floating Breakwaters at Brighton c.1845
oil on canvas 66 x 132
FA000319

British (English) School
A Village Church c.1850
oil on canvas 30 x 41
FA000861

British (English) School
Coastal Scene c.1850
oil on canvas 61.5 x 107.2
FA000692

British (English) School
Garden Arbour c.1850
oil on canvas 35.0 x 24.5
FAPM090036

British (English) School
Man-O'-War at Sea c.1850
oil on canvas 45.8 x 60.4
FA000203

British (English) School
Portrait of a Woman c.1850
oil on canvas 76.2 x 63.2
FA000802

British (English) School
Savonarola c.1850
oil on canvas 63 x 49
FA000533

British (English) School
Two Arabs c.1850
oil on panel 20.0 x 25.4
FAPM090035

British (English) School
Valley Landscape c.1850
oil on wood panel 23.1 x 31.4
FA000484

British (English) School
William Stanford the Younger (1809–1853)
c.1850
oil on canvas 77 x 64
FAPM090034

British (English) School
Brighton Viaduct c.1860
oil on canvas 75.5 x 121.1
FA000701

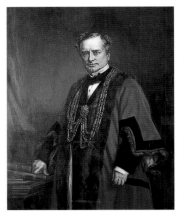

British (English) School
Sir John Cordy Burrows c.1860
oil on canvas 134.0 x 107.5
FA000673

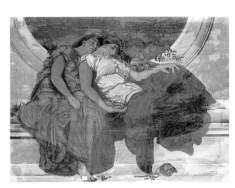

British (English) School
Sleeping Couple c.1860
oil on canvas 102.0 x 127.3
FA000711

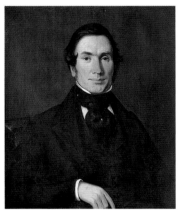

British (English) School
Thomas Lulham c.1860
oil on canvas 76.5 x 64.0
FA000729

British (English) School
R. Waller 1865
oil on canvas 30.5 x 25.1
FA000963

British (English) School
Charles Carpenter c.1870
oil on canvas 127 x 102
FA000915

British (English) School
Terriers with a Caged Ferret 1875
oil on canvas 30.5 x 37.0
FA000427

British (English) School
Jim: Yorkshire Terrier 1880
oil on canvas 45 x 39
FAPM090066

Facing page: Philpot, Glyn Warren, 1884–1937, *Acrobats Waiting to Rehearse* (detail), 1935, Brighton and Hove Museums and Art Galleries, (p. 161)

British (English) School
Portrait of a Man 1880
oil on canvas 91.5 x 71.0
FA000792

British (English) School
Portrait of a Woman c.1880
oil on canvas 25.0 x 20.2
FA000949

British (English) School
Prince Peter Kropotkin c.1880
oil on canvas 61 x 46
FA000815

British (English) School
Mayor Slingsby Roberts c.1890
oil on canvas 191.8 x 129.0
FA000712

British (English) School
Portrait of a Gentleman with Bust c.1890
oil on canvas 144.0 x 107.3
FA000617

British (English) School
Portrait of a Mayor c.1890
oil on canvas 251 x 182
FA000873

British (English) School
Mayor Botting 1896
oil on canvas 93.5 x 75.0
FA000850

British (English) School
Old Chain Pier, Brighton 1896
oil on board 25.2 x 35.4
FA001125

British (English) School
The Chain Pier 1896
oil on canvas 30.5 x 61.0
FA000504

British (English) School early 19th C
Portrait of a Boy in a Red Suit
oil on canvas 44 x 35
FAPM090052

British (English) School early 19th C
Portrait of a Man
oil on canvas 74 x 64
FA001232

British (English) School 19th C
*Alderman W. Hallett, Mayor of Brighton
(1855–1856)*
oil on canvas 240 x 148
FA001180

British (English) School 19th C
*A Lifeguardsman Attacking a Cuirassier at
Waterloo*
oil on canvas 30.5 x 40.7
FAH1985.25

British (English) School 19th C
Ann Vallance
oil on canvas 95.0 x 75.7
FAH1952.71

British (English) School 19th C
Brighton Front and Chain Pier
oil on canvas 33.4 x 53.6
FA000556

British (English) School 19th C
Brighton Sammy the Walking Fishmonger
oil on canvas 41.0 x 31.0
FA000262

British (English) School 19th C
Brighton to London Coach
oil on canvas 57 x 65
FA000943

British (English) School 19th C
Brooker Vallance
oil on canvas 70.8 x 63.5
FAH1954.1

British (English) School 19th C
Chain Pier
oil on paper 15.9 x 22.7
FA103769

British (English) School 19th C
Coaching Scene
oil on canvas 50.5 x 61.0
FA000941

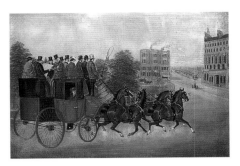

British (English) School 19th C
Coaching Scene
oil on canvas 51 x 69
FA000942

British (English) School 19th C
Frederick Akbar Mahomed (1849–1884)
oil on canvas 91.5 x 71.5
FA001135

British (English) School 19th C
George Battcock
oil on canvas 77.0 x 63.8
FA000192

British (English) School 19th C
Henry Soloman
oil on canvas 25.9 x 21.2
FA000475

British (English) School 19th C
James Vallance
oil on canvas 95 x 76
FAH1952.70

British (English) School 19th C
Lewis Slight
oil on canvas 127.5 x 101.6
FA001117

British (English) School 19th C
Mrs Brooker Vallance
oil on canvas 75.5 x 63.5
FAH1954.2

British (English) School 19th C
Napoleon
oil on canvas 71.4 x 61.4
FA000560

British (English) School 19th C
Shakespearian Characters
oil on board 13.5 x 10.0,
10.8 x 18.5
FA102202

British (English) School 19th C
Shakespearian Characters
oil on board 21 x 16
FA102203

British (English) School 19th C
Shakespearian Characters
oil on board 17.5 x 18.0
FA102204

British (English) School 19th C
Street Scene
oil on board 22.5 x 28.8
FA001228

British (English) School 19th C
Sunset by the River Amazon
oil on canvas 97.5 x 150.0
FA000241

British (English) School 19th C
Village Revels
oil on canvas 80.5 x 185.8
FA000604

British (English) School 19th C
William Stanford the Younger (1809–1853)
oil on canvas 75 x 62
FAPM090055

British (English) School 19th C
William IV on the Chain Pier
oil on canvas 116 x 90
FA001201

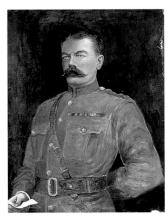

British (English) School late 19th C
Lord Kitchener
oil on paper on canvas 81.0 x 60.5
FA001212

British (English) School late 19th C
The Chain Pier
oil on board 20.4 x 16.3
FA001129

British (English) School late 19th C–early
20th C
Interior of a Church
oil on canvas 35.8 x 45.7
FA001192

British (English) School
*Cape Hangklip, Sand Dunes Fish Hoek,
Simonsberg* c.1900
oil on card 10 x 55
FAPM090090

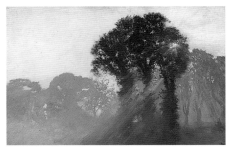

British (English) School
Landscape c.1900
oil on board 48.2 x 68.3
FA000639

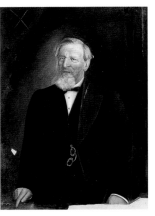

British (English) School
Portrait of a Man c.1900
oil on canvas 117 x 76
FA000851

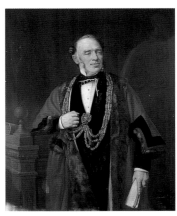

British (English) School
Portrait of a Mayor c.1900
oil on canvas 128.0 x 103.2
FA000616

British (English) School
Portrait of a Dignitary c.1909
oil on canvas 127.5 x 101.7
FA000439

British (English) School
Alderman Sir Herbert Carden, JP c.1910
oil on canvas 76.5 x 62.0
FA000302

British (English) School
Flowers in a Vase c.1910
oil on canvas 51.2 x 41.2
FA000450

British (English) School
Mrs Polson c.1910
oil on canvas 91.5 x 71.3
FA000382

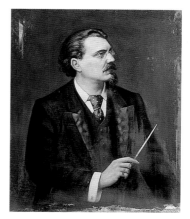

British (English) School
Portrait of a Conductor c.1910
oil on canvas 86.3 x 69.4
FA000794

British (English) School
Riverside Scene c.1925
oil on board 26.4 x 35.2
FA000471

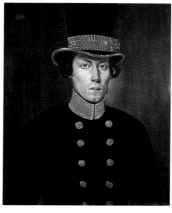

British (English) School
W. M. Giles, the Last Town Crier c.1929
oil on canvas 72.7 x 60.3
FA000308

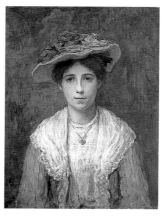

British (English) School
Girl in a Flowery Hat c.1930
oil on canvas 73.8 x 54.8
FA000370

British (English) School
Vase of Flowers c.1930
oil on canvas 53.0 x 35.2
FA000596

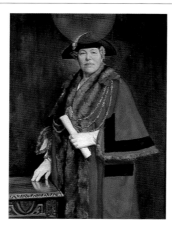

British (English) School
Alderman Miss Margaret Hardy c.1933
oil on canvas 91.5 x 70.0
FA000301

British (English) School
Woman in a Blue Dress c.1945
oil on canvas 77.5 x 64.0
FA000349

British (English) School early 20th C
Portrait of a Girl
oil on board 27.6 x 25.4
FA001247

British (English) School 20th C
Peasant's Hovel
oil on canvas 19 x 40
FA000986

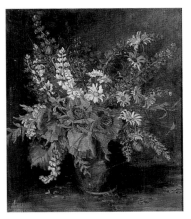

British (English) School 20th C
Poppies in a Jug
oil on canvas 77 x 65
FA001186

British (English) School 20th C
Seascape
oil on canvas 28.9 x 38.6
FA001196

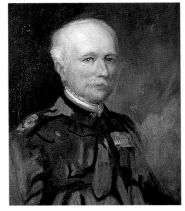

British (English) School 20th C
Viscount Wolseley
oil on canvas 58 x 48
FA001234

British (English) School
The Manor House, Hove
oil on canvas 15 x 22
FAH1945.145

British School & French School late 17th C
Decorative Coach Panel
oil on wood panel 60.4 x 45.1
FA000184

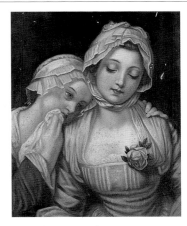

Bromley, W. 19th C
Two Girls
oil on canvas 61.4 x 50.6
FA000570

Brooks, Marjorie 1904–1980
Girl with Parasol 1961
oil on board 33.2 x 23.2
FA000575

Brooks, Marjorie 1904–1980
Seated Girl on a Beach 1961
oil on board 26.6 x 35.1
FA000574

Brooks, Marjorie 1904–1980
Blue Flowers
oil on canvas 39.4 x 49.5
FA000681

Brooks, Marjorie 1904–1980
Tea on the Lawn
oil on canvas 60.8 x 76.2
FA000573

Broughton, J. 19th C
*Martha Gunn Holding the Infant George IV
(after John Russell)*
oil on canvas 75.5 x 61.5
FAH1974.32

Brown, J. Taylor active 1893–1943
When Dead Leaves Flicker and Fall c.1900–
1906
oil on canvas 35 x 46
FA000404

Brown, Sheila Napaljarri b.1940
*Ceremonial Pole Dreaming (Witi
Jukurrpa)* 1994
acrylic on canvas 125 x 48
WA507229

Brueton, Frederick active 1882–1909
Benjamin Lomax 1899
oil on canvas 76.5 x 51.0
FA000316

Brueton, Frederick active 1882–1909
George De Paris 1899
oil on canvas 77 x 51
FA000793

Brueton, Frederick active 1882–1909
Daniel Friend (1816–1902)
oil on canvas 104.0 x 85.5
FA000939

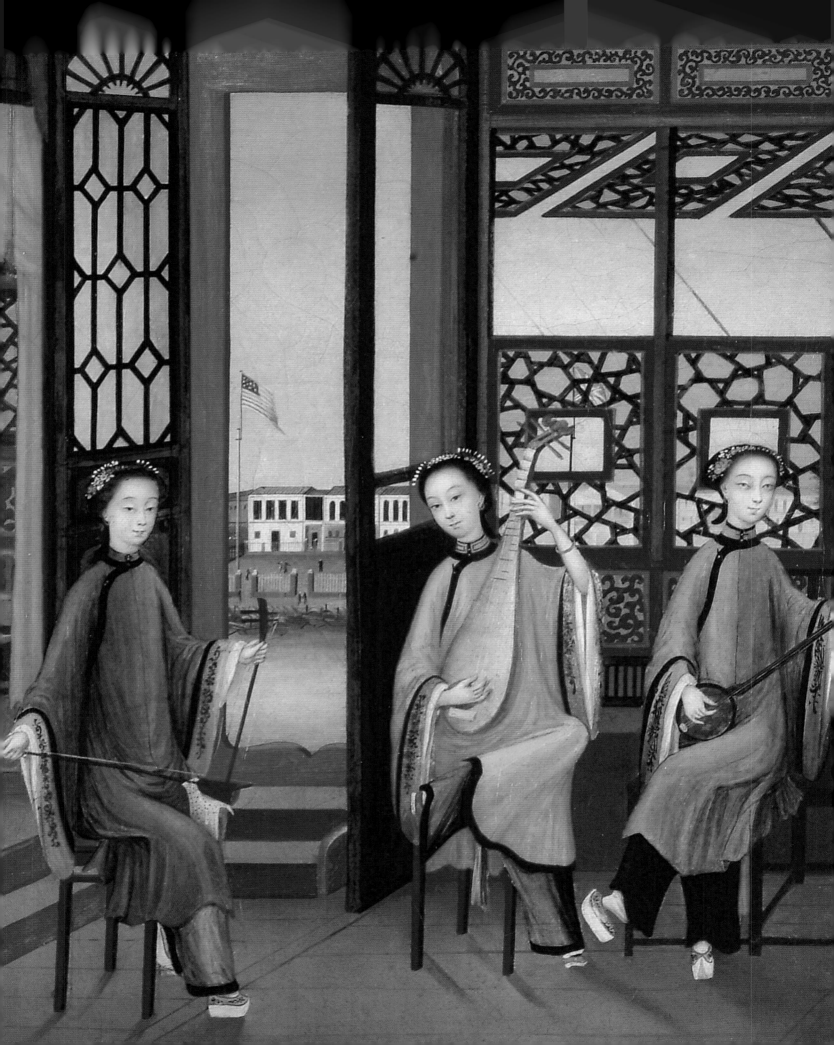

Brueton, Frederick active 1882–1909
John George Bishop
oil on canvas 122 x 91
FA000957

Brueton, Frederick active 1882–1909
William Woodward, the Chartist
oil on canvas 68.7 x 51.0
FA001206

Bryson White, Iris 20th C
Lychgate, St Wulfran's Church, Ovingdean
oil on canvas 51 x 56
FAH1964.43

Bulmer, Lionel 1919–1992
The Water Meadow c.1960
oil on board 91.0 x 136.7
FA000392

Burle Marx, Roberto 1909–1994
Landscape 1943
oil on canvas 60.0 x 73.2
FA000410

Burleigh, Averil 1883–1949
Washerwomen c.1930
oil on canvas 94.2 x 119.2
FA000595

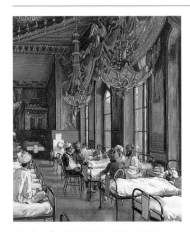

Burleigh, C. H. H. 1869–1956
Music Room of the Royal Pavilion as a Hospital for Indian Soldiers 1915
oil on canvas 69.5 x 56.5
FA000311

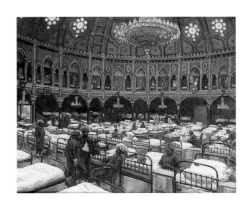

Burleigh, C. H. H. 1869–1956
The Dome as an Indian Military Hospital c.1915
oil on canvas 66.3 x 76.0
FA000409

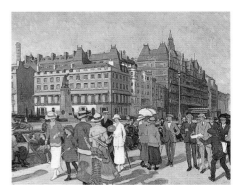

Burleigh, C. H. H. 1869–1956
Brighton Front c.1920
oil on canvas 56 x 69
FA000304

Facing page: Chinese School, *Musical Quartet with an American Flag* (detail), c.1800, Brighton and Hove Museums and Art Galleries, (p. 57)

Burleigh, C. H. H. 1869–1956
Portrait of an Organist 1921
oil on canvas 93 x 71
FA000847

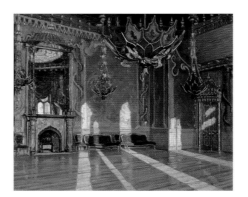

Burleigh, C. H. H. 1869–1956
The Music Room of the Royal Pavilion
c.1923–1924
oil on canvas 62.5 x 75.0
FA000677

Burleigh, C. H. H. 1869–1956
Brighton Arts Club c.1930
oil on canvas 49.0 x 59.6
FAH1988.83

Burleigh, C. H .H. 1869–1956
*Averil Burleigh Painting at 7, Wilbury
Crescent* c.1940
oil on canvas 63.5 x 76.5
FA001168

Burleigh, C. H. H. 1869–1956
Lieutenant Colonel S. Moens, CBE
oil on canvas 75 x 62
FA000964

Burleigh, C. H. H. 1869–1956
Portrait of an Old Man
oil on canvas 76.0 x 63.5
FA000890

Burleigh, C. H. H. 1869–1956
The Rotunda, Royal Pavilion, Brighton
oil on canvas 64.5 x 77.0
FAH1938.259

Burleigh, Veronica 1909–1998
Self Portrait with the Artist's Parents c.1937
oil on canvas 101 x 76
FAH1983.17

Burleigh, Veronica 1909–1998
Portrait of the Artist's Father c.1940
oil on canvas 75.5 x 59.5
FAH1983.16

Burn, Rodney Joseph 1899–1984
The Red Lion Inn c.1927–1930
oil on canvas 87.5 x 93.0
FA000901

Burrows, R. d.1855
View on the Orwell
oil on canvas 60.5 x 92.0
FA000906

Busfield, Brian b.1926
Devil's Dyke c.1972
oil on canvas 41 x 92
FAH1994.53

Buss, Robert William 1804–1875
Masters Boydell & Sidney Graves c.1844
oil on canvas 61 x 50
FA000891

H. C.
*Remnants of the Chain Pier after
Destruction* 1896
oil on board 17.2 x 24.6
FA001132

H. C.
The Chain Pier 1897
oil on board 17.1 x 24.8
FA001133

Cadell, Francis Campbell Bolleau
1883–1937
Dancer
oil on board 44.8 x 37.2
FA000442

Caffyn, Walter Wallor 1845–1898
*A Quiet Evening on the Thames near
Sonning* 1885
oil on canvas 20 x 30
FAPM090016

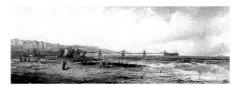

Callow, George D. active 1856–1873
Chain Pier, Brighton 1856
oil on board 15.2 x 38.0
FA000386

Calthrop, Claude Andrew 1845–1893
In Saint Peter's 1874
oil on canvas 197.0 x 148.5
FA000857

Capobianchi, Vincenzo 1836–1928
Roman Children at Indoor Archery 1881
oil on wood panel 41.7 x 78.8
FA000050

Caraf 19th C
Port
oil on board 57.5 x 46.0
FA000899

Carline, Hilda Anne 1889–1950
Elsie 1931
oil on canvas 173 x 81
FAH1981.1

Carlone, Carlo Innocenzo 1686–1775
The Glorification of a Saint 1760
oil on canvas 60.0 x 38.5
FA000064

Carlone, Carlo Innocenzo (style of)
1686–1775
Vision of Saint Anthony c.1730
oil on canvas 45.1 x 32.0
FA000065

Carlone, Carlo Innocenzo (style of)
1686–1775
Court Scene c.1750
oil on canvas 62.9 x 50.3
FA000071

Carmichael, James Wilson 1800–1868
Kemp Town from the Sea 1840
oil on canvas 76.5 x 113.0
FA000087

Carmichael, James Wilson 1800–1868
At Anchor
oil on wood panel 25.4 x 35.0
FAH1933.29 [1]

Carmichael, James Wilson 1800–1868
The Coming Storm
oil on wood panel 25.2 x 35.4
FAH1933.29 [2]

Carpenter, Leslie 20th C
We Three
oil on canvas 75.7 x 50.7
FAH1968.1

Cassiers, Hendrick 1858–1944
Winter in Amsterdam
oil on canvas 55.6 x 55.6
FA000407

Cavalcanti, Emiliano di 1897–1976
Women from Bahai
oil on canvas 65 x 54
FA000649

Chailloux, Robert b.1913
Notre Dame from the Seine
oil on canvas 39.0 x 46.6
FA000578

Chamberlin, Mason active c.1786–1826
Water Mill
oil on canvas 63.2 x 76.0
FA000189

Chamberlin, William Benjamin active
1880–1934
An Artist's Studio
oil on canvas 35.8 x 25.6
FA000647

Chamberlin, William Benjamin active
1880–1934
An Interior
oil on canvas 71.5 x 61.0
FAH1933.14

Chamberlin, William Benjamin active
1880–1934
Shoreham Suspension Bridge
oil on wood panel 17.8 x 25.4
FAH1936.49

Champaigne, Phillippe de 1602–1674
St Veronica's Veil c.1640
oil on canvas 64.5 x 49.0
FA000171

Chapman, Max b.1911
Chinese 1963
oil & emulsion on canvas 91.5 x 81.5
FA000276

Chappel, Edouard 1859–after 1936
River Cagnes c.1930
oil on canvas 33.0 x 40.8
FA000476

Chappel, Edouard 1859–after 1936
Still Life
oil on canvas 123 x 123
FA000718

Charles, James 1851–1906
Apple Blossom
oil on canvas 34.7 x 43.0
FA000462

Chater, Cedric 20th C
The Cuckmere from the Beach
oil on canvas 37.5 x 60.7
FAH1977.21

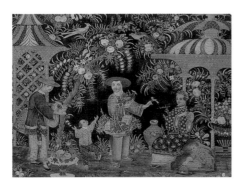

Chinese School
A Bird-Seller in a Garden c.1800
oil on wood panel 36.9 x 47.5
FA000246

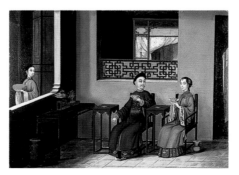

Chinese School
A Couple Drinking Tea c.1800
oil on canvas 43.0 x 58.3
FA000253

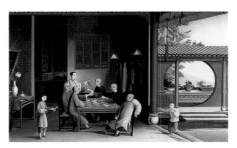

Chinese School
A Dining Scene c.1800
oil on canvas 55.9 x 91.3
FA000252

Chinese School
A Gentleman Reading on a Bed c.1800
oil on canvas 51.0 x 64.7
FA000255

Chinese School
A Trio of Musicians c.1800
oil on canvas 51.1 x 64.5
FA001110

Chinese School
Card Players on an Open Terrace c.1800
oil on canvas 58.3 x 91.5
FA000251

Chinese School
Domestic Interior c.1800
oil on canvas 44.4 x 57.0
FA000623

Chinese School
Family Group c.1800
oil on canvas 50.3 x 63.4
FA000254

Chinese School
*Figures Approaching a Riverside
Mansion* c.1800
oil on canvas 35.0 x 48.2
FA000247

Chinese School
Glass Picture c.1800
oil on glass 40.0 x 30.7
FA000813

Chinese School
Ladies Playing Cards c.1800
oil on canvas 50.9 x 64.2
FA000250

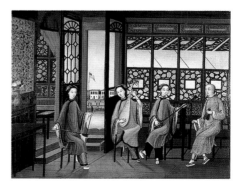

Chinese School
*Musical Quartet with an American
Flag* c.1800
oil on canvas 50.1 x 63.6
FA000248

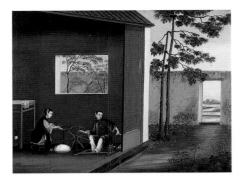

Chinese School
Two Women Spinning c.1800
oil on wood panel 43.4 x 56.2
FA000622

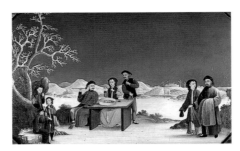

Chinese School
Water Scene with a Distant Fortress c.1800
oil on canvas 55.7 x 89.0
FA000249

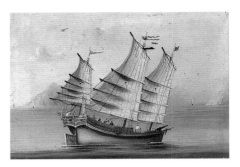

Chinese School 19th C
Junk Sailing from Left to Right
oil on canvas 20 x 29
FA001191

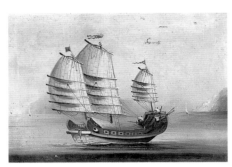

Chinese School 19th C
Junk Sailing from Right to Left
oil on canvas 20 x 29
FA001190

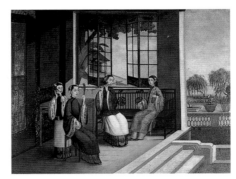

Chinese School 19th C
Musicians
oil on canvas 51.1 x 64.5
FA001111

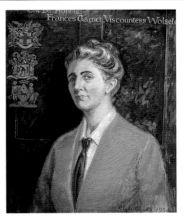

Christie, Clyde
*The Right Hon. Frances Garnet, Viscountess
Wolseley* 1934
oil on canvas 61.0 x 49.5
FAH1960.351

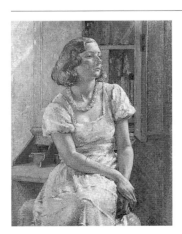

Church, Katherine b.1910
Mary Elizabeth Church c.1932
oil on canvas 92.5 x 71.4
FA000359

Churchill, Martin b.1954
Church of the Sacred Heart 1981
oil on canvas 117.0 x 148.6
FAH1983.2

Clairmonte, Christopher b.1932
Hove Beach 1976
oil on canvas 70.5 x 88.0
FAH1976.46

Facing page: Little, Roy, *Girl in a Swansdown Hat* (detail), c.1955, Brighton and Hove Museums and Art Galleries, (p. 141)

Clark, Norman Alexander 1913–1992
The Train Home from School 1948
oil on canvas 35.5 x 46.0
FAH1997.29

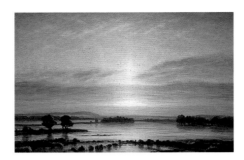

Clarkson, William H. 1872–1944
Floods in the Arun Valley c.1934
oil on canvas 61.1 x 91.7
FA000369

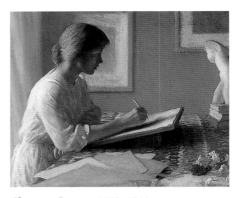

Clausen, George 1852–1944
The Student c.1908
oil on canvas 64.2 x 76.5
FA001137

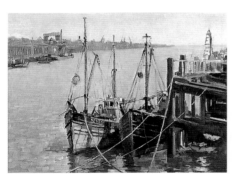

Clement Smith, Winifred b.1904
At Newhaven
oil on board 39.4 x 49.8
FAH1967.8

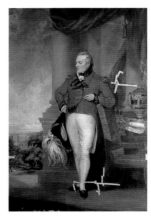

Clint, George 1770–1854
The Third Earl of Egremont
oil on canvas 268 x 177
FA000665

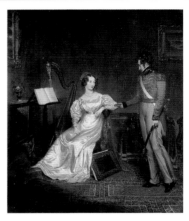

Clint, George (style of) 1770–1854
*The Betrothal of Princess Charlotte and Prince
Leopold* c.1816
oil on canvas 76.3 x 63.5
FA000021

Clowes, Daniel 1774–1829
Horse and Groom
oil on canvas 49 x 65
FA000960

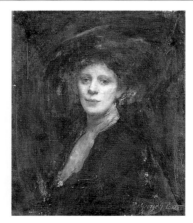

Coates, George James 1869–1930
Mrs Rae c.1909
oil on canvas 61.2 x 50.9
FA000358

Cobbett, W.
Beach Cottages, Hove 1905
oil on cardboard 19.0 x 78.5
FAH1970.3

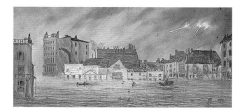

Cobbett, W.
Great Storm at Brighton 1905
oil on canvas 30.5 x 61.0
FA000500

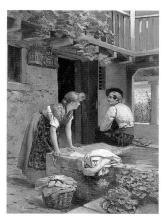

Codina y Langlin, Victoriano 1844–1911
Two Sides to the Question c.1870
oil on canvas 40.1 x 30.5
FA000097

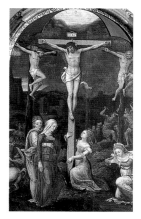

**Coecke van Aelst, Pieter the elder
(attributed to)** 1502–1550
The Crucifixion c.1530
oil on wood panel 73.5 x 45.8
FA000104

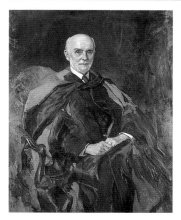

Cohen, Isaac 1884–1951
*Sir Charles Thomas Stanford in Degree Robes
of DLitt, University of Wales* 1927
oil on canvas 125 x 100
FAPM090045

Cole, Chisholm 1871–1902
The Estuary
oil on canvas 50.0 x 75.8
FA000679

Cole, George 1810–1883
Morwell Rocks, on the Tamar 1871
oil on board 31.0 x 45.8
FA000432

Cole, George 1810–1883
Arundel at Sunset 1872
oil on canvas 89.2 x 152.5
FA000592

Cole, George 1810–1883
A Cornfield 1876
oil on canvas 51.2 x 77.0
FA000362

Cole, George 1810–1883
Landscape with Sheep 1876
oil on canvas 59.1 x 83.8
FA000055

Cole, George 1810–1883
On the Arun 1878
oil on canvas 61.6 x 92.3
FA000373

Cole, George 1810–1883
Landscape with Farm
oil on canvas 64.3 x 76.8
FA000277

Cole, John 1903–1975
Almshouse Gateway c.1927
oil on canvas 47.5 x 37.3
FA000428

Cole, Rex Vicat 1870–1940
The Thatched Barn 1919
oil on canvas 122.3 x 154.0
FA000791

Cole, Rex Vicat 1870–1940
The Mill 1922
oil on canvas 91.5 x 122.0
FA000668

Cole, Rex Vicat 1870–1940
Towpath Bridge 1923
oil on canvas 76.8 x 124.0
FA000375

Cole, Rex Vicat 1870–1940
Cartmel Priory 1935
oil on canvas 86 x 118
FA000685

Cole, Solomon active 1845
Portrait of a Young Girl
oil on panel 18.5 x 14.5
FA000894

Collcutt, Grace Marion 1875–1954
Firelight c.1925
oil on canvas 55.9 x 45.7
FAH1953.4

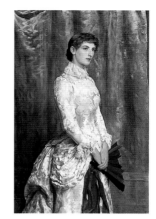

Collier, John 1850–1934
The Very Reverend John Julias Hannah 1902
oil on canvas 240 x 147
FA000983

Collier, John 1850–1934
Mrs Griffiths
oil on canvas 130 x 101
FA000688

Collier, John 1850–1934
Mrs Harland Peck
oil on canvas 132.4 x 91.7
FA001166

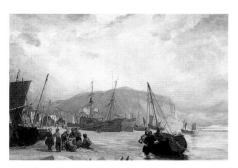

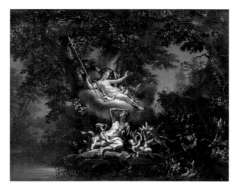

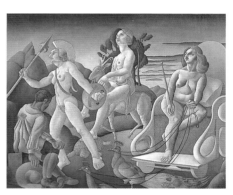

Collins, William 1788–1847
Hastings
oil on canvas 44.3 x 61.0
FA000293

Colombo, Giovanni Battista Innocenzo
1717–1793
Diana and Endymion 1762
oil on canvas 80.4 x 95.4
FA000182

Colquhoun, Ithell 1906–1988
The Judgement of Paris 1930
oil on canvas 62 x 75
FAH1980.7

Colquhoun, Ithell 1906–1988
Interior 1939
oil on board 89.5 x 59.5
FAH1981.8

Colson, Jean François 1733–1803
Portrait of a Lady 1766
oil on canvas 63.6 x 53.9
FA000085

Colville, William
On the Conway
oil on canvas 31.0 x 54.5
FAPM090022

Conca, Sebastiano 1680–1764
The Education of Dionysus c.1730
oil on canvas 78.0 x 64.3
FA000077

Conder, Charles 1868–1909
Stormy Day in Brighton 1905
oil on canvas 50.5 x 91.7
FA000360

Conger, C. C. 19th C
Portrait of a Bearded Man
oil on canvas 56 x 46
FA000537

Constant, Jean Joseph Benjamin 1845–1902
Stormy Sea from the Hotel Metropole c.1890
oil on wood panel 19.5 x 13.1
FA000469

Cooper, C.
Chain Pier 1894
oil on board 17.9 x 28.5
FA001130

Cooper, C.
On the Beach at Brighton 1894
oil on board 17.9 x 28.2
FA001131

Cooper, Thomas Sidney 1803–1902
Landscape with Cows 1881
oil on board 25.2 x 40.5
FA000042

Cooper, Thomas Sidney 1803–1902
Cattle 1899
oil on canvas 28 x 34
FAPM090017

Copnall, Teresa 1882–1972
Alderman Kingston 1928
oil on canvas 164.5 x 108.0
FA001198

Coppard, C. Law active 1858–1891
Manor House, Preston Place, Sussex 1875
oil on canvas 41 x 69
FAPM090081

Coppard, C. Law active 1858–1891
Wood in Autumn 1878
oil on canvas 51.2 x 76.3
FA000799

Corbould, Walter Edward b.1860
Venus and Cupid
oil on canvas 49.8 x 40.2
FA000569

Cornelis, Albert c.1500–1532
The Assumption of the Virgin
oil & tempera on wood panel 89.5 x 82.0
FA000009

Costantini, David A.
Mr Murray Marks 1905
oil on panel 47.5 x 33.2
FA000122

Cotman, Frederick George 1850–1920
Sunset, St Ives 1915
oil on canvas 77.5 x 128.7
FA000702

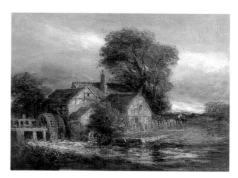

Cotman, Frederick George 1850–1920
Spellbound
oil on canvas 107 x 136
FA000689

Cox, David the elder 1783–1859
Landscape with Cottages
oil on canvas 35.5 x 49.5
FA000634

Cox, David the elder 1783–1859
The Old Mill
oil on canvas 36.8 x 49.5
FA000633

Cranach, Lucas the elder 1472–1553
Frederick III, Elector of Saxony 1532
oil on wood panel 20.7 x 14.6
FA000105

Cranach, Lucas the elder 1472–1553
*John I, 'The Constant', Elector of Saxony
(1525–1532)* c.1532
oil on panel 20.7 x 14.0
FA000106
STOLEN

Creffield, Dennis b.1931
Greenwich 1957
oil on canvas 71.2 x 91.4
FAH1997.27

Creffield, Dennis b.1931
Brighton Beach c.1974
oil on canvas 76.2 x 101.3
FAH1997.28

Creswick, Thomas 1811–1869
Landscape with Cows 1860
oil on canvas 53.0 x 71.5
FA000555

Cuming, Frederick b.1930
Studio with Strip Light c.1975
oil on canvas 91 x 70
FAH1977.20

Cundall, Charles Ernest 1890–1971
Servicing a Sunderland 1941
oil on canvas 61.0 x 100.5
FA000317

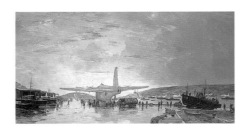

Cundall, Charles Ernest 1890–1971
Marine Craft and Sunderlands 1944
oil on canvas 76 x 137
FA001003

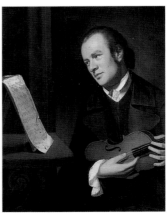

Dance-Holland, Nathaniel 1735–1811
The Music Lesson
oil on canvas 86.2 x 68.6
FA000140

Danckerts, Hendrick (attributed to)
1625–1680
The Manor House, Creswells c.1670
oil on canvas 77.7 x 183.7
FA000589

Darwin, Robin 1910–1974
Ice Hockey at the Empress Hall 1952
oil on canvas 70.5 x 90.5
FAH1952.65

David, Ferdinand b.1860
Banks of the Canal at Agen
oil on canvas 26.8 x 37.2
FA000511

Davis, Henry William Banks 1833–1914
Landscape with Cattle, Morning 1894
oil on canvas 30.4 x 51.2
FA000237

Davis, Henry William Banks 1833–1914
Landscape with Cattle, Evening 1896
oil on canvas 30.4 x 51.2
FA000238

Davis, Joseph Barnard 1861–1943
Millstream, Cotswolds
oil on canvas 50.9 x 40.5
FA000583

Davis, Joseph Barnard 1861–1943
Village Sentinels
oil on canvas 75 x 95
FA000343

Dawson, Henry 1811–1878
Before the Storm 1874
oil on board 21.8 x 29.6
FA000048

Dawson, Henry 1811–1878
Landscape, River Scene 1878
oil on board 22.0 x 29.5
FA000049

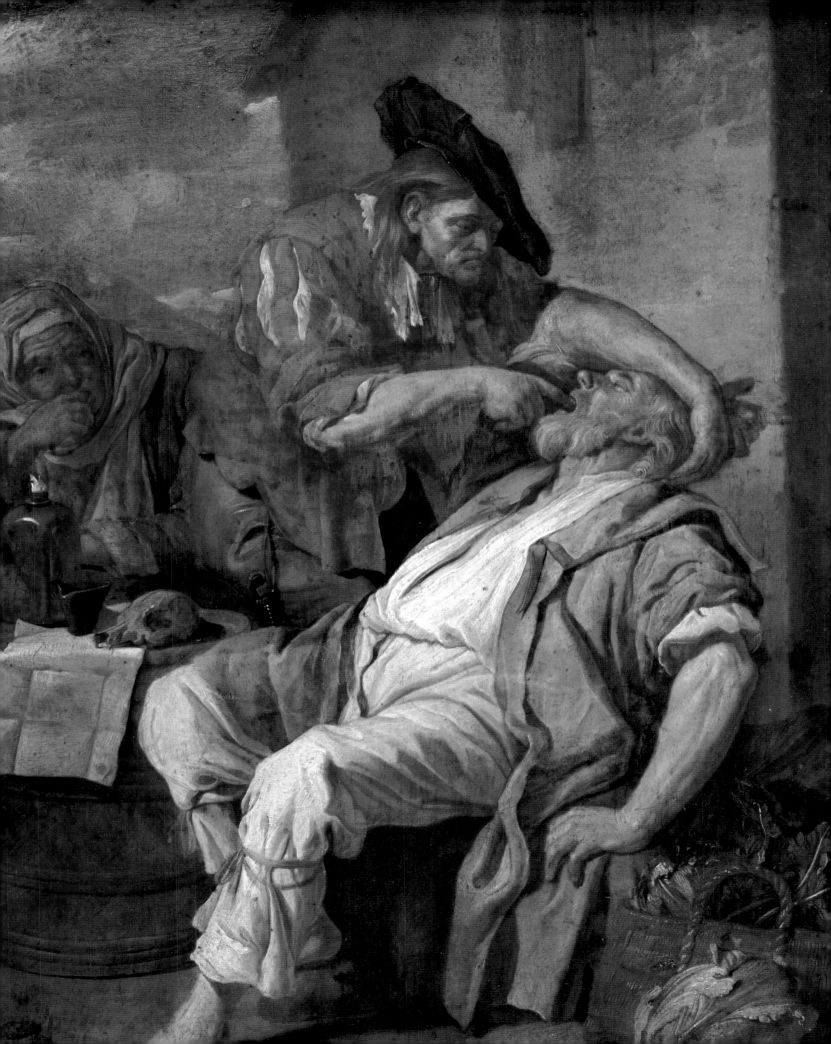

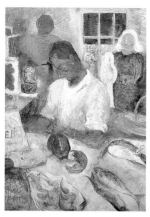

Debenham, Alison 1903–1967
At the Fishmonger's c.1950
oil on board 77.0 x 51.5
FAH1977.31

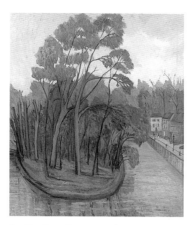

De Karlowska, Stanislawa 1876–1952
The Eyot, Richmond c.1941
oil on canvas 60.9 x 50.8
FA000292

Delaney, Barbara b.1941
Spinning Red: Suspended 1995
acrylic on canvas 35.2 x 35.7
FA001167

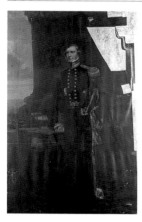

Desanges, Louis William 1822–c.1887
Captain Pechell
oil on canvas 268.5 x 190.0
FA000876

De Soria, Manuel Lugue
A Thaw, Sunset 1908
oil on canvas 59.0 x 85.5
FA000290

Devereux, F. 19th C
James White, MP 1894
oil on canvas 90 x 71
FA000841

Diana, Giacinto 1730–1803
St Augustine of the Flaming Heart c.1775
oil on canvas 44.1 x 50.8
FA000066

Diaz de la Peña, Narcisse Virgile 1808–1876
*The Approaching Storm on the Coast near
Bolougne*
oil on canvas 57.2 x 86.5
FA000722

Dicksee, John Robert 1817–1905
The Waitress 1872
oil on canvas 35.8 x 30.6
FA000058

Facing page: Toorenvliet, Jacob, c.1635–1719, *The Dentist* (detail), c.1690, Brighton and Hove Museums and Art Galleries, (p. 182)

Dicksee, Margaret Isabel 1859–1903
The Child Handel, Discovered by His Parents 1893
oil on canvas 91.5 x 122.0
FA000165

Dicksee, Thomas Francis 1819–1895
Frederick Crace 1849
oil on canvas 90 x 70
FA000322

Dickson, W.
Wide, Wild and Open to the Sea 1904
oil on canvas 121.0 x 184.5
FA000664

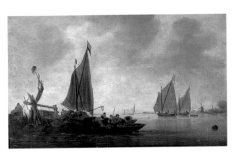

Diest, Willem van 1610–1673
River Scene
oil on wood panel 41.4 x 63.5
FA000261

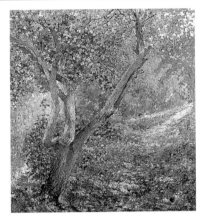

Dilsey, F.
Wood Scene 1915
oil on canvas 72.5 x 65.0
FA000924

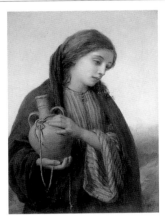

Dobson, William Charles Thomas
1817–1898
Rebecca 1876
oil on wood panel 40.3 x 30.3
FA000542

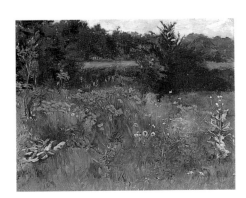

Dodson, Sarah Paxton Ball 1847–1906
Poppies 1890
oil on canvas 50.5 x 61.0
FA000490

Dodson, Sarah Paxton Ball 1847–1906
Malvern 1892
oil on canvas 50.5 x 61.0
FA000501

Dodson, Sarah Paxton Ball 1847–1906
Head of a Woman in a Red Cap
oil on canvas 19.4 x 25.3
FA000447

Dollman, John Charles 1851–1934
The Dogs Refuge 1871
oil on canvas 91 x 119
FA000918

Dollman, John Charles 1851–1934
Thirty Pieces of Silver
oil on canvas 76.8 x 127.0
FAH1959.154

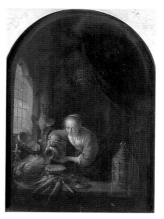

Dou, Gerrit (after) 1613–1675
The Housekeeper c.1660
oil on wood panel 45.5 x 35.5
FA000112

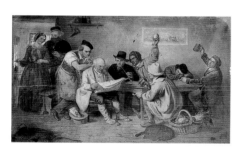

Downard, Ebenezer 1830–1894
Reading the News
oil on canvas 85.6 x 112.0
FA000662

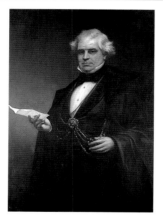

Downard, Ebenezer 1830–1894
Colonel John Fawcett, First Mayor of Brighton
oil on canvas 157.5 x 112.0
FA000674

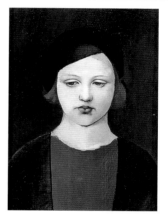

Downton, John 1906–1991
Frances Witts c.1935
oil on panel 34.2 x 24.7
FA001146

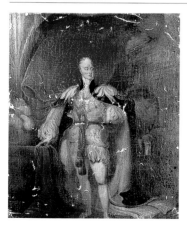

Drake, John P. 19th C
William IV
oil on canvas 109 x 83
FA001230

Drucker, Amy J. 1873–1951
Arab Water Carriers
oil on board 24.7 x 35.1
FA100559

Drummond, Malcolm 1880–1945
The Stag Tavern 1929
oil on canvas 100.5 x 75.0
FAH1980.6

Drummond, Samuel 1765–1844
Sake Deen Mahomed
oil on canvas 68 x 56
FA000843

Dubery, Frederick b.1926
Beach Scene
oil on board 26.1 x 58.5
FA000422

Dugdale, Thomas Cantrell 1880–1952
The Good Earth c.1940
oil on canvas 92.0 x 76.4
FA000588

Dughet, Gaspard (attributed to) 1615–1675
Campagna Landscape
oil on canvas 37.9 x 46.9
FA000266

Dughet, Gaspard (attributed to) 1615–1675
Tivoli
oil on canvas 38.7 x 49.5
FA000265

Dujardin, Karel (attributed to) 1626–1678
Landscape
oil on canvas 34.5 x 40.4
FA000869

Dunlop, Ronald Ossory 1894–1973
Cagnes sur Mer, South of France c.1931
oil on board 54 x 45
FAH1933.73

Dunlop, Ronald Ossory 1894–1973
Burpham, Sussex c.1951
oil on canvas 116 x 153
FA000613

Dunstan, Bernard b.1920
The Cottage Bedroom c.1953–1955
oil on board 28 x 36
FA000739 🐝

Dürer, Albrecht (after) 1471–1528
Not This Man but Barabbas
tempera on canvas 93.8 x 68.6
FA000181

Dutch School
Resurrection c.1515
oil on wood panel 93.7 x 33.2
FA000098

Dutch School 16th C
Crucifixion
oil on canvas 145 x 131
FA000129

Dutch School
Landscape c.1600
oil on panel 23 x 75
FA000919

Dutch School
Still Life with Squirrel c.1650
oil on canvas 42.3 x 62.5
FA000225

Dutch School
Young Boy with Flowers c.1650
oil on canvas 82.5 x 63.7
FA000193

Dutch School
Marine View c.1680
oil on canvas 38
FAPM090018

Dutch School
Marine View c.1680
oil on canvas 38
FAPM090019

Dutch School
Romantic Landscape c.1690
oil on copper 15.5 x 21.5
FA000895

Dutch School 17th C
Poultry
oil on copper 10.0 x 7.5
FA000995

Dutch School 17th C
Poultry
oil on copper 10.0 x 7.5
FA000996

Dutch School
Pastoral Scene c.1700
oil on panel 45.3 x 57.0
FA001097

Dutch School
Landscape with Mill c.1750
oil on canvas 27.6 x 23.0
FA000483

Dutch School
Woman with a Flute c.1750
oil on copper 20.0 x 15.5
FA000525

Dutch School
Trompe l'oeil c.1850
oil on canvas 63.0 x 49.8
FA000641

Dutch School
Fiddler in a Tavern c.1870
oil on wood panel 45.3 x 35.5
FA000460

Dyce, William 1806–1864
Study for 'Cain'
oil on board 48.1 x 41.0
FA000550

Dyet, Alfred 19th C
Horses in a Stable
oil on canvas 28 x 36
FA000817

Earp, Clarence St John 1937–1989
Apocalypse c.1964
oil on canvas 83 x 133
FA000907

Earp, Clarence St John 1937–1989
Cliffs, South Coast
oil on canvas 51.8 x 76.5
FAH1970.9

Earp, Frederick 1827–1897
Preston Manor 1843
oil on canvas 25.3 x 35.5
FA000962

Earp, Frederick 1827–1897
Downland Scene c.1890
oil on canvas 35.5 x 53.4
FA000541

Earp, Frederick 1827–1897
How Doth the Little Busy Bee
oil on board 46.0 x 61.5
FA000920

Earp, Henry 1831–1914
The Village of Portslade in 1840 c.1880
oil on canvas 29.8 x 60.0
FAH1995.30

Earp, Henry (attributed to) 1831–1914
Going to Service
oil on board 47 x 61
FA001202

Earp, William 19th C
Chain Pier
oil on canvas 30.6 x 60.7
FA000561

Eastlake, Charles Lock 1793–1865
Coliseum
oil on canvas 37 x 46
FA001000

Elsley, Arthur John 1861–1952
Ellen Benett-Stanford Riding 'Congress' 1885
oil on canvas 67 x 83
FAPM090084

Elsley, Arthur John 1861–1952
Pickle 1893
oil on canvas 49.5 x 39.5
FAPM090063

Elsley, Arthur John 1861–1952
Girl Picking Primroses 1902
oil on canvas 67.5 x 49.5
FA000400

Elsley, Arthur John 1861–1952
Chu-Ki: Portrait of a Pekinese Dog 1927
oil on canvas 50.5 x 56.5
FAPM090009

Elsley, Arthur John 1861–1952
Quiet Afternoon 1928
oil on panel 50.0 x 39.5
FA001109

Elsley, Arthur John 1861–1952
Crossing the Stream
oil on canvas 74.5 x 54.5
FA000198

Elsley, Arthur John 1861–1952
Faithful and Fearless: Kylin
oil on canvas 45 x 54
FAPM090065

Engebrechtsz., Cornelius (circle of) c.1465–1527
The Lamentation over the Dead Christ
oil on panel 45.7 x 35.0
FAPM090092

Estall, William Charles 1857–1897
Sussex Common
oil on canvas 36.0 x 62.0
FA000324

Facing page: Allinson, Adrian Paul, 1890–1959, *Winter Magic* (detail), Brighton and Hove Museums and Art Galleries, (p. 13)

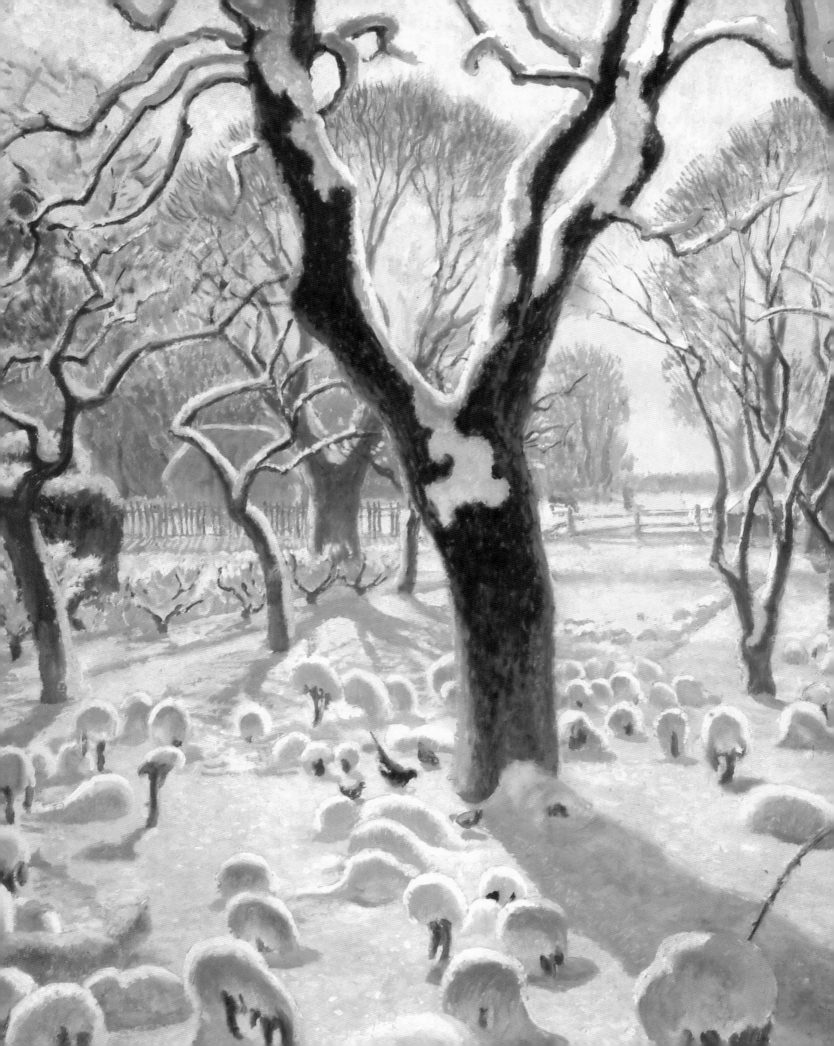

Etty, William 1787–1849
Arabella Morris 1816–1818
oil on canvas 75.5 x 62.0
FAPM090047

Etty, William 1787–1849
Girl Touching Her Head 1830
oil on board & wood panel 23.4 x 29.5
FA000260

Eurich, Richard Ernst 1903–1992
The Mummers 1952
oil on canvas 88 x 92
FAH1978.9 🐝

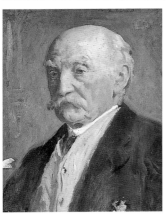

Eves, Reginald Grenville 1876–1941
Thomas Hardy 1923
oil on canvas 51.2 x 41.3
FA000577

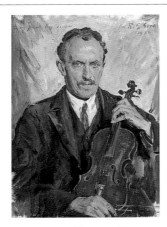

Eves, Reginald Grenville 1876–1941
Mr Percy Sharman 1930
oil on canvas 75.5 x 54.1
FAH1945.180

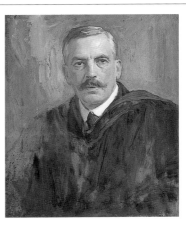

Eves, Reginald Grenville 1876–1941
Dr Cyril Norwood
oil on canvas 64 x 52
FA000932

Eves, Reginald Grenville 1876–1941
Portrait of a Young Man
oil on canvas 50.8 x 40.7
FA000491

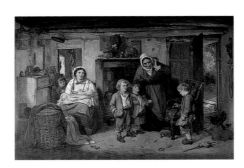

Faed, Thomas 1826–1900
The Mitherless Bairn 1855
oil on canvas 35.1 x 61.7
FA000053

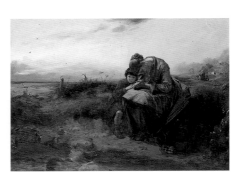

Faed, Thomas 1826–1900
The Waefu' Heart 1882
oil on canvas 58.6 x 83.2
FA000052

Fanner, Alice Maud 1865–1930
The Chestnut Tree 1898
oil on canvas 128 x 183
FA001178

Fanner, Alice Maud 1865–1930
The Seaside c.1920
oil on canvas 101.6 x 152.5
FA000137

Fawcett, E. 20th C
Flowers I
oil on canvas 71 x 58
FA001240

Fawcett, Gertrude active 1916–1939
Flowers by a Window
oil on canvas 76.5 x 65.0
FA000346

Fawcett, Gertrude active 1916–1939
Flowers in a Green Jug
oil on canvas 64.5 x 76.5
FA000348

Fawcett, Gertrude active 1916–1939
Flowers in a Vase
oil on canvas 92 x 70
FA001231

Fawcett, Gertrude active 1916–1939
Sunflowers
oil on canvas 76.5 x 63.5
FA000347

Fawcett, Gertrude active 1916–1939
Tulips and Peonies
oil on canvas 50.5 x 50.5
FA000508

Fawcett, Gertrude active 1916–1939
Vase of Flowers
oil on canvas 73 x 63
FA001187

Fawkes, W.
Princess Charlotte 1818
oil on canvas 74.5 x 63.0
FA000830

Fell, Sheila Mary 1931–1979
Potato Picking at Aigle Ghyll c.1963
oil on canvas 102.0 x 127.5
FAH1982.1

Fielding, Anthony V. C. 1787–1855
Skelwith Bridge, Ambleside
oil on canvas 46.5 x 61.5
FAH1960.405

Fildes, Luke 1844–1927
Venetian Girl with a Flask 1870
oil on canvas 50 x 37
FA000089

Fildes, Luke 1844–1927
A Venetian Market Girl 1876
oil on canvas 48 x 35
FA000088

Fisher, Mark 1841–1923
Milking Time 1881
oil on canvas 34.3 x 50.5
FA000735

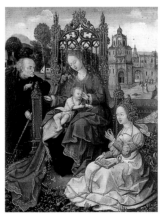

Flemish (Antwerp) School early 16th C
Mystic Marriage of St Catherine of Alexandria
oil on wood panel 62.2 x 46.1
FAPM090014

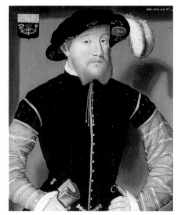

Flemish School
Phillip de Monmorency, Comte de Horn 1543
oil on wood panel 56.5 x 45.5
FAPM090015

Flemish School
Rocky Landscape c.1580
oil on wood panel 17.5 x 23.4
FA000845

Flemish School
Adoration of Shepherds c.1680
oil on canvas 78 x 116
FA000864

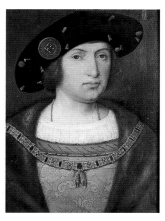

Flemish School early 16th C
Portrait of a Nobleman
oil on wood panel 35.4 x 27.0
FAPM090013

Flemish School
Holy Family with St Catherine of Alexandria
oil on wood panel 58.1 x 43.7
FA000100

Flemming, Rosie Nangala b.1928
Fire Country Dreaming (Warlukurlangu Jukurrpa) 1995
acrylic on canvas 121 x 90
WA507228

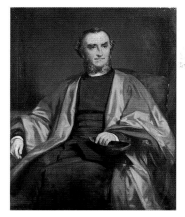

Floris, Emily J.
John Hannah, Vicar of Brighton 1871
oil on canvas 127.6 x 101.8
FA000704

Flowers, Peter 1916–1950
Richmond, Yorkshire 1938
oil on canvas 76 x 102
FA000345

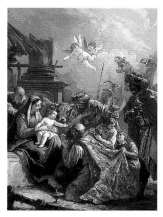

Fontebasso, Francesco (style of) 1707–1769
The Adoration of the Magi c.1750
oil on canvas 39.1 x 29.5
FA000067

Foottet, Frederick Francis 1850–1935
Sunrise off the Dorset Coast 1930
oil on canvas 70.8 x 85.5
FA000599

Forbes, Stanhope Alexander 1857–1947
Christmas Eve 1897
oil on canvas 183.2 x 137.2
FA001136

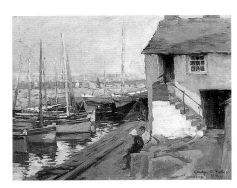

Forbes, Stanhope Alexander 1857–1947
Mousehole Harbour 1910
oil on canvas 35.5 x 45.8
FAH1945.168 🐝

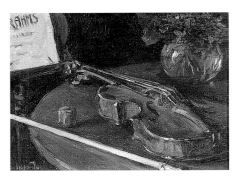

Forbes, Stanhope Alexander 1857–1947
Study of Violin and Bow 1913
oil on board 13.8 x 19.0
FAH1945.162 🐝

Fox, Edward 1788–1875
Rottingdean 1839
oil on canvas 25.2 x 38.0
FA000825

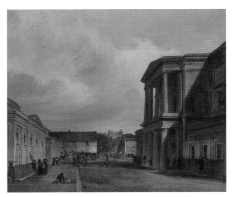

Fox, Edward 1788–1875
The Town Hall, Brighton c.1840
oil on canvas 30 x 36
FA001241

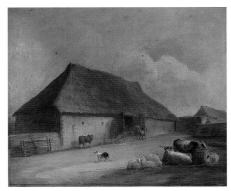

Fox, Edward 1788–1875
Old Barn 1842
oil on canvas 30.0 x 35.2
FA000820

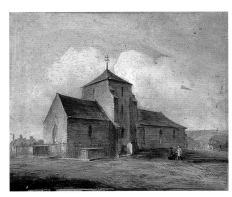

Fox, Edward 1788–1875
Rottingdean Church 1842
oil on canvas 30.0 x 35.4
FA000839

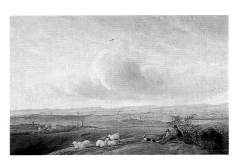

Fox, Edward 1788–1875
Brighton from the Race Hill 1846
oil on canvas 35.0 x 48.3
FA000440

Fox, Edward 1788–1875
Market Street, Brighton
oil on canvas 21.4 x 16.6
FA000481

Francken, Frans II 1581–1642 &
Neeffs, Peeter the younger 1620–1675
Interior of an Imaginary Cathedral
oil on canvas 37.8 x 54.5
FA000946

Franks-Owen, Dorothy E. 20th C
Palace of Gold
oil on board 76.5 x 76.5
FA000326

Fraser, John 1858–1927
The Chain Pier, Brighton 1883
oil on canvas 49.0 x 100.5
FA000296

Freeth, Herbert Andrew 1912–1986
NAAFI Counter c.1943
oil on canvas 51.1 x 76.5
FA000275

French School
Allegory of Homage to a Monarch c.1720
oil on canvas 48.4 x 65.0
FA000010

French School
A Festival in Honour of Bacchus c.1750
oil on canvas 73.2 x 132.7
FA000179

French School
Satyrs c.1750
oil on canvas 100.3 x 126.5
FA000233

French School
Dinan from the River c.1800
oil on wood panel 14.8 x 28.3
FA000467

French School
The First Step c.1860
oil on paper laid on canvas 28.7 x 37.0
FA000822

French School 19th C
Bonne journée
oil on canvas 25.5 x 20.0
FA000529

French School 19th C
Mauvaise journée
oil on canvas 25.5 x 20.0
FA000530

Frimlargst, P. A. active 1667
Woody Landscape with Classical Urn 1667
oil on canvas 59.4 x 83.8
FA000199

Gabain, Ethel 1883–1950
The Nymph c.1935–1936
oil on canvas 51 x 42
FA000283

Gabain, Ethel 1883–1950
The Little Red-Haired Girl
oil on canvas mounted on board 40 x 29
FAH1951.100

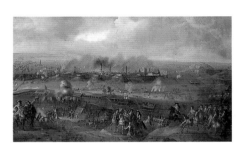

Gaelen, Alexander van 1670–1728
The Siege of Bonn by the Dutch Army in 1703 c.1703
oil on canvas 108.0 x 177.2
FA000138

Gainsborough, Thomas 1727–1788
Open Landscape at the Edge of a Wood c.1744–1745
oil on canvas 32.5 x 37.0
FAH1955.76

Gandolfi, Gaetano 1734–1802
Christ and the Woman Taken in Adultery c.1775
oil on canvas 36.2 x 45.7
FA000082

Garbeth, David 20th C
Figures in a Park
oil on canvas 90 x 128
FA001171

Garrido, Leandro Ramón 1868–1909
Study for 'His First Offence'
oil on canvas 39.7 x 32.5
FA000458

Garstin, Norman 1847–1926
Moulin de la ville, Quimperlé 1901
oil on canvas 68 x 92
FA000745

Gaspari, Giovanni Paolo (attributed to)
1714–1775
Capriccio Interior with Ruins c.1750
oil on canvas 34.3 x 44.5
FA000084

Gaspari, Giovanni Paolo (attributed to)
1714–1775
Capriccio with Statuary c.1750
oil on canvas 35.2 x 51.5
FA000220

Gelder, Aert de 1645–1727
The Marriage Contract c.1670
oil on canvas 94.6 x 143.5
FA000014

Gerrard, Kaff 1894–1970
The Big Wave c.1950
oil on canvas 89.5 x 120.2
FA001098

Gerrard, Kaff 1894–1970
The Cornfield by Moonlight
oil on hardboard 30.5 x 41.0
FA001099

Gertler, Mark 1892–1939
The Dutch Doll 1926
oil on canvas 73.6 x 76.2
FA000157

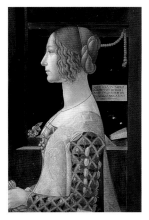

Ghirlandaio, Domenico (copy after)
1449–1494
Giovanna Tornabuoni 19th C
oil on wood panel 76.7 x 51.4
FA000152

Gifford, Peter 19th C
Highland Scene
oil on canvas 91 x 71
FA000372

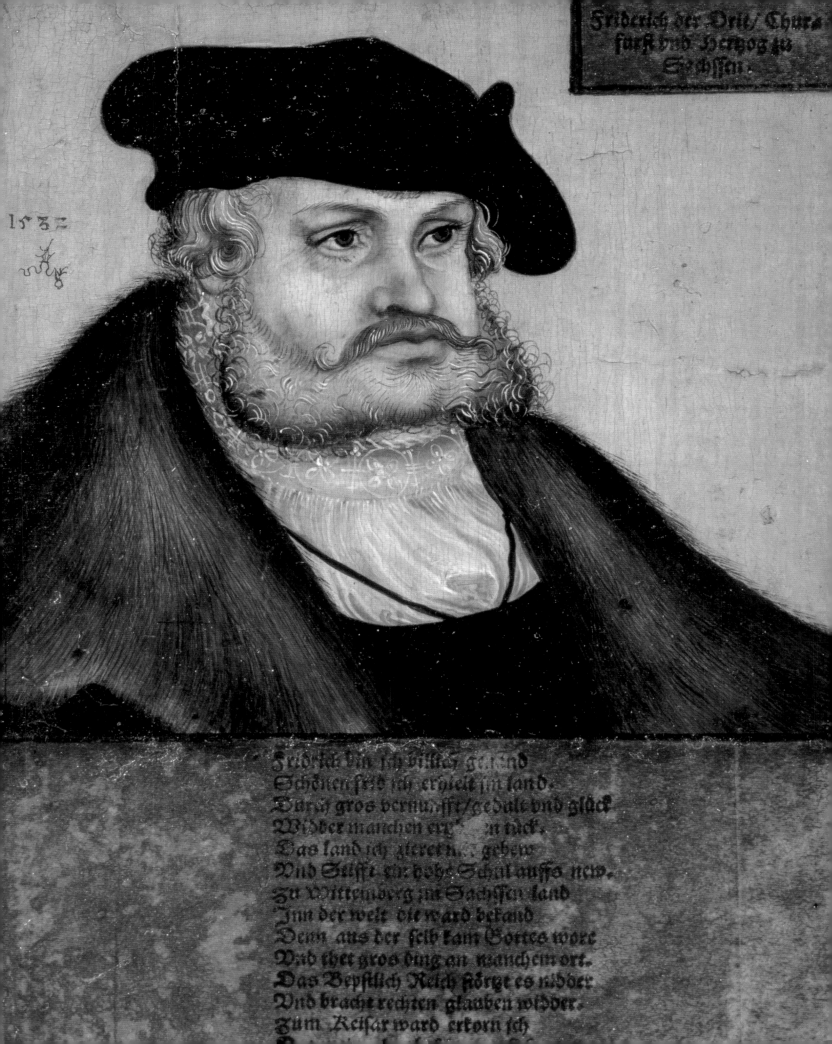

1532

Friderich bin ich billich genand
Schönen fried ich erhielt im land.
Durch gros vernunfft/gedult vnd glück
Widder manchen ergen tück.
Das land ich zieret mit gebew
Vnd Stifft ein hohe Schul auffs new.
Zu Wittenberg im Sachssen land
Inn der welt die ward bekand
Denn aus der selb kam Gottes wort
Vnd thet gros ding an manchem ort.
Das Bepstlich Reich störtz es nidder
Vnd bracht rechten glauben widder.
Zum Keisar ward erkorn ich

Gillies, William George 1898–1973
Still Life with Cactus c.1933
oil on canvas 89 x 122
FAH1983.8

Gilman, Harold 1876–1919
The Coral Necklace 1914
oil on canvas 61.0 x 45.8
FA000213

Ginner, Charles 1878–1952
Leicester Square 1912
oil on canvas 64.2 x 55.9
FA000158

Ginner, Charles 1878–1952
Lancaster from Castle Hill Terrace c.1947
oil on canvas 50.5 x 68.0
FAH1979.06

Ginnett, Louis 1875–1946
Houghton Bridge 1906
oil on canvas 50.4 x 41.0
FAH1932.10

Ginnett, Louis 1875–1946
The Coat of Many Colours c.1926
oil on canvas 68.6 x 59.0
FA000159

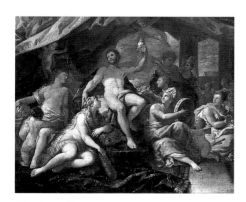

Giordano, Luca 1634–1705
Hercules and Omphale c.1680
oil on canvas 63.5 x 76.5
FA000081

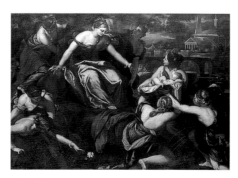

Giordano, Luca 1634–1705
The Finding of Moses
oil on canvas 199 x 268
FA000564

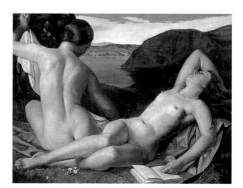

Glasson, Lancelot Myles 1894–1959
Repose c.1928–1929
oil on canvas 90 x 110
FA000917

Facing page: Cranach, Lucas the elder, 1472–1553, *Frederick III, Elector of Saxony* (detail), 1532, Brighton and Hove
Museums and Art Galleries, (p. 66)

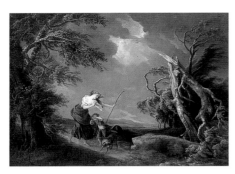

Glimes, P. de active 1750–1800
Stormy Landscape with Shepherdess
oil on canvas 62.9 x 83.8
FA000208

Gluckstein, Hannah 1895–1978
The Devil's Altar 1932
oil on canvas 137.0 x 76.2
FA000092

Goff, Robert Charles 1837–1922
Farm Study
oil on canvas 17.1 x 24.8
FA000416

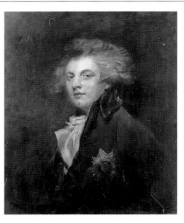

Gogin, Alma 1854–1948
Chrysanthemums 1927
oil on canvas 33.7 x 50.6
FA000461

Gogin, Alma 1854–1948
Anemones
oil on board 40.5 x 32.0
FA000425

Gogin, Alma 1854–1948
George, Prince of Wales (after Joshua Reynolds)
oil on canvas 73.9 x 61.3
FA000197

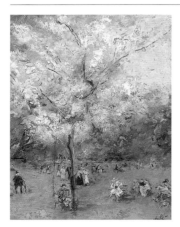

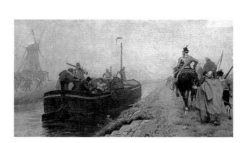

Gogin, Alma 1854–1948
Spring in Regent's Park
oil on board 39.8 x 31.8
FA000421

Gogin, Charles 1844–1931
Conveying Prisoners of War by 'The Spaniard' 1885
oil on board 39.3 x 69.5
FA000337

Gogin, Charles 1844–1931
Kingston Buci Lighthouse 1888
oil on board 35.5 x 25.9
FA000464

Gogin, Charles 1844–1931
My Wife Reading 1888
oil on canvas 47 x 54
FA000645

Gogin, Charles 1844–1931
Girl in a White Cap 1892
oil on board 38.2 x 29.2
FA000470

Gogin, Charles 1844–1931
The Reverie 1900
oil on canvas 120.0 x 79.5
FAH1931.38

Gogin, Charles 1844–1931
Alma Gogin
oil on canvas 50 x 39
FA000640

Gogin, Charles 1844–1931
Alma Gogin
oil on canvas 53.5 x 43.0
FA000878

Gogin, Charles 1844–1931
Bandstand, Brighton Chain Pier
oil on board 14.1 x 18.8
FAH1932.28

Gogin, Charles 1844–1931
Landscape at Walberton
oil on board 25.7 x 56.9
FA000419

Gogin, Charles 1844–1931
Sussex Landscape
oil on board 33.5 x 66.0
FA000582

Gogin, Charles 1844–1931
The Old Chain Pier
oil on board 27.6 x 35.6
FA001126

Goodall, Frederick 1822–1904
A Halt at a Brittany Well 1844
oil on wood panel 18.1 x 25.2
FA000044

Goodall, Frederick 1822–1904
Palm Offering 1866
oil on wood panel 25.5 x 17.5
FA000479

Goodall, Frederick 1822–1904
Sultan Hassan's School, Cairo
oil on canvas 38.3 x 56.0
FA000553

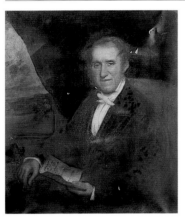

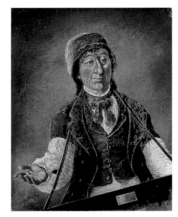

Goodrich, Jerome active 1829–1859
Sir Charles Dick
oil on canvas 92.2 x 76.9
FA000801

Goostry, Charles 19th C
'Brandy Balls'
oil on canvas 80.3 x 63.0
FA000800

Gorton, Lesley-Ann b.1939
The Earth Is Life Itself 1967
oil on hardboard 122.2 x 91.5
FA001147

Gosden, Victor 20th C
Moonlight in the Lanes 1951
oil on board 51 x 36
FA000866

Gosse, Laura Sylvia 1881–1968
La rue Cousine, Dieppe c.1930
oil on canvas 59 x 49
FAH1979.15

Gowing, Lawrence 1918–1991
Woods near Petworth 1947
oil on canvas 51 x 61
FA000334

Grace, Alfred Fitzwalter 1844–1903
Amberley Ferry 1872
oil on canvas 68.2 x 106.8
FA000700

Grace, Alfred Fitzwalter 1844–1903
Clayton Mills 1886
oil on canvas 140 x 206
FA000790

Grace, Alfred Fitzwalter 1844–1903
Portrait of a Man in a Dark Suit 1892
oil on canvas 64.0 x 54.3
FA000356

Grace, Alfred Fitzwalter 1844–1903
Church Street, Steyning
oil on board 23.5 x 32.0
FAH1936.50(b)

Grace, Alfred Fitzwalter 1844–1903
Harvest Moon
oil on canvas 140 x 205
FA000859

Grace, Alfred Fitzwalter 1844–1903
Steyning
oil on canvas 140 x 207
FA000934

Grace, Alfred Fitzwalter 1844–1903
Sunset near Amberley
oil on canvas 12 x 21
FA000512

Grace, Alfred Fitzwalter 1844–1903
Valley of the Cuckmere
oil on canvas 140 x 207
FA000933

Grace, Alfred Fitzwalter 1844–1903
Washing Barge on a Normandy River
oil on wood panel 12 x 21
FA000513

Grace, Frances Lily active 1876–1909
Lady Abinger 1883
oil on canvas 93.0 x 72.5
FA000937

Grace, Frances Lily active 1876–1909
Still Life
oil on canvas 76.0 x 55.8
FA001237

Graham, Peter 1836–1921
Coastal View with Gulls 1890
oil on canvas 40.5 x 61.0
FA000502

Grant 20th C
Kersey, Suffolk
oil on canvas 53.0 x 86.5
FAH1972.9

Grant, Duncan 1885–1978
*Painted Panel for the Music Room of the
Lefevre Gallery* c.1932
oil & chalk on canvas laid on panel with inset
mirror 224.0 x 152.5
FA000095

Grant, Duncan 1885–1978
The Sofa 1944
oil on canvas 76.0 x 63.5
FA000120

Grant, Duncan 1885–1978
Landscape near Firle, Sussex 1947
oil on canvas 54.0 x 74.5
FAH1949.79

Grant, Francis 1803–1878
*Frederick William Hervey, First Marquis of
Bristol* c.1839
oil on canvas 127.3 x 101.6
FA000709

Grant, Francis 1803–1878
Marchioness of Bristol c.1850
oil on canvas 127.6 x 102.2
FA000708

Green, Josephine 20th C
Sir John Howard
oil on canvas 51.2 x 35.5
FA000627

Gregory, George 19th C
The Mull of Cantyre
oil on canvas 39 x 65
FAPM090083

Greuze, Jean-Baptiste 1725–1805
Family Worship
oil on canvas 85.0 x 111.5
FA000658

Griffier, Robert 1688–1760
Landscape with River and Ferry
oil on canvas 49.0 x 57.3
FA000195

Grose, Margaret 20th C
John Otter, Mayor of Brighton 1915
oil on canvas 111.5 x 85.7
FA000971

Grose, Margaret 20th C
King George V 1915
oil on canvas 75.5 x 56.0
FA000829

Grose, Margaret 20th C
Edward VIII as Prince of Wales
oil on canvas 77.0 x 56.5
FA000908

Grose, Margaret 20th C
Queen Mary
oil on canvas 56 x 46
FA000816

Guardi, Francesco (after) 1712–1793
Fanciful View of Venice mid-18th C
oil on canvas 62.0 x 83.5
FAPM090085

Guardi, Francesco (after) 1712–1793
Fanciful View of Venice mid-18th C
oil on canvas 62.0 x 83.5
FAPM090086

Guardi, Francesco (after) 1712–1793
Fanciful View of Venice mid-18th C
oil on canvas 62.0 x 89.5
FAPM090087

Guardi, Francesco (after) 1712–1793
Fanciful View of Venice mid-18th C
oil on canvas 62 x 90
FAPM090088

Guardi, Giacomo 1764–1835
Grand Canal, Venice
oil on canvas 380 x 510
FAPM090030

Guimaraens, R. A. F. 1880–1960
Dyke Road, Brighton
oil on canvas 41 x 31
FA000881

Guimaraens, R. A. F. 1880–1960
Near Russell Square, Brighton
oil on canvas 30.8 x 25.6
FA000466

Guimaraens, R. A. F. 1880–1960
The Corner of a Yard
oil on canvas 40.6 x 30.3
FA000872

Guthrie, Kathleen 1905–1981
Red Picture c.1965
oil on canvas laid on board 68 x 91
FA000842

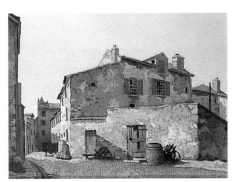

Guy, Cyril Graham active 1929–1938
Le tonnelier 1930
oil on canvas 40 x 50
FA000675

Facing page: Reeve, James, b.1939, *Bevis Hillier* (detail), 1971, Brighton and Hove Museums and Art Galleries, (p. 165)

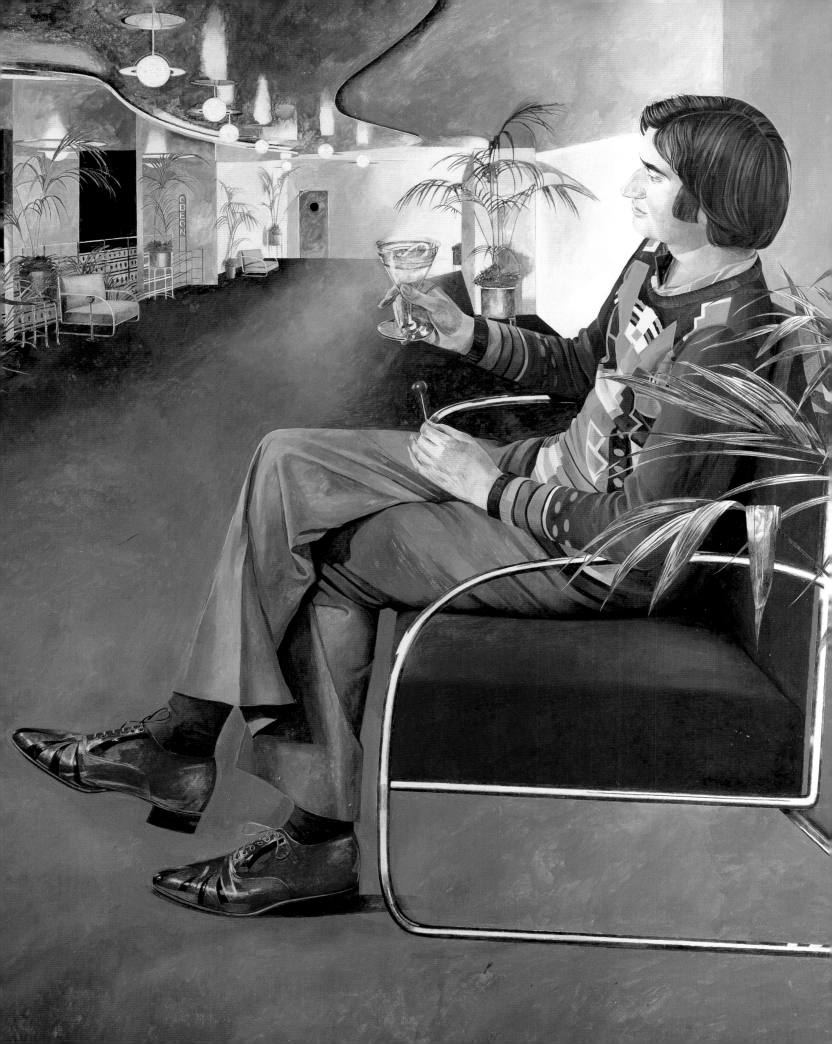

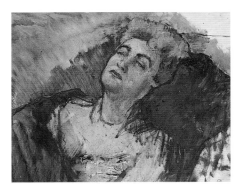

D. H. 20th C
Woman Reclining
oil on board 51.0 x 59.3
FA000284

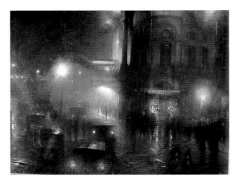

Hacker, Arthur 1858–1919
Flare and Flutter: Piccadilly Circus at Night 1912
oil on canvas 71.3 x 91.4
FA000215

Hacker, Arthur 1858–1919
Daisies at Burnham c.1918
oil on board 14.2 x 23.8
FA000807

Halbique, Roger Charles 1900–1977
Landscape in Algeria, near Algez 1971
oil on canvas 60 x 71
FAH1982.15

Halbique, Roger Charles 1900–1977
Still Life with Watermelon
oil on canvas 60 x 71
FAH1982.13

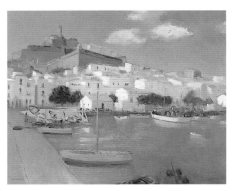

Halbique, Roger Charles 1900–1977
The City of Ibiza from the Harbour
oil on canvas 60 x 71
FAH1982.14

Halbique, Roger Charles 1900–1977
View of the Road between St Paul de Vence and Vence
oil on canvas 65 x 80
FAH1982.12

Hall, Oliver 1869–1957
The Edge of the Forest: Autumn c.1900
oil on canvas 48.3 x 73.0
FA000352

Hall, Oliver 1869–1957
Coates Common, Sussex c.1909
oil on canvas 55.0 x 71.5
FA000314

Hall, W. F. 19th C
Milking Time
oil on canvas 50.5 x 76.2
FA000804

Hamilton, William 1751–1801
A Scene from 'As You Like It' 1790
oil on canvas 195.6 x 259.1
FA000023

Hamilton, William 1751–1801
A Scene from 'The Tempest' c.1790
oil on canvas 101 x 127
FA000989

Hamme, Alexis van 1818–1875
Poultry Seller 1855
oil on panel 65.5 x 53.0
FA000902

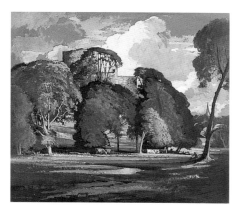

Harris, Edwin Lawson James 1891–1961
Pevensey Castle 1938
oil on board 180 x 280
FAH1962.6

Harris, Gunner A. F.
A Manor House in France 1917
oil on canvas 50.2 x 65.0
FA000493

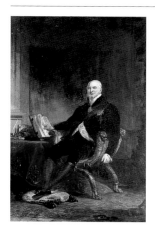

Hart, Solomon Alexander 1806–1881
Portrait of a Man Wearing a Garter Star c.1840
oil on canvas 268.0 x 178.5
FA000880

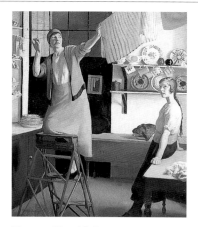

Harvey, Harold C. 1874–1941
A Kitchen Interior c.1918
oil on canvas 69 x 57
FA000333 ✻

Harvey, Michael b.1946
Dreadnought Garage 1979
oil on board 58.0 x 80.6
FA001233

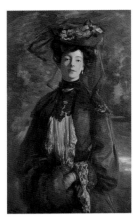

Hayward, Alfred Robert 1875–1971
The Morning Walk 1907
oil on canvas 127.4 x 76.9
FA000717

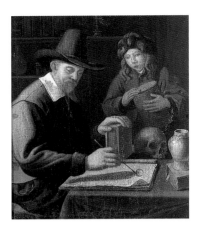

Helmont, Mattheus van (follower of)
1623–c.1674
The Alchemist c.1650
oil on canvas 34.3 x 29.9
FA000115

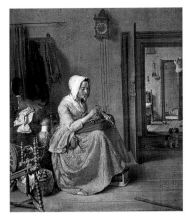

Hendriks, Wybrand 1744–1831
The Lace Maker
oil on canvas 45.8 x 38.0
FA000267

Hennessy, William J. 1839–1917
Relic of the Chain Pier 1897
oil on canvas 91.0 x 138.5
FA000618

Hennessy, William J. 1839–1917
The Woodcutter c.1900
oil on canvas 123 x 118
FA000848

Hepher, David b.1935
Still Life 1964
oil on canvas 153 x 183
FA000593

Herkomer, Hubert von 1849–1914
Francis John Tillstone, Town Clerk 1899
oil on canvas 143.3 x 112.2
FA000611

Herring, John Frederick I 1795–1865
The Racehorse Actaeon c.1830
oil on wood panel 24.7 x 30.5
FA000103

Hicks, Monica Leighton 20th C
Boats off Portugal
oil on board 61 x 123
FA000364

Hilditch, George 1803–1857
View of Hove c.1850
oil on canvas 24.5 x 49.5
FAH1986.41

Hill, Adrian Keith Graham 1895–1977
Rain at Brighton c.1935–1939
oil on board 62.8 x 76.5
FA000299

Hinchliff, Woodbine K. b.1874
Chestnut Wood
oil on canvas 61.2 x 51.0
FA000357

Hinchliff, Woodbine K. b.1874
Dusk in Lincoln Cathedral
oil on canvas 71 x 102
FA000637

Hinchliff, Woodbine K. b.1874
Landscape with Wild Roses
oil on canvas 50.8 x 61.0
FA000489

Hinchliff, Woodbine K. b.1874
Scottish Mountain Landscape
oil on canvas 51.0 x 76.4
FA000406

Hinchliff, Woodbine K. b.1874
The Quince Tree
oil on canvas 50.8 x 76.0
FA000885

Hinchliff, Woodbine K. b.1874
Weare Gifford
oil on canvas 30.6 x 46.0
FA000454

Hitchens, Ivon 1893–1979
Forest c.1940
oil on canvas 52 x 106
FA000327

Hitchens, Ivon 1893–1979
Pink Lily No.3 c.1946
oil on canvas 60.0 x 54.6
FA000169

Hitchens, John b.1940
Lowland Lights 1967
oil on canvas 45.5 x 110.0
FA001193

Hodges, William (attributed to) 1744–1797
The Inner Crater of Mauna Loa, Hawaii
oil on canvas 100.5 x 127.0
FA000032

Hodgkins, Frances 1869–1947
Still Life: Eggs, Tomatoes and Mushrooms c.1929
oil on canvas 64 x 53
FAH1940.92

Hogarth, William (attributed to) 1697–1764
Portrait of a Girl
oil on canvas 77.1 x 64.6
FA000178

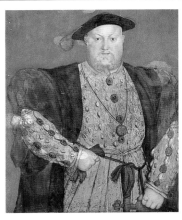

Holbein, Hans the younger (after) 1497/1498–1543
King Henry VIII 16th C/17th C
oil on wood panel 92.5 x 77.2
FA000139

Holbein, Hans the younger (after) 1497/1498–1543
Bess of Hardwicke
oil on panel 45.8 x 35.0
FA000459

Holl, Frank 1845–1888
Captain Henry Hill 1880
oil on canvas 128.0 x 103.5
FA000603

Holl, Frank 1845–1888
Field Marshall Lord Wolseley
oil on canvas 58 x 48
FAH1960.485

Holland, James 1800–1870
Venice 1851
oil on canvas 45.6 x 59.7
FA000554

Holland, James 1800–1870
Street in Genoa
oil on canvas 43.3 x 27.8
FA000446

Holst, Laurits Bernhard 1848–1934
Madeira 1891
oil on canvas 35 x 56
FAPM090069

Holst, Laurits Bernhard 1848–1934
Madeira at Sunset 1891
oil on canvas 36 x 56
FAPM090071

Holst, Laurits Bernhard 1848–1934
The Pontinha, Madeira 1899
oil on canvas 36 x 61
FAPM090075

Holst, Laurits Bernhard 1848–1934
The Pontinha, Madeira 1899
oil on canvas 35.5 x 62.0
FAPM090076

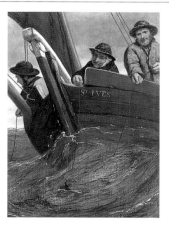

Holzhandler, Dora b.1928
Ice Cream Parlour, Jerusalem 1988
oil on board 39 x 29
FA001141

Hook, James Clarke 1819–1907
Luff, Boy! 1859
oil on canvas 17 x 22
FA000516

Hook, James Clarke 1819–1907
Deep Sea Fishing 1861
oil on canvas 50.8 x 39.5
FA000096

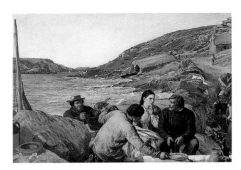

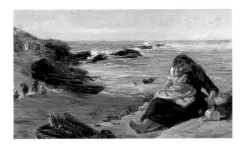

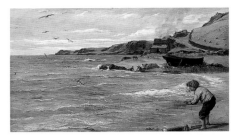

Hook, James Clarke 1819–1907
Sailor's Wedding 1863
oil on canvas 67.2 x 93.0
FA000606

Hook, James Clarke 1819–1907
Song and Accompaniment 1872
oil on canvas 14.2 x 23.2
FA000045

Hook, James Clarke 1819–1907
The Gull Catcher 1877
oil on canvas 52.5 x 84.0
FA000903

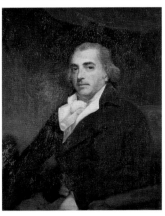

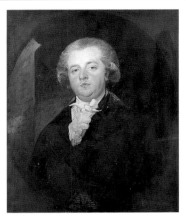

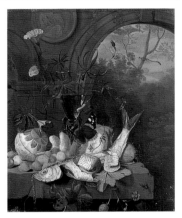

Hoppner, John 1758–1810
John Crace c.1800
oil on canvas 88 x 68
FA001173

Hoppner, John 1758–1810
Sir Henry Watkins Dashwood, Bt c.1800
oil on canvas 76.0 x 64.3
FA000024

Horton, James 20th C
Still Life (after Jan Davidsz. de Heem)
oil on wood panel 35 x 29
FA000413

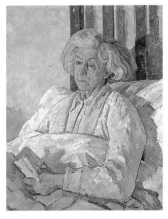

Horton, Percy Frederick 1897–1970
Portrait of the Artist's Mother c.1939
oil on board 71.8 x 54.8
FA000272

Horton, Ronald 1902–1981
The 'Rustler' Aground 1953
oil on hardboard 35.8 x 50.7
FA001195

Horton, Ronald 1902–1981
Dick Pennifold
oil on canvas 63.5 x 48.2
FA001229

Howard, Ken b.1932
Interior, South Bolton Gardens 1983
oil on canvas 145 x 176
FAH1984.45 🐝

Howes, Kenneth
Seascape
oil on canvas on board 34.2 x 49.5
FAH1967.9

Hubbard, Eric Hesketh 1892–1957
A Welsh Castle
oil on canvas 49.2 x 64.8
FAH1958.5

Hubbard, Eric Hesketh 1892–1957
The Cuckmere Valley
oil on canvas 51.0 x 76.5
FA000313

Huchtenburgh, Jan van 1647–1733
Battle Piece (I)
oil on canvas 65.2 x 91.9
FA000151

Huchtenburgh, Jan van 1647–1733
Battle Piece (II)
oil on canvas 64.9 x 91.8
FA001242

Hudson, Thomas (attributed to) 1701–1779
Mary Western
oil on canvas 124 x 99
FAPM090039

Hudson, Thomas (attributed to) 1701–1779
Portrait of a Lady
oil on canvas 74.2 x 61.5
FAH1936.21

Hughes, Arthur 1832–1915
The Swineherd c.1875
oil on canvas 49.6 x 77.0
FA000789

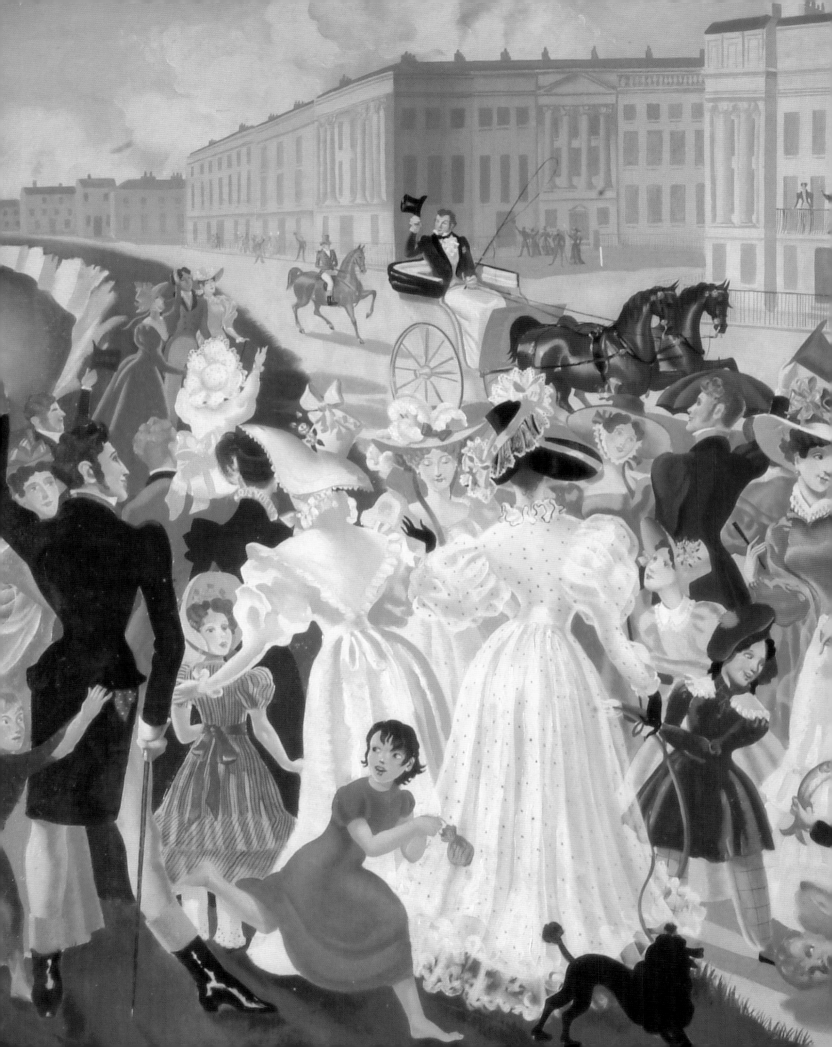

**Hughes-Stanton, Herbert Edwin
Pelham** 1870–1937
Corfe Castle 1905
oil on canvas 71.5 x 102.0
FA000366

**Hughes-Stanton, Herbert Edwin
Pelham** 1870–1937
View of Avignon from Villeneuve 1922
oil on canvas 86.5 x 150.0
FA000687

Hulk, William Frederik b.1852
Cattle Grazing
oil on canvas 76.6 x 127.2
FA000714

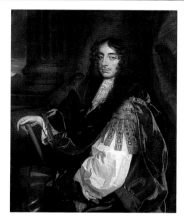

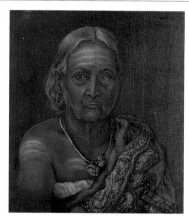

Hunter, Ian b.1939
Table Top Nude 1973
oil on board 75.5 x 60.5
FAH1975.5

Huysmans, Jacob (circle of) c.1633–1696
Charles II
oil on canvas 123.5 x 100.0
FAH1936.33

Indian School
Indian Woman c.1940
oil on canvas 47 x 38
FA000534

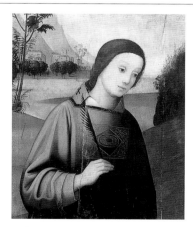

Innes, James Dickson 1887–1914
The Seine at Caudebec 1908
oil on canvas 60.2 x 81.0
FA000175

Italian (Bolognese) School 15th C–early
16th C
A Saint
oil on wood panel 70.5 x 56.3
FA000172

Italian School
Tobias and the Angel c.1500
oil on wood panel 108.0 x 72.5
FA000741

Facing page: Zinkeisen, Anna Katrina, 1901–1976, *Brighton in the Regency* (detail), c.1939, Brighton and
Hove Museums and Art Galleries, (p. 194)

105

Italian School
Holy Family c.1550
oil on canvas 119.5 x 91.4
FA000234

Italian School early 16th C
Laura
oil on wood panel 67.4 x 51.5
FA000194

Italian School
Mary Magdalene c.1600
oil on canvas 98.2 x 73.8
FA000694

Italian School
A Massacre c.1650
oil on canvas 91.2 x 63.4
FA000227

Italian School
Madonna and Child with Saints Anne and John c.1650
oil on canvas 74 x 94
FA000216

Italian School
The Baptism of Christ c.1650
oil on canvas 56.5 x 42.1
FA000224

Italian School
The Drunkenness of Lot c.1650
oil on canvas 103.3 x 76.5
FA000243

Italian School
Martyrdom of a Saint c.1670
oil on canvas 150.0 x 102.3
FA000854

Italian School
Cleopatra c.1680
oil on canvas 130.4 x 104.5
FA000232

Italian School
St Jerome c.1680
oil on canvas 105.6 x 92.0
FA000226

Italian School 17th C
Battle Scene
oil on canvas 58.5 x 75.5
FA000190

Italian School 17th C
Susannah and the Elders
oil on canvas 155 x 176
FA000929

Italian School
Head of a Saint c.1700
oil on canvas 53.0 x 42.8
FA000945

Italian School
Battle Scene c.1750
oil on canvas 65.8 x 114.4
FA000384

Italian School
Classical Ruins c.1750
oil on canvas 35.5 x 69.3
FA000884

Italian School
Madonna and Child c.1750
oil on canvas 67.6 x 47.0
FA000426

Italian School
Rome with St Peter's and Castel Sant'Angelo c.1750
oil on canvas 79.5 x 103.0
FA000217

Italian School
Archer in a Mythical Landscape c.1780
oil on canvas 109.0 x 167.8
FA000608

Italian School 18th C
David and Goliath
oil on canvas 105.7 x 163.3
FA001211

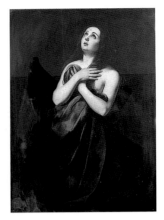

Italian School
Mary Magdalene c.1800
oil on canvas 145.5 x 103.5
FA000601

J. W. J.
Ruins in the North of Devon c.1820
oil on panel 22.8 x 30.5
FA000998

M. J.
Forest Glade 1842
oil on canvas 73.3 x 126.5
FA000837

Jackson 19th C
Saint Savant-Prise du Taillard
oil on panel 14 x 28
FA000898

Jacomb-Hood, George Percy 1857–1930
The Garden of the Padronale, Portofino 1905
oil on canvas 54 x 45
FAH1934.32c

Jacomb-Hood, George Percy 1857–1930
Hove Beach 1920
oil on panel 22.2 x 31.2
FAH1990.23

Jacquet, Gustave Jean 1846–1909
Lady with a Staff
oil on wood panel 21.5 x 15.8
FA000510

Jamieson, Alexander 1873–1937
Dieppe Cliffs 1904
oil on canvas 104 x 127
FA000295

Jamieson, Robert Kirkland 1881–1950
A Sluice on the 'Windrush'
oil on canvas 63.5 x 76.2
FA000298

Jenner, Isaac Walter 1836–1901
Brighton Beach with Fishing Boats 1877
oil on board 14.0 x 29.3
FA000492

Jenner, Isaac Walter 1836–1901
Bambro' Castle, Northumberland
oil on canvas 32 x 60
FAPM090073
STOLEN

Jenner, Isaac Walter 1836–1901
Fishing Boats off Brighton
oil on canvas 91.9 x 153.9
FA000128

Jenner, Isaac Walter 1836–1901
Sunrise: Eastern Arms of Shoreham Harbour
oil on board 13.7 x 19.7
FA000638

Jenner, Isaac Walter 1836–1901
The Bridge, Plymouth Sound
oil on canvas 36 x 75
FAPM090074

Jervas, Charles (after) c.1675–1739
Portrait of a Lady
oil on canvas 74.0 x 63.6
FA000173

Joanovitch, Paul 1859–1957
Greek Soldiers with a Woman Traitor
oil on canvas 100.4 x 133.2
FA000602

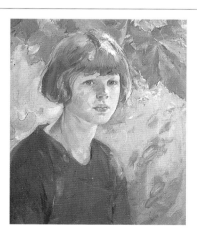

Johnson, Ernest Borough 1866–1949
Portrait of a Girl 1930
oil on canvas 55.7 x 47.0
FA000403

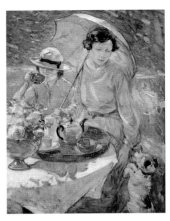

Johnson, Esther Borough 1867–1949
Tea Table in the Garden c.1925
oil on canvas 55.7 x 47.0
FA001094

Jones, Christine b.1961
Brighton Pride 2002
oil on board 122 x 137
FA001174

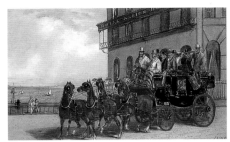

Jones, H. J. active 19th C
*The Brighton to London Coach by the Royal
Albion Hotel* 1869
oil on canvas 30.3 x 45.8
FA000485

Jones, H. J. active 19th C
The London to Brighton Coach on the Road
oil on canvas 30.3 x 45.8
FA000486

Jones, Robert active 1815–1835
Chinese Scene c.1817
oil on canvas 268 x 220
FA001181

Jones, Robert active 1815–1835
Chinese Scene c.1817
oil on canvas 268 x 220
FA001182

Jonzen, Basil 1913–1967
Still Life 1944
oil on paper 79.0 x 65.5
FA000335

Juncker, Justus (attributed to) 1703–1767
Interior of a Tavern c.1750
oil on wood panel 24.2 x 38.2
FA000110

**Kallstenius, Gottfried Samuel
Nikolaus** 1861–1943
Fir Trees at the Coast 1910
oil on canvas 90 x 100
FA000378

Kauffmann, Angelica 1741–1807
Penelope at Her Loom 1764
oil on canvas 169 x 118
FAH1975.33

Kauffman, Angelica 1741–1807
Mrs Marriot
oil on canvas 60.3 x 49.5
FA000123

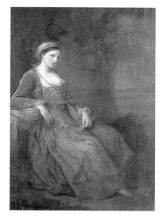

Kauffmann, Angelica 1741–1807
Portrait of a Woman
oil on canvas 168 x 118
FAH1975.32

Kessell, Mary 1914–1978
Winter Wood 1956
oil on canvas 76 x 67
FA000698

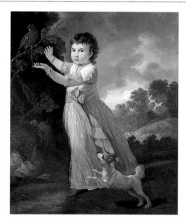

Kettle, Tilly 1735–1786
Francis Graham c.1774
oil on canvas 124 x 99
FAH1953.769

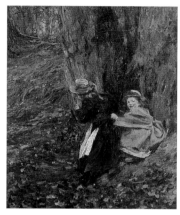

King, Gunning 1859–1940
Hide and Seek c.1899
oil on canvas 77.5 x 63.0
FA000862

King, Gunning 1859–1940
Country Scene with Haystacks and Large Tree 1920
oil on wood panel 24.0 x 37.5
FA001092

King, Gunning 1859–1940
Landscape and Cloud Study 1921
oil on wood panel 26.8 x 37.6
FA001160

King, Gunning 1859–1940
Mrs Hodges and Her Son 1921
oil on canvas 142.9 x 112.0
FA000619

King, Gunning 1859–1940
Cotswold Country (I) 1928
oil on canvas 45.8 x 61.0
FA000496

King, Gunning 1859–1940
Cotswold Country (II) 1928
oil on canvas 50.7 x 66.0
FA000497

King, Gunning 1859–1940
Gloucestershire Village (I) 1928
oil on canvas 51 x 66
FA000494

King, Gunning 1859–1940
Thundery Weather 1929
oil on wood panel 28.8 x 37.4
FA001049

King, Gunning 1859–1940
Autumnal Trees and Farm Buildings 1930
oil on wood panel 37.5 x 29.0
FA000758

King, Gunning 1859–1940
Black Cow 1930
oil on wood panel 20 x 29
FA000786

King, Gunning 1859–1940
Bridge over a River 1930
oil on wood panel 29.0 x 37.5
FA000761

King, Gunning 1859–1940
Brown Bull: Cow Looking Left 1930
oil on wood panel 20 x 29
FA000784

King, Gunning 1859–1940
Brown Bull: Cow Looking Right 1930
oil on board 20 x 29
FA000783

Facing page: Weight, Carel Victor Morlais, 1908–1997, *American Girl and Doll* (detail), 1975, Brighton and Hove Museums and Art Galleries, (p. 189)

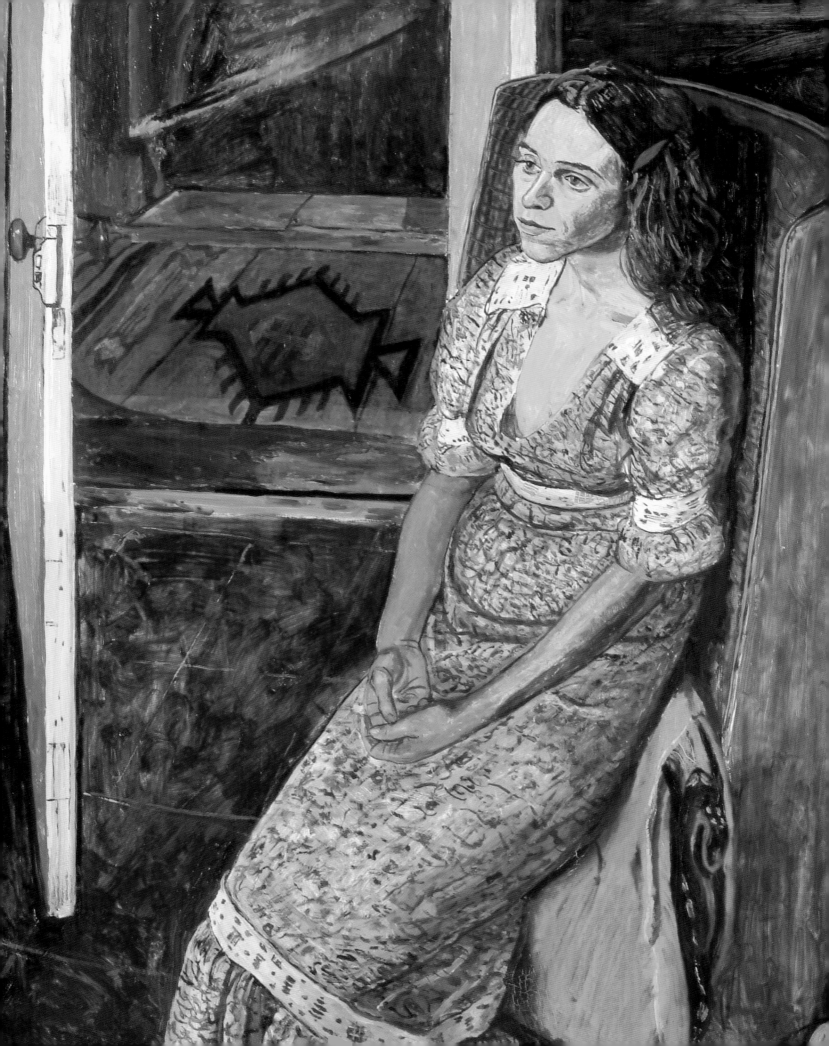

King, Gunning 1859–1940
Brown Bullock 1930
oil on wood panel 29.0 x 37.5
FA000756

King, Gunning 1859–1940
Cow Grazing 1930
oil on board 20 x 29
FA000782

King, Gunning 1859–1940
Cow Lying in the Grass 1930
oil on wood panel 20.5 x 29.0
FA000777

King, Gunning 1859–1940
Cow Standing 1930
oil on wood panel 29.0 x 20.5
FA000778

King, Gunning 1859–1940
Forest Scene 1930
oil on wood panel 29.0 x 37.5
FA000760

King, Gunning 1859–1940
Landscape Looking down into a Valley 1930
oil on wood panel 29.0 x 37.5
FA000773

King, Gunning 1859–1940
Landscape with Cloudy Sky 1930
oil on wood panel 29.0 x 37.5
FA000767

King, Gunning 1859–1940
*Landscape with Cloudy Sky and Purple
Heather* 1930
oil on wood panel 29.0 x 37.5
FA000764

King, Gunning 1859–1940
Landscape with Large Cloudy Sky 1930
oil on wood panel 29.0 x 37.5
FA000775

King, Gunning 1859–1940
Landscape with Sun-Tinged Clouds 1930
oil on wood panel 20 x 29
FA000779

King, Gunning 1859–1940
Landscape with Trees 1930
oil on wood panel 29.0 x 37.5
FA000754

King, Gunning 1859–1940
Landscape with Trees and Purple Flowers 1930
oil on wood panel 29.0 x 37.5
FA000762

King, Gunning 1859–1940
Mill Pond 1930
oil on wood panel 29.0 x 37.5
FA000755

King, Gunning 1859–1940
Moonlight on Lake with Statues 1930
oil on wood panel 29.0 x 37.5
FA000759

King, Gunning 1859–1940
Moonlight Scene with Statue 1930
oil on wood panel 29.0 x 37.5
FA000757

King, Gunning 1859–1940
Pathway through the Trees 1930
oil on wood panel 29.0 x 37.5
FA000769

King, Gunning 1859–1940
Pink Flowers 1930
oil on wood panel 37.5 x 29.0
FA000753

King, Gunning 1859–1940
Rural Scene with Village and Church Spire 1930
oil on wood panel 29.0 x 37.5
FA000771

King, Gunning 1859–1940
Sheep and Farm Workers 1930
oil on wood panel 29.0 x 37.5
FA000774

King, Gunning 1859–1940
The Approach to a Village Church 1930
oil on wood panel 29.0 x 37.5
FA000766

King, Gunning 1859–1940
Three Cows Grazing in a Field 1930
oil on board 20 x 29
FA000780

King, Gunning 1859–1940
Two Cows Grazing 1930
oil on wood panel 20 x 29
FA000781

King, Gunning 1859–1940
View of Open Countryside 1930
oil on wood panel 29.7 x 37.4
FA001047

King, Gunning 1859–1940
White Cow Following Brown Cow 1930
oil on wood panel 20 x 29
FA000785

King, Gunning 1859–1940
*Woman in Green Dress Sitting on the
Grass* 1930
oil on wood panel 29.0 x 37.5
FA000770

King, Gunning 1859–1940
*Woodland Clearing Overlooking Lower
Land* 1930
oil on wood panel 29.0 x 37.5
FA000765

King, Gunning 1859–1940
Woodland Landscape 1930
oil on wood panel 29.0 x 37.5
FA000768

King, Gunning 1859–1940
Woodland Scene 1930
oil on wood panel 29.0 x 37.5
FA000763

King, Gunning 1859–1940
Woodland Scene 1930
oil on wood panel 29.0 x 37.5
FA000776

King, Gunning 1859–1940
Woodland Scene on Hill 1930
oil on wood panel 29.0 x 37.5
FA000772

King, Gunning 1859–1940
Wooded Scene 1931
oil on wood panel 29.7 x 37.7
FA001043

King, Gunning 1859–1940
Autumn 1933
oil on canvas 35.9 x 46.2
FA000418

King, Gunning 1859–1940
Golden Spring 1933
oil on canvas 35.5 x 46.0
FA000979

King, Gunning 1859–1940
Harting, Sussex 1934
oil on canvas 74.5 x 101.0
FA001188

King, Gunning 1859–1940
Kimmeridge, Dorset 1936
oil on canvas 35.7 x 46.0
FA000954

King, Gunning 1859–1940
Blue Pool 1937
oil on canvas 46 x 56
FA000984

117

King, Gunning 1859–1940
Evening 1938
oil on canvas 35.8 x 46.0
FA000420

King, Gunning 1859–1940
Downland 1939
oil on canvas 41.5 x 51.5
FA000488

King, Gunning 1859–1940
A Brown Cow
oil on board 20.8 x 29.3
FA001084

King, Gunning 1859–1940
A Bull
oil on wood panel 20.5 x 29.4
FA001011

King, Gunning 1859–1940
A Bull
oil on panel 33.0 x 41.2
FA001061

King, Gunning 1859–1940
A Church
oil on panel 44.1 x 32.5
FA001064

King, Gunning 1859–1940
A Church and a Lady
oil on wood panel 33.0 x 40.5
FA001075

King, Gunning 1859–1940
A Country Scene
oil on wood panel 30 x 37
FA001035

King, Gunning 1859–1940
A Cow Eating
oil on wood panel 35.7 x 25.2
FA001088

King, Gunning 1859–1940
A Moored Boat
oil on wood panel 25.0 x 35.6
FA001091

King, Gunning 1859–1940
A Pig
oil on wood panel 20.5 x 29.4
FA001007

King, Gunning 1859–1940
A River Running through Green Fields
oil on canvas on board 31.5 x 40.5
FA001073

King, Gunning 1859–1940
A Sheep Grazing
oil on board 20.5 x 29.4
FA001023

King, Gunning 1859–1940
Autumnal Scene
oil on wood panel 29.5 x 37.5
FA001042

King, Gunning 1859–1940
A View through Trees
oil on canvas on board 40.9 x 32.8
FA001066

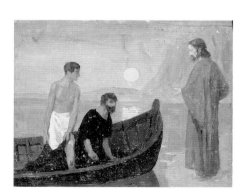

King, Gunning 1859–1940
Biblical Scene
oil on wood panel 29.7 x 37.5
FA001036

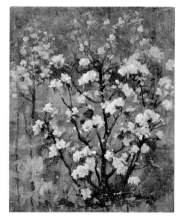

King, Gunning 1859–1940
Blossom
oil on wood panel 37.6 x 29.5
FA001041

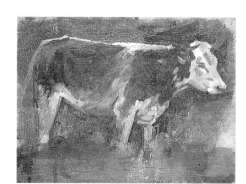

King, Gunning 1859–1940
Bull in a Field
oil on panel 20.5 x 29.4
FA001028

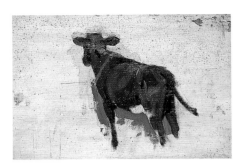

King, Gunning 1859–1940
Calf
oil on panel 20.5 x 29.4
FA001026

King, Gunning 1859–1940
Calf
oil on wood panel 24.9 x 35.5
FA001162

King, Gunning 1859–1940
Calf Drinking from Trough
oil on wood panel 33.5 x 41.0
FA001072

King, Gunning 1859–1940
Carol Singers
oil on canvas 185.8 x 153.0
FA000565

King, Gunning 1859–1940
Cattle Heads
oil on panel 20.5 x 29.4
FA001017

King, Gunning 1859–1940
Cloudscape
oil on wood panel 20.5 x 26.5
FA001030

King, Gunning 1859–1940
Cloudscape
oil on panel 26.8 x 33.8
FA001152

King, Gunning 1859–1940
Cloudscape over a Hill
oil on board 20.5 x 29.4
FA001008

King, Gunning 1859–1940
Cloudy Sky and Green Fields with Specks of Orange
oil on wood panel 20.3 x 29.5
FA001080

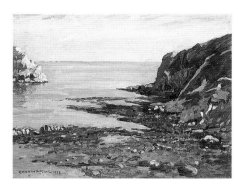

King, Gunning 1859–1940
Corfe
oil on canvas 35.5 x 45.0
FA000976

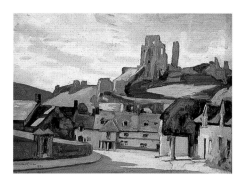

King, Gunning 1859–1940
Corfe Castle
oil on canvas 35.9 x 46.0
FA000973

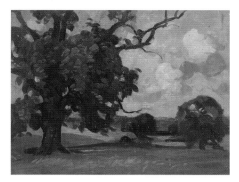

King, Gunning 1859–1940
Country Scene
oil on panel 32.9 x 41.9
FA001059

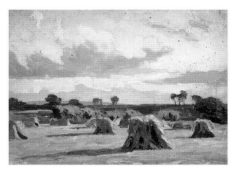

King, Gunning 1859–1940
Country Scene with Field of Haystacks
oil on wood panel 27.2 x 37.2
FA001085

King, Gunning 1859–1940
Country Scene with River, Barn and House
oil on panel 32.6 x 40.6
FA001062

King, Gunning 1859–1940
Country Scene with Trees
oil on wood panel 25.4 x 36.3
FA001087

King, Gunning 1859–1940
Cow Grazing
oil on wood panel 20.5 x 29.4
FA001019

King, Gunning 1859–1940
Cow in a Field
oil on wood panel 20.5 x 29.4
FA001029

King, Gunning 1859–1940
Cow in a Field
oil on wood panel 20.5 x 29.4
FA001031

King, Gunning 1859–1940
Cows and Sheep
oil on wood panel 20.5 x 29.4
FA001027

King, Gunning 1859–1940
Cows Feeding
oil on board 20.5 x 29.4
FA001015

King, Gunning 1859–1940
Cows from behind
oil on wood panel 20.5 x 29.4
FA001025

King, Gunning 1859–1940
Cows in a Field
oil on wood panel 29.4 x 20.5
FA001006

King, Gunning 1859–1940
Cows in a Field
oil on board 20.5 x 29.0
FA001022

King, Gunning 1859–1940
Cows in a Field
oil on wood panel 20.5 x 29.4
FA001032

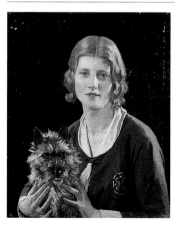

King, Gunning 1859–1940
England and Scotland
oil on canvas 66.3 x 51.0
FA000498

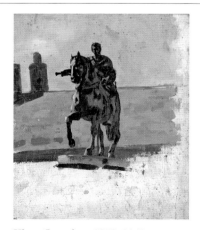

King, Gunning 1859–1940
Equestrian Statue
oil on panel 32.8 x 27.9
FA001151

King, Gunning 1859–1940
Farmyard Buildings
oil on board 40.4 x 32.8
FA001163

Facing page: Dürer, Albrecht (after), 1471–1528, *Not This Man but Barabbas* (detail), Brighton and Hove Museums and Art Galleries, (p. 73)

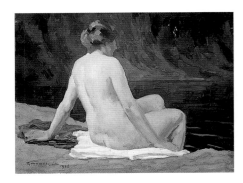

King, Gunning 1859–1940
Figure
oil on canvas 35.5 x 46.0
FA000974

King, Gunning 1859–1940
Flock of Sheep in Sunset
oil on panel 25.0 x 35.5
FA001090

King, Gunning 1859–1940
Flowering Plants
oil on wood panel 37.7 x 30.0
FA001044

King, Gunning 1859–1940
Flowers
oil on board 20.5 x 29.4
FA001024

King, Gunning 1859–1940
Gloucestershire Village (II)
oil on canvas 46 x 61
FA000495

King, Gunning 1859–1940
Grazing Cow
oil on wood panel 29.4 x 20.5
FA001010

King, Gunning 1859–1940
Grazing Cows
oil on wood panel 20.5 x 29.4
FA001013

King, Gunning 1859–1940
Green Leaves
oil on wood panel 29.5 x 20.2
FA001079

King, Gunning 1859–1940
Harbour
oil on panel 32.9 x 40.8
FA001068

King, Gunning 1859–1940
Harting
oil on canvas 35.5 x 45.7
FA000940

King, Gunning 1859–1940
Harting Church
oil on canvas 28 x 44
FA000680

King, Gunning 1859–1940
Harting Church: Sunset
oil on canvas 71 x 61
FA000338

King, Gunning 1859–1940
Harting Village and Pond
oil on canvas 92.0 x 124.3
FA000396

King, Gunning 1859–1940
House in Rural Woodland Setting
oil on wood panel 29.5 x 20.3
FA001081

King, Gunning 1859–1940
House in the Country
oil on wood panel 29.7 x 36.6
FA001048

King, Gunning 1859–1940
Interior View with Arched Window
oil on panel 26.2 x 36.1
FA001058

King, Gunning 1859–1940
Landscape
oil on canvas 36.2 x 46.4
FA000752

King, Gunning 1859–1940
Landscape
oil on board 45.0 x 60.5
FA000835

King, Gunning 1859–1940
Landscape
oil on canvas 29.5 x 45.0
FA000926

King, Gunning 1859–1940
Landscape
oil on canvas 38 x 46
FA000956

King, Gunning 1859–1940
Landscape
oil on canvas 35.5 x 46.0
FA000978

King, Gunning 1859–1940
Landscape
oil on wood panel 21.4 x 26.8
FA001033

King, Gunning 1859–1940
Landscape Study
oil on panel 41.0 x 32.5
FA001060

King, Gunning 1859–1940
Landscape with Clouds
oil on board 26.9 x 36.8
FA001154

King, Gunning 1859–1940
Landscape with Grey Clouds
oil on panel 24.5 x 35.6
FA001158

King, Gunning 1859–1940
*Landscape with Pond in Foreground, Large
Tree on Left*
oil on wood panel 24.9 x 35.5
FA001150

King, Gunning 1859–1940
Landscape with Silver Birches
oil on board 29.8 x 37.4
FA001246

King, Gunning 1859–1940
Large Tree
oil on canvas board 40.3 x 32.8
FA001159

King, Gunning 1859–1940
Lines of Haystacks with Hills in Background
oil on canvas on board 31.5 x 40.5
FA001074

King, Gunning 1859–1940
Man Going to Work
oil on panel 41.5 x 33.4
FA001063

King, Gunning 1859–1940
Man in Thought
oil on wood panel 29.4 x 20.5
FA001009

King, Gunning 1859–1940
Mill Lane, Harting
oil on canvas 35.5 x 46.0
FA000977

King, Gunning 1859–1940
Nude
oil on canvas 46.0 x 35.5
FA000955

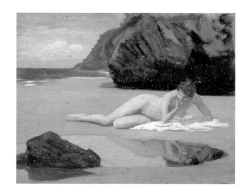

King, Gunning 1859–1940
Nude on Beach
oil on wood panel 30.0 x 37.5
FA001038

King, Gunning 1859–1940
Orange Sunset over Blue Lake
oil on wood panel 20.3 x 29.4
FA001076

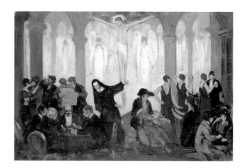

King, Gunning 1859–1940
*Party Scene inside a Church with Party Guests,
Angels and a Nun*
oil on wood panel 25.0 x 35.5
FA001093

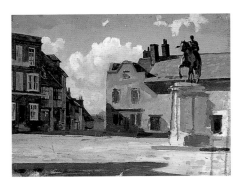

King, Gunning 1859–1940
Petersfield Square
oil on canvas 35.8 x 46.0
FA000975

King, Gunning 1859–1940
Pillars
oil on panel 29.4 x 20.5
FA001012

King, Gunning 1859–1940
Porch of a Church
oil on board 35.5 x 25.1
FA001227

King, Gunning 1859–1940
Portrait of a Woman
oil on wood panel 29.2 x 20.0
FA001083

King, Gunning 1859–1940
Portrait of a Woman
oil on panel 39.8 x 32.0
FA001148

King, Gunning 1859–1940
River Scene
oil on wood panel 26.8 x 33.2
FA001157

King, Gunning 1859–1940
Scene with Trees
oil on wood panel 29.9 x 37.5
FA001046

King, Gunning 1859–1940
Seated Woman
oil on board 31.0 x 22.7
FA001052

King, Gunning 1859–1940
Shepherd Tending His Sheep
oil on board 25.5 x 31.5
FA001089

King, Gunning 1859–1940
Shepherd with a Sheep and Its Lamb
oil on board 31.8 x 25.1
FA001164

King, Gunning 1859–1940
Shepherd with Sheep
oil on board 25.4 x 32.0
FA001053

King, Gunning 1859–1940
Spring
oil on panel 29.6 x 37.8
FA001050

King, Gunning 1859–1940
Statue in Clearing
oil on wood panel 29.7 x 38.0
FA001037

King, Gunning 1859–1940
Study of a Cow
oil on board 12.6 x 21.7
FA001127

King, Gunning 1859–1940
Sunset
oil on board 17.8 x 25.5
FA001056

King, Gunning 1859–1940
The Altar
oil on canvas 66 x 51
FA000507

King, Gunning 1859–1940
The Heath
oil on canvas 35.8 x 45.8
FA000417

King, Gunning 1859–1940
Three Cows Grazing
oil on panel 20.5 x 29.4
FA001020

King, Gunning 1859–1940
Trees and Grey Road
oil on canvas board 32.8 x 40.2
FA001149

King, Gunning 1859–1940
Trees in a Lane with Buildings and a Wall
oil on canvas board 32.9 x 40.4
FA001153

King, Gunning 1859–1940
Two Black Cows
oil on wood panel 20.4 x 29.2
FA001078

King, Gunning 1859–1940
Two Bulls
oil on board 21.0 x 29.1
FA001082

King, Gunning 1859–1940
Two Cows Grazing
oil on board 17.1 x 29.2
FA001021a

King, Gunning 1859–1940
Two Cows Grazing
oil on board 17.1 x 29.2
FA001021b

King, Gunning 1859–1940
Vegetation
oil on wood panel 27.2 x 33.1
FA001155

King, Gunning 1859–1940
View across a Field
oil on wood panel 20.5 x 29.4
FA001018

King, Gunning 1859–1940
View across Fields
oil on panel 27.9 x 33.0
FA001055

Facing page: Sharp, Dorothea, 1874–1955, *Children on a Hillside* (detail), Hastings Museum and Art Gallery, (p. 313)

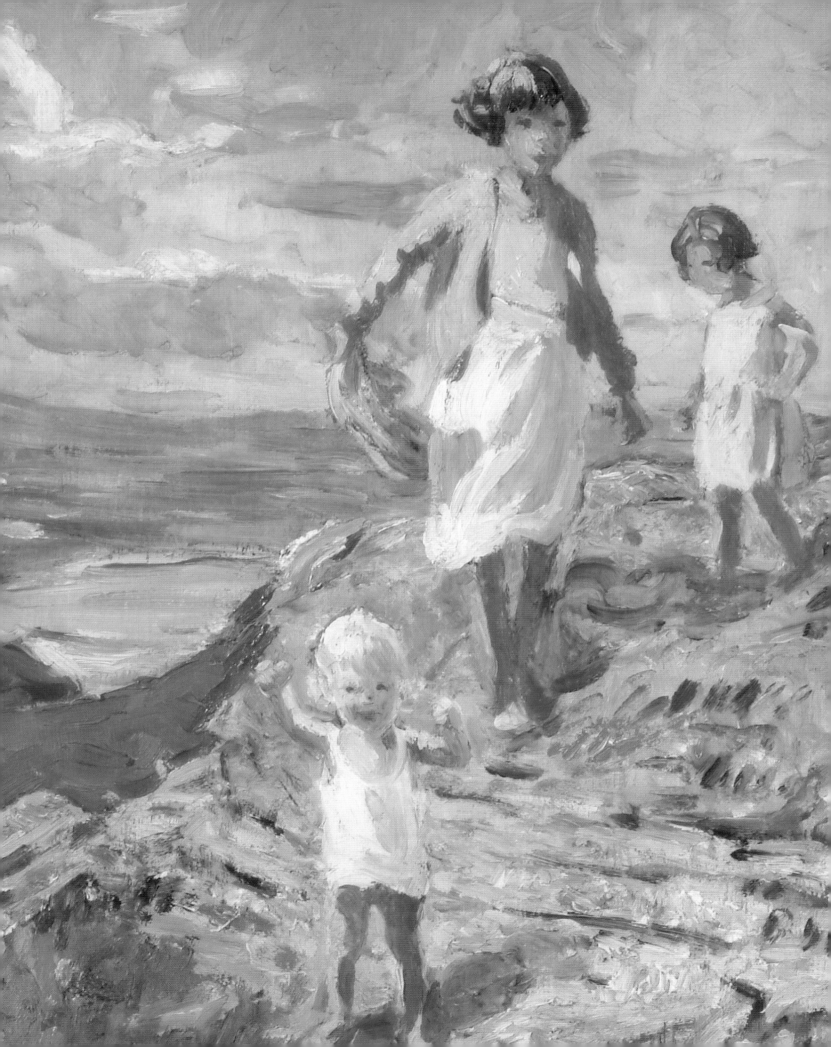

King, Gunning 1859–1940
View of Hill and Field at Dusk
oil on canvas on board 30.3 x 40.0
FA001069

King, Gunning 1859–1940
View of Town Centre with Equestrian Monument
oil on canvas on board 32.8 x 40.9
FA001067

King, Gunning 1859–1940
Village Scene
oil on canvas 35.7 x 46.0
FA000951

King, Gunning 1859–1940
Walking Cow
oil on panel 27.2 x 33.3
FA001054

King, Gunning 1859–1940
Wild Flowers
oil on canvas 35.8 x 46.0
FA000457

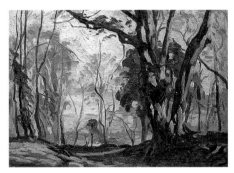

King, Gunning 1859–1940
Winter
oil on wood panel 26.8 x 36.1
FA001156

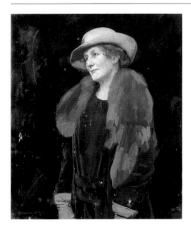

King, Gunning 1859–1940
Woman in Purple
oil on canvas 95.5 x 76.0
FA000344

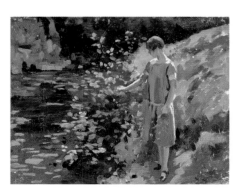

King, Gunning 1859–1940
Woman in Purple Dress Picking Flowers on Riverbank
oil on wood panel 31.8 x 40.5
FA001070

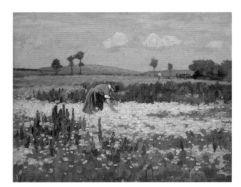

King, Gunning 1859–1940
Woman Picking Flowers
oil on panel 32.8 x 41.8
FA001065

King, Gunning 1859–1940
Wooded Scene
oil on wood panel 29.7 x 38.0
FA001039

King, Gunning 1859–1940
Wooded Scene
oil on wood panel 29.7 x 37.5
FA001045

King, Gunning 1859–1940
Wooded Scene of Trees
oil on board 37.2 x 26.7
FA001086

King, Gunning 1859–1940
Wooded Scene with Statue
oil on wood panel 29.7 x 37.5
FA001040

King, Gunning 1859–1940
Woodland: Flowers on Reverse
oil on wood panel 33.2 x 40.5
FA001071

King, Gunning 1859–1940
Woods
oil on wood panel 32.4 x 40.7
FA001161

King, Gunning 1859–1940
Young Woman
oil on canvas 61 x 46
FA000953

Kinnear, James active 1880–1917
Shipping 1879
oil on canvas 25.5 x 18.0
FA001245

Kinnear, James active 1880–1917
*Southwick and Fishersgate from
Portslade* 1879
oil on canvas 35 x 61
FA000624

Kinnear, James active 1880–1917
Southwick Harbour View 1879
oil on canvas 30.7 x 60.7
FA001226

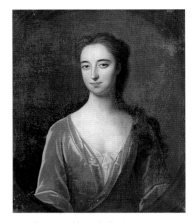

Kneller, Godfrey (after) 1646–1723
A Court Beauty 1720
oil on canvas 76.0 x 63.9
FA000141

Knight, Charles 1901–1990
Bridgnorth 1926
oil on canvas 76 x 102
FA000751

Knight, Charles 1901–1990
The Shower 1940
oil on canvas 101.8 x 128.3
FA000607

Knight, Harold 1874–1961
The Reader c.1910
oil on canvas 45 x 45
FAH1945.179

Knight, Laura 1877–1970
The Ballet Shoe c.1932
oil on board 46 x 40
FA000332

Koe, Lawrence 1869–1913
Venus and Tannhauser c.1896
oil on canvas 141.8 x 243.0
FA000590

Koe, Lawrence 1869–1913
Idyll c.1908–1911
oil on canvas 61.0 x 51.2
FA000395

J. H. L.
The Gleaner 1876
oil on board 32.2 x 23.4
FA000545

Lamb, Henry 1883–1960
The Behrend Family 1927
oil on canvas 53.5 x 67.5
FAH1979.4

Lamb, Henry 1883–1960
Valentine, Canadian Forces 1941
oil on board 35.6 x 46.0
FA000414

Lambert, Clement 1855–1925
Landscape with Horses and Sheep c.1900
oil on canvas 75 x 127
FAH1941.111

Lambert, Clement 1855–1925
The Sheep Wash, Sussex c.1900
oil on canvas 75 x 125
FAH1941.108

Lambert, Clement 1855–1925
The Chattri at Patcham c.1920
oil on canvas 30.6 x 61.2
FA000798

Lambert, Clement 1855–1925
Bramber Flooding
oil on canvas 76 x 127
FAH1941.110

Lambert, Clement 1855–1925
Home to the Fold
oil on canvas 76 x 127
FAH1941.112

Lambert, Clement 1855–1925
Landscape with Rainbow and Sheep
oil on canvas 76 x 127
FAH1941.115

Lambert, Clement 1855–1925
Southdown Village
oil on canvas 50.5 x 91.0
FA000905

Lambert, Clement 1855–1925
The Dust Storm
oil on canvas 76 x 127
FAH1941.109

Lambert, Clement 1855–1925
The Mill beside the Stream
oil on canvas 51 x 76
FAH1941.155

Lambert, George Washington 1873–1930
Horse Fair c.1908
oil on canvas 40.6 x 60.9
FA000239

Lamqua II
Hexing (Wo Hing) of Hong Kong 1864
oil on canvas 78.5 x 62.0
FA000631

Lamqua II
*The Fourth Concubine of Hexing (Wo Hing) of
Hong Kong* 1864
oil on canvas 78.5 x 62.0
FA000632

Lancret, Nicolas (after) 1690–1743
Musicians (A Pastoral Conversation Piece)
oil on canvas 26.7 x 35.0
FA000947

Landseer, Edwin Henry (after) 1802–1873
Study of a Dog's Head 19th C
oil on canvas 25.7 x 30.8
FA000478

Langendijk, Dirk 1748–1805
*De Ruyter's Raid on the English Ships off
Chatham* c.1790
oil on wood panel 78.1 x 113.6
FA000229

La Thangue, Henry Herbert 1859–1929
A Hillside Village in Provence c.1910–1914
oil on canvas 84.5 x 74.5
FA000342

Latouche, Gaston de 1854–1913
The Swans at Play c.1909
oil on canvas 165.0 x 180.5
FA000657

Lavery, John 1856–1941
Hazel 1916
oil on canvas 61.3 x 33.0
FA000646

Lawrence, Thomas 1769–1830
Emily and Harriet Lamb as Children 1792
oil on canvas 73 x 63
FA000218

Lawrence, Thomas 1769–1830
*King George IV, Seated, in Morning
Dress* c.1820–1821
oil on canvas 266.6 x 175.2
FA000026

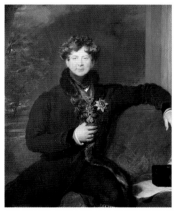

Lawrence, Thomas 1769–1830
*King George IV, Seated, in Morning
Dress* 1821–1822
oil on canvas 142.3 x 111.8
FA000027

Lawrence, Thomas (after) 1769–1830
George IV, Seated 19th C
oil on board 60.7 x 42.0
FA000726

Lawrence, Thomas (studio of) 1769–1830
*King George IV, Standing, in Garter Robes,
'Coronation Portrait'*
oil on canvas 293.4 x 203.2
FA000028

Lawrence, Thomas (style of) 1769–1830
*King George IV, Standing in Garter Robes,
'Coronation Portrait'* c.1821
oil on canvas 257 x 158
FA000029

Lawrenson, Charlotte 1883–c.1971
Girl Knitting 1925
oil on canvas 71 x 56
FA000339

Lawrenson, Edward Louis 1868–1940
Moonrise on the Rape of Hastings
oil on canvas 63.4 x 76.8
FA000294

Leader, Benjamin Williams (after)
1831–1923
A Rocky Stream
oil on canvas 59.0 x 89.5
FAPM090021

Lear, Edward 1812–1888
View of Gwalior, India 1884
oil on canvas 82.5 x 165.8
FA000039

Leathem, William J. 1815–1857
Shipping off Shoreham 1850
oil on canvas 123.3 x 185.9
FA000615

Leathem, William J. 1815–1857
Portsmouth Harbour
oil on canvas 50 x 150
FA000659

Leathem, William J. 1815–1857
The Battle of Trafalgar
oil on canvas 213 x 427
FA000733

Le Bas, Philip b.1925
Brighton Street Musicians c.1951–1952
oil on board 127.2 x 101.7
FA000117

Lees, Derwent 1885–1931
Spanish Landscape 1912
oil on board 32 x 40
FAH1990.24

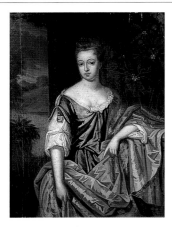

Lely, Peter (after) 1618–1680
Portrait of a Woman
oil on board 50.8 x 37.0
FA000990

Lemon, Arthur 1850–1912
Cattle in a Wood
oil on canvas 71.0 x 50.5
FA000350

Lemon, Arthur 1850–1912
Leading Cattle
oil on canvas 56.5 x 85.5
FA000391

Leslie, George Dunlop 1835–1921
Alice in Wonderland c.1879
oil on canvas 81.4 x 111.8
FA000381

Lessore, Thérèse 1884–1945
The New Cap
oil on canvas 51.0 x 60.7
FA000401

Liberti, O. 19th C
Copy of a Wall Painting from Pompeii
oil on canvas 47.0 x 36.7
FA000887

Liberti, O. 19th C
Copy of a Wall Painting from Pompeii
oil on canvas 47.0 x 36.7
FA000888

Lievens, Jan 1607–1674
The Raising of Lazarus 1631
oil on canvas 107.0 x 114.3
FA000001

Linnell, James Thomas 1826–1905
Driving Sheep: A View from Reigate 1863
oil on canvas 42 x 62
FA000057

Linnell, John 1792–1882
Woody Landscape 1824
oil on wood panel 24.7 x 32.2
FA000056

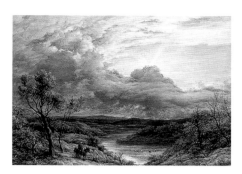

Linnell, John 1792–1882
Sun behind Clouds 1874
oil on canvas 74 x 100
FA000367

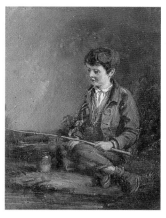

Linnell, John 1792–1882
Boy Fishing
oil on wood panel 25.0 x 19.5
FA000480 🐝

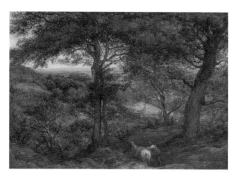

Linnell, John 1792–1882
Woody Landscape
oil on board 46.5 x 61.5
FA000666

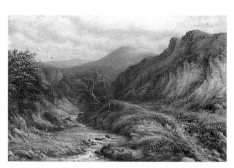

Linnell, Mrs James Thomas 1826–1905
Mountain Track 1899
oil on canvas 26.0 x 36.3
FA000415

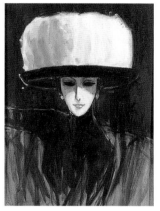

Little, Roy
Girl in a Swansdown Hat c.1955
oil on canvas 40.8 x 30.7
FA000279

Liverton, Lysbeth b.1942
Camber Sands 1965
oil on canvas 71 x 92
FA000676

Lloyd, Elizabeth Jane 1928–1995
Blackberries and Sunflowers c.1960
oil on board 61.5 x 122.5
FA000870 🐝

Lomi, Giovanni 1889–1969
Towards the Sunset c.1925
oil on canvas 63.2 x 74.9
FA000318

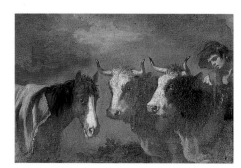

Londonio, Francesco 1723–1783
Cattle and Shepherd
oil on canvas 30.8 x 44.0
FA000429

Facing page: Barrett, Jerry, 1814–1906, *Sheridan Assisting Miss Linley on Her Flight from Bath* (detail), Brighton and Hove Museums and Art Galleries, (p. 17)

141

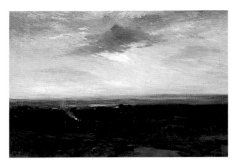

Longhurst, Joseph 1874–1922
The Pilgrims' Way
oil on canvas 30.5 x 40.7
FA000625

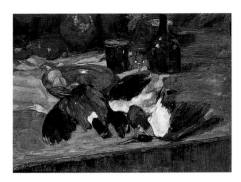

Looy, Jacobus van 1882–1971
Lapwings
oil on canvas 70.0 x 90.5
FA000271

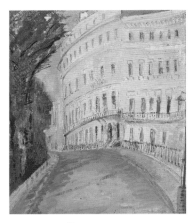

Lucas, Caroline Byng c.1886–1967
Adelaide Crescent, Hove 1952
oil on board 35.5 x 30.5
FA000424

Lucas, Caroline Byng c.1886–1967
Welsh Landscape (Brondanw, Merioneth)
oil on canvas 30.5 x 38.1
FA000448

Lyttleton, Westcott Witchurch Lewis
1818–1879/1886
Off Southampton
oil on canvas 45 x 60
FAPM090032

Machard, Jules Louis 1839–1900
Mrs Gilbert Farquhuar Davidson 1873
oil on canvas 136.0 x 100.5
FAH1955.128

Maclise, Daniel 1806–1870
Sacrifice of Abel
oil on canvas 68.3 x 54.0
FA000548

Macquoid, Percy 1852–1925
Theresa Isa Dent 1883
oil on canvas 76 x 59
FAPM090091

MacWhirter, John 1839–1911
Florence from San Miniato al Monte
oil on canvas 52.4 x 95.3
FA000393

Madrazo y Garreta, Ricardo de 1852–1917
Girl with a Flute
oil on wood panel 30.5 x 17.8
FA000523

Maes, Nicolaes 1634–1693
A Young Boy with His Dog in a Landscape 1662
oil on panel 36.8 x 45.7
FA000004

Maidment, Thomas b.1871
Farm Scene, St Ives 1932
oil on canvas 56 x 76
FA000988

Manfredi, Bartolomeo c.1582–1622
Soldiers Playing Trik-Trak
oil on canvas 56.0 x 49.3
FA000186

Mangeant, Paul Emile b.1868
Young French Girl 1902
oil on canvas 47.0 x 38.2
FA000655

Manson, James Bolivar 1879–1945
Breezy Day, Sussex c.1935
oil on canvas 51.0 x 61.2
FA000354

Manson, James Bolivar 1879–1945
Evening, Martigues (Bouche-sur-Rhone) c.1935
oil on wood panel 35.8 x 45.7
FA000355

Marquis, James Richard active 1853–1885
St Mary's Harbour, Scilly Isles
oil on canvas 35.8 x 60.9
FA000204

Martin, Nicholas b.1957
The Royal Pavilion 1983
emulsion on canvas 118 x 259
FA000853

Mason, Arnold 1885–1963
Quai du port, Martigues 1925
oil on canvas 38 x 46
FA000499

Mason, Arnold 1885–1963
Seated Nude 1937
oil on canvas 75.9 x 61.1
FA000274

Mears, George 1826–1906
Beach Scene at Rottingdean c.1870–1890
oil on canvas 44.0 x 75.5
FAH1975.7

Mears, George 1826–1906
The Chain Pier 1901
oil on board 25.3 x 35.4
FA001128

Meninsky, Bernard 1891–1950
Boy with a Cat 1925
oil on canvas 123.5 x 55.5
FAH1977.1

Meninisky, Bernard 1891–1950
Young Girl: Nude Study
oil on canvas 110.9 x 65.9
FA000163

Menzies, William A. active 1886–1911
Louisa, Viscountess Wolseley
oil on canvas 61.1 x 50.4
FAH1960.353

Merry, Godfrey active c.1883–1915
'Dinna Ye Hear the Pipes?' c.1910
oil on canvas 92 x 125
FA000969

Merry, Godfrey active c.1883–1915
The Late Captain Merry
oil on canvas 44.5 x 38.5
FA000661

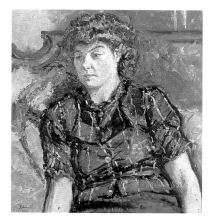

Methuen, Paul Ayshford 1886–1974
Margaret Ware c.1943
oil on canvas 69.0 x 64.5
FA000340

Methuen, Paul Ayshford 1886–1974
*Pulteney Bridge, Bath, under
Reconstruction* c.1951
oil on board 33.0 x 49.5
FA000656

Methuen, Paul Ayshford 1886–1974
North Wraxall, Wiltshire c.1955–1956
oil on canvas 102.2 x 76.3
FA000379

Methuen, Paul Ayshford 1886–1974
West Kington, Wiltshire c.1955–1956
oil on canvas 102.0 x 76.5
FA000148

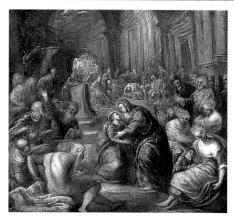

Michieli, Andrea
probably 1542–probably 1617
*Jesus Returning to His Mother after
Confounding the Elders in the Temple* c.1604
oil on canvas 90 x 90
FA000080

Mileham, Harry Robert 1873–1957
Miss Amy Scott 1945
oil on canvas 33 x 25
FAH1946.46

Mileham, Harry Robert 1873–1957
In the Mirror 1946
oil on canvas 61 x 51
FAH1946.118

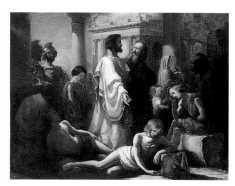

Millais, John Everett 1829–1896
Non angli sed angeli
oil on canvas 106.8 x 133.3
FAH1945.47

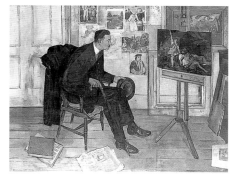

Minton, John 1917–1957
Neville Wallis 1952
oil on canvas 122.0 x 154.5
FA000353

Mockford, Harold b.1932
Bracken Hill 1961
oil on board 125.5 x 124.5
FAH1977.24

Mockford, Harold b.1932
Gateway to the Downs 1968
oil on board 89.5 x 120.5
FAH1977.23

Mockford, Harold b.1932
The Park 1974
oil on board 121.0 x 89.5
FAH1978.10

Mockford, Harold b.1932
The Bridge, Hailsham 1975
oil on board 93 x 240
FAH1977.26

Mockford, Harold b.1932
The Bandstand c.1975
oil on board 90 x 120
FAH1980.12

Moira, Gerald 1867–1959
The Sketching Party 1932
oil on board 63.5 x 75.5
FA000176

Molenaer, Jan Miense (after) c.1610–1668
Tavern Scene
oil on wood panel 23 x 30
FA000524

Molyneux, Maud active 1927–1936
Peter
oil on canvas 48.5 x 38.5
FAPM090064

Momper, Joos de the younger (attributed to)
1564–1635
Winter Scene
oil on canvas 136 x 107
FAPM090041

Monamy, Peter 1681–1749
Man of War
oil on canvas 87.0 x 100.3
FA000235

Monnoyer, Jean-Baptiste 1636–1699
Flower Study
oil on canvas 83.6
FA000154

**Monticelli, Adolphe Joseph Thomas
(attributed to)** 1824–1886
Women in a Landscape
oil on wood panel 44.0 x 61.2
FA000286

Mor, Antonis (attributed to)
1512–1516–c.1576
Portrait of a Man ('Memento Mori')
oil on wood panel 96.6 x 65.4
FA000377

Morland, George 1763–1804
Selling Carrots 1795
oil on canvas 76.0 x 63.5
FA000715

Morley, Harry 1881–1943
The Judgement of Paris 1929
oil & tempera on canvas 127 x 105
FA001004

Morley, Julia b.1917
Palace Pier, Brighton c.1947
oil on canvas 87.6 x 161.5
FA000291

Moroni, Giovanni Battista (attributed to)
c.1525–1578
Portrait of a Senator
oil on wood panel 63.5 x 51.0
FA000156

Morris, Charles Alfred 1898–1983
Old Town Hall, Worthing 1934
oil on canvas 61.0 x 70.8
FA000287

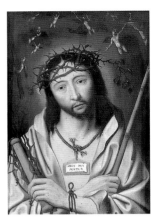

Moss, Sidney Dennant 1884–1946
Adelaide Crescent, Brighton 1937
oil on canvas 54.5 x 76.2
FA000147

Mostaert, Jan (attributed to)
c.1475–1555/1556
Christ Crowned with Thorns ('Ecce Homo') c.1525
oil on wood panel 47.0 x 33.5
FA000062

Moynihan, Rodrigo 1910–1990
Self Portrait 1938
oil on canvas 46.3 x 36.0
FA000285

Müller, William James 1812–1845
A Street in Cairo 1840
oil on wood panel 38.1 x 27.0
FA000054

Müller, William James 1812–1845
Slave Market 1841
oil on wood panel 33.0 x 25.4
FA000013

Müller, William James 1812–1845
The Opium Seller
oil on wood panel 38.2 x 26.4
FA000546

Müller, William James 1812–1845
Welsh Scene
oil on canvas 34.0 x 45.5
FA000852

Munnings, Alfred James 1878–1959
The Shady Grove 1910
oil on canvas 63.5 x 76.2
FA000177

Munnings, Alfred James 1878–1959
Landscape with Cow 1912
oil on canvas 34.5 x 45.0
FAH1945.163

Murray, Graham 20th C
Failford Bridge
oil on board 40.8 x 25.7
FA000455

Napper, John b.1916
Chantry Mill Pond 1950
oil on canvas 30.7 x 40.7
FA000435

Nash, Frederick 1782–1856
Shoreham Harbour 1835
oil on panel 47.0 x 68.2
FA001051

Nash, Paul 1889–1946
Granary 1922–1923
oil on canvas 75 x 62
FAH1993.13

Nash, Thomas Saunders 1891–1968
Figures in a Park 1927
oil on card 24.5 x 34.9
FA000162

Nasmyth, Alexander 1758–1840
Wooded Landscape
oil on canvas 21.5 x 27.0
FAPM090025

Nasmyth, Patrick 1787–1831
Landscape with River and Cottage 1828
oil on panel 29.8 x 40.2
FA000549

Nasmyth, Patrick 1787–1831
Landscape
oil on panel 22.5 x 30.5
FA000630

Nasmyth, Patrick 1787–1831
Landscape
oil on canvas 36.1 x 44.9
FA001244

Neeffs, Peeter the elder (school of)
c.1578–1656–1661
Interior of a Church
oil on wood panel 23.2 x 19.3
FA000223

Neer, Aert van der 1603–1677
Skating on a Frozen River c.1660
oil on canvas 37.3 x 48.4
FA000003

Nevinson, Christopher 1889–1946
French Landscape c.1940
oil on canvas 30.5 x 45.8
FA000411

Newman, Ian b.1953
Still Life 1982
oil on canvas 95.5 x 70.5
FAH1982.19

Newton, Algernon Cecil 1880–1968
Paddington Basin 1925
oil on canvas 98 x 135
FA000716

Nibbs, Richard Henry 1816–1893
Queen Victoria Landing at Brighton 1843
oil on canvas 107.0 x 183.5
FA000133

Nibbs, Richard Henry 1816–1893
'HMS Vengeance' at Spithead 1851
oil on canvas 61 x 112
FA000727

Nibbs, Richard Henry 1816–1893
Seaford Head, Sussex 1872
oil on canvas 61 x 51
FA001184

Nibbs, Richard Henry 1816–1893
Stanmer Park 1874
oil on canvas 61.2 x 91.6
FA000383

Facing page: Bratby, John Randall, 1928–1992, *John with Two Pattis, Beauport Park, Hastings* (detail), 1990, Hastings Museum and Art Gallery, (p. 292)

Nibbs, Richard Henry 1816–1893
Guildhall 1878
oil on canvas 45.6 x 61.0
FA000950

Nibbs, Richard Henry 1816–1893
Cloisters, Canterbury Cathedral 1884
oil on canvas 71.9 x 122.9
FA000380

Nibbs, Richard Henry 1816–1893
*Dutch Boats Leaving Harbour in a
Breeze* 1884
oil on canvas 51 x 76
FA000912

Nibbs, Richard Henry 1816–1893
Shoreham 1887
oil on canvas 25.4 x 20.1
FA000482

Nibbs, Richard Henry 1816–1893
Shipping on the Medway 1890
oil on canvas 61.0 x 91.5
FA001185

Nibbs, Richard Henry 1816–1893
Climping Church
oil on canvas 50.5 x 76.0
FA000803

Nibbs, Richard Henry 1816–1893
Cross Channel Steamer 'Belfast' off Brighton
oil on canvas 40.7 x 55.8
FA000449

Nibbs, Richard Henry 1816–1893
Frederic Chatfield
oil on canvas 76.0 x 63.5
FA000831

Nibbs, Richard Henry 1816–1893
Martello Tower
oil on canvas 101 x 184
FA000936

Nibbs, Richard Henry 1816–1893
Near Lancing, Sussex
oil on canvas 38.0 x 76.2
FA000505

Nibbs, Richard Henry 1816–1893
Near Midhurst, Sussex
oil on canvas 38.0 x 76.2
FA000506

Nibbs, Richard Henry 1816–1893
Old Drawbridge on the Ouse at Barcombe
oil on canvas 61 x 122
FA000858

Nibbs, Richard Henry 1816–1893
Old Grammar School, Steyning
oil on canvas 34.5 x 47.2
FA000562

Nibbs, Richard Henry 1816–1893
Ote Hall, Wivelsfield
oil on canvas 61 x 51
FA000699

Nibbs, Richard Henry 1816–1893
St Mary's Chichester
oil on panel 17.5 x 23.0
FA000515

Nibbs, Richard Henry 1816–1893
The Crypt at Eastbourne
oil on canvas 15.2 x 20.3
FA000522

Nicholls, Bertram 1883–1974
Riverside Town 1926
oil on canvas 48.0 x 53.5
FA000402

Nicholson, Ben 1894–1982
Cumberland Farm 1930
oil on canvas 38.5 x 43.0
FA001170

Nicholson, Winifred 1893–1981
Still Life by a Window c.1927
oil on canvas 88.9 x 71.1
FAH1988.135

Niemann, Edmund John 1813–1876
Woody Lane 1856
oil on board 45.5 x 35.3
FA000558

Niemann, Edmund John 1813–1876
Richmond, Yorkshire
oil on canvas 64.1 x 147.0
FA001138

Nolan, Sidney 1917–1992
Landscape 1967
mixed media on paper 52 x 76
FA000576

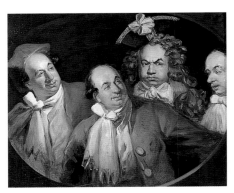

Northcote, James 1746–1831
John Reeve as 'Henry Alias' in 'One, Two, Three, Four, Five' c.1829
oil on canvas 51 x 61
FA000155

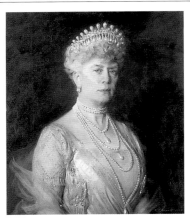

Nowell, Arthur Trevethin 1861–1940
Queen Mary 1935
oil on canvas 76.5 x 63.5
FA000408

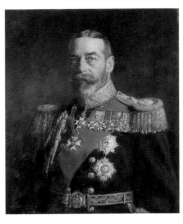

Nowell, Arthur Trevethin 1861–1940
King George V c.1935
oil on canvas 76.5 x 63.5
FA000312

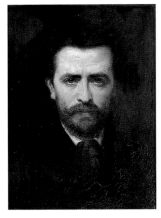

Oakes, Frederick active 1866–1870
Portrait of the Artist 1867
oil on canvas 46.5 x 33.6
FAH1949.65

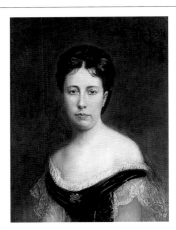

Oakes, Frederick active 1866–1870
Selena Oakes 1870
oil on canvas 60.5 x 46.2
FAH1949.64

Oakley, Thornton 1881–1953
Old and New Brighton c.1951
oil on panel 35.3 x 45.5
FA000451

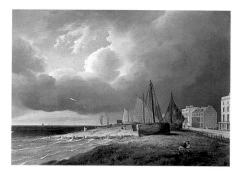

O'Connor, James Arthur 1792–1841
Worthing Beach 1827
oil on canvas 22.5 x 30.5
FA000538

O'Connor, James Arthur (attributed to)
1792–1841
Landscape
oil on canvas 20 x 26
FA000893

Olitski, Jules b.1922
Open Option 1971
acrylic on canvas 260 x 210
FA001144

Opie, John 1761–1807
Mrs Mary Chatfield c.1795
oil on canvas 76.7 x 63.5
FA000030

Organ, Robert b.1933
Portraits and Self Portraits, the Uffculme Children 1982/1983
oil on canvas 60 x 60
FAH1984.5

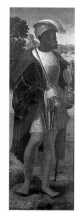

Orley, Bernaert van (attributed to)
c.1492–1541
Balthazar 1525
oil on canvas 93.8 x 32.2
FA000099

Orpen, William 1878–1931
Sir Charles Thomas-Stanford 1913
oil on canvas 114 x 90
FAPM090048

Orrente, Pedro (style of) c.1580–1645
St John the Baptist as a Child c.1630
oil on canvas 50.7 x 41.2
FA000059

Os, Georgius Jacobus Johnannes van
1782–1861
Vase of Flowers
oil on canvas 68.3 x 50.2
FAPM090011

Osborne, Cecil 1909–1996
Sunday Morning, Farringdon Road 1929
oil on canvas 30.3 x 45.5
FA000463

Owen, Samuel 1768–1857
Windmill and Brick Kiln on Riverside
oil on wood panel 15.4 x 22.0
FA000514

Owen, William 1769–1825
Portrait of an Old Lady
oil on canvas mounted on board 61.0 x 50.8
FAH1934.67

Padwick, Philip Hugh 1876–1958
Sussex Hills c.1928
oil on canvas 61.0 x 91.5
FA000368

Padwick, Philip Hugh 1876–1958
Bridge at Arundel
oil on board 31 x 41
FAH1959.30

Padwick, Philip Hugh 1876–1958
Quayside at Low Tide
oil on board 31.5 x 41.2
FAH1959.28

Padwick, Philip Hugh 1876–1958
The Sussex Weald
oil on canvas mounted on board 42.8 x 60.7
FAH1937.19

Padwick, Philip Hugh 1876–1958
View near Pulborough
oil on canvas 60.5 x 91.1
FA000361

Pagano, Michele c.1697–1732
Landscape with Ruinous House
oil on canvas 38.8 x 72.7
FA000443

Pagano, Michele c.1697–1732
Rocky Landscape
oil on canvas 38.8 x 72.7
FA000444

Panini, Giovanni Paolo (attributed to)
c.1692–1765
The Forum, Rome
oil on canvas 45.0 x 73.5
FAH1934.59

Parez, Joseph active 1823–1836
Sir David Scott 1836
oil on board 27.7 x 22.8
FA001095

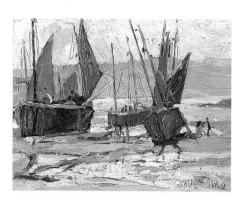

Park, John Anthony 1880–1962
Fishing Boats on the Sands
oil on board 19.6 x 24.4
FAH1945.161

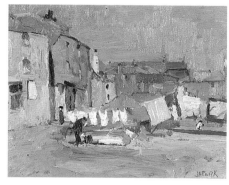

Park, John Anthony 1880–1962
Monday Morning
oil on board 18.5 x 23.5
FAH1945.160

Parkin, Molly b.1932
New York, Evening 1964
oil on canvas 127.0 x 125.5
FA000609

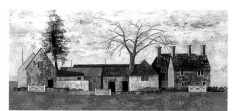

Parkinson, Gerald b.1926
English Farm 1959
oil on hardboard 61 x 122
FA001200

Parrott, William 1813–after 1875
The Negro Boat Builder c.1850
oil on wood panel 33.7 x 39.2
FA000118

Parsons, Arthur Wilde 1854–1931
Queen Elizabeth Passing down the Avon in 1574 1915
oil on canvas 40.6 x 61.0
FA000882

Paterson, Emily Murray 1855–1934
Cortile, Doge's Palace
oil on wood panel 27.0 x 34.9
FA000438

Paterson, Emily Murray 1855–1934
Pink Roses
oil on canvas 40.5 x 33.0
FA000682

Patinir, Joachim (attributed to)
c.1480–before 1524
Building the Tower of Babel
oil on wood panel 74.0 x 103.5
FA000011

Paye, Richard Morton 1750–c.1821
Angel
oil on canvas 63.5 x 76.5
FA000985

Paye, Richard Morton 1750–c.1821
Children Playing
oil on canvas 71.2 x 91.5
FA000914

Paye, Richard Morton 1750–c.1821
Girl with Her Hands Folded
oil on canvas 76.3 x 62.7
FA000143

Paynter, David 1900–1975
L'après-midi c.1935
oil on canvas 99.0 x 122.0
FA000164

Pearson, Mary Martha 1799–1871
Mrs Otho Manners
oil on canvas 127 x 101
FA000707

Pellegrini, Giovanni Antonio 1675–1741
Philip of Macedonia Checking the Anger of Alexander
oil on canvas 47.6 x 37.5
FA000007

Penley, Aaron Edwin 1807–1870
Aldrington Basin c.1850
oil on card 25.4 x 35.0
FAH1930.7

Penley, Aaron Edwin 1807–1870
The Music Room, Royal Pavilion: The Grand Re-Opening Ball 1851
oil on canvas 63.5 x 84.1
FA000389

Peploe, Samuel John 1871–1935
The Yellow Jug c.1930
oil on canvas 46.2 x 41.0
FA000441

Pether, Abraham 1756–1812
The Shepherd 1805
oil on canvas 62 x 75
FAH1948.64

Pether, Abraham 1756–1812
Moonlit Landscape with River
oil on wood panel 15.2 x 19.0
FAH1957.42

Pether, Abraham 1756–1812
Moonlit Scene
oil on canvas 59 x 71
FAPM090033

Pether, Henry (style of) active 1828–1865
Moonlit Landscape
oil on canvas 63.5 x 76.3
FA000567

Pether, Henry (style of) active 1828–1865
Moonlit Scene
oil on canvas mounted on board 45.5 x 61.0
FA001203

Pether, Henry (style of) active 1828–1865
Moonlit Scene
oil on canvas mounted on board 45.0 x 60.5
FA001204

Philipson, Robin 1916–1992
Altar II 1971
oil on canvas 91 x 91
FAH1983.9

Phillip, John 1817–1867
The Fortune Teller 1851
oil on wood panel 38.5 x 56.1
FA000051

Phillip, John 1817–1867
In the Garden, Seville 1862
oil on canvas 56.0 x 46.8
FA000041

Phillip, John 1817–1867
Breakfast in the Highlands 1865
oil on wood panel 36.0 x 25.7
FA000636

Phillips, Thomas 1770–1845
Mr Barratt 1810
oil on canvas 140 x 102
FA000970

Philpot, Glyn Warren 1884–1937
*Mrs Basil Fothergill and Her Two
Daughters* c.1911
oil on canvas 198 x 137
FA000651

Philpot, Glyn Warren 1884–1937
Journey of the Spirit 1921
oil on canvas 197 x 243
FA000423

Philpot, Glyn Warren 1884–1937
The Angel of the Annunciation 1925
oil on canvas 112.0 x 87.1
FA000388

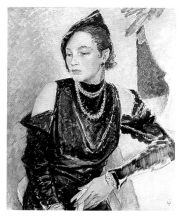

Philpot, Glyn Warren 1884–1937
Miss Gwendoline Cleaver 1933
oil on canvas 73.0 x 60.5
FA001165

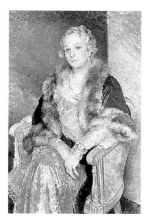

Philpot, Glyn Warren 1884–1937
Mrs Woolmer c.1933–1934
oil on canvas 114.7 x 76.6
FA000540

Philpot, Glyn Warren 1884–1937
Acrobats Waiting to Rehearse 1935
oil on canvas 115.5 x 87.6
FA000091

Philpot, Glyn Warren 1884–1937
Melancholy Negro 1936
oil on canvas 129.5 x 74.2
FA000132

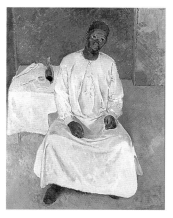

Philpot, Glyn Warren 1884–1937
Negro Thinking of Heaven 1937
oil on canvas 99 x 76
FA000170

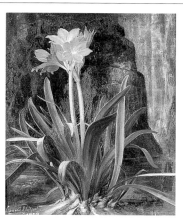

Philpot, Leonard Daniel 1877–1973
The Canyon 1929
oil on canvas 61.5 x 51.0
FA000748

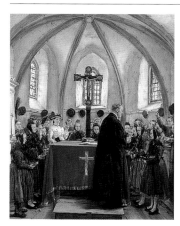

Piltz, Otto 1864–1910
The Sunday School
oil on board 73.3 x 58.6
FAH1931.130

Pine, Robert Edge 1742–1788
Captain William Baillie
oil on canvas 66.5 x 57.2
FAH1933.76

Piper, W. F.
The Evening Meal 1892
oil on canvas 52.3 x 36.8
FA000644

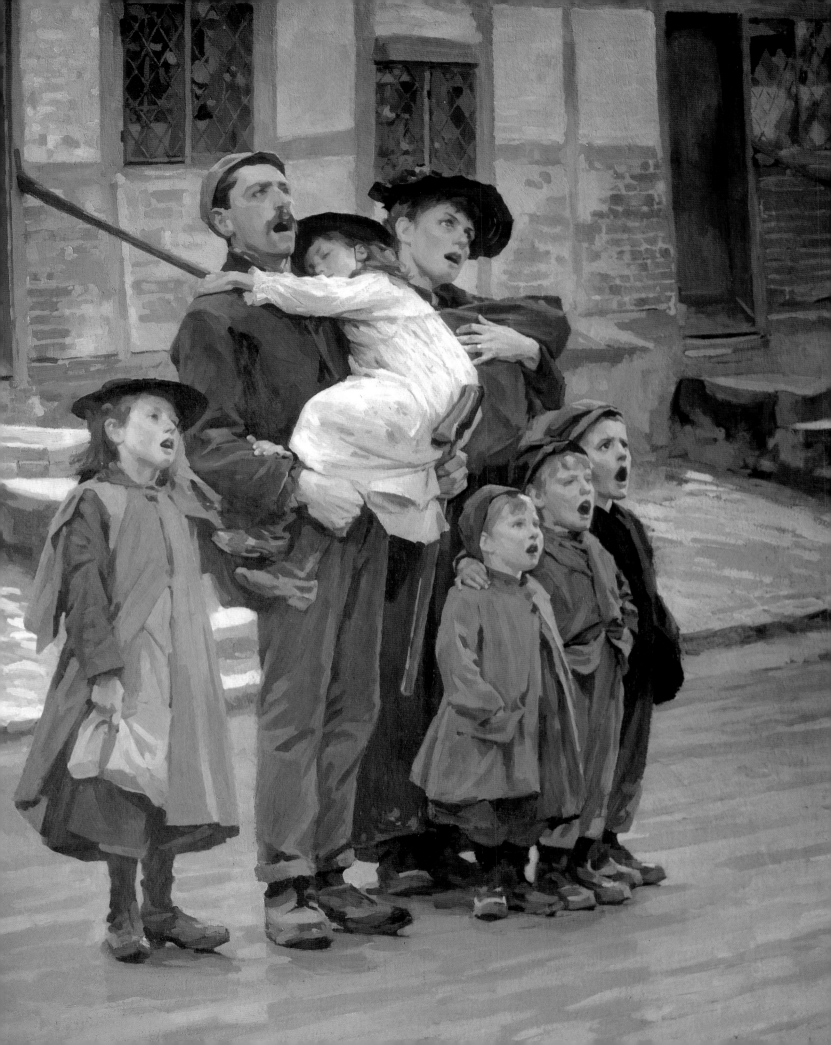

Pissarro, Lucien 1863–1944
The Hills from Hayfield Green 1917
oil on canvas 43.0 x 53.3
FA000167

Pissarro, Lucien 1863–1944
Le Cabanon, le lavandou 1929
oil on canvas 65.0 x 50.2
FA000678

Pitter, H.
Mrs Fitzherbert c.1825
oil on wood panel 25.8 x 22.0
FA000749

**Pittoni, Giovanni Battista the younger
(after)** 1687–1767
Haman, Esther and Ahasuerus c.1750
oil on canvas 76.0 x 63.5
FA000076

Polsoni, Edigio 18th C
Study of Flowers 1712
oil on canvas 66.5 x 51.2
FA000509

Poons, Larry b.1937
Untitled (78–C–3) 1978
acrylic on canvas 230 x 144
FA001143

Poulson, Ivy Napangardi b.1959
Pikilyi Dreaming (Pikilyi Jukurrpa) 1995
acrylic on canvas 97 x 49
WA507230

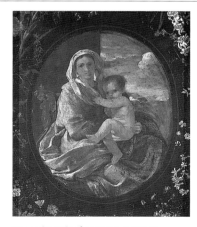

Poussin, Nicolas 1594–1665 **&
Seghers, Daniel** 1590–1661
*Virgin and Child in a Garland of
Flowers* 1625–1627
oil on canvas 57.5 x 48.5
FAPM090001

Poynter, Edward John 1836–1919
On the Temple Steps 1890
oil on canvas 36.5 x 22.0
FA000036

Facing page: King, Gunning, 1859–1940, *Carol Singers* (detail), Brighton and Hove Museums and Art Galleries, (p. 120)

Preston, Lawrence 1883–1960
Newhaven Bridge
oil on canvas 38.6 x 52.5
FAH1960.359

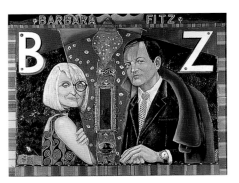

Price, Chris b.1947
Barbara and Fitz 1975–1994
oil & mixed media on panel 94 x 124
FA001172

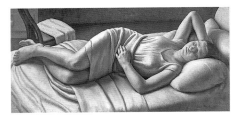

Procter, Dod 1892–1972
Early Morning 1927
oil on canvas 51.4 x 101.6
FAH1978.13

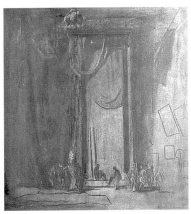

Pryde, James 1869–1941
Death of the Great Bed c.1920
oil on canvas 167.0 x 154.9
FA000653

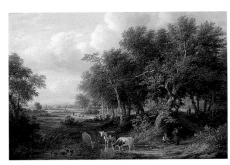

Puller, John Anthony active c.1821–1866
Landscape
oil on canvas 45.0 x 60.5
FAPM090029

Puyl, Gerard van der 1750–1824
George IV
oil on canvas 91.5 x 54.0
FAH1936.32

Pyne, James Baker 1800–1870
Valle Crucis Abbey, North Wales 1839
oil on wood panel 54.7 x 60.5
FA000201

Pyne, James Baker 1800–1870
Shoreham, Sussex
oil on wood panel 37.7 x 38.7
FA000219

Ranken, William Bruce Ellis 1881–1941
A Venetian Gala 1907
oil on canvas 91.5 x 71.7
FA000587

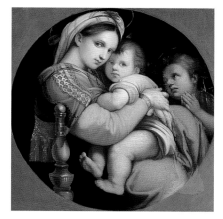

Raphael (after) 1483–1520
Madonna della sedia 19th C
oil on canvas 74.7
FA000196

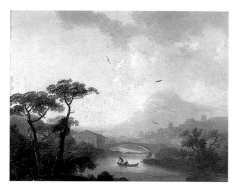

Rathbone 19th C
River Scene
oil on canvas 45 x 55
FA000868

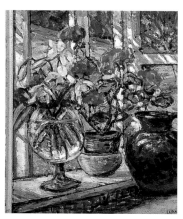

Rawlins, Ethel Louise active c.1900–1962
Geraniums
oil on board 61.0 x 50.5
FA000282

Rayner, F. 19th C
An Old Baronial Hall
oil on canvas 55.2 x 70.8
FA000697

Rea (née Halford), Constance active
1891–1925
Ladies of Quality c.1910–1912
oil on canvas 88.0 x 93.2
FA000363

Redpath, Anne 1895–1965
Cups and Saucers 1949
oil on wood panel 68.6 x 83.8
FAH1984.47

Redpath, Anne 1895–1965
Venetian Altarpiece c.1963
oil on board 76.2 x 63.5
FAH1981.10

Reeve, James b.1939
Bevis Hillier 1971
oil on canvas 137 x 137
FA001134

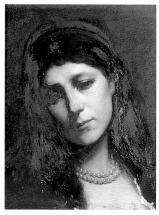

Regnault, Henri 1843–1871
Study for the Head of Salome c.1870
oil on canvas 40.2 x 31.5
FAPM090010

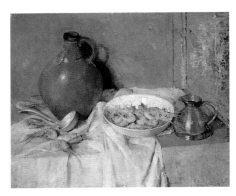

Remington, Mary b.1910
Still Life with Prawns c.1959
oil on canvas 63.5 x 76.0
FA000684

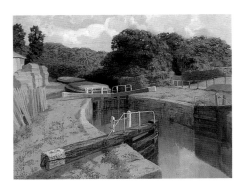

Rendle, Morgan 1889–1952
The Timber Lock, Rickmansworth
oil on canvas 56.0 x 71.2
FAH1961.102

Revilliod, Daniel
Dieppe c.1965
oil on canvas 54.3 x 73.0
FA000281

Reynolds, Alan b.1926
The Night Fair c.1954
oil on canvas laid on board 54.0 x 74.5
FAH1988.92

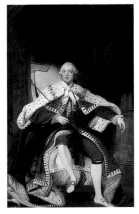

Reynolds, Joshua (after) 1723–1792
George III c.1765
oil on canvas 236.1 x 175.3
FA000743

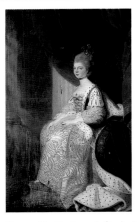

Reynolds, Joshua (after) 1723–1792
Queen Charlotte c.1765
oil on canvas 236.1 x 175.3
FA000744

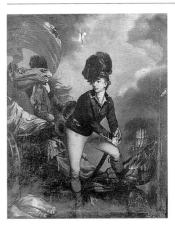

Reynolds, Joshua (after) 1723–1792
Colonel Tarleton 1795
oil on canvas 96.0 x 71.1
FA000174

Reynolds, Joshua (after) 1723–1792
Head of a Boy
oil on canvas 44.7 x 36.9
FA000430

Reynolds, Joshua (after) 1723–1792
Lady Fitzpatrick as 'Sylvia'
oil on canvas 44.5 x 35.7
FA000431

Reynolds, Joshua (after) 1723–1792
Robinetta
oil on canvas 72.6 x 57.0
FA000568

Richmond, William Blake 1842–1921
Adam and Eve Expelled from Eden c.1876
oil on canvas 202.5 x 89.9
FA000877

Richter, Herbert Davis 1874–1955
Peonies and Cornflowers c.1927–1928
oil on canvas 76.5 x 63.5
FA000320

Ritchie, John active 1857–1875
*Little Nell and Her Grandfather Leaving
London* 1857
oil on canvas 42.7 x 51.1
FA000040

Riviere, Briton 1840–1920
Endymion
oil on canvas 35.2 x 49.4
FA000257

Riviere, Briton (copy of) 1840–1920
Sympathy
oil on canvas 100 x 79
FAPM090026

Robins, Thomas Sewell 1814–1880
Leutesdorf on the Rhine
oil on canvas 39.5 x 68.0
FA000503

Rogers, Philip Hutchings c.1786–1853
Pevensey Bay 1829
oil on canvas 56.0 x 86.3
FA000667

Romney, George 1734–1802
Thomas Alphonso Hayley as 'Puck' c.1790
oil on canvas 76.1 x 63.5
FA000146

Romney, George (after) 1734–1802
A Veiled Lady
oil on canvas 72.5 x 57.5
FA000663

Romney, George (attributed to) 1734–1802
Mrs Hills
oil on canvas 76.5 x 64.0
FA000808

Rondel, Henri 1857–1919
Portrait of a Young Woman
oil on canvas 62.5 x 48.7
FA000626

Roos, Philipp Peter 1657–1706
Goatherd and Goats
oil on canvas 123 x 172
FA000935

Roper, William
Hove Lawns 1942
oil on canvas 59.5 x 50.5
FA001194

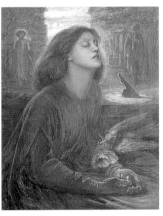

Rossetti, Dante Gabriel (after) 1828–1882
Beata Beatrix
oil on canvas 70.9 x 53.2
FA000543

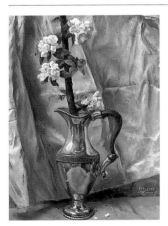

Roussel, Theodore 1847–1926
Grey and Silver
oil on canvas 60.7 x 45.7
FA000581

Royle, Herbert F. 1870–1958
Landscape with Sheep
oil on canvas 51.5 x 61.5
FA000280

Royle, Herbert F. 1870–1958
River and Viaduct
oil on canvas 61.8 x 46.0
FA000288

Rubens, Peter Paul (follower of) 1577–1640
Diana and Her Nymphs Hunting c.1640
oil on wood panel 87.2 x 117.4
FA000005

Ruff, George 1826–1903
Saint Peter's Church, Brighton, from the Level 1850
oil on canvas 49.5 x 70.5
FA000879

Ruff, George 1826–1903
Brighton Beach 1853
oil on canvas 46.3 x 51.0
FA000205

Ruff, George 1826–1903
Saint Peter's Church, Brighton, from the Level, 1845
oil on board 12.2 x 15.2
FA000472

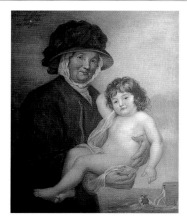

Russell, John 1745–1806
Martha Gunn and the Prince of Wales
oil on canvas 61.4 x 51.2
FA000385

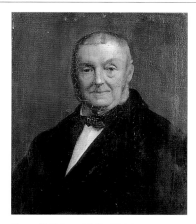

Russell, John 1745–1806
Portrait of a Man
oil on canvas 61.0 x 50.3
FA000833

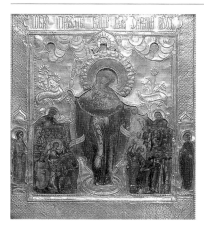

Russian School 17th C
Mater Consolatrix
oil on wood panel 44.5 x 38.3
FA000264

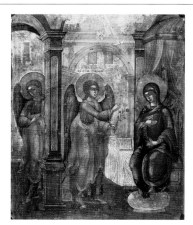

Russian School early 18th C
Annunciation
tempera on panel 36.0 x 26.5
FA001104

Russian School 18th C
Entry into Jerusalem
tempera on panel 29.0 x 23.5
FA001223

Russian School 18th C
Five Saints
tempera on panel 31.5 x 27.0
FA001103

Russian School 18th C
Scenes from the Life of the Virgin Mary
tempera on panel 36 x 27
FA001100

Russian School 18th C
St Simon, St Aviv and St Gurri
tempera on panel 23.0 x 20.7
FA001224

Russian School 18th C
Virgin and Child
tempera on panel 23 x 19
FA001105

Russian School 18th C
Virgin and Child
tempera on panel 21.5 x 18.0
FA001216

Russian School 18th C
Virgin and Child
tempera on panel 22.3 x 17.6
FA001217

Russian School 18th C
Virgin and Child
tempera on panel 21.0 x 18.5
FA001221

Russian School 18th C
Virgin and Child
tempera on panel 20.5 x 18.0
FA001222

Russian School late 18th C
Christ Pantocrator
mixed media on panel 21.5 x 17.5
FA001239

Russian School late 18th C
Dormition of the Virgin
tempera on panel 23 x 21
FA001106

Russian School late 18th C–early 19th C
Holy Trinity
tempera on panel 25.5 x 18.5
FA001107

Russian School late 18th C–early 19th C
Virgin and Child
tempera on panel 27.2 x 21.8
FA001108

Russian School 19th C
Holy Family
tempera on panel 22.3 x 17.6
FA001218

Russian School 19th C
Icon of a Bishop
oil on panel 31.0 x 24.5
FA001220

Russian School 19th C
Icon of St Metrophanes
oil on panel 30.0 x 23.4
FA001219

Russian School 19th C
Nativity
tempera on panel 37 x 30
FA001101

Russian School 19th C
The Ascension of Christ
tempera on panel 23 x 20
FA001215

Russian School 19th C
Virgin and Child
tempera on panel 22.0 x 18.5
FA001102

Rutherston, Albert 1881–1953
The Brook 1907
oil on canvas 59.0 x 49.5
FA000965

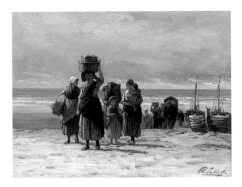

Sadée, Philip Lodewijk Jacob Frederik
1837–1904
Arrival of Fishing Smacks c.1875
oil on wood panel 18.7 x 24.0
FA000047

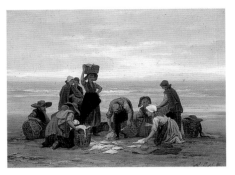

Sadée, Philip Lodewijk Jacob Frederik
1837–1904
Waiting for the Boats c.1875
oil on wood panel 18.7 x 24.0
FA000046

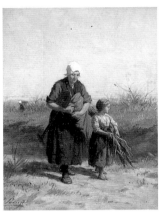

Sadée, Philip Lodewijk Jacob Frederik
1837–1904
Returning from Labour
oil on wood panel 23.2 x 18.8
FA000453

Sajó, Gyula 1918–1989
Chrysanthemums 1959
oil tempera on board 54 x 70
FAH1967.1

Sajó, Gyula 1918–1989
Landscape with Trees 1962
oil tempera on board 21.7 x 51.6
FAH1967.2

Sajó, Gyula 1918–1989
Sussex Landscape 1966
oil on board 64.5 x 90.6
FAH1961.112

Sajó, Gyula 1918–1989
Merchant Ship on Thames
oil tempera on board 62.3 x 83.0
FAH1960.139

Salentin, Hubert 1822–1910
The Foundling 1881
oil on canvas 77 x 104
FAH1931.131

Facing page: Jones, David, 1895–1974, *Madonna and Child in a Landscape* (detail), Ditchling Museum, (p. 218)

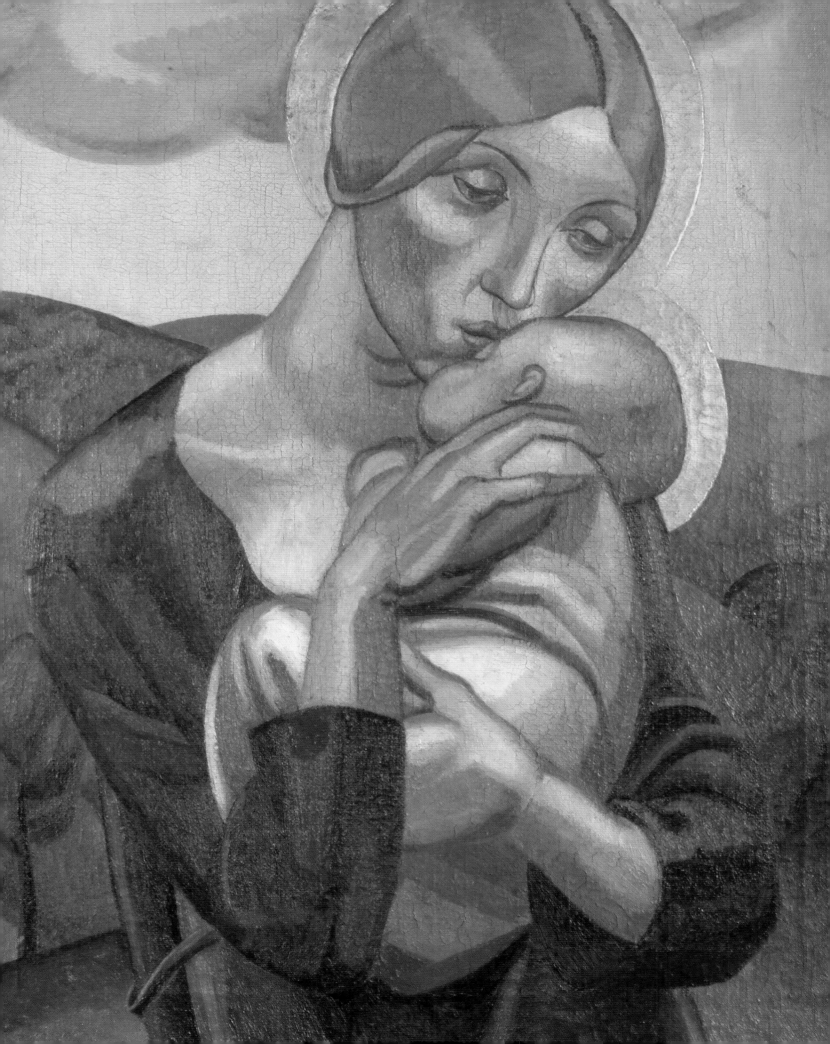

Salisbury, Frank O. 1874–1962
Finding of Moses 1895
oil on canvas 126 x 100
FAPM090068

Salisbury, Frank O. 1874–1962
J. E. Stafford, Mayor of Brighton 1900
oil on canvas 132.5 x 110.2
FA000703

Santoro, Francesco Raffaello b.1844
The Ponte Vecchio, Florence 1888
oil on canvas 75.5 x 135.7
FA000614

Santoro, Francesco Raffaello b.1844
Via Sistina, Rome
oil on canvas 29.4 x 25.0
FA001002

Sassoferrato (after) 1609–1685
The Madonna in Prayer
oil on canvas 74 x 61
FA000188

Saunders, Peter b.1940
Hove Town Hall on Fire 1966
oil on board 59.5 x 88.5
FAH1984.98

Sawyers, Robert 1923–2002
Italian Station Café c.1952
oil on board 122.3 x 91.6
FA000605

Schgoer, Julius 1847–1885
Returning from the War
oil on wood panel 22.7 x 17.9
FA000256

Scott, Amy 1862–1950
Temptation, Study of a Cat with Game Birds
oil on canvas 75 x 93
FAH1953.830

Scott, Edmund 1758–1815
George, Prince of Wales as Grand Master of Freemasons 1800
oil on canvas 143 x 108
FA000572

Scott, William George 1913–1989
Boy and a Birdcage 1947
oil on canvas 78.8 x 86.4
FA000168

Scott-Moore, Elizabeth 1902–1993
Alfred Hayward c.1959–1960
oil on canvas 91 x 71
FA001118

Seabrooke, Elliot 1886–1950
Landscape with Mountains and Lakes 1927
oil on canvas 62 x 74
FAH1956.50

Seabrooke, Elliot 1886–1950
'The Farm' 1928
oil on board 61.0 x 49.5
FAH1931.82

Sears, M. U. (style of) b.c.1800
St Peter's Church c.1830
oil on board 61.8 x 86.2
FA000019

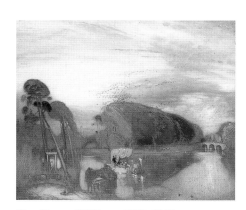

Shackleton, William 1872–1933
Autumn in Parham Park 1904
oil on canvas 76.7 x 86.3
FA000374

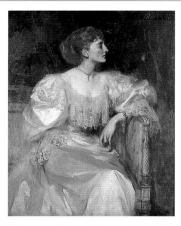

Shannon, James Jebusa 1862–1923
Diana MacDonald 1894
oil on canvas 125 x 98
FAPM090058

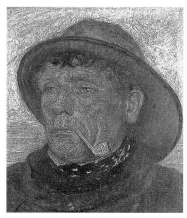

Sharp, George 1802–1877
Well Seasoned
oil on canvas 35.8 x 30.5
FA000660

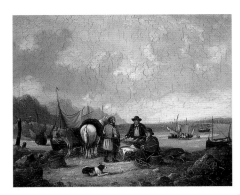

Shayer, William 1788–1879
Fisher Folk by the Sea
oil on canvas 60 x 74
FAPM090031

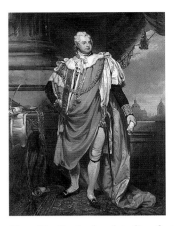

Shee, Martin Archer (studio of) 1769–1850
William, Duke of Clarence
oil on panel 65.8 x 54.0
FA000398

Short, Frank 1857–1945
Exceat Farm and the Cuckmere Valley
oil on canvas 61.3 x 91.8
FA000149

Short, Frank 1857–1945
Newhaven
oil on canvas 62.8 x 93.6
FA000150

Short, Frederik Golden 1863–1936
Heath with Standing Water 1925
oil on board 15.0 x 30.2
FA000826

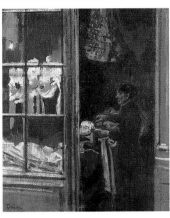

Sickert, Walter Richard 1860–1942
The Laundry Shop, Dieppe 1885
oil on canvas 50.2 x 39.4
FAH1984.48

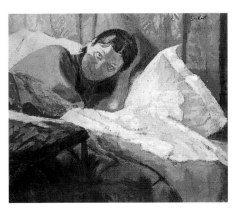

Sickert, Walter Richard 1860–1942
The Hon. Lady Fry c.1935
oil on canvas 113.8 x 127.5
FA000093

Simmons, Michael 20th C
School House, Falmer
oil on board 24.0 x 46.7
FAH1973.4

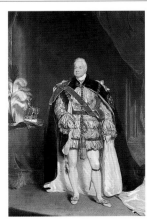

Simpson, John 1782–1847
King William IV 1830
oil on canvas 272.0 x 178.5
FA000797

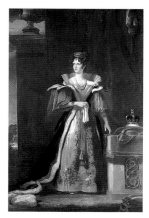

Simpson, John 1782–1847
Queen Adelaide 1832
oil on canvas 272.0 x 178.5
FA000796

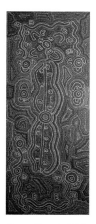

Sims, Bessie Nakamarra b.1932
Possum Dreaming (Janganpa Jukurrpa) 1995
acrylic on canvas 152 x 61
WA507231

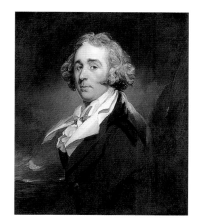

Singleton, Henry 1766–1839
The Second Viscount Maynard c.1794
oil on canvas 74.5 x 62.0
FAH1937.41

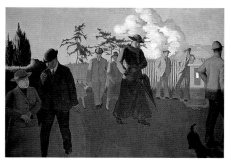

Smith, Alison 20th C
Country Sunday
oil on canvas 61 x 84
FA000586

Smith, George 1714–1776
Landscape with Fishermen c.1750
oil on canvas 23.5 x 31.8
FA000109

Smith, George 1714–1776
Landscape with Boy Fishing
oil on canvas 30.8 x 39.7
FA000836

Smith, George 1714–1776
Landscape with Footbridge
oil on wood panel 31.0 x 44.3
FA000436

Smith, George (attributed) 1714–1776
River Landscape
oil on canvas 30.6 x 40.0
FA000871

Smith, George 1829–1901
Have Some Nuts
oil on canvas 51.2 x 41.3
FA000552

Smith, Jack b.1928
Various Activities, Central and out 1965
oil on canvas 152 x 152
FAH1983.1

Smith, Matthew Arnold Bracy 1879–1959
Femme en chemise c.1928
oil on canvas 76.2 x 63.5
FA000160

Snyders, Frans 1579–1657
Wildfowl
oil on canvas 122 x 152
FAPM090043

Sole, Giovan Gioseffo dal (style of)
1654–1719
Rape of Lucretia c.1690
oil on canvas 37.8 x 27.7
FA000086

Sotherby, John
On the Steine, Brighton 1780
oil on canvas 31.5 x 44.0
FA000987

Spanish School 17th C
Beggar
oil on canvas 53 x 48
FA000958

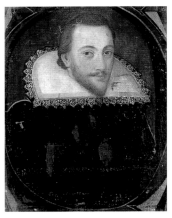

Spanish School
A Gentleman in a Lace Collar c.1750
oil on canvas 61 x 47
FA000528

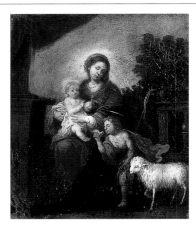

Spanish School 18th C
Holy Family
oil on canvas 28 x 24
FA000527

Spanish School
Seated Figure with Book c.1800
oil on canvas 73.7 x 62.0
FA000142

Spanton, H. Margaret b.1874
Portrait of a Lady in an Interior
oil on canvas 136 x 95
FA000910

Spear, Ruskin 1911–1990
Brighton Beach 1965
oil on board 46.3 x 28.0
FA000306 🐝

Spencer, Gilbert 1893–1979
Boy Holding a Rabbit 1931
oil on canvas 60.1 x 76.5
FAH1982.6 🐝

Spencer, Gilbert 1893–1979
Air Raid Warning 1940
oil on canvas 88.0 x 53.5
FAH1980.5 🐝

Spender, John Humphrey 1910–2005
Staked Rose 1953
oil on canvas 56 x 72
FA000597

Spink
Second Lieutenant Ernest Beal, VC 1919
oil on paper 75.0 x 69.8
FA000635

Stanfield, Clarkson 1793–1867
Teignmouth Harbour
oil on canvas 51.0 x 82.5
FA000566

Stanfield, George Clarkson 1828–1878
Huy on the Meuse, Belgium
oil on canvas 59.3 x 94.9
FA000547

Stark, James 1794–1859
Road through a Forest
oil on wood panel 42.5 x 56.0
FA000202

Steegman, Philip 1903–1952
David Horner 1926
oil on canvas 63.5 x 56.0
FA000734

Steggles, Harold 1911–1971
Wharf Houses c.1930
oil on canvas 39.5 x 46.0
FA000456

Stella, Frank b.1936
Red Scramble 1977
acrylic on canvas 175 x 350
FA001142

Stöcklin, Christian 1741–1795
Church Interior with Figures
oil on canvas 33.5 x 24.0
FA000686

Storck, Abraham 1644–1708
Seascape with Boats
oil on panel 13.3 x 17.3
FA000896

Storck, Abraham (attributed to) 1644–1708
Harbour Scene
oil on canvas 93.4 x 120.0
FA000153

Story, Julian Russell 1857–1919
The Hon. Frances Wolseley 1884
oil on canvas 58 x 43
FAH1967.13

Stothard, Thomas 1755–1834
Diana Sleeping
oil on panel 39.4 x 52.4
FA000221

Stroudley, James 1906–1985
Telscombe Beach c.1962
oil on board 74.5 x 121.0
FA000923

Stubbs, George (after) 1724–1806
Shooting c.1769
oil on canvas 100.3 x 126.0
FA000008

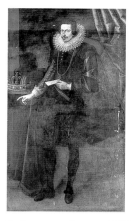

Suttermans, Justus 1597–1681
Duke of Tuscany
oil on canvas 204.5 x 115.5
FA000720

Sutton, R. Fran b.1912
Brentford 1955
oil on board 30.2 x 40.4
FA000477

Swanevelt, Herman van c.1600–1665
Landscape with Figures of Tobias and the Angel
oil on wood panel 31.4 x 42.6
FA000742

Swynnerton, Annie Louisa 1844–1933
Girl with a Lamb
oil on canvas 66.5 x 56.0
FA000310

Taylor, Walter 1860–1943
*Two Figures in an Interior in Brunswick
Square* c.1925
oil on canvas 63.5 x 76.2
FAH1995.43

Teniers, David II (after) 1610–1690
Hearing
oil on wood panel 20.0 x 16.5
FA000520

Teniers, David II (after) 1610–1690
Sight
oil on wood panel 20.0 x 16.5
FA000519

Teniers, David II (after) 1610–1690
Smell
oil on wood panel 20.0 x 16.5
FA000517

Teniers, David II (after) 1610–1690
Taste
oil on wood panel 20.0 x 16.5
FA000521

Teniers, David II (after) 1610–1690
Touch
oil on wood panel 20.0 x 16.5
FA000518

Thomson, Alfred Reginald 1894–1979
Mrs Vivienne Hilliard 1934
oil on canvas 89.0 x 73.5
FA001034

Thorbjornsen, Simon 1879–1951
Thorshov 1911
oil on canvas 85.5 x 97.2
FA000371

Thornhill, James 1675–1734
Olympian Scene c.1720
oil on canvas 51.3 x 26.3
FA000214

Tintoretto, Domenico (after) 1560–1635
Crucifixion
oil on wood panel 91.5 x 155.5
FA000397

Todd, Arthur Ralph Middleton 1891–1966
The Artist's Mother 1938
oil on canvas 61.1 x 51.2
FA000580

Toorenvliet, Jacob c.1635–1719
The Dentist c.1690
oil on copper 31.7 x 24.7
FA000114

Torrance, James 1859–1916
Primrose Hill 1897
oil on canvas 30.5 x 23.1
FA000452

Trangmar, T.
Old Unicorn Inn, North Street 1893
oil on canvas 35.8 x 53.7
FA000559

Travis, Walter 1888–1962
Mayor Ernest Marsh c.1949
oil on canvas 76 x 63
FA001169

Tryon, Wyndham J. 1883–1942
Spanish Landscape c.1911–1914
oil on canvas 64.4 x 95.2
FA000594

Tuke, Henry Scott 1858–1929
Miss Muriel Lubbock 1898
oil on canvas 127.5 x 95.0
FA000710

Tuson, George E. c.1820–1880
Sir John Cordy Burrows, Mayor of Brighton 1864
oil on canvas 239.0 x 146.7
FA001179

Tyler, Philip b.1964
Daedalus Weeps 1995
oil on canvas 58.3 x 58.3
FAH1995.108

Tyler, Philip b.1964
Shadow Dreams 1995
oil on paper 70 x 70
FAH1995.110

Tyler, Philip b.1964
Wrestlers
oil on canvas 32.6 x 32.6
FAH1995.109

unknown artist
Nativity c.1790
oil on canvas 144.5 x 199.0
FA000865

unknown artist 18th C
Saint
oil on canvas 93.0 x 73.5
FA000938

C. V. 19th C
Busy Bee Boat at Shoreham
oil on canvas 30.5 x 46.0
FA000925

Velde, Esaias van de I 1587–1630
A Boat Moored before a Walled Farm 1623
oil on wood panel 29.2 x 49.0
FA000107

Velde, Esaias van de I (circle of) 1587–1630
English Men-O'-War near the Coast
oil on canvas 62 x 77
FAPM090067

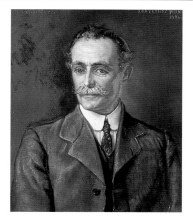

Verner, Ida 1850–1937
J. W. Lister, Borough Librarian and Curator c.1922
oil on canvas 59.5 x 48.5
FAH1922.5

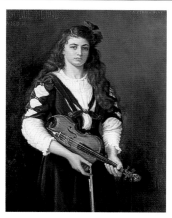

Verner, Ida 1850–1937
Isolde Menges
oil on canvas 111.0 x 85.5
FAH1951.163

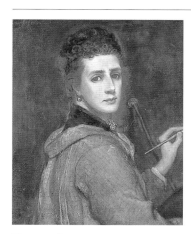

Verner, Ida 1850–1937
Self Portrait
oil on canvas 59.7 x 49.5
FAH1951.164

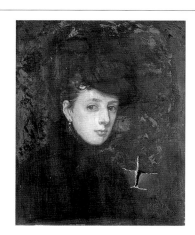

Verner, Ida 1850–1937
Self Portrait
oil on canvas 59.0 x 49.5
FAH1978.21

Verner, Ida 1850–1937
'Thy Will Be Done' Study of a Lady in Oils
oil on canvas 126 x 101
FAH1951.174

Facing page: Harvey, Harold C., 1874–1941, *A Kitchen Interior* (detail), c.1918, Brighton and Hove Museums and Art Galleries, (p.97)

Veronese, Paolo (after) 1528–1588
The Family of Darius before Alexander
oil on canvas 47.7 x 91.2
FA000207

Veronese, Paolo (studio of) 1528–1588
The Centurian of Capernaum c.1570
oil on canvas 99.0 x 152.5
FA000070

Veronese, Paolo (studio of) 1528–1588
Europa and the Bull c.1580
oil on canvas 22.7 x 57.0
FA000079

Victors, Jan 1619–after 1676
Jacob's Deception c.1650
oil on canvas 77.7 x 152.5
FA000006

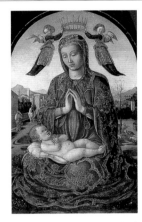

Vivarini, Bartolomeo (school of)
d. after 1500
Madonna and Child with Cherubs c.1480
oil & tempera on wood panel 67.4 x 42.0
FA000075

Von Kamptz, Fritz 1817–1901
William Woodward, the Chartist 1898
oil on canvas 113 x 96
FA000840

W. W.
Lewes Coach on the Road 1896
oil on canvas 35.5 x 45.9
FA000487

Wadsworth, Edward Alexander 1889–1949
Light Sections 1940
tempera on panel 63.4 x 75.6
FA000161

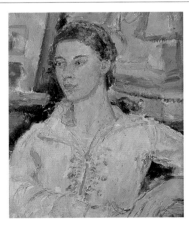

Walker, Ethel 1861–1951
Portrait of a Woman 1936
oil on canvas 61 x 51
FA000670 🐝

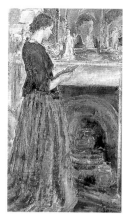

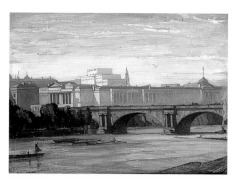

Walker, Ethel 1861–1951
The Miniature 1936
oil on canvas 109.8 x 62.0
FA000671

Wallace, Robin 1879–1952
Waterloo Bridge 1927
oil on canvas 71.0 x 91.2
FA000341

Wallace, Robin 1879–1952
Landscape 1929
oil on canvas 68.3 x 88.8
FA000270

Walton, John Whitehead active 1831–1885
Frederick William Hervey, First Marquess of Bristol
oil on canvas 271 x 180
FA000724

Ward, James 1769–1859
Duckweeds 1845
oil on panel 40.0 x 67.2
FAH1990.72

Ward, Richard b.1957
Untitled c.1970
oil? on canvas 177 x 194
FAH1994.52

Warren, William White 1832–1915
Chain Pier, Brighton
oil on canvas 17.4 x 26.0
FA000468

Warrington, Ellen active 1931–1939
Cineraria
oil on canvas 61.0 x 45.7
FA000648

Watson, Harry 1871–1936
Woodland Scene, Sussex
oil on canvas 62.0 x 75.5
FA000966

Watson, Robert active 1899–1920
Highland Sheep 1903
oil on canvas 61.6 x 79.3
FA000642

Watteau, Jean-Antoine (after) 1684–1721
Fête galante: Conversation Piece
oil on canvas 63.2 x 96.7
FA000209

Way, Emily C. active 1886–1907
Ellen Benett-Stanford 1895
oil on canvas 132 x 102
FAPM090057

Webb, James c.1825–1895 &
Earl, George active 1856–1883
Brighton from the West Pier c.1870
oil on canvas 84.0 x 152.5
FA000018

Weenix, Jan Baptist 1621–1660/1661
Shipping in Harbour
oil on canvas 114.7 x 169.4
FA000584

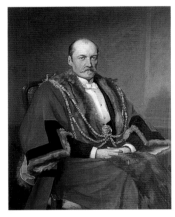

Weigall, Henry 1829–1925
Alderman Sir John Ewart 1894
oil on canvas 127.0 x 101.8
FA000713

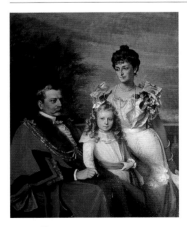

Weigall, Henry 1829–1925
Sir John George Blaker and Family c.1900
oil on canvas 160 x 130
FA000909

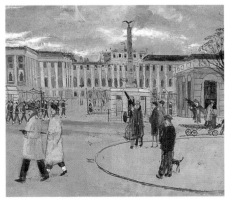

Weight, Carel Victor Morlais 1908–1997
Cold Day, Schönbrunn 1945
oil on board 36.0 x 42.3
FA000747

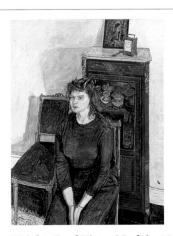

Weight, Carel Victor Morlais 1908–1997
Jane I 1961
oil on canvas 101.7 x 76.5
FA000119

Weight, Carel Victor Morlais 1908–1997
Dialogue c.1973
oil on canvas 127 x 100
FAH1980.4

Weight, Carel Victor Morlais 1908–1997
American Girl and Doll 1975
oil on board 75 x 75
FAH1977.19

Weller, Norma b.1932
Frederick Alexander c.1960–1963
oil on canvas 128.0 x 101.9
FA000612

Weller, Norma b.1932
Fire Cavern c.1966
acrylic on canvas 152 x 101
FA000610

Wetherbee, George Faulkner 1851–1920
Oenone Forsaken
oil on canvas 66.0 x 152.5
FA000838

Wheatley, Francis 1747–1801
Mother and Child c.1775
oil on canvas 85.8 x 70.9
FA000035

Wheatley, Francis 1747–1801
The Encampment at Brighton, Scotland 1788
oil on canvas 101.6 x 126.0
FA000033

Whistler, Reginald John 1905–1944
HRH the Prince Regent Awakening the Spirit of Brighton 1944
oil on wallpaper 157.5 x 246.0
FA000017

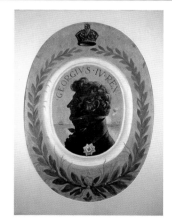

Whistler, Reginald John 1905–1944
King George IV 1944
oil on wallpaper 177 x 93
FA000725

Whiting, Frederic 1874–1962
Girl in a Green Jersey c.1908
oil on canvas 127.5 x 89.7
FA000126

Whiting, Frederic 1874–1962
The Professional
oil on canvas 92.5 x 71.6
FA000585

Whittle, Thomas active c.1854–1895
Nutfield Village
oil on canvas 61.0 x 45.8
FA000883

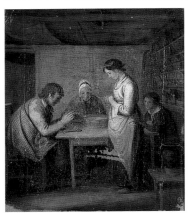

Wilkie, David (after) 1785–1841
Grace before Meat
oil on canvas 42.9 x 37.3
FA000434

Williams, Alfred Walter 1824–1905
On the Cumberland Fells 1880
oil on canvas 117 x 184
FA000621

Williams, E. W. 19th C
John Cordwell
oil on canvas 76.5 x 63.0
FA000832

Williams, John Edgar active 1846–1883
*Alderman David Smith, Mayor of
Brighton* 1881
oil on canvas 76 x 64
FA000834

Williams, J. M.
Mounted Figure with Hounds 1839
oil on canvas 41.0 x 52.5
FAPM090079

Williams, Terrick 1860–1936
Seaweed Gatherers 1903
oil on canvas 71.5 x 107.0
FA000365

Williams, William 1808–1895
Cader Idris 1860
oil on canvas 17 x 25
FAPM090072

Williamson, James active 1868–1889
Silver Birches, Hassocks Gate 1881
oil on canvas 76 x 51
FA000809

Williamson, James active 1868–1889
Silver Brook, Hassocks Gate 1881
oil on canvas 76 x 51
FA000810

Wilson, Benjamin 1721–1788
Dr Richard Russell, FRS c.1755
oil on canvas 126.0 x 100.5
FA000016

Wilson, Margaret Evangeline b.1890
Mrs Blackman 1928
oil on canvas 76.5 x 64.0
FA000351

Wilson, Richard 1713/1714–1782
River View with Figures on the Bank c.1760
oil on canvas 36.2 x 45.8
FA000025

Wilson, Richard (after) 1713/1714–1782
Landscape with Lake and Figures c.1765
oil on canvas 35.7 x 46.2
FA000111

Wilson, Richard (after) 1713/1714–1782
Figures by a Lake
oil on canvas 63.6 x 76.4
FA000269

Wilson, Richard (after) 1713/1714–1782
Italian Landscape
oil on canvas 44.4 x 53.4
FA000263

Wilson, Richard (circle of) 1713/1714–1782
Landscape with River
oil on canvas 64.0 x 76.5
FA000728

Wilson, Richard (follower) 1713/1714–1782
Landscape
oil on canvas 63.0 x 78.5
FA000922

Wingate, James Lawton 1846–1924
The Flock
oil on canvas 77.5 x 107.3
FA001213

Wivell, Abraham Junior active 1840–1865
Mrs Rotton, neé Charlotte S. Barton 1860
oil on canvas 86.3 x 75.0
FAH1927.76

Wolf-Ferrari, Teodoro 1878–1945
Lo spitz di mezzodì da Brusa Adaz a Zolno Alto
oil on board 57.2 x 74.0
FA000303

Wolgemut, Michael (studio of)
1434/1437–1519
Triptych with the Nativity and Saints (inner panels) c.1500
oil & tempera on wood panel 55.9 x 18.3 (…)
FA000015

Wolgemut, Michael (studio of)
1434/1437–1519
Triptych with the Nativity and Saints (outer panels) c.1500
oil & tempera on wood panel 55.9 x 18.3(x2)
FA000015

Wood, Christopher 1901–1930
Girl in a Cloche Hat 1926
oil on canvas 43 x 35
FAH1977.27

Wood, Christopher 1901–1930
Seated Nude c.1926–1928
oil on canvas 92.0 x 65.2
FA000328

Woods, Henry 1846–1921
Street in Venetia 1891
oil on wood panel 53.1 x 39.1
FA000240

Wouwerman, Philips (attributed to)
1619–1668
Battle Scene
oil on canvas 74.8 x 97.0
FA000245

Wright, Joseph of Derby 1734–1797
Catherine Sophia Macauley c.1770
oil on canvas 74.5 x 61.0
FAH1934.40

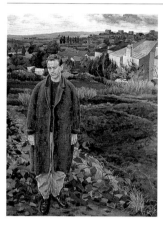

**Wright (née Dawson), Patricia
Vaughan** b.1925
*Vincent Lloyd on Blythe Hill, South London,
with Kent Hills beyond* 1985/1986
oil on canvas 137 x 102
FAH1987.2

Wyndham, Richard 1896–1948
Winter Landscape c.1925
oil on canvas 59.8 x 49.7
FA000598

Wyndham, Richard 1896–1948
Tickerage Mill c.1939
oil on canvas 92.0 x 72.3
FA000329

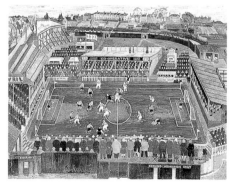

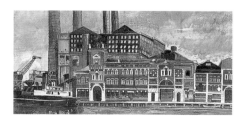

Yarber, Robert b.1948
False Dawn 1988
acrylic on canvas 213.0 x 152.5
FA001145

Yates, Fred b.1922
Saturday Afternoon 1953
oil & tempera on gesso board 200 x 220
FAH1998.7

Yates, Fred b.1922
Shoreham Power Station 1956
oil on board 58.5 x 170.5
FAH1987.8

Yates, Norman b.1923
Three Flags 1967
pencil, acrylic & tinfoil 76 x 56
FA102373

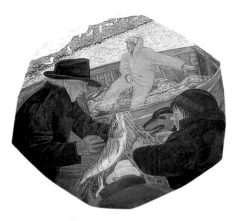

Yhap, Laetitia b.1941
*Paul Helping His Brother Doug, and Scoby,
Will and Saxon* 1980–1981
oil on board 115 x 121
FAH1982.5

**Ziem, Félix François Georges
Philibert** 1821–1911
The Doge's Palace, Venice
oil on canvas 35 x 53
FAPM090024

**Ziem, Félix François Georges
Philibert** 1821–1911
Venetian Scene: Gondolas and Sailing Boats
oil on canvas 73.0 x 86.5
FAPM090008

Zinkeisen, Anna Katrina 1901–1976
Brighton in the Regency c.1939
oil on canvas 101.2 x 127.0
FA000571

Zinkeisen, Anna Katrina 1901–1976
King George IV
oil on canvas 132 x 98
FA000300

Zoffany, Johann 1733–1810
John Maddison 1783
oil on canvas 125.2 x 100.4
FA000022

Zuccarelli, Franco 1702–1788
Pastoral Scene with Cowherds c.1750
oil on canvas 64.7 x 117.8
FA000072

Zuccarelli, Franco 1702–1788
Pastoral Scene with Goatherds c.1750
oil on canvas 65.0 x 117.5
FA000068

Facing page: Hayward, Alfred Robert, 1875–1971, *The Morning Walk* (detail), 1907, Brighton and
Hove Museums and Art Galleries, (p. 98)

The Aldrich Collection, University of Brighton

The origins of the Aldrich Collection lie in the Brighton School of Art which was founded in the city in 1859. Since then, the Brighton School of Art has undergone several changes in name. In the 1870s, the School became known as the Brighton School of Art and Science. At this time, it occupied a purpose-built Romanesque-style building, the foundation stone of which was laid by the dominant figure of Victorian art and design education in Britain, Sir Henry Cole. More recently, it was a major constituent in the foundation of Brighton Polytechnic, established in 1970, and is currently represented as the Faculty of Arts and Architecture of the University of Brighton.

The Aldrich Collection offers an absorbing insight into the changing nature of art education and cultural production in Brighton and beyond over the past century and a half. The majority of the works in the collection have been produced by staff and students of the School of Art, many of whom are well known figures in the creative arts nationally and internationally. Several others works have been purchased from significant artists and designers whose work has been featured in exhibitions held at the University of Brighton Art Gallery. The collection was given a considerable boost in 1995 with the intervention of Michael and Sandy Aldrich who decided to collect and commission artworks to be donated to the University's Foundation Fund. In doing so, they sought to promote Brighton's place as a major centre for artistic creativity and, as a result of this generous initiative, the University decided to donate many of its own collected works to the Aldrich Collection in order to provide a unified holding.

In common with many other well-known British institutions of art and design with origins in the 19th century, Brighton's creative legacy before the Second World War has been heavily weighted in favour of the fine arts, although the School of Art was awarded a number of medals across a wide range of categories at the celebrated 1925 *Exposition des arts décoratifs et industriels modernes* in Paris.

The Aldrich Collection includes two Victorian works by George Ruff, an 1875 sepia wash of a male bust and an 1873 conté crayon anatomical drawing. Ruff was a Brighton art student and photographer who won several prizes for his studies. Works from the earlier decades of the 20th century include a hand-carved marble piece, *Alphabet*, of 1909 by the celebrated sculptor Eric Gill, who lived in the nearby village of Ditchling, and a striking woodcut of a windmill by E. A. Sallis Benney, appointed Principal of the School of Art in 1934.

Graphic media are well represented in the collection and include Edward Bawden's distinctive linocuts of *Westminster Abbey* (1969) and *Brighton Pier* (1975). Edouardo Paolozzi's pop-flavoured screenprint combining biological, industrial and primitive elements (1965) as well as George Hardie's mixed media artwork for a Grolsch poster (1986) are also crucial examples of this media. Trained at the RCA, and teaching at Brighton since 1986, Professor Hardie has enjoyed a distinguished career in graphic design, including membership of the prestigious international organisation *Alliance Graphique Internationale*. Book arts are also well represented in the highly original work of John Vernon Lord, a Brighton colleague of Hardie and the internationally celebrated illustrator Raymond Briggs in the Department of Graphic Design. Examples of Professor Lord's work in the collection include pen and ink artwork for his distinctive illustrations for *The Nonsense Work of Edward Lear*

(1979) and *The Runaway Rollerskate* (1973). Other notable examples of illustrative work include Quentin Blake's *Women with a Book* (1999). Blake, a Fellow of the University of Brighton since 1992, is a distinguished illustrator and Royal Designer for Industry.

The collection also embraces photography, including examples by Mark Power, widely known for his series of documentary photographs including those commemorating the construction of the Millennium Dome at Greenwich between 1998 and 2000. There are also many distinctive examples of fine art including a series of etchings by the John Moores prize-winning artist Professor Andrzej Jackowski, and a screenprint and an acrylic on canvas by former Head of Fine Art at Brighton, Professor Brendan Neiland. In terms of painting, Alan Davie's expressive works in gouache and oil are a focal point of the collection. This internationally renowned Scottish painter has held several key exhibitions at the University of Brighton.

Since its initiation in 1995, the Aldrich Collection has embraced paintings and a wide range of media including ceramics, jewellery, metalware, furniture and plastics in its holdings of more than 200 works of visual art.

Professor Jonathan M. Woodham, Director of the Design History Research Centre

Bucher, Mayo b.1963
J. S. B. 1998
oil & acrylic mixed on wood 120.0 x 120.5
268

Bucher, Mayo b.1963
Red Over Black 2001
oil & acrylic mixed on wood 120 x 120
269

Burke, Patrick
Five Figures on Red Ground 1990
oil on canvas 77 x 61
249

Burke, Patrick
Red Night 1990
oil on canvas 30.5 x 23.0
250

Burton, Simon b.1973
Garden Furniture 1995
oil on canvas 183 x 146
184

Burton, Simon b.1973
Naples 1995
oil on canvas 180 x 149
115

Clements, Keith 1931–2003
Estranged 1972
acrylic on board 61 x 122
10 (P)

Clements, Keith 1931–2003
Pecking Order 1972
acrylic on board 122 x 91
145 (P)

Creffield, Dennis b.1931
Still Life with Bread and Jug 1961
oil on board 92 x 122
26

Daniels, Harvey b.1936
Zigzag 1980
acrylic on canvas 212 x 212
231

Davie, Alan b.1920
Crazy Ikon (op. no. 258) 1959
oil on canvas 213 x 173
57

Davie, Alan b.1920
Egg Filler 1961
oil on canvas 122.0 x 152.5
143 (P)

Davie, Alan b.1920
Wheels for the Sweet Life 1965
oil on canvas 122.0 x 152.5
142 (P)

Davie, Alan b.1920
Woodpecker's Choice 1965
oil on canvas 102 x 122
104 (P)

Davie, Alan b.1920
See You in Heaven 1968
oil on board 102 x 122
144 (P)

Gillespie, Paula
Mists of Memories No.2 1997
oil on canvas 234 x 195
147

Gregory, Patricia
The Meeting 1989
acrylic on canvas 165 x 241
11

Gregory, Patricia
The Meeting 1989
acrylic on canvas 155 x 183
33

Griffiths, Michael b.1951
Suspension 1977
oil on canvas 51.0 x 68.5
20

Horton, Ronald 1902–1981
Shoreham Harbour 1930
oil on canvas 51.0 x 40.5
25

Imai, Yasuo
White Chrysanthemum 1997
acrylic on wood panel 80 x 60
177

Imai, Yasuo
Yellow Chrysanthemum 1997
acrylic on wood panel 80.5 x 60.5
178

Imai, Yasuo
Morning Glory 1998
acrylic on wood panel 127 x 82
179

Kam Kow, Choong
Earth Mood 2 1992
acrylic on handmade paper 43 x 56
220

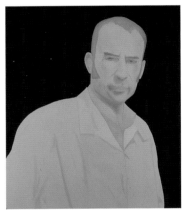

Kemmenor, James
One of the Faces 1999
oil on denim 119 x 100
114

Martin, Leigh b.1964
M. Matissée in Nice 1998
oil on canvas 24.5 x 26.0
172

Martin, Leigh b.1964
M. Matissée in Nice 1998
oil on canvas 24.5 x 26.0
172 A

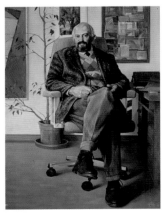

Martin, Leigh b.1964
M. Matissée in Nice 1998
oil on canvas 24.5 x 26.0
172 B

Martin, Leigh b.1964
M. Matissée in Nice 1998
oil on canvas 23.0 x 24.5
172 C

McKendry, Kenneth
Robin Plummer 1980
oil on board 102 x 76
181

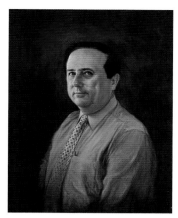

McKendry, Kenneth
Michael Aldrich 1999
oil on board 91.5 x 71.0
182

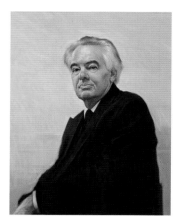

McKendry, Kenneth
Professor Geoffrey Hall, CBE 1999
oil on board 90.5 x 70.5
183

McKendry, Kenneth
Professor John Vernon Lord 1999
oil on board 91 x 71
180

Mooney, Martin b.1960
Dark Orange Still Life 1986
oil on canvas 154 x 218
232

Neiland, Brendan b.1941
Brighton 1993
acrylic on canvas 81 x 122
54

Neiland, Brendan b.1941
Aldrich Library 1999
acrylic on canvas 181 x 124
116

O'Connor, Lisa b.1965
Abstract 1995
acrylic on canvas 180 x 123
35

O'Connor, Lisa b.1965
White, Green, Yellow Abstract 1995
acrylic on canvas 180 x 123
36

Plummer, Robin b.1931
Sea View No.2 1982
oil on canvas 151 x 121
51

Rice, Brian b.1936
Kalender 1996
oil on canvas 127.0 x 91.5
253

Spanyol, Jessica
Part of a Triptych 1987–1988
acrylic on paper 91 x 45 (panel 1)
218

Spanyol, Jessica
Part of a Triptych 1987–1988
acrylic on paper 91 x 85 (panel 2)
219

Spanyol, Jessica
Part of a Triptych 1987–1988
acrylic on paper 91 x 45 (panel 3)
133

Stevens, Christopher b.1961
Two Women 1980
oil on canvas 68 x 51
111

Udagawa, Norito
TRIPLE X–2 2000
oil & tempera on canvas 61 x 100
265

Wilson, Tony b.1944
Study for a Wall 1987
oil on canvas 31.0 x 35.5
275

Wilson, Tony b.1944
Lost Letter 2002
oil on canvas 122.0 x 152.5
273

Facing page: Weigall, Henry, 1829–1925, *Sir John George Blaker and Family* (detail), c.1900, Brighton and Hove Museums and Art Galleries, (p. 188)

University of Sussex

The foundation of the University of Sussex as one of the key new universities of the early 1960s initially raised great hopes for a distinguished collection of contemporary art. The buildings, designed by Sir Basil Spence, fresh from his triumph at Coventry Cathedral, encouraged the ambition to match the idealism of the time. Across this well-established parkland, Spence created some of the most beautiful vistas of the period, suggesting displays of sculpture. There were such displays, but always temporary. Artists in residence during the 1960s and 1970s sold well to staff, students and local residents but rarely to the institution. Distinguished London dealers such as Gimpel Fils sent works on loan but they never found a permanent home. One great work of the 1960s remains, but the large Ivon Hitchens, still *in situ* in Falmer House, was never matched by the works of art that might have surrounded it.

What can be found today throughout the University buildings can only be described as a rather eclectic mix, and works were never purchased with any consistent policy or view on the contemporary. Some of the works look backwards, to Bloomsbury, to a lyrical and painterly tradition of the past, or even to the Euston Road School (Keith Clements) rather than forwards to the new, challenging work of the 1960s and 1970s. Nevertheless, there are some faint signs of artistic lineage to be found. The concern to purchase records of the locality, inspired by Hitchens, was continued in works by McHugh and Creffield. Oxtoby is a contemporary of Hockney and from the same part of England. A highly significant moment of student and youth culture is caught in the works of Upton, his *Christ's Entry into Brighton* recording the style and content of a lot of public wall painting that he carried out in Brighton and is now lost.

The early commitment to art of the new Commonwealth of the 1960s is certainly present here in works by Akolo and Assad. Finally, action of some foresight was taken by Norbert Lynton, then Professor of Art History, in accepting on behalf of the University the Daghani Collection, stored for many years, but now a very important part of the University's commitment to the German Jewish tradition, and to the subject of changing displays.

Roderick Kedward, Emeritus Professor of History and David Alan Mellor, Professor of Art History

Akolo, Jimo b.1935
Hausa Drummer 1961
oil on board 122.0 x 81.4
066PTG

Akolo, Jimo b.1935
Hausa Procession 1962
oil on board 94.4 x 182.8
064PTG

Akolo, Jimo b.1935
Northern Horsemen 1963
oil on canvas 147.3 x 94.4
065PTG

Bradley, Martin b.1931
Zen 1961
oil on canvas 86.4 x 144.7
052PTG

Chevallier, Annette b.1944
'Geometric Shapes'
acrylic on canvas 47 x 63
099PTG

Child, St John active from 1960s
Cayley's Flying Machine 1963
oil on canvas 154.0 x 122.5
005PTG

Child, St John active from 1960s
Untitled 1963
oil on canvas 123 x 154
101PTG

Child, St John active from 1960s
Woodlands 1963
oil on canvas 122.5 x 154.0
006PTG

Child, St John active from 1960s
Knights of the Flying Circus 1968
oil on canvas 154.0 x 122.5
103PTG

Clements, Keith 1931–2003
The Painter's Wife with Cat 1958
oil on board 99 x 50
007PTG

Clements, Keith 1931–2003
Revolutionary Study 1968
oil on board 50.8 x 38.2
072PTG

Clements, Keith 1931–2003
Sir Denys Wilkinson 1990
oil on canvas 120.6 x 76.4
086PTG

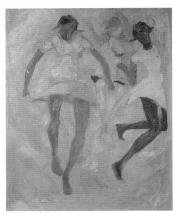

Cook, Bill
Study of Dancing Children 1966
oil on canvas 76 x 61
008PTG

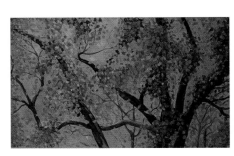

Cook, Bill
Study of Leaves 1966
oil on canvas 38.2 x 50.8
073PTG

Creffield, Dennis b.1931
July Evening, Brighton 1985
oil on canvas 86.4 x 91.4
053PTG

Daghani, Arnold 1909–1985
'*Abstract Multicoloured Lines*' 1954
oil on board 32 x 10
A1343

Daghani, Arnold 1909–1985
Abstract Geometric Shapes 1955
gouache & acrylic on paper 28 x 18
A1346

Daghani, Arnold 1909–1985
George Enescu: 'Rumanian Rhapsody' 1958
oil & gouache on card 28 x 20
A3

Daghani, Arnold 1909–1985
III 1959
oil on paper 65 x 50
D23.05

Daghani, Arnold 1909–1985
Abstract with Fish on Red Background 1960
acrylic & gold paint on paper 56 x 47
A749

Daghani, Arnold 1909–1985
Townscape 1960–1963
oil on brass 8 x 30
A12

Daghani, Arnold 1909–1985
Coin de la vieille ville de Vence 1960s
oil on canvas 41 x 25
A200

Daghani, Arnold 1909–1985
VII 1962
oil on board 65 x 50
D23.08

Daghani, Arnold 1909–1985
Shadowy Face 1963
oil on board 69 x 47
A680

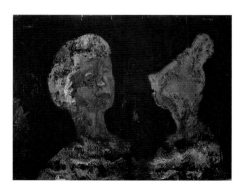

Daghani, Arnold 1909–1985
'Two Female Portraits on Dark Background'
1963
oil on board 50 x 63
A676

Daghani, Arnold 1909–1985
Cyclists 1965
oil on board 46 x 35
A207

Daghani, Arnold 1909–1985
Hommage à Jean-François Millet (Les glaneuses) 1965
oil & gouache on paper 30 x 50
A1121

Ferguson, Pauline
'Three Square Shapes'
acrylic on canvas 53 x 53
098PTG

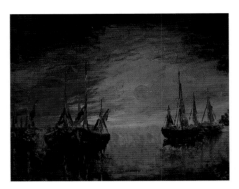

Fox, J.
'Ships' 1978
oil on board 49.0 x 63.5
223PTG

Frey, Barbara 20th C
Engineering Theme, Greens and White
acrylic & ink on canvas 82.6 x 61.0
089PTG

Ginloud, Colin 20th C
Painting in Black, Grey and White
acrylic on hardboard 91.5 x 92.0
038PTG

Gladwell, Rodney 1928–1979
Flowers in Vase 1962
oil on board 104 x 77
009PTG

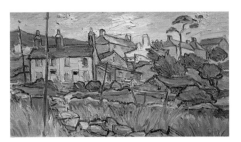

Gladwell, Rodney 1928–1979
'Cottages' 1967
oil on board 46 x 70
222PTG

Gung, Zhu
Sir Leslie Fielding 1992
oil on canvas 122.0 x 94.4
085PTG

Hesse, Lebrecht
Market Woman in Ghana 1947
oil on canvas 61.0 x 50.5
010PTG

Hitchens, Ivon 1893–1979
Day's Rest, Day's Work (Polyptych) 1960
wax & oil on four panels 365.6 x 731.5
093PTG

H. K.
Unknown 1968
oil on board 132 x 157
441PTG

Leukiwicz 20th C
Francesca and Death
oil on canvas 60 x 49
410PTG

Marle, Judith
Passing through 1966
oil on canvas 93 x 93
412PTG

Martin, Kingsley 1897–1969
Downland Scene from the Artist's Garden
oil on canvas 39.4 x 48.4
185PTG

McHugh, Christopher
The Sea, The Sea, The Sea 1992
oil & wax on wood 46.0 x 208.5
224PTG

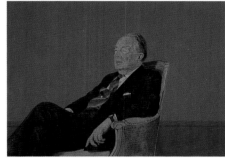

Organ, Bryan b.1935
Lord Shawcross Seated 1986
oil on canvas 111.6 x 137.1
084PTG

Oxtoby, David b.1938
Explosion (Flash) 1969
oil on canvas 122 x 122
058PTG

Oxtoby, David b.1938
Ya Ya (Burst) 1969
oil on canvas 96.9 x 76.4
059PTG

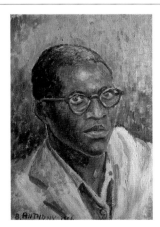

Pibias
Self Portrait as St Anthony 1964
acrylic 48.4 x 30.5
208PTG

Ribeiro, Lancelot b.1933
Bombay 1964
oil on board 61 x 84
413PTG

Salvendy, Frieda 1887–1965
Fishermen in Boat, Italy 1932
washes of oil on paper 34.2 x 45.7
190PTG

Salvendy, Frieda 1887–1965
Market Scene at Mihalovce 1937
washes of oil on paper 34 x 45
189PTG

Salvendy, Frieda 1887–1965
Anemones and Magnolia in Vase
oil on board 51.0 x 40.5
011PTG

Salvendy, Frieda 1887–1965
Girl with Doll
oil on canvas 68.5 x 54.0
012PTG

Salvendy, Frieda 1887–1965
Gladioli in Vase
oil on canvas 73.5 x 53.3
081PTG

Salvendy, Frieda 1887–1965
Still Life: Fruit and Anemones
oil on canvas 50.5 x 60.5
014PTG

Salvendy, Frieda 1887–1965
Tulips in Vase
oil on board 60.8 x 40.5
013PTG

Sebree, Charles 1914–1985
Blue Drinker 1965
acrylic on board 28 x 19
004PTG

Shields, Barbara b.1922
Still Life, Rose and Lemons 1979
oil on board 51 x 45
191PTG

unknown artist late 18th C
Philadelphi, Daughter of Sir John Dixon Dyke Baronet, 1790
oil on board 24.7 x 19.7
017PTG

unknown artist late 19th C
The Brighton Chain Pier (after Joseph Mallord William Turner)
oil on canvas 69.7 x 134.6
186PTG

unknown artist 20th C
Artist's Studio
oil on canvas 81.4 x 101.6
063PTG

Upton, John b.1933
Christ's Entry into Brighton 1967
oil on five hardboard panels 175.6 x 709.6
062PTG

Upton, John b.1933
And She Was the Princess 1969
acrylic & mixed media on hardboard
169.5 x 121.0
217PTG

Upton, John b.1933
Nude with Mirror 1969
acrylic on hardboard 63 x 124
0133PTG

Wheatley, Grace
Lord Fulton of Falmer 1974
oil on canvas 111.6 x 85.1
088PTG

Yassin, Assad b.1911
Black and White African Scene 1960
oil on canvas 16 x 22
213PTG

Ditchling Museum

Ditchling Museum was founded in 1985 by two sisters, Joanna and Hilary Bourne. The sisters bought the village school to house the museum and from this point they began to build a collection that would celebrate the history and people of Ditchling as well as its artistic lineage. Prior to the introduction of structured collecting policies, collections developed in a more organic manner and this freedom and enthusiasm is directly reflected in the eclectic nature of the objects acquired for the museum. For the first years the people of Ditchling gave generously and the founders were eager to record and collect the whole gamut of life in Ditchling - from the people who lived in the village to the working life of the community and the remarkable surrounding landscape.

The uniqueness of the collection lies in the fact that Ditchling has a place within the history of the applied arts in Great Britain. Eric Gill moved to Ditchling in 1907 and in 1920 founded the Guild of St Joseph and St Dominic - a group of sculptors, letter cutters, weavers, silversmiths, printers and a painter, David Jones. Jones came to Ditchling in 1921 after studying at Westminster School of Art under Bernard Meninsky where he was influenced by Post Impressionism. Profoundly affected by his time in the trenches in the First World War, like many soldiers who survived he sought reasons for what he had witnessed and tried to find an inner peace. He appeared to have found this within the Guild and his subsequent conversion to Catholicism. On his arrival at the Guild he was encouraged to work in the carpentry workshops and his graphic style developed rapidly through the woodcuts and wood engravings he made as illustrations for the St Dominic's Press.

The painting in Ditchling Museum's collection, *Madonna and Child in the Landscape* is regarded as his first major work as it presents two key aspects of his work at this period: the South Downs landscape of the area surrounding Ditchling as well as his religious convictions. The painting was given to Eric Gill's daughter Petra by Jones when they were engaged and although the engagement was eventually broken off they remained close friends. The painting remained unknown and unpublished in his lifetime and only re-emerged on Petra's death many years later when it was purchased by the museum with financial assistance from the National Art Collection Fund, Resource and the Victoria & Albert Museum Purchase Grant as well as the Friends of Ditchling Museum and a number of individual donors.

A supportive environment to artists, the village was also home to Edward Johnston and painters such as Louis Ginnett, Charles Knight, Arthur Henry Knighton Hammond and Frank Brangwyn. While the strength of the collection lies in the applied arts, it also celebrates the fine artists of the village and the recent arrival of the Louis Ginnett bequest, the long-term loans of Charles Knight and that of Frank Brangwyn go someway to strengthen the presence of the fine arts.

Ginnett was born into a circus family in Brighton in 1875. He was educated at Brighton Grammar School and studied painting in both London and Paris. Some of his most powerful work was completed while serving in the First World War when he captured the desperation in the trenches and the devastation around Arras where he was based. A painter and a stained glass artist he later went on to teach at Brighton Art School and lived in Ditchling from 1919 until his death in 1946. His most famous works are, perhaps, the

murals in Brighton and Hove Grammar School that record the history of Sussex, but the paintings that Ditchling Museum holds are sensitive, personal works that depict a love of his family and their domestic life. While teaching at Brighton School of Art he taught Charles Knight and the two developed a rapport that was strengthened when Knight returned to the school to teach. Knight also came to live in Ditchling where he was to remain from his marriage in 1934 until his death in 1990.

Seeing his work and feeling the presence of the Downs, it almost seems as if Knight could have lived nowhere else - yet Knight went on many sketching trips to visit old friends throughout the country and with Ginnett travelled to France. He credits Ginnett with increasing his appreciation of European culture. Another item in the museum's collection that illustrates their continuing friendship in Ditchling is a rather naïve painted poster with an archetypal image of a painter at the top that announces *Mr Louis Ginnett, ROI & Mr Charles Knight, RWS will hold at their studios in Ditchling classes in Portrait Drawing and Painting, Landscape & Still-life Painting, Illustration, Figure Composition, Etching and Wood-engraving.* Knight's undoubted talent as a topographical painter led to him being involved in the *Recording Britain*, a scheme established in 1940 that, as the name suggests, recorded social change. Ditchling was chosen as one of the sites and Knight was asked to be a recorder.

The village continues to inspire and to be home to many painters and applied artists and Ditchling Museum continues to acquire, document, exhibit and encourage access for all to this collection of both national and international significance.

Hilary Williams, Director

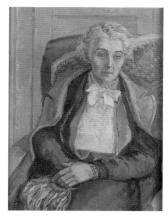

Cobbam, Rose
Mrs Parkinson
oil on canvas 50 x 43 (E)
DITLM1988.639.1

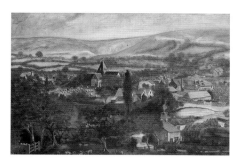

Elms, G. D.
Ditchling 1912
oil on board 54 x 57
DITLM1988.748.1

Ginnett, Louis 1875–1946
The Picnic 1922
oil on wood 55 x 67 (E)
DITLM1998.2889.3 (P)

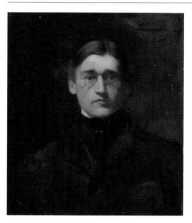

Ginnett, Louis 1875–1946
Portrait 1924
oil on canvas 61 x 51
DITLM1998.2888.9 (P)

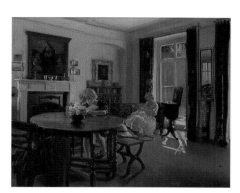

Ginnett, Louis 1875–1946
A June Interior
oil on canvas 66 x 77 (E)
DITLM1998.2888.4 (P)

Ginnett, Louis 1875–1946
Amy Sawyer
oil on canvas 76 x 64
DITLM1998.2747.1 (P)

Ginnett, Louis 1875–1946
Boy's Head
oil on canvas 11.5 x 8.5
DITLM2000.3232.1 (P)

Ginnett, Louis 1875–1946
Cathedral Facade
oil on canvas 30.0 x 39.5
DITLM1998.2890.7 (P)

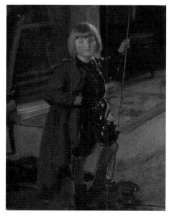

Ginnett, Louis 1875–1946
Child in Green Cape
oil on canvas 39 x 30
DITLM1999.3101.15 (P)

Facing page: Lessore, Thérèse, 1884–1945, *The Daredevils* (detail), Hastings Museum and Art Gallery, (p. 306)

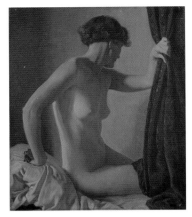

Ginnett, Louis 1875–1946
Female Nude
oil on canvas 77 x 65
DITLM1998.2888.7 (P)

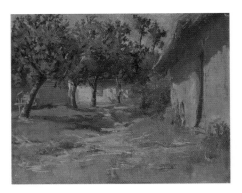

Ginnett, Louis 1875–1946
Four Trees and a Building
oil on canvas 38.5 x 46.5
DITLM1998.2890.10 (P)

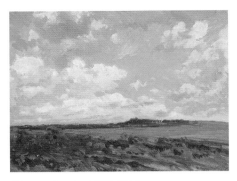

Ginnett, Louis 1875–1946
Hampstead Heath
oil on wood 31 x 41
DITLM1994.1971.1

Ginnett, Louis 1875–1946
Head of Unknown Lady
oil on canvas 30 x 27 (E)
DITLM1998.2890.12 (P)

Ginnett, Louis 1875–1946
Lady with a Blue-Brimmed Hat
oil on canvas 14.5 x 23.0
DITLM2000.3232.3 (P)

Ginnett, Louis 1875–1946
Little Venice
oil on canvas 32 x 42
DITLM2000.3233.4 (P)

Ginnett, Louis 1875–1946
Mary
oil on canvas 67 x 57 (E)
DITLM1998.2888.2 (P)

Ginnett, Louis 1875–1946
Mary
oil on canvas 15 x 30 (E)
DITLM1998.2890.17 (P)

Ginnett, Louis 1875–1946
Mary
oil on wood 23.5 x 19.0
DITLM2000.3232.4 (P)

Ginnett, Louis 1875–1946
Mary Ginnett
oil on canvas 77 x 64
DITLM1998.2888.5 (P)

Ginnett, Louis 1875–1946
Mary Sitting in a Wood
oil on wood 22.0 x 26.5 (E)
DITLM1998.2890.16 (P)

Ginnett, Louis 1875–1946
Mary under Sunshade
oil on canvas 20.0 x 17.5 (E)
DITLM1998.2897.2 (P)

Ginnett, Louis 1875–1946
Portrait of a Lady
oil on canvas 27 x 25 (E)
DITLM1998.2890.13 (P)

Ginnett, Louis 1875–1946
Portrait of a Man
oil on canvas 49 x 40
DITLM1998.2890.6

Ginnett, Louis 1875–1946
Portrait of an Unknown Girl
oil on wood 62 x 51
DITLM1998.2889.6 (P)

Ginnett, Louis 1875–1946
Ruined Castle
oil on canvas 23 x 28
DITLM1998.2890.17 (P)

Ginnett, Louis 1875–1946
Ruins
oil on canvas 38 x 28 (E)
DITLM2000.3233.3 (P)

Ginnett, Louis 1875–1946
Seascape
oil on canvas 26.5 x 34.0
DITLM1998.2890.11 (P)

Ginnett, Louis 1875–1946
Seashore
oil on canvas 34.5 x 43.0
DITLM1998.2890.8 (P)

Ginnett, Louis 1875–1946
The Picture Book
oil on canvas 55 x 67 (E)
DITLM1998.2888.3 (P)

Ginnett, Louis 1875–1946
The Secret Bather
oil on canvas 41 x 44 (E)
DITLM1998.2889.4 (P)

Ginnett, Louis 1875–1946
Unknown Lady
oil on canvas 73 x 59 (E)
DITLM1998.2888.1 (P)

Hucker, R.
Court Farm
oil on canvas 54 x 46 (E)
DITLM1996.2519.1

Incledon, Marjorie 1891–1973
Etchingham, Sussex
oil on canvas 54 x 79 (E)
DITLM1989.853.6

Incledon, Marjorie 1891–1973
Free Range
oil on canvas 54 x 64 (E)
DITLM1989.853.3

Incledon, Marjorie 1891–1973
Sussex Wood
oil on canvas 59 x 80 (E)
DITLM1989.853.4

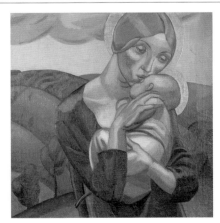

Jones, David 1895–1974
Madonna and Child in a Landscape
oil on canvas 61 x 61
DITLM2002.3403.4

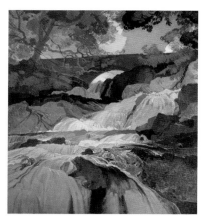

Knight, Charles 1901–1990
Mountain Waters
oil on canvas 121 x 110 (E)
DITLM1989.8641.1 (P)

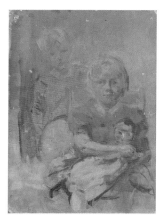

Pepler, Clare
Kilbride Family
oil on canvas 25 x 17
DITLM1999.2977.8 (P)

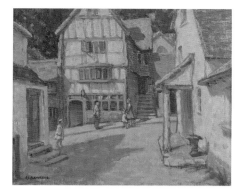

Rawlins, Ethel Louise active c.1900–1962
7 High Street
oil on canvas 65 x 77 (E)
DITLM1989.849.6

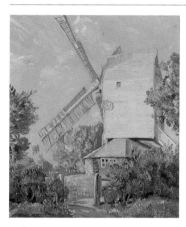

unknown artist
Oldland Mill 1931
oil on canvas 76 x 66 (E)
DITLM1989.849.5

Towner Art Gallery

The original bequest of 22 paintings by Alderman John Chisholm Towner in 1920 formed the initial collection held by the Towner Art Gallery, which opened in 1923. Victorian narrative painting, mainly of animals and children by predominantly mainstream artists, formed the basis of the Towner bequest, such as John Frederick Herring Senior's *Farm Scene with Cart Horses* or William Shayer Senior's *Shore Scene with Figures.* This bequest included both oil paintings and large-scale watercolours, reflecting its domestic rationale, a tendency that has continued throughout the first 80 years of the Towner's history, located as it is within an 18th century manor house. Therefore the Towner collection, which now numbers over 3,000 art objects is predominantly paper based, which results in the majority of the Towner's important collection unfortunately falling outside the scope of the current project. When considering that one of the Towner's chief strengths is its unrivalled holdings of works by the key early 20th century artist, Eric Ravilious, who never worked in oils, one can see that this introduction to the Towner's collection can be only be partial at best.

The Towner Art Gallery's first curator, Arthur Reeve Fowkes, instigated the practice of arranging temporary exhibitions to be shown alongside displays from the collection which today are a major feature of the Towner's work. As a result of his 'Pictures of Sussex' policy the collection gradually increased. Funded by the Corporation of Eastbourne, pictures were acquired of subjects relating to Sussex 'in order to provide the visitor with a complete review of this beautiful county'. The scheme was later extended to allow inclusion of pictures executed by Sussex artists regardless of subject matter. Following the retirement of Arthur Reeve Fowkes, the artist John Lake was appointed as curator in 1947. He extended the acquisition policy beyond simply collecting pictures of Sussex. In 1948 the Towner received a group of pictures from the Sickert Trust, who were charged with dispersing the personal collection of Walter Richard Sickert. A related gift by the Hastings artist and friend of Sickert, Sylvia Gosse, was made in 1955, and enriched the collection with an important work by Sickert, *The Poet and His Muse,* and the unusual painting, *Negro Head,* by Lawrence Alma-Tadema. This pattern of small but important gifts and bequests has strengthened the collection and characterised its growth. Limited but consistent public funds enabled some major acquisitions of work by Vanessa Bell and Henry Herbert La Thangue's *Portrait of a Young Girl* in the mid-1950s.

Under the leadership of the abstract painter William Gear, who was appointed as the Towner's curator in 1958 serving until 1964, the Towner increased its reputation so that by 1962 the *Observer* could claim it as 'the most go-ahead municipal gallery of its size in the country'. This was mainly due to the purchase of a group of works by modern abstract artists in 1961 made possible by grant-in-aid support by the Gulbenkian Foundation. This funding coupled with a second Gulbenkian grant in 1964 and support from the Victoria & Albert Museum Purchase Grant Fund enabled Gear to purchase work by many of the major British abstract artists of the 1950s and 1960s for the Towner's collection including Trevor Bell, Sandra Blow, Alan Davie, Roger Hilton, Henry Mundy, Ceri Richards and Bryan Wynter. In 1962 the Reverend George Mitchell, the Rector of Berwick Church, gave over 35 studies and

sketches for the Berwick Church murals by Duncan Grant, Vanessa Bell and Quentin Bell.

The scope of the collection widened under the curatorship of David Galer from 1964–1981. His friendship with Lucy Carrington Wertheim led to her bequeathing some of her collection to the Towner in 1971. The bequest, the largest made to the gallery, included work by Christopher Wood, Alfred Wallis, Frances Hodgkins and Phelan Gibb as well as some primitive artists. The bequest of Irene Law in 1976 further enlarged the collection by the representation of European art from the 16th to 18th centuries, including Joseph van Aken's *The Music Party*, Herri met de Bles' triptych *Madonna and Child with St Christopher and St Anthony the Great* and *River Landscape* by Joseph Wright of Derby. Throughout the 1960s and 1970s works of art were acquired by drawing on available public grants including those administered by the Victoria & Albert Museum and the National Art Collections Fund such as *Self Portrait in Character* by the 18th century Eastbourne artist John Hamilton Mortimer, Edward Wadsworth's *Bronze Ballet* and a large work by Carel Weight entitled *The Old Woman in the Garden No. 2*. In 1965 the Friends of the Towner was formed and immediately presented the gallery with Ruskin Spear's painting, *Spring in Hammersmith*. Since then, the Friends have consistently raised funds on behalf of the Towner which have been used to purchase or contribute towards the purchase of works of art.

During the 1980s the collection continued to increase in volume and reputation, particularly in two areas. Firstly in 1982, the family of the artist Eric Ravilious (who studied and taught at Eastbourne School of Art) deposited on loan an important body of his work. Secondly, as a result of an agreement made in 1983 with the South East Arts Association for jointly purchasing contemporary art from artists in the region, the Towner now houses the South East Arts Collection of Contemporary Art. Further bequests in 1988 and 1990 resulted in groups of works by David Bomberg and Victor Pasmore entering the collection, whilst once again the Towner's commitment to purchasing contemporary art was recognised nationally during Penny Johnson's tenure as curator (1986–1996).

The Towner has been a member museum of the Contemporary Art Society since the 1950s and has received a number of significant gifts through their regular Distribution Scheme such as Ivon Hitchens' *Evening Sky over Hills*, presented by the Society in 1959, Keith Vaughan's *Standing Figure*, Christopher Le Brun's *Painting, February 1982* and Stephen Farthing's *Louis XIV Rigaud* as well as other works on paper and sculpture. Alongside this association, in 1994 the Towner commenced a three-year pilot phase of the Special Collection Scheme in partnership with the Contemporary Art Society with the aim to build the collection in a more structured and strategic way. This was to be achieved by making significant funds available for the purchase of contemporary works of art by artists of national and international reputation for the first time in the Towner's history, without recourse to *ad hoc* grant-in-aid funding applications. The purchases were made around the specific theme of 'the landscape and the coast' to complement these strengths within the Towner's existing collections. This significant development has resulted in a number of Britain's most accomplished contemporary artists entering the Towner collection, often being the first public collection in Britain for young emerging artists and the first regional collection for those well established enough to be represented within national collections. Major paintings by

Callum Innes, Ian McKeever and John Virtue were purchased at this time with a major public commission of a sculpture by the internationally acclaimed sculptor David Nash marking the culmination of the pilot phase of this project.

Consolidation and planning for the future characterised the development of the collection under Fiona Robertson (1996–1998). Following the death in 1997 of William Gear, Curator of the Towner from 1958–1964, the Towner purchased a small number of significant examples of his work to commemorate his time in Eastbourne. Following the successful pilot phase of the Special Collection Scheme in 1997, the project received Lottery funding, for a wider scheme for 15 museums nationally, including the Towner, to work over five years to build a network of strong regional collections of contemporary art and develop curatorial practice in collecting.

Since 1999, a number of works have been added to the collection through grant-in-aid funding and the support of the Friends of the Towner and other donations. These have included a rare painting by Thomas Jones of the cliffs near Eastbourne, *Coastal Scene with Approaching Storm* dated 1771 and a group of paintings from the 1960s and 1970s to strengthen this area of the collection whilst the market allows it. Artists such as Robyn Denny, Brian Fielding, John Hubbard, Mark Lancaster and John Plumb have all been added to the collection through auction purchases in recent years. Contemporary work has been purchased from two sources. Firstly the temporary exhibition programme often involves the commissioning of new work by artists, in response to the Towner's collection or location, making the resulting work highly appropriate for purchase and following the commissioning fee, eminently affordable. Alongside the exhibition programme the Towner has been a participant in the Contemporary Art Society Special Collection Scheme which has enabled additional significant purchases for the collection to be made over a five year period. Reflecting the state of contemporary art in the 21st century many purchases have been new media or installation based work but paintings by artists such as Elizabeth Magill illustrate this key development for the Towner collection and help demonstrate its unique status as a comprehensive and contemporary collection of visual art for the region.

Matthew Rowe, Curator

Facing page: Ginnett, Louis, 1875–1946, *Mary Ginnett* (detail), Ditchling Museum, (p. 217)

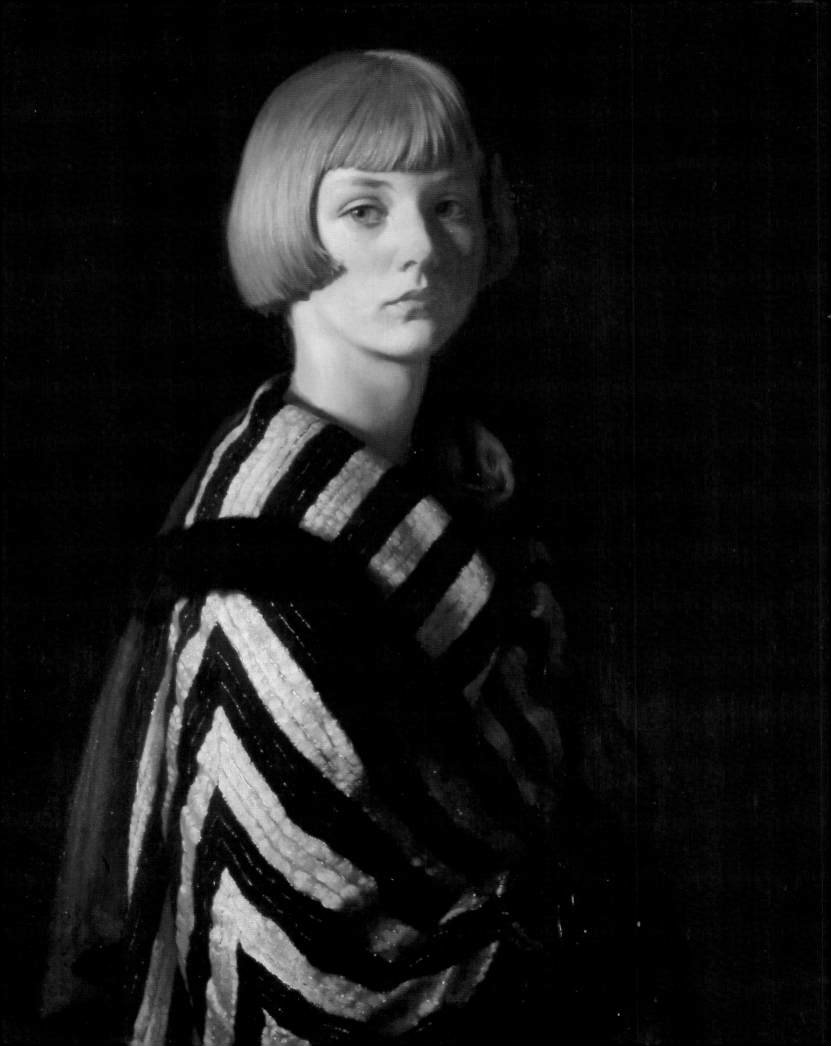

Adkins, Harriette S. active 1906–1914
Tide up at Bosham 1906
oil on canvas 45.7 x 38.4
EASTG 1335

Adkins, Harriette S. active 1906–1914
Roofs of Horsham Stone 1911
oil on canvas 34.5 x 59.5
EASTG 1330

Adkins, Harriette S. active 1906–1914
A Bit of Brighton
oil on wood panel 37.5 x 48.2
EASTG 1350

Adkins, Harriette S. active 1906–1914
Stacks
oil on canvas 19 x 24
EASTG 1366

Aken, Joseph van c.1699–1749
The Music Party c.1725
oil on canvas 75.0 x 62.3
EASTG 1554

Allsopp, Judith b.1943
Number Ten 1967
acrylic on canvas 152.5 x 137.0
EASTG 1321

Alma-Tadema, Lawrence 1836–1912
Negro Head
oil on canvas 43.9 x 43.5
EASTG 1362

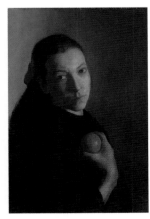

Andrews, Elizabeth d.1978
Annie
oil on canvas 50.8 x 35.5
EASTG 1380

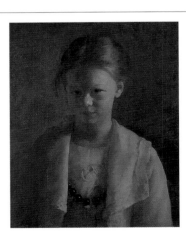

Andrews, Elizabeth d.1978
Portrait
oil on canvas 42.0 x 35.5
EASTG 1197

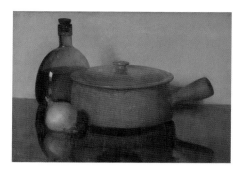

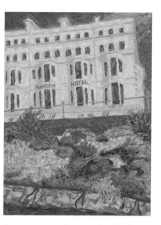

Andrews, Elizabeth d.1978
Still Life
oil on canvas 34.5 x 49.5
EASTG 1194

Armstrong, James b.1946
Mansion Hotel, Spring Arrives 1990/1991
oil on board 51 x 41
SEA 163

Barker, Kit 1916–1988
Cornish Coast 1961
oil on canvas 91.5 x 122.0
EASTG 28

Barratt, Krome 1924–1990
Fenland 1960
oil on board 81 x 61
EASTG 1331

Barry, Francis b.1965
On Land
oil on canvas 183 x 121
SEA 158

Bassano, Francesco II (attributed to)
1549–1592
Nativity Scene: The Adoration of the Shepherds
oil on canvas 81.2 x 103.0
EASTG 1675

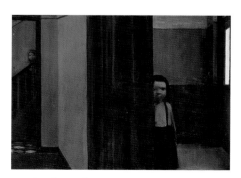

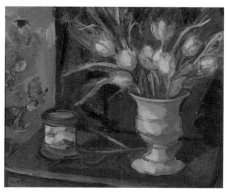

Bassingthwaighte, Lewis b.1928
Interior with Children 1964
oil on canvas 74. 9 x 100.9
EASTG 1342

Batty, Joyce
Seges est ubi troia fuit
oil on canvas 90.0 x 120.5
EASTG 1295

Baynes, Keith 1887–1977
Still Life
oil on canvas 50.8 x 60.9
EASTG 1720

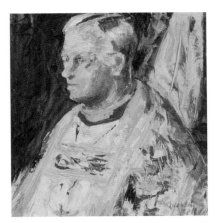

Bell, Quentin 1910–1996
Bishop Bell c.1942
oil on paper 39.0 x 37.2
EASTG 2077

Bell, Trevor b.1930
Summer Painting 1959 1959
oil on canvas 122 x 92
EASTG 1292

Bell, Vanessa 1879–1961
8 Fitzroy Street
oil on canvas 65 x 47
EASTG 1190

Benecke, Margaret d.1962
Composition: Eastbourne 1935 1935
oil on canvas 91 x 76
EASTG 1283

Benecke, Margaret d.1962
Entrance to Saffrons
oil on canvas 43.0 x 46.9
EASTG 1162

Benecke, Margaret d.1962
Glacier Forms
oil on canvas 81.2 x 81.2
EASTG 1340

Benecke, Margaret d.1962
Interior with Figure
oil on canvas 54.5 x 45.5
EASTG 1217

Benecke, Margaret d.1962
Interior with Two Figures
oil on canvas 44.4 x 40.6
EASTG 1384

Benecke, Margaret d.1962
Manor Gardens, Autumn
oil on canvas 50.8 x 50.8
EASTG 1556

Benecke, Margaret d.1962
Roofs, Upperton Gardens
oil on canvas 48.2 x 53.5
EASTG 1371

Bennett, John active 1827–1850
Eastbourne c.1850
oil on canvas 34 x 52
EASTG 1944

Benney, Ernset Alfred Sallis 1894–1966
Tarring Neville in April
oil on board 34.2 x 45.0
EASTG 1163

Berchem, Nicolaes 1620–1683
Landscape with Animals
oil on panel 49.5 x 64.8
EASTG 1594

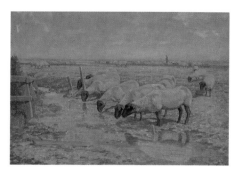

Birch, David 1895–1968
On Pevensey Marshes
oil on canvas 59.5 x 80.0
EASTG 1553

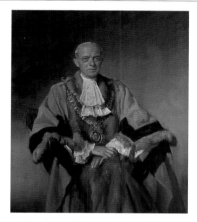

Birley, Oswald Hornby Joseph 1880–1952
*Alderman Arthur Edward Rush, JP, Mayor
(1938–1943)*
oil on canvas 154.4 x 121.9
EASTG 1785

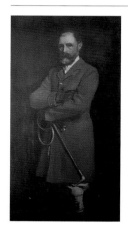

Birley, Oswald Hornby Joseph 1880–1952
*Colonel W. A. Cardwell, Master of Eastbourne
Foxhounds (1895–1910) and Mayor of
Eastbourne (1886–1887)*
oil on canvas 150 x 110
EASTG 1779

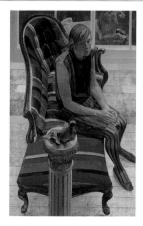

Blamey, Norman Charles 1914–1999
Stripes 1967/1968
oil on board 167.5 x 100.5
EASTG 11

Bles, Herri met de c.1510–after 1550
*Madonna and Child in a Landscape with
St Christopher and St Anthony the Great
(Triptych)*
oil on panel 56.0 x 22.5 (panel 1)
EASTG 1577b

Bles, Herri met de c.1510–after 1550
*Madonna and Child in a Landscape with
St Christopher and St Anthony the Great
(Triptych)*
oil on panel 56 x 45 (panel 2)
EASTG 1577a

Bles, Herri met de c.1510–after 1550
*Madonna and Child in a Landscape with
St Christopher and St Anthony the Great
(Triptych)*
oil on panel 56.0 x 22.5 (panel 3)
EASTG 1577c

Blow, Sandra b.1925
Painting 1962 1962
oil, ash, charcoal & sand on hardboard
119.5 x 111.5
EASTG 1304

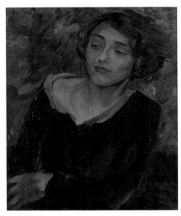

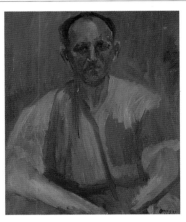

Blum, E.
The Captive Sky 1980
oil on canvas 25.4 x 35.5
EASTG 1548

Bomberg, David 1890–1957
Kitty, the Artist's Sister 1929
oil on canvas 58.5 x 47.6
EASTG 2053

Bomberg, David 1890–1957
Jim 1943 1943
oil on canvas 75.0 x 64.7
EASTG 1664

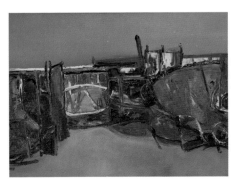

Bonner, George b.1924
Rye Harbour 1960
oil on hardboard 44.0 x 59.5
EASTG 1181

Bonner, George b.1924
Fable 1963
oil on canvas 133.5 x 92.0
EASTG 35

Bonner, George b.1924
Journey into Time I 1964
oil on board 122.0 x 91.5
EASTG 22.1

Bonner, George b.1924
Journey into Time II 1964
oil on board 122.0 x 91.5
EASTG 22.2

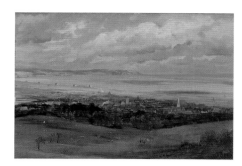

Borrow, William Henry 1840–1905
Eastbourne 1882
oil on canvas 19.5 x 29.5
EASTG 2148

Boshier, Derek b.1937
Vista City 1964
oil on canvas 198 x 303
EASTG 2241

Boswell, James 1906–1971
The Southern Edge 1961
oil on canvas 81 x 61
EASTG 1338

Bowen, Denis b.1921
Bronze Barrier
oil on canvas 121.9 x 60.9
EASTG 1345

Bradshaw, Gordon
Landscape 1961
oil on canvas 91.5 x 101.5
EASTG 1284

Brett, B. active c.1841–1918
Fishermen's Huts, the Crumbles, Eastbourne 1918
oil on canvas 50 x 60
EASTG 1210

British (English) School 19th C
Lieutenant Colonel Jarvis
oil on canvas 137.1 x 101.6
EASTG 9

British (English) School 20th C
Boats in Harbour
oil on canvas 46 x 61

British (English) School 20th C
The Football Match
oil on canvas 83.8 x 173.1
EASTG 16

Broughton, Kevin b.1962
Dialogue I
oil on canvas 171 x 224
SEA 166

Brouwer, Adriaen (circle of) 1605/1606–1638
Pastoral Scene with Children and Animals
oil on canvas 70 x 78 (E)
EASTG 1674

Bruford, Marjorie Frances b.1902
In the Flower Field 1934
oil on canvas 60 x 44
EASTG 1237

Calkin, Lance 1859–1936
*Alderman Sir Charles O'Brien Harding, JP,
MRCS, LRCP, Honorary Freeman (Admitted
1919), Mayor of Eastbourne (...)*
oil on canvas 124.0 x 99.0
EASTG 1777

Callam, Edward 1904–1980
Canal Wharf near Tring
oil on hardboard 50.8 x 60.9
EASTG 1152

Callow, William 1812–1908
*Coastal Scene, Fishermen Unloading Their
Catch*
oil on canvas 89.0 x 124.5
EASTG 8

Camp, Jeffery b.1923
Beachy Head, White Windswept Prospect 1979
oil on canvas 102 x 102
EASTG 32

Camp, Jeffery b.1923
Bluebells 1986
oil on chipboard 23 x 122
SEA 129

Carter, Bernard Arthur Ruston
(Sam) b.1909
Nude on Blue 1968
oil on canvas 99 x 126
EASTG 23

Cecconi, Lorenzo 1863–1947
Italian Interior with Two Figures
oil on canvas 40 x 62
EASTG 1147

Charlton, Mervyn b.1945
Prospero's Island 1982
acrylic on canvas 101 x 36
SEA 3

Chubb, Shirley b.1959
Inequality
photocopies, acrylic, PVA & gold leaf on
canvas 102 x 140
SEA 171

Clarke, Thomas Flowerday
active c.1930–1960
On Brighton Beach
oil on canvas 49 x 59
EASTG 1227

Clarkson, William H. 1872–1944
A Downland Park
oil on canvas 59.5 x 90.0
EASTG 1239

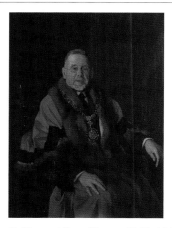

Cole, John 1903–1975
Priory Farm with St Philip Neri, Arundel
oil on board 39.5 x 50.0
EASTG 1231

Cole, Rex Vicat 1870–1940
Brooks of Bramber (Bramber Meadows) 1916
oil on panel 29.0 x 38.5
EASTG 1377

Collings, Albert Henry 1858–1947
Alderman Henry William Keay, JP, Mayor
(1893–1894, 1898–1901 & 1906–1908)
oil on canvas 140 x 112
EASTG 2288

Collins, Cecil 1908–1989
Dawn Invocation 1968
oil on board 105 x 121
EASTG 2238

Colquhoun, Robert 1914–1962
Woman and Goat 1948
oil on canvas 29.5 x 25.0
EASTG 1358

Cooper, Thomas Sidney 1803–1902
Cattle and Sheep 1850
oil on panel 35.5 x 30.0
EASTG 1557

Couch, Christopher b.1946
Preliminary Sketch for 'Saturday'
oil on paper 61.5 x 50.0
SEA 8

Coutts-Smith, Kenneth b.1929
Painting 1963
oil on canvas 90.0 x 87.5
EASTG 1337

Crozier, William b.1930
Landscape No.14
oil on canvas 91.5 x 76.5
EASTG 1975

Cuming, Frederick b.1930
Studio, Early Morning 1968
oil on hardboard 119 x 119
EASTG 1159

Cumming, James b.1922
Paraffin Carrier
oil on canvas 100 x 75
EASTG 1298

Cuthbert, Alan 1931–1995
EV from MSI
oil on canvas 60.5 x 61.0
EASTG 1216

Dane, Clemence 1888–1965
View of Midhurst 1950
oil on canvas 14.5 x 19.5
EASTG 1368

Darragh, Stephen
Untitled
oil on canvas 33.0 x 28.5
SEA 132

Darragh, Stephen
Untitled
oil on wood 21.5 x 26.5
SEA 133

Davie, Alan b.1920
Sea Gate 1960
oil on canvas 51 x 61
EASTG 1234

Dawson, Henry 1811–1878
The Bird Trap 1851
oil on panel 55.5 x 44.5
EASTG 1102

de Grey, Roger 1918–1995
Beckley Hill, Kent
oil on canvas 100 x 100
EASTG 1297

De Karlowska, Stanislawa 1876–1952
Barrage Balloons
oil on canvas 60.0 x 50.5
EASTG 1326

Denny, Robyn b.1930
Night out 1958
oil on board 122 x 122
EASTG 2237

Denny, Robyn b.1930
Apart (Here and Then Series)
oil on canvas 239 x 188
EASTG 2278

Dickson, Jennifer b.1936
Crucifixion 1961
oil on hardboard 120.5 x 60.0
EASTG 1343

Dobson, S.
Zebra Crossing
oil on canvas 66 x 51
EASTG 153

Douglas-Thompson, Marguerite 20th C
Search 1969
acrylic on paper 27.3 x 38.1
EASTG 2055

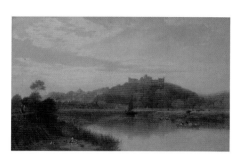

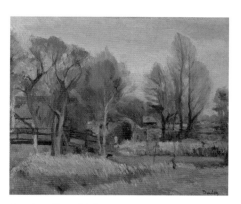

Downing, Nigel b.1964
Follow through 1992
oil on board 178.1 x 122.0
EASTG 2127

Duncan, Edward 1803–1882
Arundel Castle
oil on canvas 86.3 x 129.5
EASTG 1568

Dunlop, Ronald Ossory 1894–1973
September Landscape
oil on canvas 62.2 x 74.2
EASTG 738

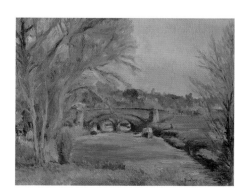

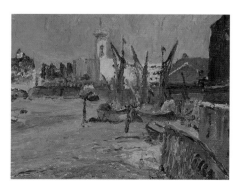

Dunlop, Ronald Ossory 1894–1973
The Arun at Pulborough
oil on canvas 60.0 x 75.5
EASTG 1158

Dunlop, Ronald Ossory 1894–1973
The Thames at Lambeth
oil on canvas 39.5 x 65.8
EASTG 1209

Dutton, Chris
Reverend Thomas Pitman, Vicar of Eastbourne
oil on canvas 150 x 110
EASTG 1774

Facing page: Bell, Vanessa, 1879–1961, *Charleston* (detail), c.1950–1955, Charleston, (p.326)

Erici (Cherry), K.
Flower 1950
oil on canvas 32 x 23
EASTG 1360

Erici (Cherry), K.
Still Life 1950
oil on canvas 23 x 34
EASTG 1357

Etchells, Frederick 1886–1973
A Group of Figures
oil on board 48.2 x 55.9
EASTG 1191

Evans, Merlyn Oliver 1910–1973
The Orchestra Pit, Covent Garden 1959
oil on canvas 101.6 x 74.9
EASTG 36

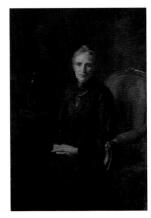

Eves, Reginald Grenville 1876–1941
Portrait of the Artist's Mother 1912
oil on canvas 144.7 x 40.0
EASTG 13

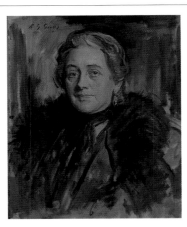

Eves, Reginal Grenville 1876–1941
Mrs W. P. H. Pollock
oil on canvas 59.5 x 49.5
EASTG 1208

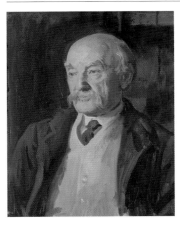

Eves, Reginald Grenville 1876–1941
Thomas Hardy
oil on canvas 63.5 x 51.0
EASTG 1103

Eyton, Anthony John Plowden b.1923
Pitgliano III
oil on canvas 75.0 x 125.5
EASTG 1346

Farthing, Stephen b.1950
Louis XIV Rigaud
oil, metal leaf & enamel on canvas
182.7 x 122.0
EASTG 1694

Farthing, Stephen b.1950
Monument to a Musician
oil on canvas 156 x 156
SEA 30

Feiler, Paul b.1918
Eastbourne Front from the Pier 1945
oil on board 40 x 53
EASTG 1382

Fell, Sheila Mary 1931–1979
Misty Evening, Cumberland
oil on canvas 71.1 x 91.4
EASTG 1299

Fenton, F. M.
The River
oil on hardboard 39.5 x 49.5
EASTG 1165

Fenton, F. M.
The Siesta
oil on canvas 49.5 x 39.0
EASTG 1186

Fielding, Brian 1933–1987
Partsong No.4 1979
oil on canvas 204.0 x 190.5
EASTG 2236

Finn, Doreen b. c.1905
Abstract
oil on hardboard 121.9 x 91.4
EASTG 1308

Finn, Doreen b. c.1905
Adventure
oil on hardboard 71.0 x 53.3
EASTG 1332

Finn, Doreen b. c.1905
Aggression
oil on board 113.0 x 150.5
EASTG 46

Finn, Doreen b. c.1905
Camouflage
oil on canvas 91.4 x 121.9
EASTG 1310

Finn, Doreen b. c.1905
Crescendo
oil on hardboard 97 x 122
EASTG 1307

Finn, Doreen b. c.1905
From a Landscape
acrylic on canvas 58.5 x 48.5
EASTG 1228

Finn, Doreen b. c.1905
Landscape
oil on board 23.5 x 19.5
EASTG 1389

Finn, Doreen b. c.1905
No.9
oil on board 63.5 x 35.4
EASTG 1459

Finn, Doreen b. c.1905
No.17
oil on board 58.4 x 48.2
EASTG 1442

Finn, Doreen b. c.1905
Painting
oil on hardboard 50.0 x 34.5
EASTG 1386

Finn, Doreen b. c.1905
The Gorseway
oil on canvas 35.5 x 50.8
EASTG 1347

Finn, Doreen b. c.1905
Untitled
oil on canvas 121.9 x 154.9
EASTG 45

Finn, Doreen b. c.1905
Untitled
oil on canvas 144.7 x 182.8
EASTG 1318

Finn, Doreen b. c.1905
Untitled
oil on hardboard 101.6 x 76.2
EASTG 1324

Finn, Doreen b. c.1905
Untitled
oil on hardboard 58.4 x 81.0
EASTG 1325

Finn, Doreen b. c.1905
Untitled
oil on hardboard 46.5 x 29.0
EASTG 1381

Finn, Doreen b. c.1905
Untitled
oil on hardboard 48.0 x 40.5
EASTG 1387

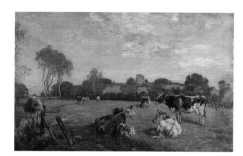

Fisher, Mark 1841–1923
Pevensey Castle
oil on canvas 122.5 x 194.5
EASTG 737

Fisher, Myrta 1917–1999
Table with Lamp, Mug and Bowl
acrylic on canvas 59.5 x 74.5
EASTG 1192

Flint, Geoffrey b.1919
Cruciform II 1961
oil on hardboard 61 x 51
EASTG 1328

Follis, Beatrice
Flowers II
acrylic on canvas 28.5 x 26.0
EASTG 1435

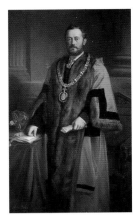

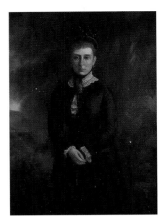

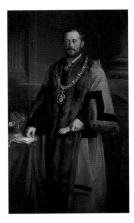

Gales, Henry active 1856–1886
G. A. Wallis, First Mayor of Eastbourne 1856
oil on canvas 110.5 x 67.5
EASTG 1969

Gales, Henry active 1856–1886
HRH Princess Alice, Daughter of Queen Victoria 1878
oil on canvas 143 x 107
EASTG 2179

Gales, Henry active 1856–1886
Reproduction of Portrait of G. A. Wallis, First Mayor of Eastbourne 1886
oil on canvas 182.8 x 106.7
EASTG 1743

Gales, Henry active 1856–1886
Alderman James Arthur Skinner
oil on canvas 81.2 x 58.4
EASTG 1224

Gales, Henry active 1856–1886
The First Mayor, Aldermen and Clerk of the Borough of Eastbourne (1883–1884)
oil on canvas 90 x 180
EASTG 1781

Garwood, Tirzah 1908–1951
Hornet with Wild Roses 1950
oil on canvas 30.5 x 40.5
EASTG 1353

Garwood, Tirzah 1908–1951
Orchid Hunters in Brazil 1950
oil on canvas 30.5 x 40.5
EASTG 1352

Gear, William 1915–1997
Composition Blue Centre 1949
oil on canvas 50 x 65
EASTG 2263

Gear, William 1915–1997
Winter Landscape 1949
oil & gouache on paper 47.0 x 66.8
EASTG 2197

Gear, Willam 1915–1997
Landscape Composition 1951
oil on canvas 55 x 43
EASTG 2191

Gear, William 1915–1997
Untitled 1959
acrylic on paper 21.0 x 30.5
EASTG 2045

Gear, William 1915–1997
Vertical Feature, September 1961 1961
oil on canvas 152 x 90
EASTG 40

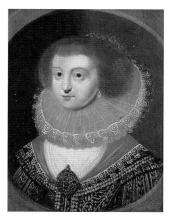

**Geeraerts, Marcus the elder
(attributed to)** c.1520–before 1604
Portrait of a Lady
oil on panel 25 x 19
EASTG 1547

Gerrard, Kaff 1894–1970
Sussex Landscape
oil on board 30.3 x 40.0
EASTG 2123

Gibb, Harry Phelan 1870–1948
Paysage 1907
oil on card 53.1 x 44.0
EASTG 1438

Gibb, Harry Phelan 1870–1948
Group of Nude Women Bathers 1909
oil on canvas 114.0 x 78.5
EASTG 1251

Gibb, Harry Phelan 1870–1948
Three Graces 1911
oil on cardboard 130 x 100
EASTG 1244

Gibb, Harry Phelan 1870–1948
Rose Nudes 1913
oil on canvas 80.0 x 115.5
EASTG 1252

Gibb, Harry Phelan 1870–1948
Six Nudes in Landscape 1915
oil on canvas 152.5 x 138.0
EASTG 1315

Gibb, Harry Phelan 1870–1948
Rose Nudes in Landscape
oil on canvas 137 x 244
EASTG 1314

Gibb, Harry Phelan 1870–1948
Study of Four Women
oil on canvas 79.0 x 115.5
EASTG 1525

Gladwell, Rodney 1928–1979
Night Voyage 1953
oil on patterned lace material 34.0 x 49.5
EASTG 1266

Gladwell, Rodney 1928–1979
Chrysanthemums 1957
oil on hardboard 89.5 x 69.5
EASTG 1177

Gladwell, Rodney 1928–1979
Abstract Head 1960
oil on hardboard 121 x 121
EASTG 1245

Gladwell, Rodney 1928–1979
*This is a Life Created, Flowing Spirit I Am
Much* 1962
oil on canvas 150 x 124
EASTG 1240

Gladwell, Rodney 1928–1979
Half-Length Male Nude
oil on canvas 76.2 x 60.0
EASTG 1517

Gladwell, Rodney 1928–1979
Male Figures
oil on board 182.5 x 84.5

Facing page: Eurich, Richard Ernst, 1903–1992, *The Mummers* (detail), 1952, Brighton and
Hove Museums and Art Galleries, (p. 78)

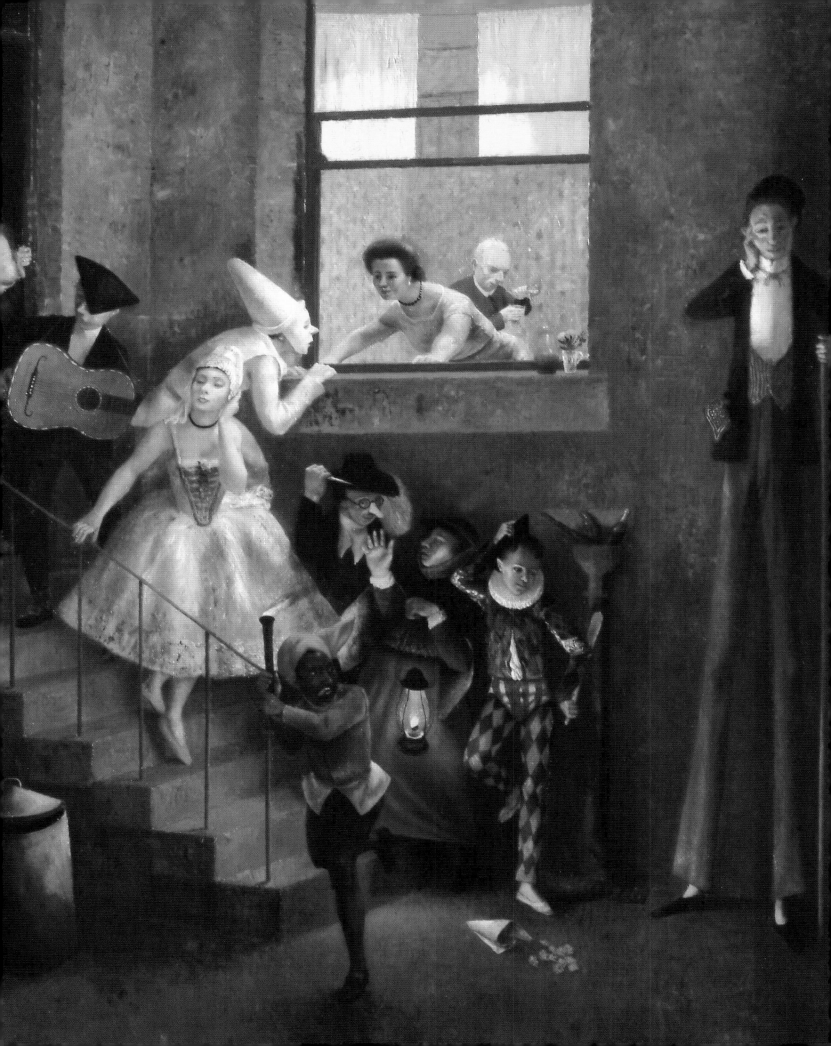

Gladwell, Rodney 1928–1979
Mushrooms
oil on hardboard 107.5 x 107.5
EASTG 1247

Glogan, Jeremy
Untitled
oil on canvas 136 x 185
SEA 168

Gogin, Charles 1844–1931
Avard's Farm, Walberton
oil on canvas 44.0 x 59.5
EASTG 1219

Gommon, David 1913–1987
Music Hall
oil on canvas 68.0 x 81.5
EASTG 1253

Goodall, Frederick 1822–1904
Gypsy Encampment 1848
oil on board 27 x 34
EASTG 1101

Goodman, Gary b.1959
Double Portrait of Teresa with Tilda and Tintin 1994
acrylic on paper 143 x 103
SEA 186

Gosse, Laura Sylvia 1881–1968
Grande patisserie, Place Nationale, Dieppe 1930
oil on canvas 42.0 x 57.5
EASTG 1188

Gosse, Laura Sylvia 1881–1968
The Column, Aix-en-Provence
oil on canvas 72.5 x 39.5
EASTG 1198

Graham, George 1881–1949
Hastings Beach with Sailing Boats
oil on board 16.5 x 24.5
EASTG 1363

Grant, Duncan 1885–1978
Study for a Portrait of Bishop Bell 1941
oil on canvas 57 x 50
EASTG 2242

Grant, Duncan 1885–1978
The Glade, Firle Park 1943
oil on canvas 71.1 x 50.8
EASTG 1174

Grant, Duncan 1885–1978
Still Life 1957
oil on wood panel 37.0 x 50.8
EASTG 1189

Grant, Keith b.1930
Pyramid Peak IV
oil on canvas 86.5 x 117.0
SEA 32

Griffiths, Hugh b.1916
*Early Spring, Distant View of Battle and
Telham Mills* 1952
oil on canvas 71.1 x 91.4
EASTG 21

Griffiths, Hugh b.1916
Landscape 1983
acrylic on canvas 28 x 35
EASTG 1766

Griffiths, Hugh b.1916
Flowering Thorn
oil on canvas 75.0 x 62.5
EASTG 1341

Griffiths, Joy b.1919
City Crossroads 1961
oil on hardboard 60.0 x 80.5
EASTG 1203

Griffiths, Joy b.1919
A Branch of Blossom
oil on canvas 30.4 x 25.4
EASTG 158

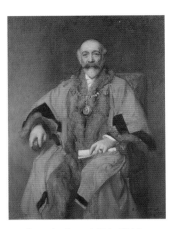

Guy, G. G. d.1978
Fishing Station, Eastbourne
oil on hardboard 34.5 x 44.5
EASTG 1378

Hacker, Arthur 1858–1919
Alderman J. A. Skinner, Mayor of Eastbourne (1895–1897)
oil on canvas 150 x 134
EASTG 1776

Hall, Kenneth 1913–1947
Buckingham Palace from the Mall
oil on canvas 76 x 101
EASTG 1526

Hall, Kenneth 1913–1947
Cap d'Ail
oil on canvas 61.0 x 74.5
EASTG 1257

Hall, Kenneth 1913–1947
Trafalgar Square
oil on canvas 150 x 126
EASTG 1928

Hall, Oliver 1869–1957
Burton Park, Sussex
oil on canvas 54.5 x 70.0
EASTG 1560

Haynes-Williams, John 1836–1908
Salle ovale, Fontainbleau
oil on canvas 49.5 x 57.0
EASTG 1230

Hayter, Stanley William 1901–1988
Coast of Erehwon 1959
oil on canvas 129.5 x 132.0
EASTG 25

Haywood, Ann b.1931
Roof Tops in Snow
gouache & tempera on paper 28.0 x 39.5
EASTG 1715

Hemming, Adrian b.1945
Arizona Ridge
oil on canvas 168.5 x 117.5
SEA 36

Henry, George F. 1858–1943
Landscape
oil on canvas 39.5 x 49.5
EASTG 1383

Herring, John Frederick I 1795–1865
The Blacksmiths 1842
oil on canvas 54.5 x 76.0
EASTG 1519

Herring, John Frederick I 1795–1865
Cattle and Ducks 1859
oil on canvas 101.5 x 127.0
EASTG 41

Herring, John Frederick I 1795–1865
Farm Scene with Cart Horses
oil on canvas 49.5 x 75.0
EASTG 1559

Herring, John Frederick I 1795–1865
*Study of the Horse B. G., West Australian
Winner of the Derby and St Leger 1853*
oil on canvas 45.0 x 60.5
EASTG 1555

Hider, Frank c.1861–1933
Splash Point, Eastbourne 1894 1894
oil on canvas 29.0 x 49.4
EASTG 1376

Hilton, Roger 1911–1975
Painting, May 1961 1961
oil on canvas 76.0 x 91.5
EASTG 1339

Hitchens, Ivon 1893–1979
Evening Sky over Hills 1957
oil on canvas 40.6 x 109.2
EASTG 1287

Hitchens, John b.1940
Duncton Down in Shadow 1964
oil on canvas 40.0 x 85.5
EASTG 1180

Hodgkins, Frances 1869–1947
Cedric Morris (Man with Macaw) 1930
oil on canvas 63.5 x 52.5
EASTG 1262

Hodgkins, Frances 1869–1947
Flatford Mill
oil on canvas 58.5 x 72.0
EASTG 1263

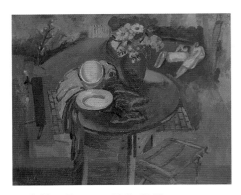

Hodgkins, Frances 1869–1947
Still Life
oil on canvas 62 x 75
EASTG 1260

Holles, Annelise b.1963
Recollections: Dressing Table 1997
oil on canvas 92 x 107
SEA 192

Holles, Annelise b.1963
Recollections: Mirror 1997
oil on canvas 91.5 x 95.0
SEA 193

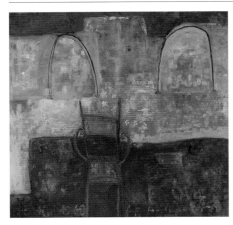

Holloway, Rachel
The Horn Chair
oil on board 180 x 180
SEA 167

Holt, Pamela
Wild Daffodils 1968
oil on hardboard 99 x 92
EASTG 1289

Horton, Percy Frederick 1897–1970
Village in Luberon
oil on canvas 43.1 x 58.4
EASTG 1172

Howard, Charles Houghton 1899–1978
Painting 61–62 No.3 1961/1962
oil on canvas 76.0 x 106.5
EASTG 1281

Hubbard, Eric Hesketh 1892–1957
Rye
oil on canvas 58 x 55
EASTG 1160

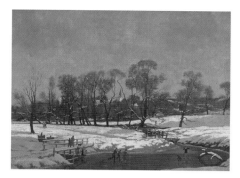

Hubbard, Eric Hesketh 1892–1957
Snow at Litlington
oil on canvas 44.0 x 59.5
EASTG 1238

Hubbard, John b.1931
Water Painting: Sandbanks 1977
oil on canvas 147.0 x 101.5
EASTG 2246

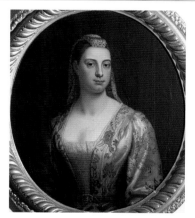

Hudson, Thomas (school of) 1701–1779
The Hon. Mrs Plummer
oil on canvas 74 x 61
EASTG 1551

Hugonin, James b.1950
Study for Untitled IV 1990–1991
oil & wax on wood 43.4 x 42.0
EASTG 2240.1

Huysmans, Jacob (attributed to)
c.1633–1696
*Arcadian Landscape with Shepherd and Other
Pastoral Figures in Background*
oil on canvas 62.3 x 76.2
EASTG 1673

Hyman, Timothy b.1946
The Procession (Sandown Race Course) 1992
oil on gesso-primed paper 70.0 x 99.5
SEA 184

Innes, Callum b.1962
Exposed Painting, Cadmium Orange 1996
oil on canvas 170 x 160
EASTG 2180

Jackowski, Andrzej b.1947
Downfalling 1983
oil on canvas 172 x 157
SEA 115

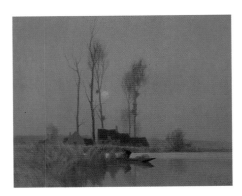

Jacob, Alexandre 1876–1972
Misty Morning 1953
oil on hardboard 33 x 41
EASTG 2019

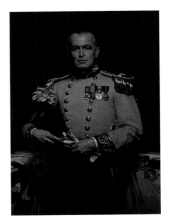

Jagger, Charles Sargeant 1885–1934
Alderman Lieutenant Colonel Roland Vaughan Gwynne, DSO, DL, JP, Mayor of Eastbourne (1928–1931)
oil on canvas 140 x 81
EASTG 1783

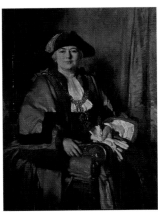

Jagger, Charles Sargeant 1885–1934
Alderman Miss Alice Hudson, JP, Mayor of Eastbourne (1925–1928 & 1943–1945)
oil on canvas 152.4 x 91.4
EASTG 1782

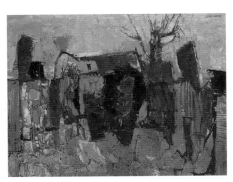

James, Louis b.1920
Suburban Landscape
oil on canvas 57.1 x 72.3
EASTG 1695

Jefferson, Anna b.1965
On the Pier 1986
oil on canvas 162 x 127
SEA 136

Jensen, Michael
Amen
oil on board 45.7 x 66.0
EASTG 1182

Johnson, Nick b.1941
Lurcher
oil on board 37.5 x 54.0
SEA 148

Jones, David 1895–1974
Sea View 1930
oil on board 48 x 58
EASTG 2100

Jones, Olwen b.1945
Cucumber Plants
oil on canvas 59 x 49
EASTG 1953

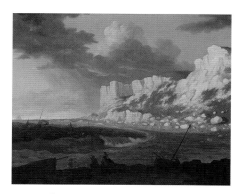

Jones, Thomas 1742–1803
Coast Scene with Approaching Storm 1771
oil on canvas 62 x 75
EASTG 2218

Kirk, S. G.
Eastbourne Town Hall 1888
oil on canvas 49.5 x 59.5
EASTG 1207

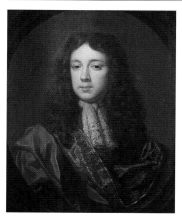

Kneller, Godfrey (studio of) 1646–1723
Portrait of a Man
oil on canvas 76.2 x 62.8
EASTG 1593

Knight, Charles 1901–1990
Ditchling Beacon c.1930s
oil on canvas 71.0 x 91.5
EASTG 1148

Knight, John William Buxton
1842/1843–1908
Cousin Annie
oil on board 34.5 x 27.4
EASTG 2115

Knight, Keith b.1946
Spectral Bands 1984
acrylic on newsprint & canvas 127 x 127
SEA 117

Knight, Loxton 1905–1993
Birling Gap
oil on canvas 36.5 x 74.5
EASTG 1193

Knight, Loxton 1905–1993
Seven Sisters
oil on canvas 34.0 x 74.5
EASTG 1211

Kolle, Helmut 1899–1931
Boy with Bird
oil on canvas 99 x 80
EASTG 1256

Kolle, Helmut 1899–1931
Bullfight
oil on canvas 78.5 x 113.5
EASTG 1254

Kulkarni, Lara Nita b.1967
Untitled 1991
oil on canvas 197 x 182
SEA 178

Lake, John Gascoyne 1903–1975
An Eastbourne Garden (A Garden in the Provinces)
oil on canvas 73.5 x 54.5
EASTG 1233

Lancaster, Mark b.1938
Diet
oil on canvas 153 x 153
EASTG 2254

Lander, Rachel b.1971
Under the Rose 1994
acrylic on canvas 91.5 x 106.5
SEA 191

La Thangue, Henry Herbert 1859–1929
Portrait of a Young Girl c.1880
oil on hardboard 43.0 x 30.5
EASTG 1204

Lawrenson, Edward Louis 1868–1940
The Last Sussex Team c.1925
oil on canvas 63.5 x 76.2
EASTG 1497

Le Brun, Christopher b.1951
Painting, February 1982 1982
oil on canvas 45.0 x 55.5
EASTG 2129

Lessore, Thérèse 1884–1945
Walcot Church, Bath
oil on canvas 76.2 x 50.8
EASTG 1149

Lewis, Gomer b.1921
Untitled 1964
oil on hardboard 39.0 x 119.5
EASTG 1294

Lewis, Gomer b.1921
Forest 1967
oil on hardboard 117.0 x 147.5
EASTG 1613

Littlejohn, William b.1929
Night Window 1967
oil on canvas 152.5 x 152.5
EASTG 1319

Lloyd, Thomas James 1849–1910
Milk for the Calves 1881
oil on canvas 86 x 160
EASTG 15

Lloyd, Walker Stuart active 1875–1913
The Ferry 1900
oil on canvas 95 x 161
EASTG 7

Loftus, Barbara b.1946
Unanswered Call 1978
acrylic on board 72.0 x 57.5
SEA 51

Lord, Sarah b.1964
Western Wind 1987/1988
oil on board 41 x 46
SEA 154

Lord, Sarah b.1964
Harbour 1988/1989
oil on board 33.5 x 40.0
SEA 155

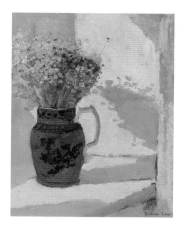

Low, Diana 1911–1975
Still Life with Brown Jug
oil on canvas 41.2 x 33.3
EASTG 2124

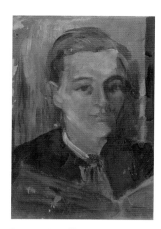

Lucas, Caroline Byng c.1886–1967
Admiral Lucas VC as a Young Man
oil on canvas 29.2 x 20.9
EASTG 1365

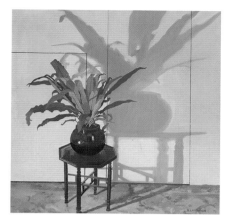

Lumsden, Bryan
Interior with Plant 1975
oil on canvas 70.5 x 70.5
EASTG 1235

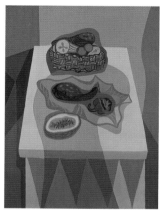

MacBryde, Robert 1913–1966
A Vegetable Still Life
oil on canvas 76.2 x 63.5
EASTG 1282

MacLagan, Philip Douglas 1901–1971
Bramber, from the South Downs 1931
oil on canvas 63.5 x 76.2
EASTG 1698

Magill, Elizabeth b.1959
Overhead 3 2002
oil on canvas 183.0 x 213.5
EASTG 2261

Mann, Alexander 1853–1908
On the Berkshire Downs
oil on canvas 50 x 65
EASTG 1226

Manson, James Bolivar 1879–1945
Edith Matthews, née Meredith
oil on canvas 185.5 x 89.0
EASTG 44

Manson, James Bolivar 1879–1945
S. F. Markham Esq.
oil on canvas 104.6 x 84.5
EASTG 1302

Facing page: Grant, Duncan, 1885–1978, *Adrian Stephen* (detail), c.1910, Charleston, (p.331)

March, Maria Elizabeth
The Parish Church, Eastbourne
oil on board 64.7 x 80.0
EASTG 1205

Marston, Freda 1895–1949
Flood the Amberley
oil on canvas 40.6 x 59.8
EASTG 1167

Martin, Nicholas b.1957
Impasse III 1983
acrylic on paper 60 x 53
SEA 53

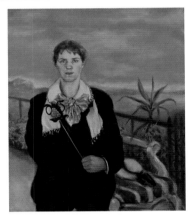

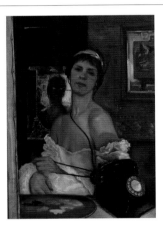

Martin, Nicholas b.1957
Untitled 1983
acrylic on paper 86.5 x 54.0
SEA 54

McCaffrey, Angela b.1962
Connoisseur of Charlatan
oil on canvas 107.0 x 92.5
SEA 176

McCaffrey, John b.1961
Information is Power
oil on canvas 122 x 92
SEA 177

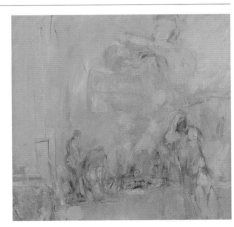

McClure, David 1926–1998
Horsemen and Icons
oil on hardboard 59 x 89
EASTG 1286

McKeever, Ian b.1946
Door Painting No.10 1991/1993
acrylic & oil on canvas 200 x 140
EASTG 2164

Medley, Robert b.1905
Figures in Movement 1962
oil on canvas 124.5 x 122.0
EASTG 31

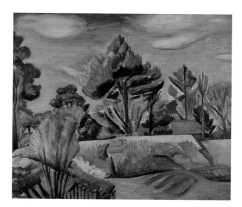

Meninsky, Bernard 1891–1950
Landscape
oil on canvas 62.5 x 75.5
EASTG 1229

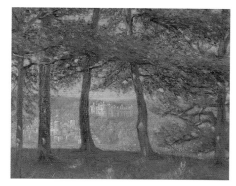

Meo, Gaetano 1849–1925
Arundel Castle, Looking from the Back of the Railway Station
oil on wood panel 26.0 x 34.3
EASTG 1361

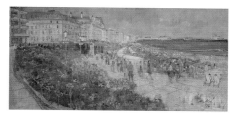

Miller, Robert b.1910
Eastbourne Front 1976
acrylic on canvas 59.0 x 120.5
EASTG 1498

Mills, Clive b.1964
Untitled
oil on canvas 198 x 213
SEA 137

Minton, John 1917–1957
Spanish Village c.1950
oil on hardboard 66.0 x 43.1
EASTG 1327

Mockford, Harold b.1932
Eastbourne 1958
oil on hardboard 86.3 x 116.8
EASTG 1309

Mockford, Harold b.1932
Chalk Pit in the Downs 1961
oil on board 89.5 x 120.0
EASTG 34

Mockford, Harold b.1932
The Little Park (Motcombe Park) 1967
oil on board 89.0 x 119.5
EASTG 1696

Mockford, Harold b.1932
Cars at Birling Gap 1969
oil on board 120.6 x 120.6
EASTG 2062

Mockford, Harold b.1932
Runner on the Downs 1969
oil on hardboard 60.3 x 45.0
EASTG 2058

Mockford, Harold b.1932
The Level Crossing (Crossing between Hailsham/ Stonecross) 1973
oil on hardboard 121.9 x 91.4
EASTG 1290

Mockford, Harold b.1932
The Windbreak 1974/1975
oil on hardboard 91.4 x 121.9
EASTG 1296

Mockford, Harold b.1932
The Sick Man 1978
oil on hardboard 121.9 x 106.6
EASTG 1305

Mockford, Harold b.1932
When the Lights Come on 1989
oil on canvas 95 x 122
EASTG 2158

Mockford, Harold b.1932
Belle toute
oil on hardboard 119 x 119
EASTG 1306

Mockford, Harold b.1932
Bon Voyage Sardinia Vera
oil on canvas 39 x 39
EASTG 2280

Monnington, Walter Thomas 1902–1976
Design on Route 5
oil on canvas 200 x 90
EASTG 1312

Morris, Cedric Lockwood 1889–1982
Herstmonceux Church 1928
oil on canvas 68.5 x 81.2
EASTG 1183

Morris, Cedric Lockwood 1889–1982
Proud Lilies 1931
oil on panel 44.5 x 39.5
EASTG 1982

Mortimer, John Hamilton 1740–1779
Self Portrait in Character c.1775–1778
oil on canvas 60.9 x 49.6
EASTG 1539

Mortimer, John Hamilton 1740–1779
*Mary, Second Wife of Reverend Henry
Lushington, DD* 1777
oil on canvas 76.2 x 63.5
EASTG 1541

Mortimer, John Hamilton 1740–1779
Reverend Henry Lushington, DD 1777
oil on canvas 76.2 x 63.5
EASTG 1542

Müller, William James 1812–1845
The Temple of Theseus 1839
oil on canvas 54.5 x 75.0
EASTG 1146

Mundy, Henry b.1919
Enclosed 1960 1960
oil on hardboard 150.0 x 157.5
EASTG 1320

Munnings, Alfred James 1878–1959
Beach Scene 1905
oil on canvas 55.8 x 68.5
EASTG 1169

Murray, David 1849–1933
Fittleworth
oil on card 38.1 x 45.7
EASTG 1372

Murray, David 1849–1933
Ludlow Castle
oil on canvas 114 x 128
EASTG 1569

Murray, David 1849–1933
Music by the Lake
oil on canvas 76.2 x 91.4
EASTG 5

Murray, David 1849–1933
Remains of Bygone Days
oil on canvas 117 x 132
EASTG 10

Murray, David 1849–1933
Springtime in the Woods
oil on canvas 151.0 x 100.8
EASTG 12

Musscher, Michiel van (attributed to)
1645–1705
The Hope Family of Rotterdam
oil on canvas 106.6 x 129.5
EASTG 1546

Mytens, Daniel I (after) c.1590–before 1648
Portrait of a Man thought to be Viscount Falkland
oil on canvas 73.5 x 60.5
EASTG 1562

Narbeth, William Arthur 1893–1961
Marar Waterfall
oil on canvas 60.9 x 91.4
EASTG 1322

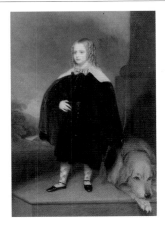

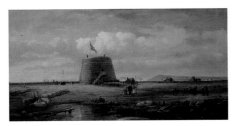

Nash, John Northcote 1893–1977
Disused Canal, Wormingfold
oil on canvas 58.7 x 73.0
EASTG 2072

Newton, William John 1785–1869
Scottish Child and Dog 1839
oil on ivory 30.4 x 21.5
EASTG 1707

Nibbs, Richard Henry 1816–1893
Pevensey, Showing a Soldier in the Uniform of the North Pevensey Legion Raised by Lord Sheffield in 1803
oil on canvas 60.0 x 110.8
EASTG 1288

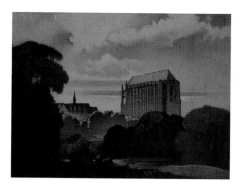

Nicholls, Bertram 1883–1974
Lancing Chapel
oil on canvas 38.1 x 49.5
EASTG 1179

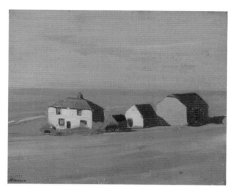

Nicholson, William 1872–1949
Judd's Farm 1912
oil on panel 33 x 41
EASTG 2168

O'Connor, John 1830–1889
Dawn near East Coast
oil on canvas 59.3 x 74.5
EASTG 2076

O'Neil, Henry Nelson 1817–1880
Portrait of a Girl
oil on canvas 76.2 x 55.8
EASTG 1724

Orrock, James 1829–1913
Showery Weather 1890
oil on board 29.0 x 44.5
EASTG 1348

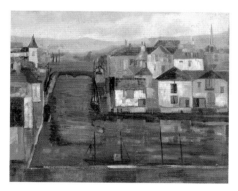

Owen, Mary
The Backwater, Weymouth 1963
oil on board 62.2 x 75.0
EASTG 48

Oxlade, Roy b.1929
Blue Flowers 1994
oil on canvas 133 x 177
SEA 181

Oxtoby, David b.1938
That's Alright
acrylic on board 90 x 121
EASTG 27

Pace, Percy Currall active 1898–1936
Victoria Drive
oil on canvas 60.9 x 91.4
EASTG 19

Palmer, Garrick b.1933
Lazarus Raised from the Dead 1964
acrylic on canvas 50 x 69
EASTG 1334

Palmer, Rozanne b.1932
Wood Burning Stove
oil on canvas 106.0 x 130.5
SEA 131

Parker, Frederick H. A. d.1904
Wish Tower, Eastbourne 1890
oil on canvas 23.0 x 30.5
EASTG 759

Parsons, Christine c.1912/1914
Three Jars 1977
oil on canvas 60.5 x 61.0
EASTG 1202

Pasmore, Victor 1909–1998
Study of a Cast of a Child's Head c.1924
oil on canvas 36 x 26
EASTG 2083

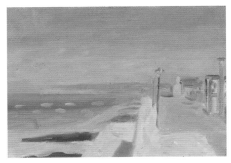

Pasmore, Victor 1909–1998
The Front at Seaford 1932
oil on board 17.5 x 25.0
EASTG 2080

Pasmore, Victor 1909–1998
Carnations in a Glass Vase
oil on canvas 30.5 x 23.0
EASTG 2084

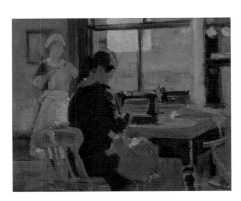

Pasmore, Victor 1909–1998
Mother and Florence
oil on panel 39 x 48
EASTG 2086

Payen, Sally b.1964
The Blue River 1993
oil on canvas 140 x 170
SEA 180

Pears, Charles 1873–1958
Beachy Head, Moonlight
oil on canvas 33.5 x 54.5
EASTG 732

Plumb, John b.1927
New Bamboo 1961 1961
PVA paint & PVC tapes on canvas 122 x 122
EASTG 2253

Preece, Patricia 1894–1966
Girl in Yellow Dress
oil on canvas 74 x 59
EASTG 1206

Preece, Patricia 1894–1966
In a Cottage
oil on canvas 60.9 x 45.7
EASTG 1218

Quigley, Peter
Flint Lines II 1962
oil on canvas 101.5 x 127.0
EASTG 29

Reeve-Fowkes, David
Fields near Rievaulx, Yorkshire 1984
oil on canvas 19 x 34
EASTG 1974

Reitlinger, Gerald 1900–1978
Still Life with Prawns 1934
oil on canvas 43.5 x 58.5
EASTG 1225

Riboulet, Jacques M. b.1930
Screaming Cliffs c.1960s
oil on canvas 89.0 x 119.5
EASTG 42

Richards, Ceri Geraldus 1903–1971
Poissons d'or 1963
oil on canvas 127 x 127
EASTG 30

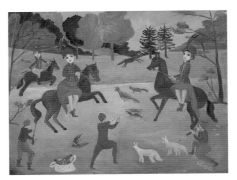

Rivers, Leopold 1852–1905
On the River Cuckmere 1889
oil on canvas 61.0 x 91.4
EASTG 1

Robertson, Tom 1850–1947
Moonrise on the Loire
oil on canvas 42.0 x 59.5
EASTG 1196

Rodmell, Ilsa b.1898
Chase (The Hunt)
oil on three-ply board 77.5 x 97.5
EASTG 1264

Salby
View of a Bridge
oil on board 55 x 38
EASTG 155

Scott, William George 1913–1989
Blue on Blue 1967
oil on canvas 61 x 61
EASTG 2230

Seabrooke, Elliot 1886–1950
Landscape
oil on board 46.9 x 40.6
EASTG 1171

Seabrooke, Elliot 1886–1950
Trees and Red Gate
oil on card 39.5 x 46.0
EASTG 1187

Shayer, William 1788–1879
Shore Scene with Figures
oil on canvas 70 x 90
EASTG 1154

Sheldon-Williams, Inglis active 1902–1945
Farm Wagon, Exceat
oil on card 23.0 x 32.5
EASTG 1356

Facing page: Flemish (Antwerp) School, early 16th C, *Mystic Marriage of St Catherine of Alexandria* (detail), Brighton and Hove
Museums and Art Galleries, (p. 80)

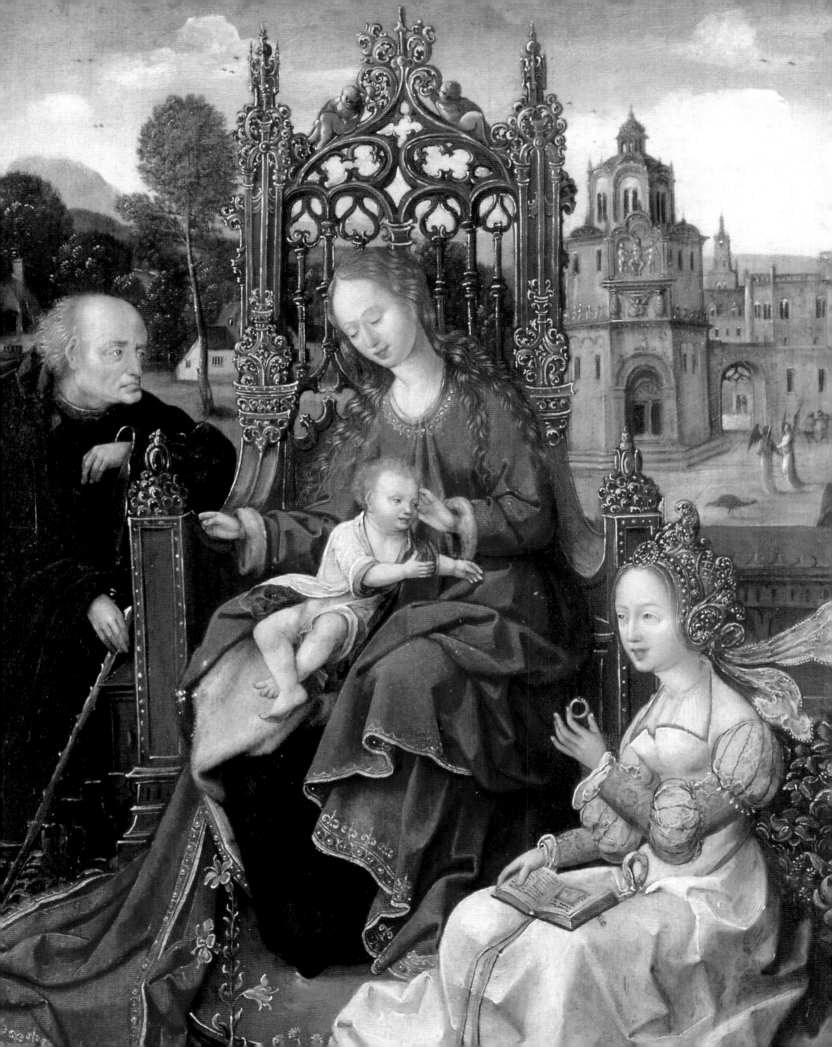

Sheldon-Williams, Inglis active 1902–1945
Oxen with Wagon
oil on card 21.5 x 31.5
EASTG 1355

Shepherd, Dominic b.1966
The Secret Language of Insects
oil on canvas 168 x 182
SEA 175

Sickert, Walter Richard 1860–1942
The Poet and His Muse 1907
oil on canvas 45.5 x 23.0
EASTG 1375

Sigrist, Anthony
Rift 1959
oil on board 114.3 x 121.9
EASTG 26

Smith, George 1829–1901
The Auction 1874
oil on canvas 30.5 x 52.5
EASTG 110

Smith, George 1829–1901
The Launch
oil on board 51 x 85
EASTG 1415

Smith, Jack b.1928
Central Disturbance 1966–1970
oil on panel 94 x 94
SEA 138

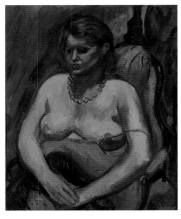

Smith, Matthew Arnold Bracy 1879–1959
Seated Female Nude
oil on canvas 73.6 x 60.9
EASTG 1156

Smythe, Canon
Chalk Pit, Sussex
oil on canvas 44.5 x 34.0
EASTG 1200

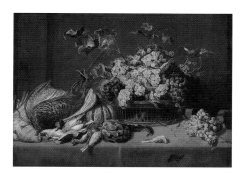

Snyders, Frans (attributed to) 1579–1657
Still Life: Fruit, Vegetables and Game on a Table
oil on canvas 89 x 122
EASTG 1595

Spear, Ruskin 1911–1990
Woman Ironing 1947
oil on canvas 44.5 x 54.5
EASTG 2260 🐝

Spear, Ruskin 1911–1990
Spring in Hammersmith
oil on canvas 52.5 x 38.5
EASTG 1166 🐝

Spencer, Charles Neame active 1896–1917
On the South Coast
oil on canvas 44.5 x 60.0
EASTG 1199

Steadman, J. T. active 1884–1911
Portrait of an Old Lady Holding Her Spectacles
oil on canvas 94 x 75
EASTG 1132

Stevens, Christopher b.1961
Two Trunked Elephants 1988
oil on canvas 168 x 149
SEA 159

Stockley, Henry 1892–1982
Flight into Egypt 1929
oil on canvas 43.5 x 55.0
EASTG 1269

Stockley, Henry 1892–1982
Through the Trees, Hyde Park 1933
oil on canvas 44.5 x 49.0
EASTG 1268

Stockley, Henry 1892–1982
Evelyn Laye in Hyde Park
oil on canvas 53 x 70
EASTG 1267

Stockley, Henry 1892–1982
Girl and Dogs
oil on canvas 60.9 x 46.9
EASTG 1124

Stott, Edward 1859–1918
Lambing Time
oil on canvas 71.0 x 63.5
EASTG 1323

Stott, Edward 1859–1918
Saturday Night
oil on canvas 66.0 x 82.5
EASTG 1150

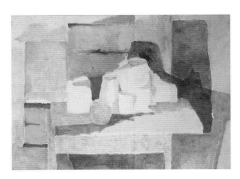

Street, Evelyn active 1950s–1960s
Still Life
oil on board 89.5 x 120.5
EASTG 39

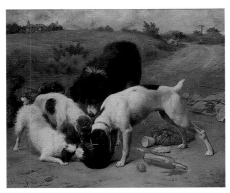

Strutt, Alfred William 1856–1924
Pot Luck
oil on canvas 60.5 x 70.5
EASTG 1550

Swanwick, Joseph Harold 1866–1929
Alfriston
oil on canvas 21.0 x 32.5
EASTG 1349

Swanwick, Joseph Harold 1866–1929
Oxen Ploughing, South Downs
oil on hardboard 23.0 x 38.5
EASTG 1354

Tennant, John F. 1796–1872
View of Martello Towers near Bexhill, Looking towards Beachy Head 1835
oil on canvas 47 x 69
EASTG 1096

Tennant, John F. 1796–1872 **& Herring, John Frederick I** 1795–1865
Resting at Plough
oil on canvas 75.0 x 130.8
EASTG 2

Thompson, Estelle b.1960
Winterlude 1987
oil on canvas 152 x 152
SEA 146

Thorpe, L.
Study of a Man Wearing a Felt Hat 1944
oil on canvas 60.0 x 40.6
EASTG 1123

Tindle, David b.1932
Beach Scene 1960
oil on canvas 31.5 x 35.5
EASTG 1164

Tindle, David b.1932
Beach '61 1961
oil on board 34 x 47
EASTG 1170

Towner, Donald Chisholm 1903–1985
The Pool of London, 1935 1935
oil on canvas 76.2 x 63.5
EASTG 748

Towner, Donald Chisholm 1903–1985
Church Row Gardens, Spring 1961
oil on canvas 80.0 x 63.5
EASTG 1176

Townsend, Kenneth 1935–2001
Tregarthen 1961
oil on board 48.0 x 119.5
EASTG 163

Townsend, William 1909–1973
Sundance Canyon
oil on canvas 76.2 x 101.6
EASTG 1344

Townshend, Jo b.1967
Shoreline
oil & acrylic on canvas 183 x 366
SEA 182 (3 panels)

Trevelyan, Julian 1910–1989
Durance Valley 1961
oil on canvas 75.0 x 60.5
EASTG 1173

Trollope, Roy b.1933
Falling 1995
acrylic on paper 85.0 x 120.5
SEA 185

Turpin, Louis b.1947
Patchwork 1980
oil on canvas 100 x 80
SEA 105

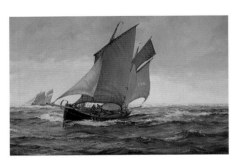

unknown artist
At Full Sail
oil on canvas 46.5 x 70.3

unknown artist
Ginger Jar and Mandarins
oil on board 29.5 x 35.7
EASTG 1896

unknown artist
Still Life with Bottle, Melon and Teapot
oil on board 32.5 x 38.0
EASTG 1931

unknown artist
Three Tone, White to Cream
oil on board 91.4 x 121.9
EASTG 173

unknown artist
Time for the Leaves to Tumble
oil on hardboard 104 x 159
SEA 197

Unsworth, Peter b.1937
Evening Bowls 1980
oil on canvas 101.6 x 101.6
EASTG 1301

Urquhart, Murray McNeel Caird 1880–1972
Rye
oil on canvas 50.0 x 67.5
EASTG 1184

Vaughan, John Keith 1912–1977
Standing Figure 1962
oil on canvas 121.5 x 91.0
EASTG 1291

Velde, Peter van den 1634–after 1687
Dutch Men O'War in a Squall off a Coastal Town
oil on canvas 35 x 45
EASTG 1580

Velde, Willem van de II (style of) 1633–1707
Storm and Shipwreck (British and Dutch Men O'War Floundering in a Gale off a Rocky Coast)
oil on canvas 87.6 x 110.0
EASTG 1676

Virtue, John b.1947
Landscape No.82 1988–1989
pen & ink & acrylic on paper 177 x 210
EASTG 2255

Virtue, John b.1947
Landscape 268 1994–1995
black ink, shellac, acrylic on canvas 183 x 184
EASTG 2161

Wadsworth, Edward Alexander 1889–1949
Bronze Ballet 1940
tempera on canvas mounted on wood
62.0 x 87.5
EASTG 542

Wallis, Alfred 1855–1942
Sailing Ship
oil on cardboard (back of a calendar)
22.5 x 32.0
EASTG 1565

Wallis, Alfred 1855–1942
Steamer
oil on irregular cardboard 33 x 64
EASTG 1258

Wallis, Alfred 1855–1942
Three Ships
oil on irregular cardboard 19.5 x 44.5
EASTG 1278

Wallis, Alfred 1855–1942
White Sails
oil on cardboard 49.5 x 60.0
EASTG 1274

Ward, John
All Night Café
oil on board 25.4 x 60.9
EASTG 161

Ward, John
The Reverend Dr Lushington
oil on hardboard 91.7 x 122.0
EASTG 1293

Warden, William 1908–1982
East Beach, Hastings 1950
oil on canvas 24.5 x 34.5
EASTG 1388

Ware, William b.1915
Battersea
oil on board 101.6 x 127.0
EASTG 1311

Webb, James c.1825–1895
Seascape 1881
oil on canvas 16 x 24
EASTG 1367

Weight, Carel Victor Morlais 1908–1997
The Old Woman in the Garden No.2 1970
oil on board 120.5 x 90.0
EASTG 24

West, C. H.
Old Town, Eastbourne
oil on board 35.5 x 45.7
EASTG 1379

Wheatley, John 1892–1955
The Darlings
oil on canvas 91.4 x 76.2
EASTG 20

Wheeler, Charles 1892–1974
Windswept Snow on Frozen Pond 1969
oil on board 51 x 61
EASTG 2075

Whelpton, Gertrude 1867–1963
*Alderman Morrison, Mayor of Eastbourne
(1889–1892)*
oil on canvas 76.2 x 63.5
EASTG 4

White, B. D. F.
Royal Welsh Agricultural Society Show 1977
acrylic on canvas 20.5 x 30.5
EASTG 1364

White, Ethelbert 1891–1972
Sussex Landscape
oil on canvas 60.9 x 76.2
EASTG 1201

Whitten, Philip John b.1922
Puerto Pollensa, Majorca 1966
oil on board 48.5 x 65.5
EASTG 1195

Wicksman, Anca b.1964
Bishop's Meadow
oil on paper 93.5 x 69.5
SEA 174

Williams, Bruce b.1962
Sea View I
oil on canvas 168 x 183
SEA 161

Wimperis, Edmund d.1946
Forest Row, Sussex, the Golf Course
oil on prepared paper 25.5 x 35.0
EASTG 1351

Wood, Christopher 1901–1930
Fair at Neuilly 1922/1923
oil on hardboard 73.5 x 98.5
EASTG 1250

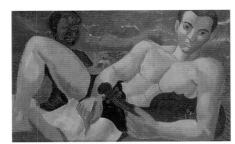

Wood, Christopher 1901–1930
Constant Lambert 1927
oil on canvas 57.0 x 89.5
EASTG 1232

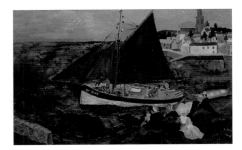

Wood, Christopher 1901–1930
French Crab Boat, Tréboul 1929
oil on card 51.5 x 78.5
EASTG 1265

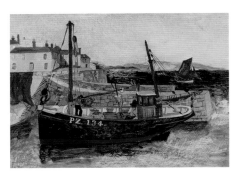

Wood, Christopher 1901–1930
PZ 134 1930
oil on hardboard 50 x 69
EASTG 1259

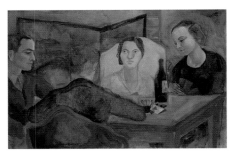

Wood, Christopher 1901–1930
Conversation Piece
oil on canvas 95.5 x 145.0
EASTG 1241

Wood, Christopher 1901–1930
Girl on a Chair (Figure for a Screen)
oil on canvas 147 x 57
EASTG 1242

Wood, Christopher 1901–1930
Paris under Snow
oil on canvas 59.5 x 72.5
EASTG 1261

Wootton, Frank 1914–1998
Windover in Winter, Alciston, January 1945
oil on canvas 40.6 x 50.8
EASTG 1178

Wootton, Kenneth Edwin c.1892–1974
Brian 1930
oil on canvas 152.4 x 91.4
EASTG 210

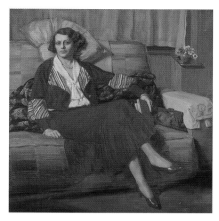

Wootton, Kenneth Edwin c.1892–1974
Mrs K .E. Wootton 1934
oil on canvas 96.5 x 96.5
EASTG 233

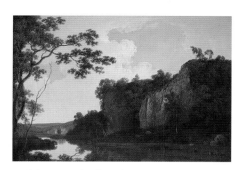

Wright, Joseph of Derby 1734–1797
River Landscape c.1785
oil on canvas 50.8 x 76.2
EASTG 1561

Wynter, Bryan 1915–1975
Red Spoor 1960 1960
oil on canvas 183 x 142
EASTG 1317

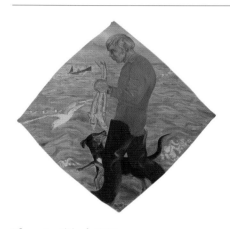

Yhap, Laetitia b.1941
Paul Carrying Robin Huss Accompanied by His Dog Saxon 1979/1980
oil & liquitex on board 86.5 x 86.5
SEA 108

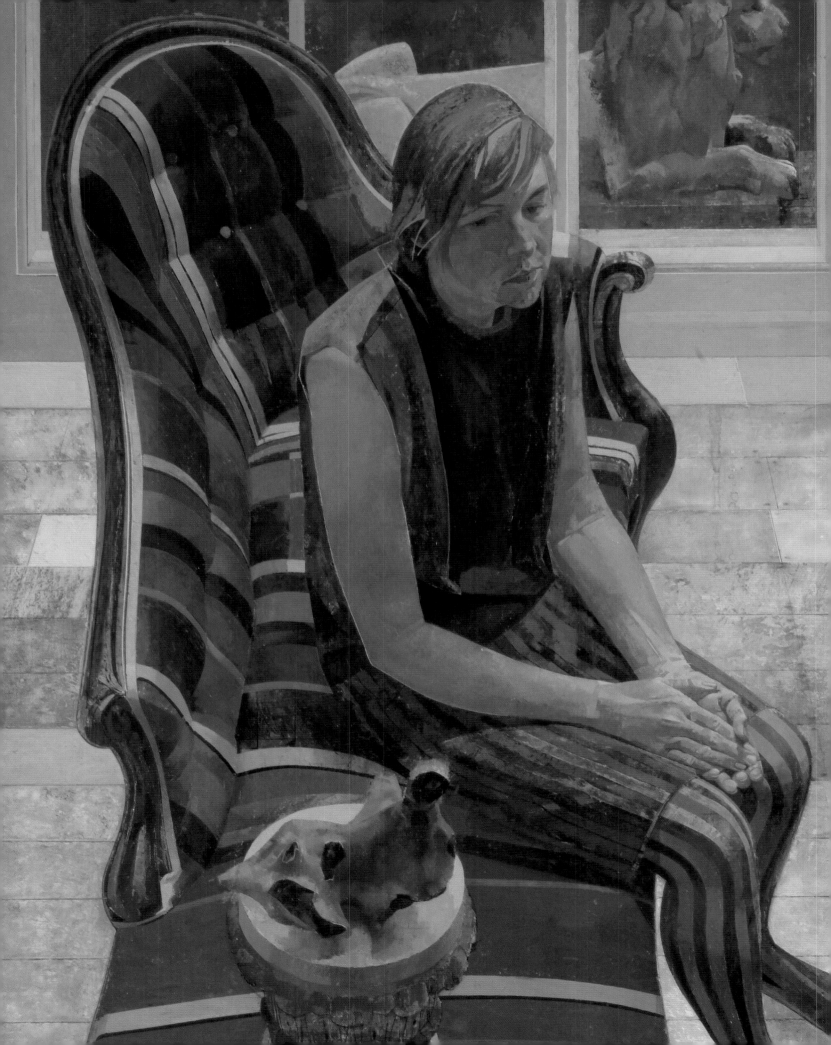

Michelham Priory

Elder, Dorothy 20th C
Red Oxen of Sussex
oil on canvas 22.2 x 65.9
HAMMP M2000.12

Gardiner, A.
Michelham Priory and Gatehouse
oil on canvas 37.7 x 50.0
HAMMP M103

Hayward, Arthur 1889–1971
Michelham Priory with Moat (South Aspect of Michelham) 1964
oil on canvas 39 x 49
HAMMP M123

Hayward, Arthur 1889–1971
Michelham Priory with Moat c.1964
oil on canvas on hardboard backing
40.7 x 50.5
HAMMP M124

Swanwick, Joseph Harold 1866–1929
Horses at Wilmington (Priory Farmyard)
oil on canvas 59.5 x 115.0
WP LI/91/1 (P)

unknown artist 19th C
William Lambe of Wilmington
oil on canvas 29.3 x 24.5
HAMMP M202

unknown artist
The Gatehouse and Moat at Michelham Priory 1964
oil on canvas 49 x 39
HAMMP M111

Facing page: Blamey, Norman Charles, 1914–1999, *Stripes* (detail), 1967–1968, Towner Art Gallery, (p. 227)

Conquest Hospital

Braven, Angela
Hastings Old Town Beach
oil on board 123 x 460
151 (P)

Brine, John b.1920
Abstract Series 2
oil on canvas 122 x 172
166 (P)

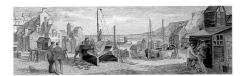

Khanna, Balraj b.1940
Sussex by the Sea
oil on canvas 165 x 239
957

Oxley, Nigel b.1949
Holidays c.1990s
oil on canvas 171 x 86
430 (P)

unknown artist
Hastings Fishing Beach c.1930s
oil on board 75 x 225
938

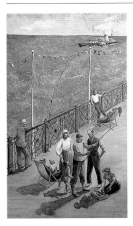

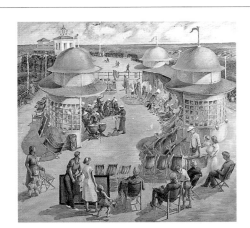

unknown artist
Hastings Pier (Triptych) c.1930s
oil on board 150 x 90 (panel 1)
937

unknown artist
Hastings Pier (Triptych) c.1930s
oil on board 150 x 143 (panel 2)
936

unknown artist
Hastings Pier (Triptych) c.1930s
oil on board 150 x 90 (panel 3)
935

Hastings Fishermen's Museum

Hastings Fishermen's Museum is housed in the church of St Nicholas which was erected in 1854 as a chapel of ease to the two parish churches of All Saints and St Clements. The church was built to serve the fishing community of the district which, with their one hundred and fifty boats, formed the bulk of the population of the old town. In those days, and until 1884, the sea washed up close to the south wall of the church, which was built on land won from the sea and acquired by the Corporation under the Elizabethan Charter of 1588. The land was never consecrated.

Early in 1955, the Borough Council approved a suggestion forwarded by the Old Hastings Preservation Society, that the one time Fishermen's Church should become a fishermen's museum. This space would house items of local interest suitable for a maritime museum, as well as the *Enterprise*, the last of the Hastings luggers built for sail only, and the last of the wooden capstans. Work was started by a borough engineer on the 10th April 1956. A breach was made in the south wall and the *Enterprise* hauled in by fishermen on the 17th April.

Under the guidance of Rear Admiral Dannreuther, work proceeded rapidly and was sufficiently advanced for the formal opening by the Mayor; the opening ceremony was recorded and televised on the 17th May 1956. Though no longer a church, christenings are still carried out in the museum and at Christmas there is a very popular carol service.

The majority of the oil paintings in the collection are of sailing fishing luggers, either on the Stade (Anglo-Saxon word for landing place) or coming ashore. Five of the most important oils were painted by the artist William Henry Borrow (1840–1905) who was brought up in High Street, Old Town, Hastings. He studied under the marine painter James Darby in London, returning to Hastings after his marriage. His artistic output mainly included oils of local fishing and coastal scenes. He exhibited at the Royal Institute of Oil Painters and the Royal Academy regularly.

Another painting of interest is a white oil on blackboard copied from a photograph taken by Frank Hurley of Shackleton's *Endurance* in the Antarctic ice, winter 1915, just before the ship was crushed by ice.

The largest painting in the collection is of the presentation of a golden winkle (Winkle Club formed in 1900 as a charity to help the poor in Hastings) to Winston Churchill on 7th September 1955. Standing behind him is Field Marshal Montgomery in his open-topped desert car named 'Old Bill'. This painting is of particular interest because a black and white photograph by Gifford Boyd was transposed onto board and sent with a colour transparency to a painter in the north of England, who made this painting matching colour to image. The painting is an early example of this process.

Phil Ornsby, Manager

Austen
Shackleton's 'Endurance' in the Antarctic Ice 1915
oil on blackboard 70 x 60 (E)
HASFM 1994.131

Borrow, William Henry 1840–1905
East Cliff and Fishing Vessels 1860
oil on canvas 57.0 x 98.3 (E)
HASFM 994.146

Borrow, William Henry 1840–1905
Fishermen on the Stade c.1872
oil on canvas 75 x 121 (E)
HASFM 994.157

Borrow, William Henry 1840–1905
A Good Catch mid-late 1800s
oil on canvas 30 x 44 (E)
HASFM 2002.134

Borrow, William Henry 1840–1905
Coming Ashore mid-late 1800s
oil on canvas 75 x 121 (E)
HASFM 994.195

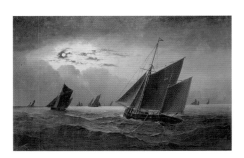

Borrow, William Henry 1840–1905
Fishing Boat at Sea mid-late 1800s
oil on canvas 30 x 42 (E)
HASFM 2002.133

Brown, Tom
Sailing Boat 1952
oil on board 18 x 23 (E)
HASFM 994.40

Burwood, George Vemply c.1845–1917
Seascape, Fishing Boats by Moonlight 1884
oil on canvas 44.5 x 69.0 (E)
HASFM 994.284

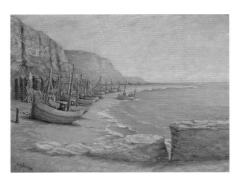

Garrod, L
Quiet Morning c.1950s
oil on canvas 38 x 50 (E)
HASFM 1995.5

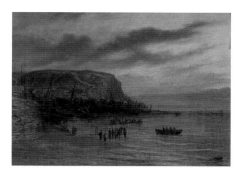

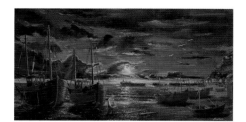

Harding, James Duffield 1798–1863
Hastings Luggers on the Beach 1831
oil on canvas 22.2 x 30.7 (E)
HASFM 994.142

Maurice
Sunset over the Stade 1950–1960s
oil on board 54 x 98 (E)
HASFM 2002.24

Moore, Jean
The Lifeboat 'Fairlight' at Sea 1970
oil on canvas 49 x 75 (E)
HASFM 1997.36

Moore, Jean
Fleet in Mourning 1971
oil on canvas 48 x 92 (E)
HASFM 2001.70

Moore, Jean
The Stade 1970s
oil on canvas 64 x 84 (E)
HASFM 2003.10

Moore, Jean
Fishermen's Boat Race, Hastings 1989
oil on canvas 25 x 117 (E)
HASFM 1998.3

Schofield, James (attributed to)
The Stade and Fishing Boat K52 1970
oil on canvas 56 x 46 (E)
HASFM 994.94

Sheppard
Looking West from Rye 1960s
oil on board 33 x 45 (E)
HASFM 2002.24

Shore, Stephen
Among the Net Sheds of Old Hastings 1961
oil on canvas 57.0 x 67.2 (E)
HASFM 994.105

Smith, E. Blackstone
The Stade, 1839 1939
oil on canvas 46.0 x 72.5 (E)
HASFM 994.138

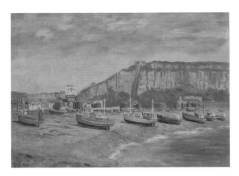

Strickland, William Francis d.2000
East Hill from Harbour Arm 1992
oil on canvas 44.5 x 60.0 (E)
HASFM 994.148

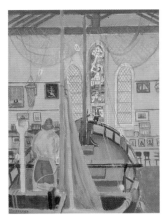

Strickland, William Francis d.2000
Hastings Fishermen's Museum 1993
oil on canvas 51 x 40 (E)
HASFM 1999.62

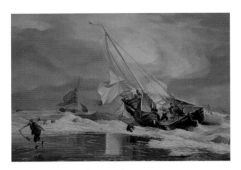

Turner, J. C. J. late 20th C
*Beaching a Pink in Heavy Weather (copy of
Edward William Cooke)*
oil on canvas 77 x 100 (E)
HASFM 1994.59

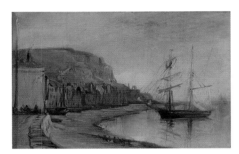

unknown artist
Sailing Vessel off Hastings 1882
oil on canvas 14.3 x 21.6 (E)
HASFM 994.91

unknown artist 19th C
Boat and Two Fishermen
oil on canvas 35.5 x 30.5 (E)
HASFM 994.498

unknown artist
*Old Fisherman with White Beard Smoking a
Pipe* early 1900s
oil on canvas 28 x 23 (E)
HASFM 2004.5

unknown artist
Hastings Fishing Boat RX10 c.1900
oil on canvas 16.8 x 24.2 (E)
HASFM 994.495

unknown artist
Charles and Robert RX266 c.1950s
oil on canvas 28 x 38 (E)
HASFM 1999.59

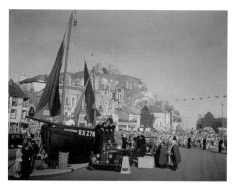

unknown artist
The Presentation of the Golden Winkle to
Winston Churchill, 7th September 1955 c.1956
oil on board 120 x 151 (E)
HASFM 994.259.1

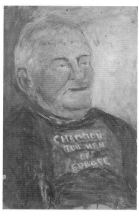

unknown artist
Biddy Stonham 1960s
oil on cardboard 39 x 25 (E)
HASFM 1998.156

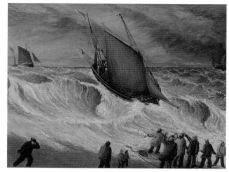

unknown artist
RX94 Industry Coming Ashore
oil on canvas 42.5 x 57.0 (E)
HASFM 994.103

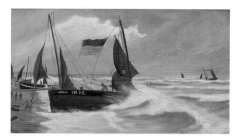

White
Mizpah RX135 1903
oil on board 25 x 45 (E)
HASFM 994.101

Yhap, Laetitia b.1941
Fishermen on Hastings Beach 1957–1979
oil on board 52.5 x 170.0 (E)
HASFM 2002.216(2)

Hastings Library

Armitage, Edward 1817–1896
A Dream of Fair Women (Diptych) 1870s
oil on panel 73.7 x 254.9 (panel 1)
001a

Armitage, Edward 1817–1896
A Dream of Fair Women (Diptych) 1870s
oil on panel 73.0 x 254.3 (panel 2)
001b

Crozier, Philip b.1947
The Fish Wife 1992
oil on canvas 105.0 x 79.3
2

Hastings Museum and Art Gallery

Hastings Museum and Art Gallery was founded by the Hastings and St Leonards Museum Association and opened in the Brassey Institute in 1892. The art section was run by Martin Sullivan, Head of the Hastings Art School and father of the illustrator, Edmund Sullivan. From the start a number of themes were established including strong holdings in watercolour painting, close links with the Hastings Art School and a preference for artists with local associations.

The earliest oils to enter the museum were by William Henry Borrow, a prolific local artist of maritime and landscape subjects. Other acquisitions were portraits of benefactors such as travel writer Augustus Hare and the Reverend John Tottenham whose collection formed the basis of the opening displays.

In 1905 ownership of the museum passed to the Corporation of Hastings. During this period only a handful of oils came into the museum, due mainly to the cramped conditions in a building shared with Hastings Library, the Schools of Art and Science and the rowing club. Larger canvases were presented to the Town Hall and came to the museum later including the animal painting, *Temptation in the Wilderness* by Alfred Strutt and early 19th century views of Hastings seafront by Charles Martin Powell and Richard Hume Lancaster.

Not all pictures were of local subject matter. *Sarrzet* by 19th century feminist Barbara Bodichon was bequeathed by her friend, Matilda Betham Edwards and an 18th century classical landscape by Giovanni Paolo Panini was the first continental work to be acquired. Subsequent donations from European schools include a study for the *Sacrifice of Jephthah* by the 17th century painter Sebastiano Mazzoni. The finished version of this painting is in the William Rockhill Nelson Gallery in Kansas.

The museum was running out of space at the Brassey Institute and the situation became critical in 1919 with the donation of the Durbar Hall and Brassey Collection. While negotiations were going on for the purchase of a new building, Alderman Went Tree left part of his estate to create an acquisition fund to be known as the Went Tree Trust. The museum finally moved to its current location in Bohemia Road in 1928. With additional space available the museum began to collect more widely. There was a flurry of rural subject

matter with the Hornblower Bequest bringing in works by Thomas Sidney Cooper, George Vicat Cole and William Shayer. A painting in similar vein, *Midday* by Henry Banks Davis was acquired through the Victoria & Albert Museum in 1936.

It was not until 1946 that the museum was able to take advantage of the Went Tree Trust. Most acquisitions were by local artists, often purchased from exhibitions. Such was the case with George Graham, a Yorkshireman by birth, who settled at Salt Dykes, Winchelsea in 1923 painting landscapes and the deeply religious *Creation* paintings. Graham was a member of the East Sussex Arts Club, as was Violet Vicat Cole whose *Tent Peg Makers* was purchased from the Club's exhibition in 1957. Other members whose paintings were acquired include Sidney Dennant Moss, Thomas Handsford Beere and Hesketh Hubbard.

In 1948 the museum started a collection of works by Sickert and his pupils beginning with the donation of *Envermeu* by Sylvia Gosse by the Sickert Trust. This was followed by Sickert's portrait, *Signor de Rossi* and the connection was reinforced when Sylvia Gosse moved to Hastings in 1951. Further examples of her work entered the museum in subsequent years and *Dare Devils* by Sickert's wife Thérèse Lessore was purchased from the estate of Sylvia's biographer, Kathleen Fisher in the 1980s.

A number of local portraits were also given at this time. One was an impressive three-quarter length of Lieutenant Colonel Henry Vassal Webster of Battle Abbey painted by Martin Archer Shee in 1814. A portrait of Mrs Eleanor Webster by Richard Buckner was also given. A descendant of James Burton gave a small oil study of her great-grandfather, the founder of St Leonards, and the museum also received a portrait of the writer Sidney Parkman by Philip Cole.

In 1955 holdings were augmented by a bequest from Violet Vicat Cole which brought in works by relatives, George and Rex Vicat Cole and her friend, Dorothea Sharp. During a spell with the Contemporary Art Society the museum received *Lighthouse, Rye Harbour* by Edward le Bas and Beatrice Bland's *Building the Rick*.

Active collecting encouraged other works to be donated through the 1950s and 1960s. The National Art Collections Fund gave a Dutch courtyard scene by Abraham van Strij from the Cook Collection and government minister, Henry Brooke donated two oil panels by his ancestor, William Henry Brooke.

The association with Hastings Art School remained close with both principals, Philip Cole and Vincent Lines on the Museum Committee influencing the selection of acquisitions. Cole's *Georgian Houses, Hastings* was acquired in 1956 reflecting his chairmanship of the Old Hastings Preservation Society. After his death in 1964 a number of the artist's portraits were received including *The Visitor*, a study of his sister-in-law, Miss Hayes.

In the 1960s pictures were acquired from single artist shows including Alice Headley Neave's *Children Returning to School, Battle* and views of Hastings by Richard Baines. Baines was tutored by Clifford Hall and it was through this connection that Hall's oils, *Llanmadoc* and *Shrouded Figure* were added in 1970 and 1971. In the 1970s there were two exhibitions by Bexhill artist, Edward Callam who donated *The Old Town, Bexhill* in 1978. Vincent Lines was commemorated with a loan exhibition in 1975 and in 1979 his painting *Hastings from John's Place* was purchased, appropriately a view taken from the back of the museum.

Since the 1980s the museum has acquired works by contemporary Hastings artists including Laetitia Yhap, Bill Day, Ken Townsend and John Bratby. There

have been historic subjects such as *Rescue at Hastings* by William George Moss, purchased with help from the MLA/V&A Purchase Grant Fund. Portraits of local figures such as Biddy the Tubman and Vincent Lines have also been added. In 1982 a large Native American collection was given by Eastbourne collector, Edward Blackmore and a number of oils relate to this such as his portrait of Chief Oskenonton of 1935.

Paintings were still acquired from exhibitions and two oils by Bloomsbury associated artist, Keith Baynes, who lived in St Leonards, were purchased from the family in 1987. The museum's long association with George Graham culminated in the donation of his *Creation* paintings by pupil Hugh Griffiths in 1995. Pictures continue to be received through the generosity of donors, the most recent being an oil by William Henry Borrow showing a distant view of the Castle.

In addition to paintings at the Hastings Museum and Art Gallery and Old Town Hall Museum, works are on loan to the Hastings Fishermen's Museum and on display at Hastings Town Hall including a fine portrait of Mrs Brassey by Francis Grant and Edwin Landseer and *Hastings Cricket Festival*, 1952 by Charles Cundall.

The oil paintings represent only a small proportion of the fine art collection at Hastings. The watercolour and drawings collection is more substantial and the combined total exceeds over 2,500 works.

Victoria Williams, Curator

Facing page: Leslie, George Dunlop, 1835–1921, *Alice in Wonderland* (detail), c.1879, Brighton and Hove Museums and Art Galleries, (p. 139)

286

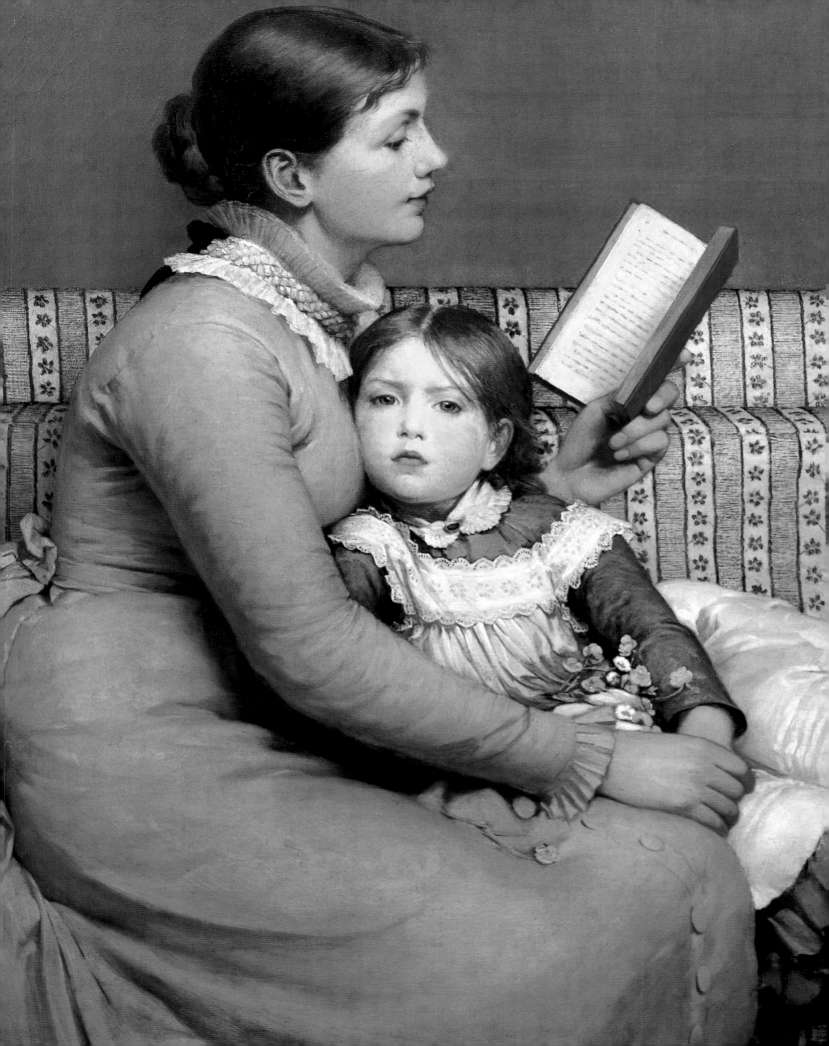

Aglio, Agostino Maria 1777–1857
Entrance to Hastings from London Road 1823
oil on board 20 x 28
HASMG:951.10

Aglio, Agostino Maria 1777–1857
Hastings from the London Road c.1825
oil on canvas 41 x 60
HASMG:946.64.8

Armitage, Edward 1817–1896
Ladies and Swans
oil on panel 21.0 x 14.5
HASMG:959.24.2

Badham, Edward Leslie 1873–1944
Autumn Sunshine, Bourne Walk,
Hastings 1914
oil on canvas 49 x 58
HASMG:921.30

Baines, Dick b. 1940
East Hill Passage 1966
oil on board 77 x 97
HASMG:968.32.2

Baines, Dick b. 1940
Hastings 1066–1966 1966–1967
oil on board 48.8 x 72.5
HASMG:968.22.2

Baines, Dick b. 1940
The Sun Inn, Tackleway 1967
oil on board 52 x 62
HASMG:968.32.1

Baines, Dick b. 1940
Prospect Place c.1967
oil on board 67.5 x 82.5
HASMG:968.22.1

Bas, Edward le 1904–1966
The Lighthouse, Rye Harbour c.1939
oil on canvas 35.6 x 48.2
HASMG:954.9.1

Baynes, Keith 1887–1977
Still Life 1962
oil on board 50 x 60
HASMG:987.40

Baynes, Keith 1887–1977
View of Lisbon from Almeria 1967
oil on canvas 50 x 60
HASMG:987.35

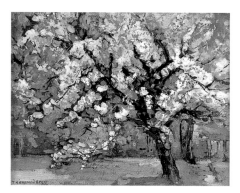

Beere, Thomas Handsford 1874–1953
April c.1950
oil on board 24 x 29
HASMG:952.33.2

Beere, Thomas Handsford 1874–1953
Landscape
oil on board 19.0 x 26.7
HASMG:969.28.1

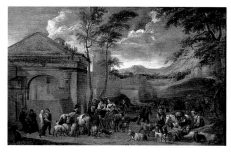

Berchem, Nicolaes (after) 1620–1683
Italian Landscape 1670
oil on canvas 50 x 71
HASMG:960.53

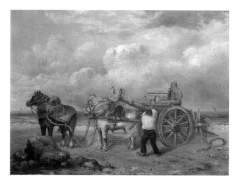

Bird, A.
After the Storm, Hastings 1873
oil on canvas 33.8 x 42.5
HASMG:981.46

Blackmore, Edward 1898–1983
Blackfoot Indians, Montana 1924
oil on canvas 39 x 55
HASMG:983.78.118

Blackmore, Edward 1898–1983
*The Supreme Appeal (from the sculpture by
Cyrus Edwin Dallin)* 1925
oil on canvas 56.0 x 45.5
HASMG:983.78.178

Blackmore, Edward 1898–1983
Chief Oskenonton 1935
oil on canvas 110.0 x 75.5
HASMG:983.78.119

Blackmore, Edward 1898–1983
Sitting Bull
oil on canvas 54.0 x 44.5
HASMG:985.78.116

Bland, Emily Beatrice 1864–1951
Building the Rick
oil on canvas 39 x 60
HASMG:952.42

Bodichon, Barbara Leigh Smith 1827–1891
Sarrzet 1860s
oil on paper 20 x 42
HASMG:919.43.3

Bond, Arnold 1905–1990
Bicycle with Boat
oil on board 46 x 65
HASMG:990.5.1

Bond, Arnold 1905–1990
Clog Clamp, Holland
oil on board 24 x 62
HASMG:990.5.2

Bond, Arnold 1905–1990
Cornfield, Sevenoaks
oil on board 29.5 x 38.0
HASMG:990.5.3

Borrow, William Henry 1840–1905
Galley Hill 1875
oil on canvas 21 x 42
HASMG:955.14

Borrow, William Henry 1840–1905
Hastings Beach 1879
oil on canvas 41 x 70
HASMG:957.30.3

Borrow, William Henry 1840–1905
Hastings from the Sea 1879
oil on board 17.0 x 28.5
HASMG:981.27.5

Borrow, William Henry 1840–1905
Hastings from Torfield c.1880
oil on canvas laid on board 20 x 31
HASMG:987.51

Borrow, William Henry 1840–1905
Fairlight Glen 1881
oil on board 18 x 37
HASMG:957.30.1

Borrow, William Henry 1840–1905
Hastings from the East Cliff 1881
oil on canvas 43.7 x 73.1
HASMG:967.39

Borrow, William Henry 1840–1905
Hastings Beach 1884
oil on canvas 35.5 x 75.0
HASMG:955.6.6

Borrow, William Henry 1840–1905
*Hastings Beach Looking East to Pelham
Crescent* 1885
oil on canvas 45.5 x 75.8
HASMG:991.18.2

Borrow, William Henry 1840–1905
Rye 1886
oil on panel 43.8 x 72.5
HASMG:956.45.1

Borrow, William Henry 1840–1905
View across Priory Valley to the Castle 1889
oil on canvas 19.5 x 32.5
HASMG:2004.37.2

Borrow, William Henry 1840–1905
Sea Piece c.1890
oil on canvas 24.5 x 42.0
HASMG:894.3.2

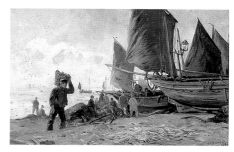

Borrow, William Henry 1840–1905
Study for 'The Harvest of the Sea' 1891
oil on board 27 x 43
HASMG:956.6.2

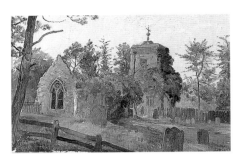

Borrow, William Henry 1840–1905
Ruins of Old Ore Church 1893
oil on paper 19.8 x 30.0
HASMG:972.56

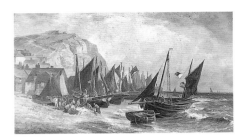

Borrow, William Henry 1840–1905
The Old East Cliff, Herring Season 1901
oil on canvas 66.0 x 119.3
HASMG:955.27

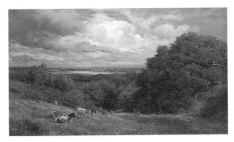

Borrow, William Henry 1840–1905
Hastings, Looking towards Westfield
oil on canvas 76 x 125
HASMG:960.27

Borrow, William Henry 1840–1905
Low Tide, Hastings
oil on board 25 x 44
HASMG:955.6.3

Borrow, William Henry 1840–1905
Pond at Fairlight Glen
oil on board 16.3 x 27.5
HASMG:957.30.2

Borrow, William Henry 1840–1905
The Fishing Quarter
oil on canvas laid on board 24.5 x 50.0
HASMG:955.6.7

Borrow, William Henry 1840–1905
Waiting for the Tide, Hastings
oil on board 26.3 x 35.0
HASMG:955.6.4

Bratby, John Randall 1928–1992
*John with Two Pattis, Beauport Park,
Hastings* 1990
oil on canvas 121 x 90
HASMG:2001.27

Bridgeman, Ann active 1958–1961
May Tree c.1958
oil on canvas 67.5 x 87.5
HASMG:958.61

British (Norwich) School
Heathland with Windmill
oil on panel 20.5 x 29.0
HASMG:948.70.1

British (Norwich) School
Norfolk Landscape
oil on canvas 67 x 90
HASMG:933.16

British (Norwich) School
River Scene with Barges and Horses by a Bridge
oil on panel 22.9 x 33.0
HASMG:948.70.2

Brooke, William Henry 1772–1860
Hastings Fishermen 1840
oil on panel 20.3 x 25.4
HASMG:957.55.1

Brooke, William Henry 1772–1860
Old London Road, Entrance to Hastings c.1846
oil on board 18 x 24
HASMG:957.55.2

Buckner, Richard 1812–1883
Mrs Eleanor Webster c.1860
oil on canvas 65 x 53
HASMG:950.29.2

Butler, Charles Ernest b.1864
134 All Saints Street 1884
oil on canvas 61 x 43
HASMG:937.46

Buxton, William Graham active 1885–1913
On Fairlight Beach 1913
oil on canvas 36 x 54
HASMG:995.29.2

Buxton, William Graham active 1885–1913
Sweet Peas, the Nursery, Ore 1913
oil on canvas 36 x 52
HASMG:995.29.1

Callam, Edward 1904–1980
The Old Town, Bexhill
oil on board 97.9 x 91.5
HASMG:978.122

Clint, Alfred 1807–1883
View of Hastings 1849
oil on canvas 41 x 66
HASMG:921.37

Colborne, Vera active 1909–1949
Miss Laura Beeforth 1947
oil on canvas 92 x 71
HASMG:2001.31.227

Colborne, Vera active 1909–1949
Alderman Mrs Farnfield 1949
oil on canvas 122 x 91 (E)
HASMG:2004.43.2

Colborne, Vera active 1909–1949
Alderman Arthur Blackman
oil on canvas 183 x 122 (E)
HASMG:2004.43.10

Cole, George Vicat 1833–1893
Hastings, View from Rock-a-Nore 1851
oil on canvas 45 x 86
HASMG:955.64

Cole, George Vicat 1833–1893
Cattle by a Stream 1860
oil on canvas 41 x 63 (E)
HASMG:933.19

Cole, George Vicat 1833–1893
Sheep at Dusk
oil on board 28 x 23
HASMG:955.66.10

Cole, John 1903–1975
Hastings from Summerfields
oil on board 30.5 x 35.5
HASMG:983.74

Cole, John 1903–1975
Hastings Trawler
oil on board 29 x 38
HASMG:962.42

Cole, Philip William 1884–1964
The Visitor, Miss Hayes 1937
oil on canvas 75 x 62
HASMG:967.51

Cole, Philip William 1884–1964
*Alderman Burden Dressed in the Robes of a
Baron of the Cinque Ports* 1953
oil on canvas 77 x 63
HASMG:2003.1.1

Cole, Philip William 1884–1964
Georgian Houses, Hastings c.1956
oil on canvas 48 x 61
HASMG:956.6

Cole, Philip William 1884–1964
Elsie Cole, née Hayes
oil on canvas 50.5 x 40.5
HASMG:968.40

Cole, Philip William 1884–1964
J. Macer Wright
oil on canvas 59 x 49
HASMG:967.43

Cole, Philip William 1884–1964
Self Portrait with Pipe
oil on canvas 60 x 50
HASMG:984.100

Cole, Philip William 1884–1964
Sidney Parkman
oil on canvas 78 x 62
HASMG:965.47

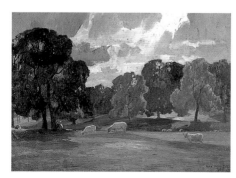

Cole, Rex Vicat 1870–1940
In Hyde Park 1934
oil on board 31 x 41
HASMG:955.66.11

Cole, Violet Vicat 1890–1955
Tent Peg Makers 1946
oil on board 35.5 x 45.0
HASMG:947.40.3

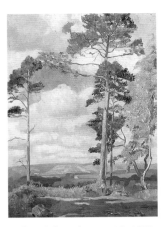

Cole, Violet Vicat 1890–1955
Roundstone, Connemara
oil on canvas 75 x 56
HASMG:955.66.4

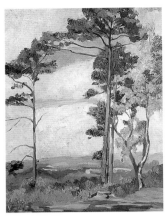

Cole, Violet Vicat 1890–1955
Roundstone, Connemara
oil on board 45.5 x 35.5
HASMG:955.66.12

Cole, Violet Vicat 1890–1955
The Bends, Connemara
oil on canvas 54.5 x 77.0
HASMG:955.66.5

Cole, Violet Vicat 1890–1955
The Flower Market
oil on board 34 x 44
HASMG:955.66.8

Cooper, Thomas Sidney 1803–1902
Cattle in a Water Meadow 1861
oil on board 34 x 49
HASMG:933.20

Cox, Leonard Carr active 1900–1909
Dr Thomas Gambier 1909
oil on canvas 123 x 100
HASMG:998.36

Craft, Percy Robert 1856–1934
Hastings Net Shops
oil on board 40 x 55
HASMG:935.24

Cundall, Charles Ernest 1890–1971
The Elephant Ride 1924
oil on board 23 x 18
HASMG:954.9.2

Cundall, Charles Ernest 1890–1971
The Clearing 1946
oil on canvas 50 x 75
HASMG:948.62.2

Cundall, Charles Ernest 1890–1971
Segovia c.1946
oil on canvas 39 x 55
HASMG:948.62.1

Cundall, Charles Ernest 1890–1971
Hastings Cricket Festival (Festival Week, Hastings) c.1952
oil on canvas 75 x 200
HASMG:2004.43.3

Davis, Arthur
Edward Blackmore 1981–1982
oil on board 91 x 60
HASMG:988.28

Davis, Henry William Banks 1833–1914
Midday 1876–1907
oil on canvas 152 x 120 (E)
HASMG:936.59

Day, Bill b.1945
Hastings Central Cricket Ground 1989
oil on canvas 74 x 111
HASMG:998.49

Detmold, Henry Edward 1854–1924
Reverend John W. Tottenham c.1897
oil on canvas 80 x 61
HASMG:897.3

Dodd, Charles Tattershall II 1861–1951
Zinnias c.1949
oil on canvas 58.4 x 43.2
HASMG:949.32.1

Emmanuel, Frank Lewis 1866–1948
Beach Scene 1900
oil on canvas laid on board 25.4 x 34.9
HASMG:948.2.5

Emmanuel, Frank Lewis 1866–1948
St Clement's Church from Hill Street
oil on panel 35.0 x 25.4
HASMG:948.2.4

Eves, Reginald Grenville 1876–1941
Hercules Brabazon Brabazon (after John Singer Sargent) c.1900
oil on canvas 71.5 x 43.0
HASMG:941.1.2

Eves, Reginald Grenville 1876–1941
Coventry Patmore (after John Singer Sargent)
oil on canvas 65 x 55
HASMG:941.1.1

Fisher, Mark 1841–1923
Winter Landscape
oil on canvas 44 x 60
HASMG:951.28.1

Francotte, W.
Swan Inn 1883
oil on board 28.5 x 22.2
HASMG:953.2.1

Francotte, W.
The Swan Shades 1883
oil on board 34.3 x 22.2
HASMG:953.2.2

Fuchs, Emil 1866–1929
Freeman Freeman Thomas MP 1906
oil on canvas 152 x 91 (E)
HASMG:2004.43.8

Giffrey, Haydn
Councillor John Hodgson 1978
oil on board 76 x 61
HASMG:2004.43.13

Gladwell, Angela b.1945
Hastings from the Castle Mound 1991–1995
oil on canvas 131.2 x 196.9
HASMG:996.34.1

Facing page: La Thangue, Henry Herbert, 1859–1929, *Portrait of a Young Girl* (detail), Towner Art Gallery, (p. 252)

Goodwin, Albert 1845–1932
Winchelsea
oil on paper 24.1 x 36.2
HASMG:949.14.1

Gosse, Laura Sylvia 1881–1968
Dieppe c.1919
oil on canvas 56.0 x 45.5
HASMG:979.80

Gosse, Laura Sylvia 1881–1968
Envermeu 1920s
oil on canvas 65 x 54
HASMG:948.75

Gosse, Laura Sylvia 1881–1968
Rochefort du Gard
oil on canvas 59 x 43
HASMG:967.21

Graham, George 1881–1949
Earth's Awakening 1935–1937
oil on canvas 67 x 80
HASMG:995.39.6

Graham, George 1881–1949
Primal Conflict 1935–1937
oil on canvas 60 x 50
HASMG:995.39.26

Graham, George 1881–1949
Spheres and Atoms 1935–1937
oil on canvas 76 x 63
HASMG:995.39.19

Graham, George 1881–1949
The Creation of Fishes 1935–1937
oil on canvas 71.0 x 91.5
HASMG:995.39.8

Graham, George 1881–1949
The Creation 1935–1938
oil on canvas 100 x 125
HASMG:995.39.28

Graham, George 1881–1949
The Creation of Flowers 1935–1938
oil on canvas 63 x 76
HASMG:995.39.11

Graham, George 1881–1949
The Empowering of the Clouds 1935–1938
oil on canvas 95 x 113
HASMG:995.39.18

Graham, George 1881–1949
In the Beginning 1935–1939
oil on canvas 65.5 x 50.0
HASMG:995.39.12

Graham, George 1881–1949
*'And the spirit of God moved upon the face of
the waters'* 1935–1945
oil on canvas 49.0 x 58.5
HASMG:995.39.22

Graham, George 1881–1949
The Lair of the Sun (First Version) 1935–1948
oil on canvas 59.5 x 49.0
HASMG:995.39.24

Graham, George 1881–1949
Evening 1936–1938
oil on canvas 68.0 x 57.5
HASMG:995.39.21

Graham, George 1881–1949
*The Creation of the Deep Seas, Salt
Dykes* 1936–1938
oil on canvas 102 x 127
HASMG:995.39.16

Graham, George 1881–1949
The Heavens Rejoice 1936–1938
oil on canvas 120 x 90
HASMG:995.39.27

Graham, George 1881–1949
The Creation of Day and Night 1936–1939
oil on canvas 90.0 x 69.8
HASMG:995.39.14

Graham, George 1881–1949
Veni sacre spiritus 1936–1939
oil on canvas 121 x 90
HASMG:995.39.17

Graham, George 1881–1949
The Creation of Heaven and Earth 1937–1938
oil on canvas 67 x 80
HASMG:995.39.9

Graham, George 1881–1949
And God Rested from His Labours 1937–1939
oil on canvas 61 x 73
HASMG:995.39.15

Graham, George 1881–1949
The Evening of Creation 1937–1939
oil on canvas 90 x 70
HASMG:995.39.3

Graham, George 1881–1949
The Morning of Creation (First Version) 1937–1939
oil on canvas 62.5 x 75.0
HASMG:995.39.13

Graham, George 1881–1949
The Great Beast 1939–1940
oil on canvas 71.0 x 91.5
HASMG:995.39.7

Graham, George 1881–1949
Worlds Unknown 1940
oil on canvas 60.5 x 74.0
HASMG:995.39.10

Graham, George 1881–1949
'And the spirit of God moved upon the face of the waters' 1941
oil on canvas 22.9 x 27.9
HASMG:946.102.5

Graham, George 1881–1949
Earth, Sun, Moon and Star, Castle Bolton 1942–1943
oil on canvas 74 x 61
HASMG:995.39.1

Graham, George 1881–1949
The Lair of the Sun (Final Version) 1942–1943
oil on canvas 76 x 63
HASMG:995.39.25

Graham, George 1881–1949
The Creation of Day and Night 1942–1944
oil on canvas 90 x 70
HASMG:995.39.2

Graham, George 1881–1949
The Morning of Creation (Final Version)
1942–1944
oil on canvas 91 x 70
HASMG:995.39.5

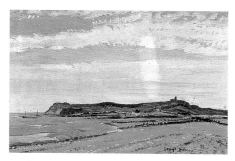

Graham, George 1881–1949
Earth's Travail 1944
oil on canvas 90 x 70
HASMG:995.39.4

Graham, George 1881–1949
The Creation of Snow 1944–1945
oil on canvas 60 x 50
HASMG:995.39.23

Graham, George 1881–1949
Fairlight Hills from Winchelsea Beach c.1946
oil on canvas 20.3 x 30.5
HASMG:946.102.6

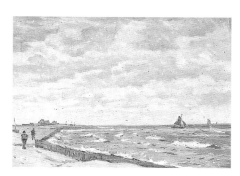

Graham, George 1881–1949
Winchelsea Beach c.1946
oil on canvas 25.4 x 35.6
HASMG:946.102.4

Graham, George 1881–1949
Evening Star
oil on canvas laid on board 19 x 15
HASMG:983.57.1

Graham, George 1881–1949
Yorkshire Landscape
oil on canvas 61.0 x 73.7
HASMG:979.198

Grant, Francis 1803–1878
Thomas First Earl Brassey c.1864
oil on canvas 244 x 122 (E)
HASMG:2004.43.5

Grant, Francis 1803–1878 **& Landseer, Edwin Henry** 1802–1873
Mrs Brassey 1864
oil on canvas 274 x 183
HASMG:2004.43.4

Graves, Charles A. 1834/1835–1918
Hop Garden in Alexandra Park c.1872
oil on canvas 35.5 x 53.0
HASMG:981.27.8

Graves, Charles A. 1834/1835–1918
Old Hastings 1896
oil on canvas 40.5 x 57.0
HASMG:966.32.1

Graves, Charles A. 1834/1835–1918
Remains of Elizabethan Harbour 1901
oil on canvas 33.7 x 66.4
HASMG:952.53.1

Hall, Clifford 1904–1973
Llanmadoc 1968
oil on board 29 x 39
HASMG:970.26

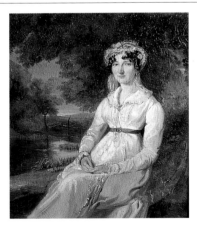

Hall, Clifford 1904–1973
Shrouded Figure 1970
oil on board 84 x 83
HASMG:971.20

Hayes, Edwin 1820–1904
Old Hastings c.1885
oil on canvas 52 x 75
HASMG:939.68

Heaphy, Thomas 1775–1835
Mrs Charlotte Shorter 1825
oil on canvas 37 x 33
HASMG:998.60.1

Hebron, W.
The River Thames in Winter 1902
oil on board 47 x 62
HASMG:2003.52

Hubbard, Eric Hesketh 1892–1957
The Fairground, Quimper c.1950
oil on canvas 36.0 x 44.5
HASMG:952.76

Hubbard, Eric Hesketh 1892–1957
Charlton Forest from Goodwood
oil on board 40.6 x 50.8
HASMG:958.18

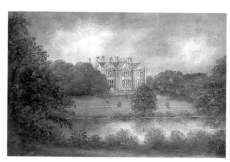

C. M. J.
Coghurst Hall 1840
oil on canvas 35.6 x 50.8
HASMG:958.40

Jennings, K. J.
A Good Catch c.1975
oil on board 45.5 x 35.5
HASMG:975.22

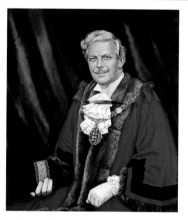

Johnson, Patrick
Councillor William Darker, Mayor (May 1973–January 1974) 1976
oil on board 61 x 51
HASMG:2004.43.12

Kerr, Charles Henry Malcolm 1858–1907
Piggie c.1889
oil on canvas 50.8 x 38.1
HASMG:938.63

Kerr, Charles Henry Malcolm 1858–1907
A Game of Bowls
oil on canvas 51 x 64 (E)
HASMG:937.2

Kilpack, Sarah Louisa active c.1867–1909
Martello Tower at Bulverhythe c.1867
oil on canvas 44 x 34
HASMG:938.19

Lancaster, Richard Hume 1773–1853
Marine Parade, Hastings 1825
oil on canvas 91.5 x 183.0
HASMG:909.31

Lancha, P.
*Councillor D. W. Wilshin, MBE, JP, Mayor
(1962–1967)* 1967
oil on canvas 183 x 122 (E)
HASMG:2004.43.1

Lansdell, Avril
Ecclesbourne Cliff, Hastings 1963
oil on board 40.6 x 22.9
HASMG:973.3.2

Lansdell, Avril
The Broken Boat 1964
oil on board 33.0 x 55.9
HASMG:973.3.1

Leggat, Douglas James
Councillor Alan Stace, Mayor (1981–1983)
c.1983
oil on board 106 x 76 (E)
HASMG:2004.43.11

Lessore, Thérèse 1884–1945
The Daredevils
oil on canvas 91.4 x 71.1
HASMG:984.1.5

Lewis, F. Howard
*HM Queen Elizabeth II in Coronation Robes
(after Herbert James Gunn)* 1953
oil on canvas 120 x 75
HASMG:960.5

Lilley, E. P.
A Bazaar
oil on board 30.5 x 38.1
HASMG:973.13

Lilley, E. P.
Marshland
oil on canvas 45.7 x 61.0
HASMG:973.61

Facing page: Flemish School, *Philip de Monmorency, Comte de Horn* (detail), 1543, Brighton and Hove
Museums and Art Galleries, (p. 80)

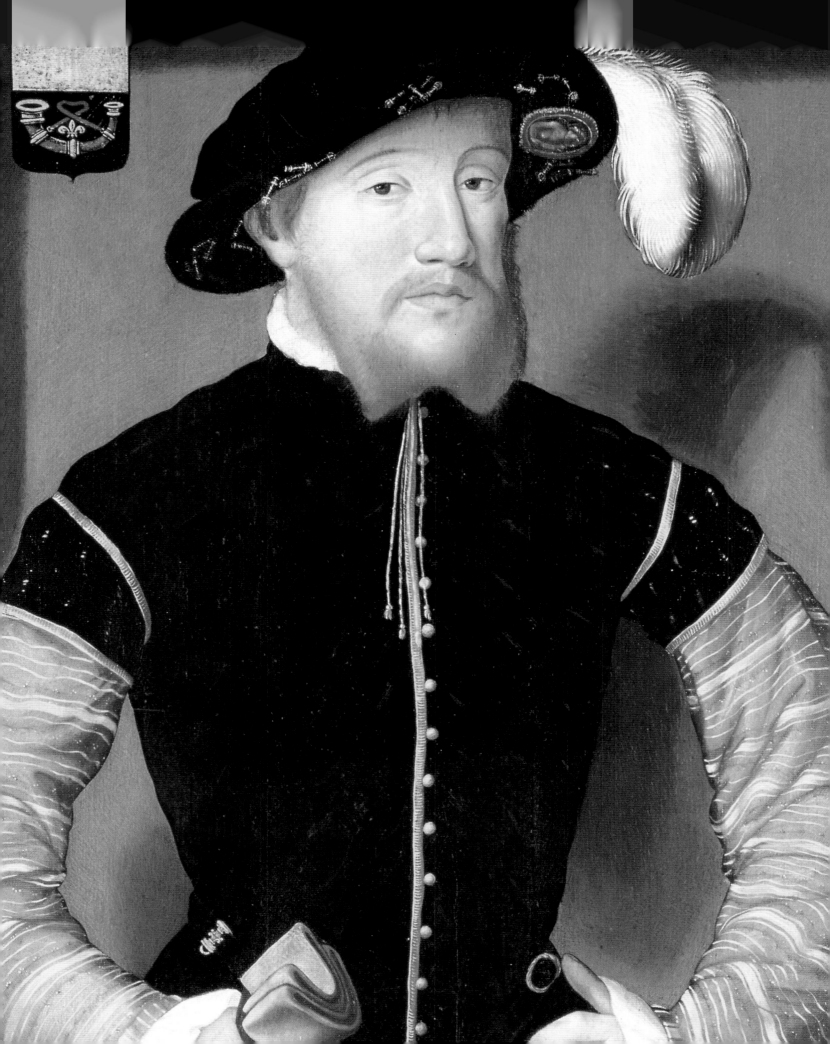

Lilley, E. P.
Summer Meadow
oil on canvas laid on board 22.9 x 33.0
HASMG:973.71

Lilley, E. P.
The Butcher's Boy
oil on canvas 38.1 x 30.5
HASMG:973.62

Lines, Vincent Henry 1909–1968
Hastings from John's Place 1959
oil on board 63.5 x 73.7
HASMG:979.78

W. J. M.
Hollington Church in the Wood 1885
oil on canvas 30.5 x 41.0
HASMG:949.39

Maitland, J.
The Railway Embankment in 1866 1866
oil on canvas 30 x 55
HASMG:956.27

Marks, Margaret 1899–1990
Net Shops at Rock-a-Nore 1950s
oil on board 57 x 40
HASMG:999.43

Mazzoni, Sebastiano c.1611–1678
Study for the Sacrifice of Jephthah
oil on canvas laid on board 25.5 x 26.5
HASMG:2003.73

Meadows, Arthur Joseph 1843–1907
Hastings Beach 1863
oil on canvas 31 x 56
HASMG:932.4

Mears, George 1826–1906
The Steam Ship 'Carrick Castle' 1885
oil on canvas 51 x 91
HASMG:937.86

Methuen, Paul Ayshford 1886–1974
Number 3, St James Street, Bath
oil on board 44 x 37
HASMG:952.77

Mitchell, John Campbell 1865–1922
Clearing after Rain 1910
oil on canvas 35.5 x 43.0
HASMG:921.28

Moss, Sidney Dennant 1884–1946
Harmony (Cattle Watering, Pevensey) 1935
oil on canvas 50.8 x 61.0
HASMG:948.79.3

Moss, William George active 1814–1838
Rescue at Hastings 1814
oil on canvas 64.5 x 89.5
HASMG:994.19

Moss, William George active 1814–1838
Hastings Town Hall c.1823
oil on canvas 24.6 x 33.8
HASMG:971.51

Murray, David 1849–1933
The Fairy Glen
oil on canvas 104 x 180
HASMG:939.82.2

Neave, Alice Headley 1903–1977
Children Returning to School, Battle 1956
oil on canvas 40.6 x 50.8
HASMG:961.13

Neave, Alice Headley 1903–1977
Smokey Afternoon, Ore c.1960
oil on board 35.6 x 40.6
HASMG:986.51

Neave, Alice Headley 1903–1977
Tree in Winter, Tunbridge Wells
oil on canvas 40.6 x 30.5
HASMG:984.8

Panini, Giovanni Paolo c.1692–1765
Classical Ruins c.1730–1740
oil on canvas 142.0 x 101.5
HASMG:923.20

Parkin, Thomas 1845–1932
Bulverhythe, St Leonards on Sea 1886
oil on board 20.5 x 33.0
HASMG:896.6

Parkin, Thomas 1845–1932
The Bull Inn, Bulverhythe 1887
oil on card 22.9 x 30.5
HASMG:946.82.1

Parks, W. J.
View from All Saints
oil on canvas 43 x 61
HASMG:979.84

Patry, Edward 1856–1940
Major Cyril Davenport 1933
oil on canvas 81.3 x 66.0
HASMG:942.1

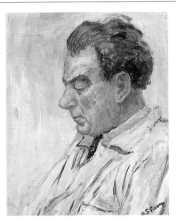

Pavey, A . J.
Vincent Lines
oil on paper laid on board 50.8 x 38.1
HASMG:970.27

Pellegrin, V.
Lifeboat House 1891
oil on canvas 36 x 53
HASMG:981.27.15

Pellegrin, V.
The East Hill Well 1891
oil on canvas 36 x 53
HASMG:981.27.14

Pether, Henry active 1828–1865
*Off Tilbury, Shipping on the Thames in
Moonlight*
oil on canvas 57 x 89
HASMG:927.4

Pike, Leonard W. 1887–1959
Autumn in the Wye Valley
oil on canvas 55.9 x 73.7
HASMG:960.8

Porter, W.
Hon. Mrs Freeman Thomas 1900
oil on canvas 152 x 91 (E)
HASMG:2004.43.6

Powell, Charles Martin 1775–1824
Hastings c.1814
oil on canvas 88 x 151
HASMG:928.27

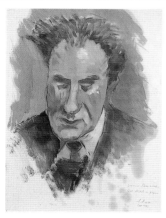

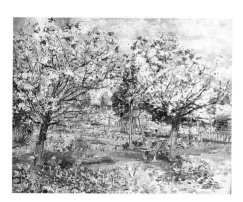

Powell, Joseph 1796–c.1834
Dutch Man of War and Frigate 1803
oil on panel 25 x 30
HASMG:937.63.1

Pratt, Leonard
Vincent Lines 1905
oil on paper 43.2 x 33.0
HASMG:984.154

Prout, Margaret Fisher 1875–1963
Blossom Time 1947
oil on board 44 x 61
HASMG:951.28.2

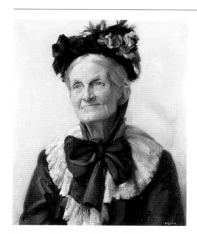

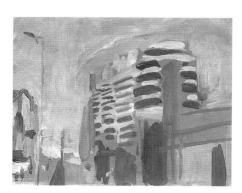

Quick, Horace Edward d.1966
The Old Lady
oil on canvas 61.0 x 50.8
HASMG:971.10

Rankle, Alan b.1952
Marine Court, St Leonards 1988
oil on board 20.0 x 25.5
HASMG:989.33

Ray, Edith 1905–c.1989
Ebb Tide, Cleddau, Pembrokeshire
oil on board 45.7 x 58.4
HASMG:989.21.1

Ray, Edith 1905–c.1989
Gatigues, Provence
oil on board 45.7 x 61.0
HASMG:989.21.2

Ray, Edith 1905–c.1989
Old Mill, Winchelsea
oil on board 48.3 x 61.0
HASMG:989.21.3

Ray, Edith 1905–c.1989
Rye Harbour, Sussex
oil on board 51 x 61
HASMG:989.21.4

Read, Arthur Rigden b.1879
September Sunshine 1929
oil on canvas 64 x 48 (E)
HASMG:934.22.7

Reni, Guido (after) 1575–1642
Head of Christ 19th C
oil on canvas 61.5 x 35.0
HASMG:973.32

Richardson, Bob b.1928
*Trek to Birch Lake, out of Cabano,
Quebec* 1983
oil on canvas 40.6 x 50.8
HASMG:984.102

Roberts, Arthur Spencer 1920–1997
*'HMS Corunna' and 'Agincourt' at Hastings
during the Coronation Celebrations* 1953
oil on canvas 41 x 50
HASMG:955.19

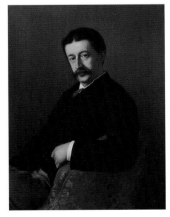

Romagnoli, Angiolo
Augustus Hare 1879
oil on canvas 101.5 x 76.0
HASMG:903.3

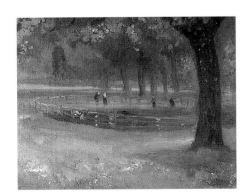

Roussel, Theodore 1847–1926
Parkland in Summer 1925
oil on canvas 48.3 x 58.4
HASMG:964.4

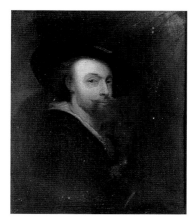

Rubens, Peter Paul (school of) 1577–1640
Rubens
oil on canvas 33.0 x 27.9
HASMG:953.15

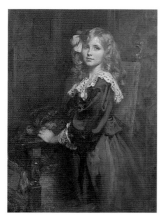

Shannon, James Jebusa 1862–1923
Miss D. L. Smith 1903
oil on canvas 109.2 x 83.8
HASMG:971.31

Sharp, Dorothea 1874–1955
By the Lakeside
oil on canvas 61.0 x 76.2
HASMG:955.66.2

Sharp, Dorothea 1874–1955
Children on a Hillside
oil on board 36 x 44
HASMG:955.66.7

Shayer, William 1788–1879
Carthorses and Rustics by a Stream 1840
oil on canvas 40 x 89 (E)
HASMG:933.17

Shee, Martin Archer 1769–1850
*Lieutenant Colonel Sir Henry Vassal
Webster* c.1814
oil on canvas 121.9 x 91.4
HASMG:950.29.1

Sickert, Walter Richard 1860–1942
Signor de Rossi 1901
oil on canvas 56 x 45
HASMG:949.8.1

Smith, E. Blackstone
The Oil Stove
oil on paper 137.2 x 76.2
HASMG:960.4.2

Stallard, Constance b.1870
Jerusalem from Mount Scopus 1935
oil on canvas 52 x 67
HASMG:943.2

Strickland, William Francis d.2000
Old St Helen's Church c.1988
oil on board 30 x 40
HASMG:988.17

Strickland, William Francis d.2000
The Last Over c.1989
oil on board 47.0 x 63.5
HASMG:989.26

Strickland, William Francis d.2000
Darwell Reservoir 1991
oil on board 46 x 55
HASMG:991.63

Strickland, William Francis d.2000
Engine Houses, Brede Pumping Station 1991
oil on board 35.6 x 46.0
HASMG:991.19.1

Strickland, William Francis d.2000
Tangye Engine at Brede Pumping Station 1991
oil on board 46 x 32
HASMG:991.19.2

Strickland, William Francis d.2000
Evening at Rye
oil on canvas laid on board 27.9 x 38.1
HASMG:979.192

Strij, Abraham van 1753–1826
Dutch Girl and Boy on House Doorstep
oil on canvas 66 x 52
HASMG:955.37

Strutt, Alfred William 1856–1924
Temptation in the Wilderness c.1901
oil on canvas 101 x 213
HASMG:915.94

Thorpe, John 1813–1897
The Rope Walk
oil on canvas 68.5 x 89.0
HASMG:954.4

Townsend, Kenneth 1935–2001
Fieldmark 1960s
oil on board 28 x 37
HASMG:2000.2

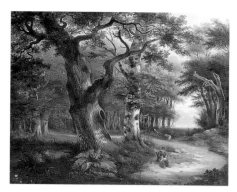

unknown artist
Poacher in a Wood c.1810
oil on canvas 54 x 65
HASMG:2003.77

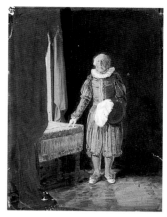

unknown artist
*William Phillips Lamb, Mayor of Rye in His
Robes as a Baron of the Cinque Ports* 1821
oil on board 17 x 13
HASMG:2004.42

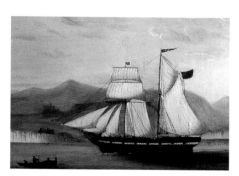

unknown artist
*The Schooner 'London' Built at Chester in
1827* c.1827
oil on canvas 49.0 x 67.5
HASMG:983.34.1

unknown artist
*Reverend Thomas Vores as a Young
Man* 1830s
oil on canvas 77 x 63
HASMG:932.27

unknown artist
*Marianne Barnfather Eagles in Middle
Age* c.1850
oil on canvas 76 x 64
HASMG:980.121

unknown artist
*William Barnfather Eagles in Middle
Age* c.1850
oil on canvas 91 x 70
HASMG:980.118

unknown artist
The Reverend Thomas Vores 1870–1880s
oil on canvas 91 x 78
HASMG:2004.41

unknown artist
*View of Old Town from above All Saints
Church* c.1880
oil on board 29.1 x 45.0
HASMG:987.92

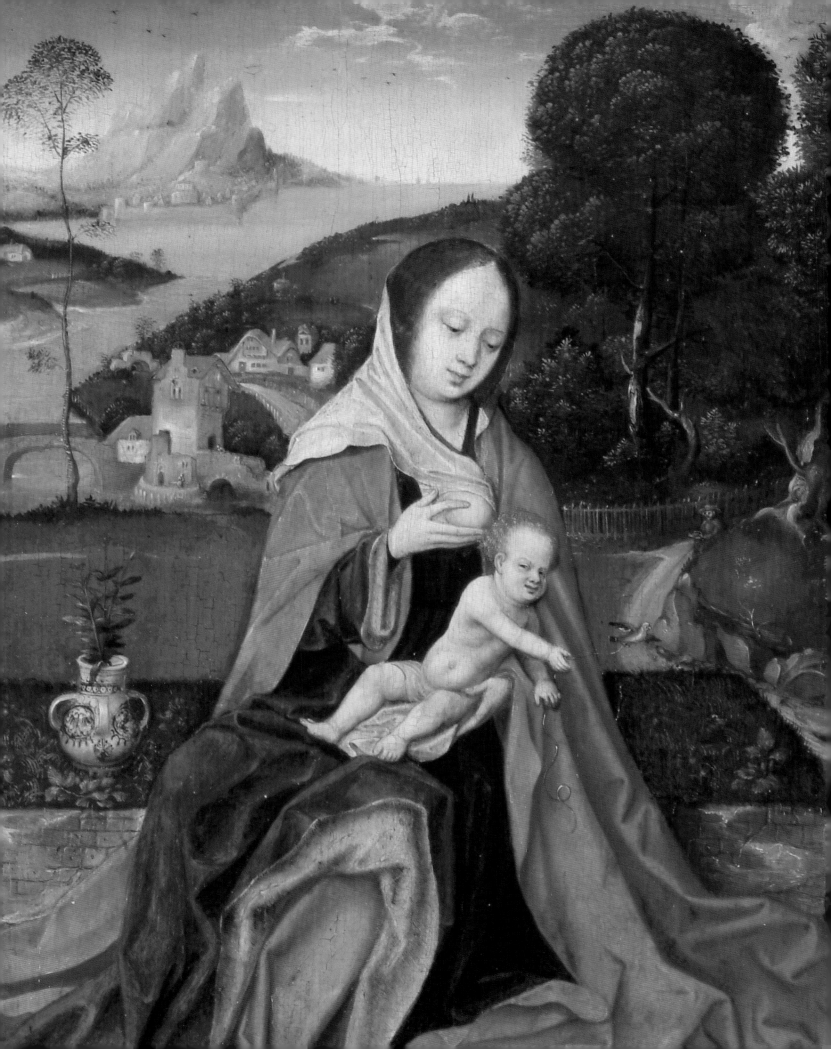

unknown artist
Edwin Bradnam in Mayoral Robes 1884–1890
oil on canvas 92 x 71
HASMG:977.58

unknown artist
Copy of Diamond Jubilee Portrait of Queen Victoria 1897
oil on canvas 168 x 122
HASMG:2004.43.9

unknown artist early 19th C
John Goldsworthy Shorter, Mayor of Hastings
oil on canvas 75 x 62 (E)
HASMG:972.4.1

unknown artist
E. D. Compton MA, Headmaster of Summerfields School (1903–1928) c.1928
oil on canvas 76 x 63
HASMG:966.44.1

unknown artist
Biddy the Tubman 1960s
oil on board 40.0 x 30.5
HASMG:979.173

unknown artist
James Burton (1761–1837), Founder of St Leonards
oil on board 43 x 35
HASMG:952.9

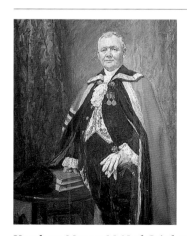

Urquhart, Murray McNeel Caird 1880–1972
Alderman Arthur Blackman 1937
oil on canvas 104 x 91
HASMG:2004.43.14

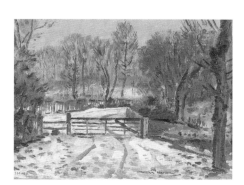

Warden, William 1908–1982
The Gate 1950
oil on canvas 22.9 x 33.0
HASMG:951.14

Weight, Carel Victor Morlais 1908–1997
Holland Walk c.1946
oil on canvas 63.5 x 53.3
HASMG:954.60.1

Facing page: Bles, Herri met de, c. 1510–after 1550, *Madonna and Child in a Landscape with St Christopher and St Anthony the Great* (detail), Towner Art Gallery, (p. 228)

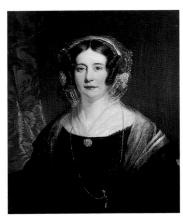

West, Samuel c.1810–after 1867
*Marianne Barnfather Eagles as a Young
Woman* c.1830
oil on canvas 76 x 64
HASMG:980.120

West, Samuel c.1810–after 1867
*William Barnfather Eagles as a Young
Man* c.1830
oil on canvas 76 x 64
HASMG:980.119

West, Samuel (attributed to)
c.1810–after 1867
James Breeds Junior c.1850
oil on canvas 85 x 63
HASMG:993.89

Williams, Ina Sheldon 1876–1955
Oxen Ploughing, the Cuckmere c.1904
oil on canvas 33.0 x 40.6
HASMG:939.6

Williams, Ina Sheldon 1876–1955
Sussex Oxen and Hayricks c.1904
oil on canvas 50.5 x 76.0
HASMG:973.107

Williams, Terrick 1860–1936
The Harbour at Mevagissey, Cornwall
oil on canvas 24.5 x 39.5
HASMG:952.53.2

Williams, Walter 1835–1906
Hastings Beach 1856
oil on canvas 36.5 x 64.0
HASMG:919.6.10

Williams, Walter 1835–1906
Misty Morning, Old Hastings 1856
oil on canvas 36 x 63
HASMG:956.45.2

Williamson, J. active 1850–1919
*German Lifeboat U118 Stranded at Hastings
Beach* 1919
oil on board 31 x 47
HASMG:980.96

Williamson, William Henry 1820–1883
Shipping off Dover 1861
oil on canvas 76 x 125
HASMG:933.45

Wright, Macer active 1893–1919
*Man with White Hair and Beard Holding
Papers* 1893
oil on canvas 91 x 61
HASMG:2004.43.16

Wright, Macer active 1893–1919
*Unidentified Mayor (Possibly Alderman
Mitchell)* 1919
oil on canvas 76 x 61
HASMG:2004.43.15

Yale, W.
*Copeland Plaque, Rough Day, off
Bexhill* c.1880
oil on porcelain 25 x 29
HASMG:977.103

Yale, W.
Copeland Plaque, View off Hastings c.1880
oil on porcelain 25 x 49
HASMG:977.102

Yhap, Laetitia b.1941
The Boat 1987
oil on board 108.0 x 166.4
HASMG:991.62

Zermati, Jules 1875–1925
A Pinch of Snuff
oil on canvas 39 x 56
HASMG:959.24.4

Charleston

In 1916 the artist Vanessa Bell moved her household to Charleston in Sussex as a refuge from the war. There her companions, the artist Duncan Grant and his friend David Garnett, conscientious objectors, could undertake prescribed farm labour. Although the conditions in this traditional Sussex farmhouse were primitive and makeshift the artists, animated by memories of Italian fresco painting and the pre-war Post-Impressionist exhibitions, soon began to redecorate the walls, doors and furniture. Between the wars the house, leased from the Gage Estate, remained a home for holidays and became a favourite meeting place for the Bloomsbury group of artists, writers and intellectuals. Vanessa Bell's husband Clive Bell, Maynard Keynes and Roger Fry spent much time there; Lytton Strachey, the MacCarthys, and Leonard and Virginia Woolf (Vanessa Bell's sister) were regular visitors. Many others, including E. M. Forster, T. S. Eliot, Dame Ethel Smyth and Frances Partridge were welcome guests.

In the course of time the house was made more comfortable. In 1925 a studio, planned by Fry, was built, in the 1930s electricity and the telephone were installed and with the approach of the Second World War Charleston became the Bells' and Grant's full-time home. Further structural improvements were instituted by Vanessa Bell, including a second studio in the attic.

Vanessa Bell died in 1961, and Clive Bell in 1964. During Duncan Grant's late years the house fell into a state of disrepair and after his death in 1978 the Charleston Trust was formed to acquire and restore the building and its neglected garden, and preserve the interior with its decorations and contents. Thanks to the generosity of the family these remain remarkably complete. The collection of paintings is largely made up of those that hung in the house or were stored in its studios during the artists' lifetimes. They form part of a broader collection that includes murals, stencilled wall decorations, painted furniture, carpets, curtains, ceramics and a library of over 4,000 books.

As a collection, the paintings represent the work that Bell and Grant admired as well as their own work and that of their friends and family. Matthew Smith, for example, exchanged pictures with Duncan Grant, and the artists Frederick and Jessie Etchells were fellow collaborators in the Omega Workshops where Bell and Grant were co-directors with Roger Fry from 1913. A Vanessa Bell painting, now in Tate Britain's collection, shows Frederick Etchells standing at an easel and his sister Jessie sitting on the floor to paint at Bell's former Sussex home, Asheham, in 1912. The Etchells' paintings at Charleston date from around this period.

The Omega Workshops encouraged its artists to copy from old masters. It organised an exhibition of copies and visual translations in 1917 and Roger Fry's *The Healing of the Wounded Man of Lerida* was painted for this show. Bell and Grant made copies throughout their careers which were prominently hung in the house. Duncan Grant's *The Duke of Urbino*, after Piero della Francesca, (c.1904) still hangs in its historic position in the dining room and Vanessa Bell's copy of Raphael's *St Catherine* (c.1922) takes pride of place above the fireplace in Grant's bedroom. Some of the copies in the house, however, mark absences where paintings were sold during the artists' lifetimes. Clive Bell purchased Vlaminck's *Poissy le Pont* at the first Post-Impressionist exhibition in 1910 for example, and Vanessa Bell made a copy to hang in its place before the original was sold in the 1950s.

Clive Bell was a progressive art critic and writer. When Vanessa Bell listed the paintings at Charleston in 1951 his collection included a Matisse, a Gris, several Sickerts, a Rouault and a Picasso. These were dispersed before the formation of the Charleston Trust but the Picasso - believed to be the first in a private collection in Britain - is marked by a copy by Bell's son, Quentin, *Pots et citron* (c.1960).

Vanessa Bell's and Duncan Grant's artistic influences can be charted through the works on paper as well as the paintings in the collection. Their admiration for Cézanne is clearly established in a copy of *Madame Cézanne* by Duncan Grant, excluded from this catalogue because it is a watercolour, and there are prints and drawings by Delacroix, Whistler, Redon, Signac, Pissaro, Derain, Maillol and Picasso in Charleston's collection. The artistic friendships which shaped the collection were often informal. There are two picnic plates in the collection onto which are sketched portraits of Clive and Quentin Bell by Augustus John. Several of the French paintings which belonged to Clive Bell are inscribed to him and paintings and prints by Sickert which were given to Vanessa Bell and Duncan Grant or purchased by them are evidence of a relationship which was personal and professional. Sickert influenced Bell's and Grant's early paintings and they knew one another socially. In 1920 Grant leased Sickert's former studio at 8 Fitzroy Street in London and as late as 1938 he lectured at the Euston Road School after lunching with the Bells and Grant. *One of Madame Villain's Sons* was one of six Sickert paintings originally at Charleston and Grant was firmly of the opinion that it was a portrait of Sickert's illegitimate child by his landlady in Dieppe - a theory disputed by modern scholarship.

Charleston's collection of paintings by Vanessa Bell and Duncan Grant ranges in quality from some of the finest examples of their work to unfinished pieces stashed away in the studio racks. Understandably, some of their most intimate paintings were retained at Charleston. Grant's early *Self Portrait in a Turban* (c.1909) originally hung in Vanessa Bell's bedroom together with his portraits of their daughter, Angelica, and Vanessa Bell's two sons. Bell's early paintings of her baby *Julian Asleep* (c.1908) and *Julian Bell* (c.1908), and her late *Self Portrait* (c.1958) are among the most poignant in the collection. Portraits of family and friends working or relaxing at Charleston document other aspects of the collection. Bell's portrait of their housekeeper, Grace Higgens, at work in *The Kitchen at Charleston* (c.1943) was a primary source for the restoration of that room.

The quiet seriousness of these quintessentially domestic paintings evokes some of the values that Charleston represented. The importance of friendship, of beautiful surroundings, a rigorous pursuit of truth even in the everyday, and a distaste for sentimentality are evident throughout the collection. As an integral part of Charleston's interiors the paintings hang against stencilled wallpapers or reflect the same colours that the artists used in their designs for painted furniture and canvas work. They are set between decorated doors and fire surrounds accentuating Bell's and Grant's disregard for the conventional boundaries between easel painting and design. Paintings within museum collections can rarely be exhibited in an authentic domestic setting. At Charleston the paintings are perhaps most significant as an artists' collection presented within their own extraordinary home.

Wendy Hitchmough, Curator

Bagenal, Barbara 1891–1984
Menton c.1950
oil on board 25.5 x 32.5
CHA/P/241

Barne, George Hume b.1882
Still Life with Strawberries c.1928
oil on canvas 70.5 x 57.3
CHA/P/215

Bas, Edward le 1904–1966
Snow Scene c.1948–1950
oil on board 44.0 x 59.6
CHA/P/22

Baynes, Keith 1887–1977
Landscape c.1921
oil on canvas 22.2 x 28.0
CHA/P/23

Baynes, Keith 1887–1977
Still Life of White Roses c.1921
oil on canvas 29.5 x 24.5
CHA/P/219

Baynes, Keith 1887–1977
Still Life with Books, Lamp and Jug of Flowers
c.1927
oil on canvas 47.7 x 59.0
CHA/P/218

Baynes, Keith 1887–1977
Still Life, Flowers in a Jug 1930–1935
oil on canvas 46 x 36
CHA/P/135

Bell, Quentin 1910–1996
Pots et citron (copy of Pablo Picasso) c.1958
oil on canvas 53.5 x 44.0
CHA/P/61

Bell, Vanessa 1879–1961
Cornish Cottage c.1900
oil on board 22.5 x 17.5
CHA/P/245

Bell, Vanessa 1879–1961
Julian Asleep c.1908
oil on canvas 19.0 x 29.5
CHA/P/69

Bell, Vanessa 1879–1961
Julian Bell c.1908
oil on board 16.0 x 21.5
CHA/P/68

Bell, Vanessa 1879–1961
Saxon Sydney-Turner at the Piano c.1908
oil on canvas 18.5 x 24.0
CHA/P/6

Bell, Vanessa 1879–1961
Three Branches in a Jar c.1910
oil on board 80 x 30
CHA/P/345

Bell, Vanessa 1879–1961
Landscape with Buildings c.1912
oil on plywood 59 x 79
CHA/P/244

Bell, Vanessa 1879–1961
Two Figures c.1913
oil on board 81.5 x 29.5
CHA/P/104

Bell, Vanessa 1879–1961
Landscape c.1916
oil on board 43.5 x 54.2
CHA/P/247

Bell, Vanessa 1879–1961
The Pond at Charleston c.1916
oil on canvas 29.5 x 34.8
CHA/P/78

Bell, Vanessa 1879–1961
Head of Quentin Bell c.1920
oil on canvas 29.0 x 18.5
CHA/P/149

Bell, Vanessa 1879–1961
The Harbour, St Tropez c.1921
oil on board 39 x 31
CHA/P/19

Bell, Vanessa 1879–1961
St Catherine (copy of Raphael) c.1922
oil on canvas 81 x 65
CHA/P/191

Bell, Vanessa 1879–1961
Colonna Madonna (copy of Raphael) c.1923
oil on canvas 80 x 60
CHA/P/130

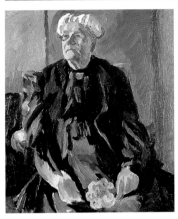

Bell, Vanessa 1879–1961
Lady Strachey c.1923
oil on canvas 42 x 34
CHA/P/190

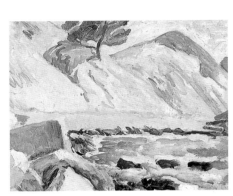

Bell, Vanessa 1879–1961
Baie de la reine c.1927
oil on canvas 37 x 44
CHA/P/250

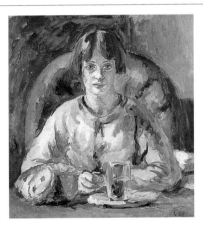

Bell, Vanessa 1879–1961
Angelica Bell c.1930
oil on canvas 62.5 x 55.0
CHA/P/154

Bell, Vanessa 1879–1961
Still Life, Polyanthus in Vase c.1930
oil on canvas 32.0 x 22.5
CHA/P/3

Bell, Vanessa 1879–1961
A Girl Reading c.1932
oil on canvas 45.5 x 38.0
CHA/P/246

Bell, Vanessa 1879–1961
Portrait of a Lady (copy of Willem Drost)
c.1934
oil on canvas 67 x 59
CHA/P/232

Bell, Vanessa 1879–1961
Queue at Lewes c.1935
oil on canvas 30 x 23
CHA/P/307

Bell, Vanessa 1879–1961
The Forum, Rome c.1935
oil on canvas 53.5 x 37.0
CHA/P/20

Bell, Vanessa 1879–1961
The Weaver c.1937
oil on canvas 29.0 x 39.5
CHA/P/214

Bell, Vanessa 1879–1961
Newhaven Lighthouse c.1938
oil on board 26.4 x 44.9
CHA/P/95

Bell, Vanessa 1879–1961
Chattie Salaman c.1940
oil on canvas 59 x 34
CHA/P/158

Bell, Vanessa 1879–1961
The Kitchen at Charleston c.1943
oil on canvas 87.3 x 119.5
CHA/P/174

Bell, Vanessa 1879–1961
A Sussex Barn 1945–1950
oil on canvas 59 x 71
CHA/P/16

Bell, Vanessa 1879–1961
*Still Life of Pears and Everlasting
Flowers* c.1945
oil on canvas 18.6 x 29.0
CHA/P/217

Bell, Vanessa 1879–1961
Still Life of Plums c.1945
oil on canvas 29 x 39
CHA/P/208

Bell, Vanessa 1879–1961
Still Life with Plaster Head c.1947
oil on board 53.5 x 44.5
CHA/P/212

Bell, Vanessa 1879–1961
The Duomo in Lucca c.1949
oil on canvas 44.5 x 37.0
CHA/P/162

Bell, Vanessa 1879–1961
Charleston c.1950–1955
oil on canvas 59.4 x 49.0
CHA/P/225

Bell, Vanessa 1879–1961
Olivier Bell c.1952
oil on canvas 51.0 x 40.5
CHA/P/251

Bell, Vanessa 1879–1961
Poissy le Pont (copy of Maurice de Vlaminck)
c.1953
oil on canvas 59.0 x 79.5
CHA/P/62

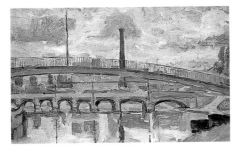

Bell, Vanessa 1879–1961
The Bridge at Auxerre c.1953
oil on canvas 23 x 34
CHA/P/220

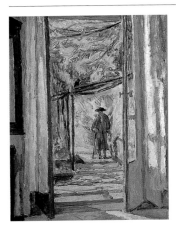

Bell, Vanessa 1879–1961
Dorothy Bussy at La Souco c.1954
oil on canvas 34.2 x 26.2
CHA/P/109

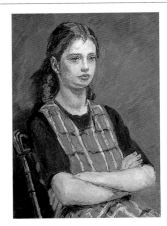

Bell, Vanessa 1879–1961
Henrietta Garnett c.1955
oil on canvas 54.5 x 39.0
CHA/P/67

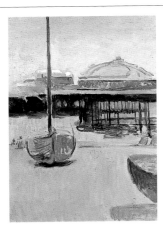

Bell, Vanessa 1879–1961
West Pier, Brighton c.1955
oil on canvas 49.5 x 37.0
CHA/P/160

Facing page: Gauffier, Louis, 1761–1801, *Godfrey Webster, Fourth Bt* (detail), 1796, English Heritage, Battle Abbey, (p.3)

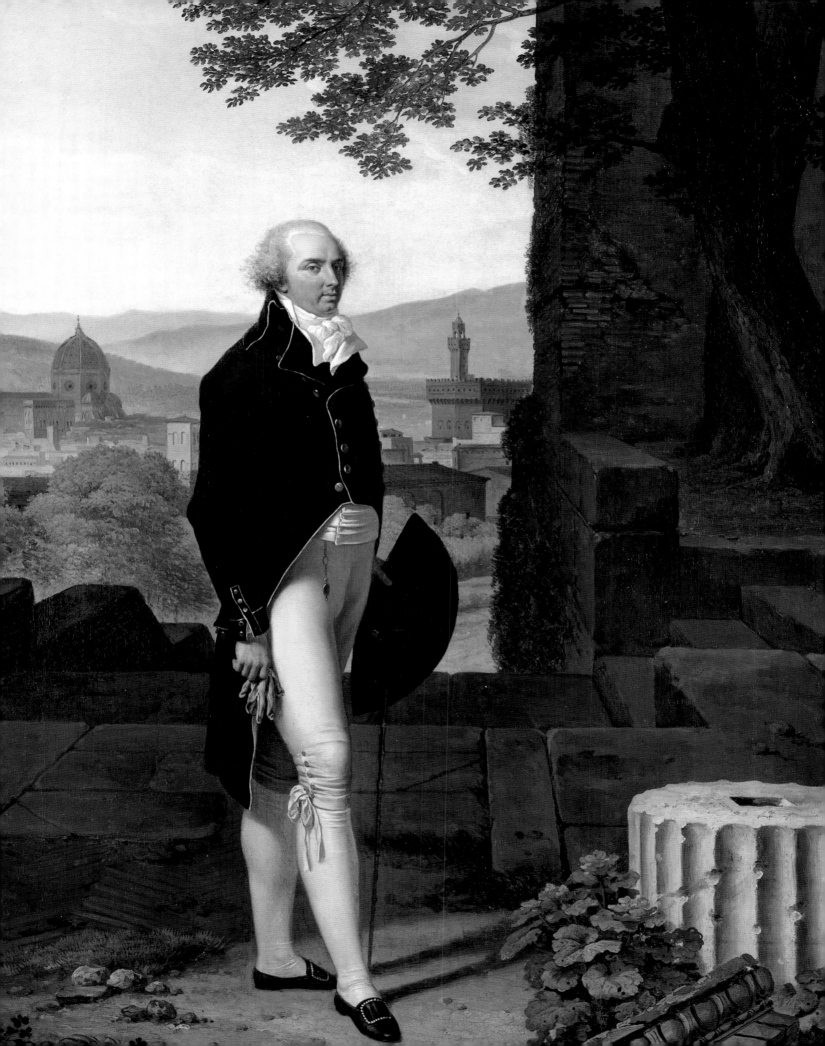

Bell, Vanessa 1879–1961
Julian Bell c.1956
oil on board 47.7 x 36.2
CHA/P/96

Bell, Vanessa 1879–1961
Julian Bell c.1956
oil on canvas 45.5 x 38.0
CHA/P/97

Bell, Vanessa 1879–1961
Self Portrait c.1958
oil on canvas 45 x 37
CHA/P/64

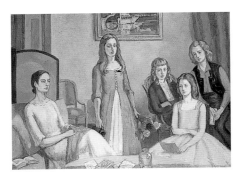

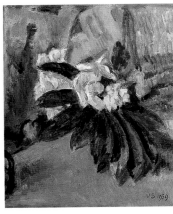

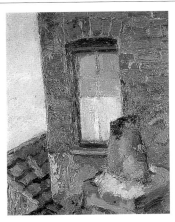

Bell, Vanessa 1879–1961
Angelica Garnett and Her Four Daughters
c.1959
oil on canvas 100 x 140
CHA/P/343

Bell, Vanessa 1879–1961
Still Life of Flowers c.1959
oil on canvas 38 x 32
CHA/P/133

Bergen, George 1903–1984
Chimney Pot and Window c.1930
oil on board 25.5 x 20.5
CHA/P/21

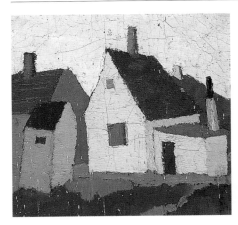

Bergen, George 1903–1984
Painting of a Group of Buildings 1930–1935
oil on card 17.6 x 18.8
CHA/P/112

Bergen, George 1903–1984
A London Street c.1931
oil on board 20.5 x 21.5
CHA/P/193

Bergen, George 1903–1984
The Policeman c.1931
oil on canvas 12.5 x 14.0
CHA/P/180

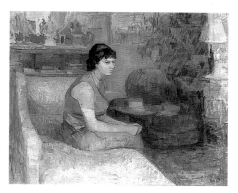

Bergen, George 1903–1984
East End Pub c.1933
oil on canvas 47 x 33
CHA/P/253

Bergen, George 1903–1984
Peñiscola c.1933
oil on canvas 27.0 x 39.6
CHA/P/188

de Grey, Roger 1918–1995
Eleanor c.1947–1951
oil on canvas 62 x 75
CHA/P/10

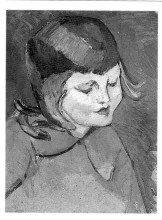

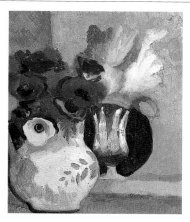

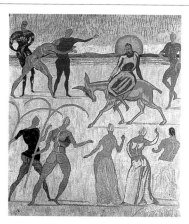

Doucet, Henri 1883–1915
Julian Bell c.1912
oil on card 44.7 x 34.5
CHA/P/216

Dufferin, Lindy
Still Life of Flowers in a Vase c.1969
oil on board 30 x 25
CHA/P/335

Etchells, Frederick 1886–1973
The Entry into Jerusalem c.1912
tempera on board 85.7 x 72.0
CHA/P/132

Etchells, Jessie 1892–1933
The Opera Box c.1912
oil on board 33.0 x 27.7
CHA/P/82

Etchells, Jessie 1892–1933
Three Figures c.1912
oil on canvas 30.4 x 45.5
CHA/P/77

Friesz, Othon 1879–1949
Apple and Pear c.1920
oil on canvas 18.0 x 12.6
CHA/P/144

Friesz, Othon 1879–1949
Landscape c.1920–1922
oil on canvas 14 x 21
CHA/P/145

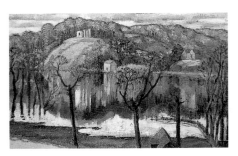

Fry, Roger Eliot 1866–1934
Flooded Valley c.1911
oil on canvas 49.5 x 75.0
CHA/P/206

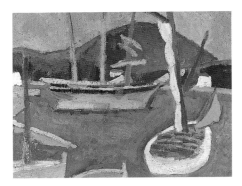

Fry, Roger Eliot 1866–1934
Mediterranean Port, La Ciotat c.1915
oil on board 24 x 32
CHA/P/211

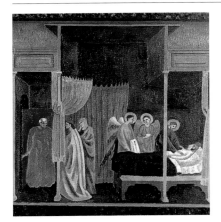

Fry, Roger Eliot 1866–1934
The Healing of the Wounded Man of Lerida
c.1917
oil on board 67 x 64
CHA/P/186

Fry, Roger Eliot 1866–1934
French Landscape with House c.1927
oil on canvas 32 x 40
CHA/P/258

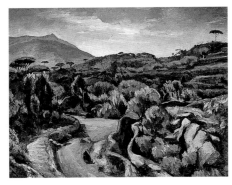

Fry, Roger Eliot 1866–1934
Landscape in Provence c.1930
oil on canvas 49.0 x 59.9
CHA/P/137

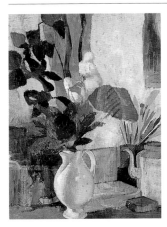

Garnett, Angelica b.1918
Still Life with Poppies c.1945
oil on canvas 58.5 x 44.0
CHA/P/136

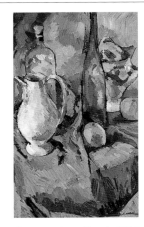

Garnett, Angelica b.1918
The Hock Bottle c.1958
oil on canvas 79.5 x 58.5
CHA/P/259

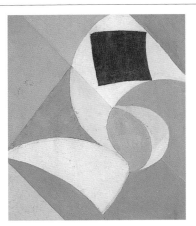

Garnett, Angelica b.1918
Abstract c.1970
oil on canvas 35 x 31
CHA/P/260

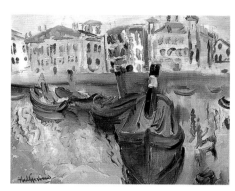

Gerbaud, Abel 1888–1954
Harbour, St Jean-de-Luz c.1920
oil on canvas 27.5 x 33.5
CHA/P/17

Grant, Duncan 1885–1978
Village Street c.1903
oil on canvas 29.6 x 24.2
CHA/P/89

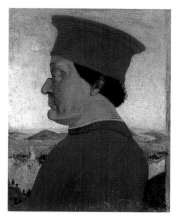

Grant, Duncan 1885–1978
The Duke of Urbino (copy of Piero della Francesca) c.1904
oil on canvas 40.6 x 31.5
CHA/P/226

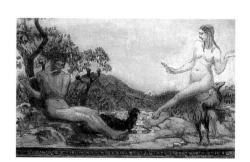

Grant, Duncan 1885–1978
Arcadian Scene c.1909
oil on canvas 55 x 80
CHA/P/138

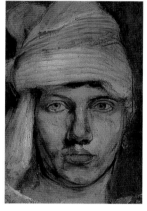

Grant, Duncan 1885–1978
Self Portrait in a Turban c.1909
oil on canvas 20.2 x 12.7
CHA/P/310

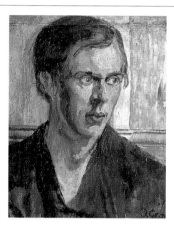

Grant, Duncan 1885–1978
Adrian Stephen c.1910
oil on canvas 36.7 x 28.0
CHA/P/111

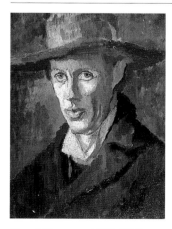

Grant, Duncan 1885–1978
Adrian Stephen c.1910
oil on canvas 33.5 x 25.0
CHA/P/161

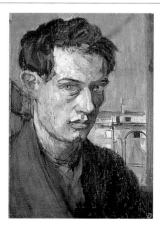

Grant, Duncan 1885–1978
Self Portrait c.1910
oil on canvas 40.5 x 29.7
CHA/P/65

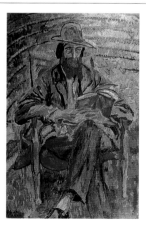

Grant, Duncan 1885–1978
Lytton Strachey c.1913
oil on plywood 91 x 59
CHA/P/2

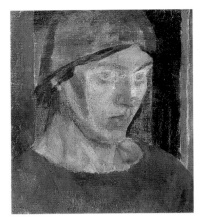

Grant, Duncan 1885–1978
Vanessa Bell in a Red Headscarf c.1917
oil on canvas 35.5 x 30.5
CHA/P/81

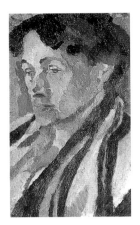

Grant, Duncan 1885–1978
Ethel Grant c.1918
oil on canvas 42.0 x 24.5
CHA/P/113

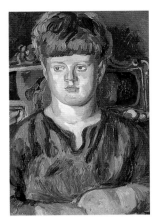

Grant, Duncan 1885–1978
Quentin Bell as a Boy c.1919
oil on board 67.0 x 52.4
CHA/P/72

Grant, Duncan 1885–1978
A Prancing Horse c.1920
oil on board 35.0 x 27.5
CHA/P/194

Grant, Duncan 1885–1978
Lady Strachey c.1920
oil on canvas 51.0 x 40.5
CHA/P/281

Grant, Duncan 1885–1978
Julian Bell Writing c.1928
oil on canvas 74.5 x 64.0
CHA/P/73

Grant, Duncan 1885–1978
Still Life with Tea Pot c.1929
oil on canvas 59.5 x 49.5
CHA/P/223

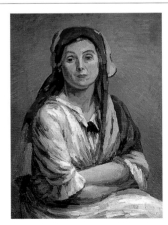

Grant, Duncan 1885–1978
Helen Anrep in Turkish Costume c.1930
oil on canvas 69 x 53
CHA/P/265

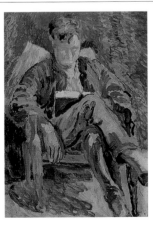

Grant, Duncan 1885–1978
Julian Bell Reading c.1930
oil on canvas 80 x 52
CHA/P/157

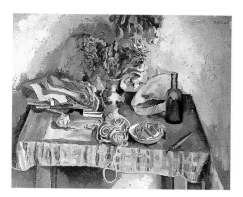

Grant, Duncan 1885–1978
Still Life c.1930
oil on canvas 75 x 87
CHA/P/341

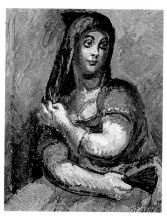

Grant, Duncan 1885–1978
Spanish Dancer c.1931
oil on board 77.0 x 59.9
CHA/P/66

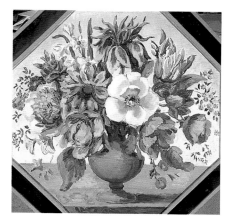

Grant, Duncan 1885–1978
Music Room Panel c.1932
oil on board 79 x 79
CHA/P/275

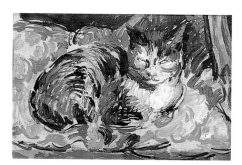

Grant, Duncan 1885–1978
The Cat, Opussyquinusque c.1932
oil on board 23 x 31
CHA/P/1

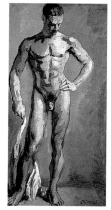

Grant, Duncan 1885–1978
Standing Male Nude, Study of Tony Asserati
c.1935
oil on canvas 97.0 x 45.5
CHA/P/84

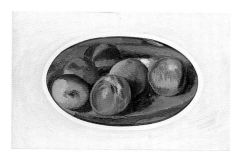

Grant, Duncan 1885–1978
Still Life with Apples 1939–1940
oil on canvas 14 x 23
CHA/P/134

Grant, Duncan 1885–1978
*Still Life with Staffordshire Figure and Wine
Bottle* c.1940
oil on board 26.7 x 34.5
CHA/P/156

Grant, Duncan 1885–1978
*Helen Anrep in the Dining Room at
Charleston* c.1945
oil on canvas 56.5 x 88.0
CHA/P/155

Grant, Duncan 1885–1978
Paul Roche Reclining c.1945
oil on canvas 55 x 76
CHA/P/228

Grant, Duncan 1885–1978
Oliver Strachey c.1947
oil on canvas 49.6 x 37.0
CHA/P/60

Grant, Duncan 1885–1978
Lucca c.1949
oil on board 72.0 x 43.9
CHA/P/59

Grant, Duncan 1885–1978
Helen Anrep c.1950
oil on canvas 56 x 41
CHA/P/273

Grant, Duncan 1885–1978
The Pond at Charleston in Winter c.1950
oil on board 38 x 47
CHA/P/70

Grant, Duncan 1885–1978
Edward le Bas Decorating a Pot c.1955
oil on board 33.2 x 26.0
CHA/P/76

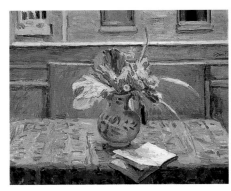

Grant, Duncan 1885–1978
Flowers in front of a Window c.1956
oil on canvas 50 x 60
CHA/P/315

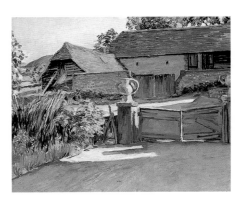

Grant, Duncan 1885–1978
The Barns from the Garden c.1959
oil on canvas 54.7 x 63.4
CHA/P/159

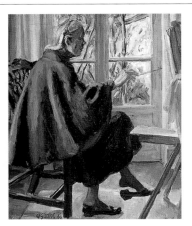

Grant, Duncan 1885–1978
Vanessa Bell Painting at La Souco c.1960
oil on canvas 46 x 38
CHA/P/103

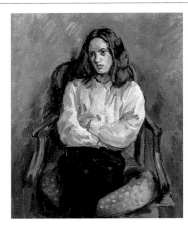

Grant, Duncan 1885–1978
Nerissa in a White Blouse c.1965
oil on canvas 59.5 x 49.5
CHA/P/181

Grant, Duncan 1885–1978
Walled Garden at Charleston c.1965
oil on canvas 49.5 x 60.0
CHA/P/274

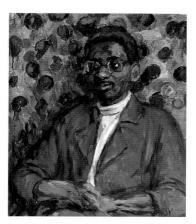

Grant, Duncan 1885–1978
Tony Haines c.1970
oil on canvas 53 x 46
CHA/P/280

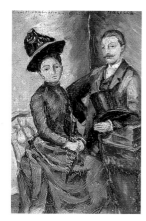

Halicka, Alice 1895–1975
Man Standing beside Seated Woman c.1922
oil on canvas 31.5 x 20.5
CHA/P/146

Hayden, Henri 1883–1970
Still Life of Fruit c.1922–1924
oil on canvas 23 x 40
CHA/P/141

Hill, Derek b.1916
Duncan Grant c.1975
oil on board 30.5 x 41.0
CHA/P/284

Lloyd, Katherine Constance active from
early 1920s
Still Life with Fan c.1920
oil on canvas 31.5 x 40.0
CHA/P/177

Marchand, Jean Hippolyte 1883–1940
Still Life with Fruit and Flower Pot c.1912
oil on canvas 48 x 39
CHA/P/63

O'Conor, Roderic 1860–1940
Flowers c.1911
oil on canvas 64 x 53
CHA/P/4

Pitchforth, Roland Vivian 1895–1982
Landscape c.1930
oil on canvas 86 x 112
CHA/P/288

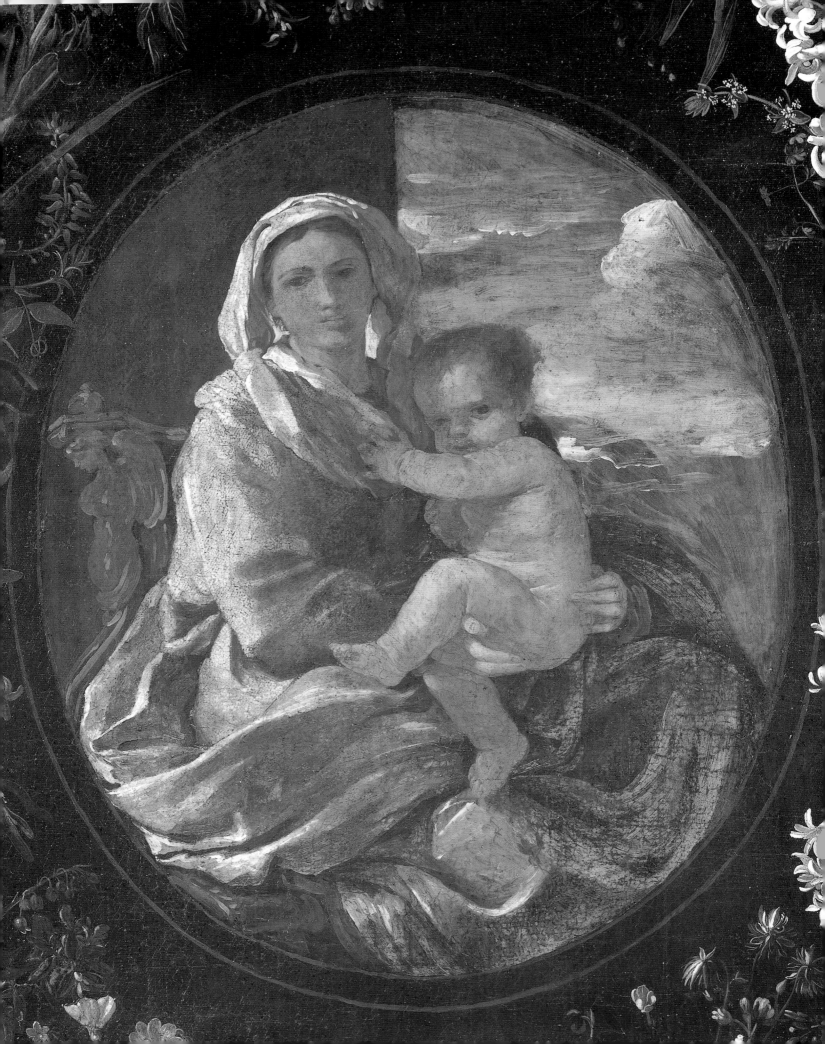

Porter, Frederick James 1883–1944
On the Arun c.1925
oil on canvas 54.5 x 80.0
CHA/P/210

Richard, Edouard b.1883
Still Life of Three Fish on a Plate c.1930
oil on canvas 18.5 x 27.0
CHA/P/142

Roy, Pierre 1880–1950
Fairy Pipe c.1925–1928
oil on canvas 26.0 x 15.5
CHA/P/143

Shone, Richard b.1948
Virginia Woolf c.1965
oil on board 36 x 25
CHA/P/336

Sickert, Walter Richard 1860–1942
One of Madame Villain's Sons c.1904
oil on canvas 49.5 x 39.5
CHA/P/230

Smith, Matthew Arnold Bracy 1879–1959
Flowers c.1925
oil on canvas 53 x 45
CHA/P/58

Thomas, Margaret b.1916
The Captain of the Hockey Team c.1947
oil on canvas 38.5 x 29.2
CHA/P/11

unknown artist
Still Life with Vegetables 1650–1699
oil on canvas 52.8 x 64.0
CHA/P/114

unknown artist
Still Life of Fruit with Decanters and Glasses
c.1750
oil on canvas 46.0 x 53.3
CHA/P/110

Facing page: Poussin, Nicolas, 1594–1665, & Seghers, Daniel, 1590–1661, *Virgin and Child in a Garland of Flowers*
(detail), 1625–1627, Brighton and Hove Museums and Art Galleries, (p. 163)

unknown artist 18th C
Carnival Figure
oil on canvas 27.5 x 18.7
CHA/P/207

unknown artist
Mother and Child 1800–1850
oil on canvas 37.5 x 27.0
CHA/P/301

unknown artist
Young Girl in a Landscape c.1810
oil on canvas 38.0 x 31.5
CHA/P/197

unknown artist
Young Woman in a Landscape c.1810
oil on canvas 38.0 x 33.0
CHA/P/197a

unknown artist
Two Girls in a Landscape c.1820
oil on canvas 44 x 35
CHA/P/152

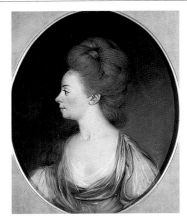

unknown artist 19th C
Portrait of a Young Woman
oil on canvas 24 x 19
CHA/P/198

unknown artist
Ancient Urn and Bible c.1900
oil on canvas 38 x 48
CHA/P/235

unknown artist
Still Life of Roman Pottery c.1900
oil on canvas 38 x 48
CHA/P/236

unknown artist
Connoisseur 1910–1925
oil on board 40.5 x 20.0
CHA/P/237

unknown artist
Chickens and Mother Hen c.1920
oil on canvas 53.0 x 62.5
CHA/P/404

unknown artist
Victor Pasmore c.1938
oil on canvas 57 x 47
CHA/P/300

unknown artist
Landscape c.1950
oil on canvas 25.3 x 36.0
CHA/P/92

unknown artist
Landscape c.1950
oil on canvas 20 x 38
CHA/P/94

unknown artist
Still Life c.1960
oil on board 51.6 x 62.0
CHA/P/240

unknown artist
Tea Things (copy of Vanessa Bell) 1988
oil on board 39.0 x 94.7
CHA/P/189

Watson, Elizabeth 1906–1955
The Garden c.1952
oil on canvas 58.0 x 47.2
CHA/P/163

Watts, George Frederick 1817–1904
Julia Stephen c.1870
oil on canvas 71.0 x 59.5
CHA/P/342

Wolfe, Edward 1897–1982
Still Life with Omega Cat c.1918
oil on canvas 29.0 x 23.5
CHA/P/213

Wolfe, Edward 1897–1982
Willows at Charleston c.1918
oil on board 31 x 40
CHA/P/222

East Sussex
Record Office

Jervas, Charles (circle of) c.1675–1739
*The Reverend Peter Baker MA of Mayfield
Place, Vicar of Mayfield (1671–1730)* c.1720
oil on canvas 123.8 x 101.1
KIR 34/3

Lambert, James I (after) 1725–1788
Lewes Old Bridge, 1781 1781
oil on canvas 39.4 x 51.4
PDA/L/6

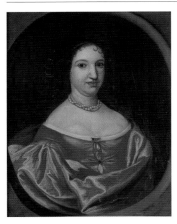

Murray, Thomas (attributed to) 1663–1734
*Marthanna, Daughter of Robert Baker of
Middle House, Wife of Peter Baker
(c.1675–1731)* c.1720
oil on canvas 121.3 x 99.1
KIR 34/4

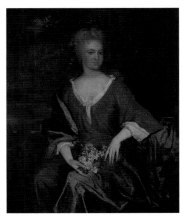

unknown artist
*Marthanna Baker?(1639–1693), Daughter of
Samuel Cole, Wife of Robert Baker* c.1670
oil on canvas 76.2 x 63.5
KIR 34/6

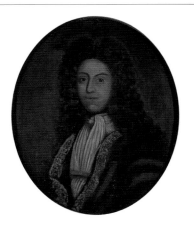

unknown artist
*Robert Baker of Middle House, Mayfield
(1635–1714)* c.1670
oil on canvas 71.1 x 58.4
KIR 34/5

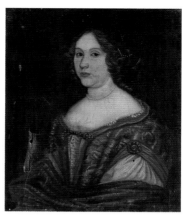

unknown artist
*Ruth, Daughter of Peter Farnden, Wife of John
Baker of Mayfield Place (1643–1724), Died
1691* c.1670
oil on canvas 69.9 x 58.4
KIR 34/2

Lewes Castle and Museum

The Sussex Archaeological Society was founded in 1846 with the stated aim 'to promote, encourage and foster the study of archaeology and history in all their branches, with special reference to the counties of East and West Sussex.'

From the beginning, the Society has collected widely across a number of fields, as is evident from the first catalogue of the museum collection published in the Society's annual volume of the Sussex Archaeological Collections in 1866. Many of the paintings published in this catalogue have formed part of the Society's collection from this early period. The oil paintings form a discreet collection within the larger flat work collections, which hold largely topographical images of the counties from the 17th century onwards.

Included in the catalogue, is the collection of paintings by the Reverend Eric Trayler Cook. Trayler Cook painted throughout his life and covered a number of subjects. He sold his work both privately and through exhibition. The paintings reproduced here are a part of a larger collection by the same hand. Trayler Cook was a long time member and exhibitor with the South London Art Group, where he sat for a number of years on the hanging committee. As well as the donation to the Society of his paintings and drawings of architecture and local topography, a significant collection of his botanical paintings was donated to the Tradescant Trust after his death in 1978.

Other paintings record or commemorate significant events and individuals in the history of Sussex, such as the painting of the Lewes avalanche which took place on December 27, 1836. The painting was commissioned by Thomas Dicker of Lewes, unfortunately, the artist's identity remains unknown. The painting shows the scene immediately after the avalanche fell on the parish poor houses in Boulder Row, burying fourteen. Eight people died in the disaster which is commemorated on a tablet in South Malling Church. The youngest survivor pulled from the snow was two year old Fanny Boaks and the dress she was wearing at the time is now in the museum collections. The avalanche is further remembered in the name of the Snowdrop Inn built on the site in 1840.

Portraits are few in number but they are not without significance. Another painting by an unknown artist depicts Lewes' most famous resident, Tom

Paine, author of *Common Sense* and *The Rights of Man*. Paine, born in Norfolk in 1737 lived in Lewes from 1768 to 1774. During his time in the town he became a leading member of the Headstrong Club, where he demonstrated his radicalism and earned the title 'most obstinate haranguer.'

The two self portraits of the James Lamberts, uncle and nephew, represent two important figures within the Society's collections. The Society owns a significant number of their watercolours, drawings and sketches of the counties, not least the Lambert Volume.

The portrait of Mark Anthony Lower by John Edgar Williams records one of the Society's founding and most dedicated members. The work initiated by Lower and his colleagues in establishing the Society, its collections and estate has stood the Society in good stead to continue to meet its original aims and more.

Emma O'Connor, Museums Officer

Adams, Elinor Proby 1885–1945
Cottage at Slindon, Sussex, opposite the Village Club 1915
oil on board 26.5 x 35.4
LEWSA.VR:3733

Archer, Archibald active 1810–1845
Charles Wille c.1820
oil on canvas 44.3 x 35.8 (E)
LEWSA:1979.41.6

Blackie, Agnes J. d.c.1961
Sussex Shepherd
oil on canvas 51.2 x 41.0
LEWSA:1962.2

Cook, Eric Trayler c.1896–1978
Clymping, Sussex 1925
oil on card 21.0 x 27.0
LEWSA.VR:2417

Cook, Eric Trayler c.1896–1978
Martello Tower 1930
oil on card 22.0 x 26.5
LEWSA.VR:2415

Cook, Eric Trayler c.1896–1978
Pevensey 1930
oil on card 22.8 x 28.0
LEWSA.VR:2420

Cook, Eric Trayler c.1896–1978
Ypres Tower, Rye 1930 1930
oil on panel 30.3 x 35.6
LEWSA.VR:2422

Cook, Eric Trayler c.1896–1978
Rodmell Church 1933
oil on card 20.5 x 25.3
LEWSA.VR:2414

Cook, Eric Trayler c.1896–1978
Bexhill Church 1937
oil on card 25.5 x 19.0
LEWSA.VR:2410

Cook, Eric Trayler c.1896–1978
Litlington Church 1937
oil on card 21.8 x 26.0
LEWSA.VR:2416

Cook, Eric Trayler c.1896–1978
Heart of Bognor 1938
oil on board 35.5 x 26.0
LEWSA.VR:2425

Cook, Eric Trayler c.1896–1978
*North End House, Rottingdean, Burne Jones's
House* 1938
oil on board 24.7 x 29.0
LEWSA.VR:2409

Cook, Eric Trayler c.1896–1978
St Mary A…m, near Bognor 1938
oil on board 48.6 x 38.2
LEWSA.VR:2428

Cook, Eric Trayler c.1896–1978
*Telscombe Church (St Laurence) near
Rottingdean (Saltdean), Sussex* 1938
oil on card 22.2 x 30.0
LEWSA.VR:2408

Cook, Eric Trayler c.1896–1978
Burne Jones's House, Rottingdean 1939
oil on card 30.5 x 45.8
LEWSA.VR:2427

Cook, Eric Trayler c.1896–1978
Field Place near Horsham 1944
oil on paper 25.0 x 45.0
LEWSA.VR:2426

Cook, Eric Trayler c.1896–1978
Blake's Cottage, Felpham near Bognor, Sussex
1946
oil on board 22.0 x 27.0
LEWSA.VR:2421

Cook, Eric Trayler c.1896–1978
Eight Acres, Ancton 1946
oil on card 30.2 x 35.2
LEWSA.VR:2423

Cook, Eric Trayler c.1896–1978
*The Medieval Chapel at Bailiff's Court near
Clymping, Sussex 1279* 1946
oil on card 21.9 x 26.6
LEWSA.VR:2413

Cook, Eric Trayler c.1896–1978
Chichester 1950
oil on card 22.2 x 26.0
LEWSA.VR:2407

Cook, Eric Trayler c.1896–1978
Chichester Close 1950 1950
oil on card 25.3 x 30.5
LEWSA.VR:2424

Cook, Eric Trayler c.1896–1978
Church Square, Rye 1953
oil on card 29.0 x 26.6
LEWSA.VR:2412

Cook, Eric Trayler c.1896–1978
Mermaid Inn, Rye 1953, Whitsun 1953
oil on panel 38.5 x 30.0
LEWSA.VR:2429

Cook, Eric Trayler c.1896–1978
Playden Church, near Rye 1953
oil on thick card 27.0 x 21.5
LEWSA.VR:2418

Cook, Eric Trayler c.1896–1978
West Street, Rye 1953
oil on card 35.5 x 25.4
LEWSA.VR:2411

Cook, Eric Trayler c.1896–1978
Hangleton, near Brighton
oil on card 24.0 x 28.4
LEWSA.VR:2419

Elvin
Black Lion Hotel, Patcham 1947
oil on canvas 30.2 x 40.5
LEWSA.VR:3761

Farmer, Kathleen active 1925–1940
Chain Pier, Brighton, 4 December 1896
oil & acrylic on canvas 30.8 x 46.2
LEWSA.VR:4178

Forestier, Amédée 1854–1930
A Centurian on the March c.1928
oil on panel 22.7 x 17.6
LEWSA.VR:141

Forestier, Amédée 1854–1930
Italic Bronze Age Warriors on the March
c.1928
oil on panel 27.0 x 22.0
LEWSA.VR:142

Forestier, Amédée 1854–1930
Roman Standard-Bearer c.1928
oil on panel 22.7 x 17.6
LEWSA.VR:139

Forestier, Amédée 1854–1930
Roman Trumpeter c.1928
oil on panel 22.7 x 17.6
LEWSA.VR:140

Garnett, Eve 1900–1991
Lewes Gasworks from South Street
c.1935–1939
oil on panel 13.4 x 17.2
LEWSA.VR:4674

Henwood, Thomas (attributed to)
1797–1861
Male Portrait c.1830
oil on canvas 30.0 x 23.5
LEWSA.VR:4153

Henwood, Thomas (attributed to)
1797–1861
Mrs Edward Minshall 1850
oil on canvas 30.0 x 23.5
LEWSA.VR:4174

Lambert, James I 1725–1788
James Lambert c.1780
oil on canvas 73.0 x 60.0
LEWSA:2004.2

Lambert, James II 1742–1799
James Lambert, Junior c.1780
oil on canvas 74.5 x 61.0
LEWSA.VR:4170

Lonsdale, James 1777–1839
John Ellman
oil on canvas 89.5 x 70.0
LEWSA.VR:4171

Riviere, Briton 1840–1920
Old Woman Lighting Tinder
oil on board 34.6 x 30.2
LEWSA:1956.16.5

Roods, Thomas active 1833–1867
Charles Ade 1840
oil on wood panel 35.0 x 30.0
LEWSA:1977.13.1

Roods, Thomas (attributed to) active
1833–1867
Catherine Sarah Ade
oil on canvas 38.5 x 31.8
LEWSA:1983.27.16

Roods, Thomas (attributed to) active
1833–1867
John Stephen Ade
oil on canvas 37.0 x 30.0
LEWSA:1983.27.15

Facing page: Barnard, Margaret, 1898–1992, *The Spell* (detail), Rye Art Gallery, (p. 356)

Roods, Thomas (attributed to) active
1833–1867
Martha Ade
oil on canvas 37.0 x 30.0
LEWSA:1983.27.14

Tennant, John F. (attributed to) 1796–1872
Mountfield Court, Battle
oil on board 28.9 x 44.5
LEWSA.VR:4180

unknown artist
First Peal, Rang July 27, 1770 c.1770
oil on plaster 75.5 x 73.4
LEWSA:1946.25

unknown artist
Dr T. White c.1770–1800
oil on canvas 78.2 x 63.4
LEWSA:1966.31.2

unknown artist
John Morris c.1780
oil on board 30.5 x 25.5
LEWSA:1979.41.4

unknown artist
Portrait of a Clerical Gentleman c.1800
oil on canvas 77.0 x 64.0
LEWSA:1956.16.8

unknown artist
Portrait of an Elderly Woman c.1800–1850
oil on canvas 76.7 x 63.5
LEWSA:1956.16.1

unknown artist
Portrait of a Gentleman c.1820
oil on board 27.0 x 21.5
LEWSA.VR:4177

unknown artist
Ann Morris c.1822
oil on board 30.6 x 25.4
LEWSA:1979.41.5

unknown artist
Female Portrait c.1840
oil on canvas 34.5 x 28.5
LEWSA.VR:4175

unknown artist
Malling Hill Lewes, c.1840 c.1840
oil on wood panel 31.2 x 44.6
LEWSA.VR:4179

unknown artist
James Pelling c.1880
oil on canvas 51.4 x 40.5
LEWSA:1962.53.2

unknown artist
Mr William Inkpen
oil on canvas 73.7 x 61.2
LEWSA:1980.35

unknown artist
Portrait of a Gentleman
oil on canvas 41.0 x 31.0
LEWSA.VR:4185

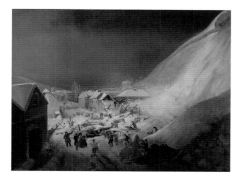

unknown artist
The Avalanche at Lewes, 1836
oil on canvas 66.6 x 81.0
LEWSA:2004.3

unknown artist
Thomas Paine
oil on canvas 60.5 x 50.0
LEWSA.VR:4173

Williams, John Edgar active 1846–1883
Mark Anthony Lower c.1865
oil on canvas 75.0 x 61.0
LEWSA.VR:4172

Williamson, J. active 1850–1919
St Clement's Church
oil on card 31.0 x 23.5
LEWSA.VR:3732

Lewes District Council

Chambers
Sailing Ship 'Tamarind' Being Towed into Portsmouth 1859
oil on canvas 30.5 x 40.0

R. F.
Cottages and Fishermen on the Coast of Fife 1883
oil on canvas 18 x 25

Halswelle, Keeley 1832–1891
Wittenham Clumps
oil on canvas 71 x 40

Lewes Town Hall

Dollman, John Charles 1851–1934
Ditchling Beacon 1921
oil on canvas 27 x 49
1

Gabell, I. E.
Sussex Weald in Winter
oil on canvas 26.0 x 35.5
2

Hardy early 20th C
Battle of Lewes, 14 May 1264
oil on canvas 46 x 64
3

Keyser, Nicaise de 1813–1887
Syrian Chief 1846
oil on canvas 57 x 39
5

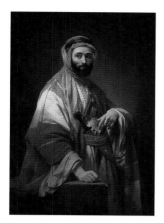

Keyser, Nicaise de 1813–1887
Syrian Chief
oil on canvas 57 x 39
6

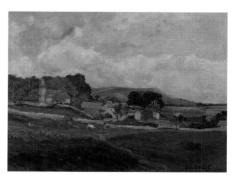

Smith, Gabell 1861–1934
Southease
oil on canvas 37.0 x 48.5
4

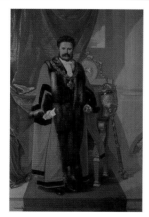

unknown artist
Wynne E. Baxter Esq. First Mayor of Lewes (1881–1882) c.1881–1882
oil on canvas 200 x 130
7

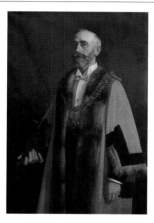

unknown artist 20th C
Alderman George Holman JP
oil on canvas 49 x 34
8

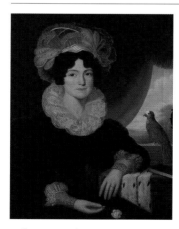

unknown artist
Audrey Wimble
oil on board 35 x 27
11

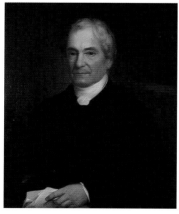

unknown artist
John Baxter, Invented Colour Printing in 1820s
oil on canvas 74 x 60
9

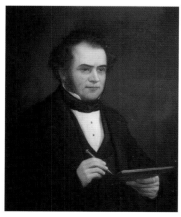

unknown artist
John Baxter's Son
oil on canvas 29 x 24
12

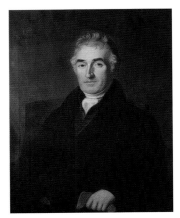

unknown artist
Nehemiah Wimble
oil on board 35 x 27
10

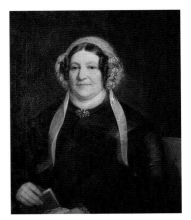

unknown artist
*Portrait of a Woman**
oil on canvas 29 x 24
13

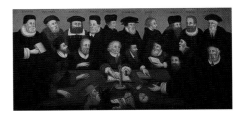

unknown artist
The Protestant Reformers
oil on board 34 x 88
14

Victoria Hospital

Bell, Julian b.1952
View of Lewes
oil on canvas 53.3 x 203.2

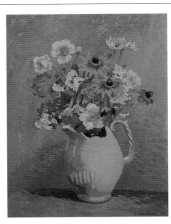

Hawkins, Irene
Flowers in White Jug 1979
oil on hardboard 154.9 x 50.8

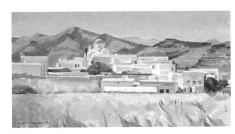

Winkworth, Jackie 1925–1992
Apollonia, Siphnos
oil on hardboard 30.5 x 53.3

Winkworth, Jackie 1925–1992
Church, Seriphos, Greece
oil on hardboard 63.5 x 76.2

Winkworth, Jackie 1925–1992
Cineraria
oil on hardboard 58.4 x 48.9

Winkworth, Jackie 1925–1992
Fortress at Rethimno, Crete
oil on hardboard 38.1 x 50.2

Winkworth, Jackie 1925–1992
View from the Terrace, St Mawes
oil on hardboard 101.6 x 63.5

Westfield House

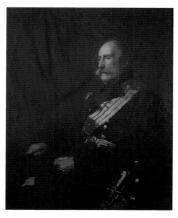

Holl, Frank 1845–1888
*Henry Thomas Pelham (1804–1886), Earl of
Chichester, Lord Lieutenant of Sussex* c.1880
oil on canvas 125.5 x 100.5
c/c/125/1

Niemann, Edmund H. 1841–1910
Lewes from Chapel Hill c.1880
oil on canvas 40 x 65
c/c/125/2

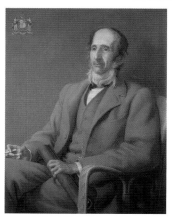

unknown artist
*John George Dodson (1825–1897), Baron
Monk Bretton, First Chairman of East Sussex
County Council* c.1890
oil on canvas 90 x 70
c/c/125/3

Rye Art Gallery

The Rye Art Gallery Trust was founded in 1957 by the artist Mary Stormont for the 'furtherance and enjoyment of the visual arts in Rye.' In 1898 Mary had eloped from her parents' home in Essex with fellow artist Howard Stormont. They were married at St Mary's Church, Rye, and went to live in Ypres Studio, Ockman Lane.

The Stormonts painted and exhibited all their lives. Howard's abilities lay in landscape painting and portraiture while Mary painted landscapes, interiors and flower paintings for which she was particularly sought after. They showed regularly at the Royal Academy of Arts, Mary in particular exhibiting there from 1899–1940, and at art societies and galleries in London and the South East. Howard was a founder member of Rye Art Club (1920–1937) to which Mary also belonged, and which was the predecessor of the current Rye Society of Artists.

After Howard's death Mary continued to live at Ypres Studio. On her death she bequeathed the Studio to the Trust and it was renamed the Stormont Studio in their memory. This bequest brought with it a collection of around one hundred works of art by the Stormonts and other artists, many of whom had a connection with Rye. They form the core of what is now, with additions from purchases, donations and bequests, the Rye Art Gallery permanent collection which comprises over 450 works. There are also text and photographic archives.

The artists represented in this collection are of national and regional importance. They include painters Edward Burra and Paul Nash, both of whom lived in Rye, also Vanessa Bell, Gus Cummins, Duncan Grant, Roger Hilton, Ivon Hitchens, Diana Low, L. S. Lowry, Oswald Moser, John Piper, Francis Le Piper, Ceri Richards, Mick Rooney, Graham Sutherland, John Ward and William Warden. The oils represent about a quarter of the collection. The Gallery's second building, the Easton Rooms, exhibits and sells the work of contemporary artists and craftspeople.

Dr Fanny Baldwin, Trustee

Facing page: Smith, Jack, b.1928, *Various Activities, Central and out* (detail), 1965, Brighton and Hove Museums and Art Galleries, (p. 178)

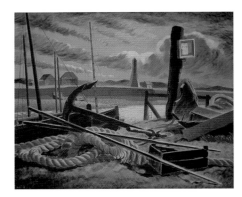

Bagley, Geoffrey Spink 1901–1992
Rye Harbour
oil on canvas 47 x 70
Bag 1

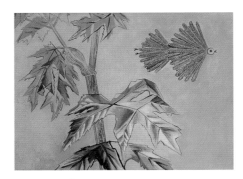

Banting, John 1902–1972
Startled Bird
oil on canvas 45.0 x 60.5
Ban 1

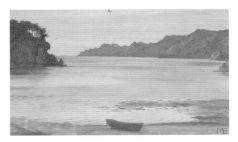

Barnard, Margaret 1898–1992
Boat in the Bay
oil on board 12 x 20
Bar 24

Barnard, Margaret 1898–1992
Island and Storm
oil on board 24 x 34
Bar 22

Barnard, Margaret 1898–1992
Rocks and Waves
oil on board 23.0 x 32.8
Bar 23

Barnard, Margaret 1898–1992
The Spell
oil on canvas 59 x 75
Bar 13

Barnard, Margaret 1898–1992
White House in Sunshine, Ravello
oil on canvas 68 x 75
Bar 12

Barnard, Margaret 1898–1992
White Rock, Sutherland
oil on canvas 39.5 x 49.8
Bar 10

Barnard, Margaret 1898–1992
90th Birthday
oil on canvas 45.7 x 37.0
Bar 11

Baynes, Keith 1887–1977
Meursault
oil on canvas 49.5 x 60.0
Bay 1

Bell, Vanessa 1879–1961
A Bridge, Paris 1911
oil on canvas/ panel? 25.4 x 39.4
Bel 1

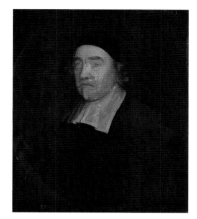

British (English) School 17th C
Portrait of a Cleric
oil on canvas 76.0 x 63.3
Unk 4

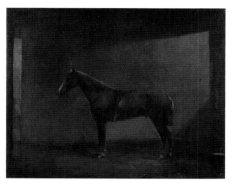

British (English) School 19th C
A Horse in Stable
oil on canvas 47.0 x 58.4
Unk 5

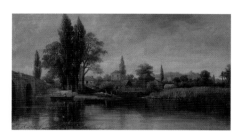

Buchanan, George F. 1800–1864
River Scene with Boat
oil on canvas 38.4 x 69.0
Buc 1

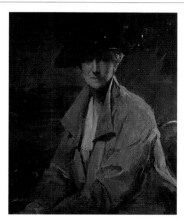

Coates, George James 1869–1930
Mary Stormont
oil on canvas 75.0 x 61.5
Coa 1

Cohen, Alfred 1920–2001
Man at Ease 1975–1976
oil on board 38.5 x 49.0
Coh 1

Crew, David b.1948
Rye Symposium 1972
oil on board 75.4 x 62.8
Crd 1

Crook, Pamela b.1945
Artist and Model 1995
acrylic on board 8.5 x 10.3
Cro 1

Daniel, Henry b.1900
Mary Stormont
oil on panel 43.2 x 35.6
Dan 1

Downie, John P. 1871–1945
Landscape
oil on board 19 x 29
Dow 1

Druce, Elsie 1880–1965
Spring Cleaning at the Lime Street Studio
oil on canvas 102.0 x 76.2
Dru 1

Druce, Elsie 1880–1965
Woodland
oil on canvas 50.1 x 60.5
Dru 2

Dutch School 17th C
Flower Study No.1
oil on canvas 44 x 29
Unk 1

Dutch School 17th C
Flower Study No.2
oil on canvas 44 x 29
Unk 2

Dutch School 18th C
Sailing Barge on River
oil on canvas 20.3 x 30.5
Unk 3

Easton, Eileen Margaret 1890–1965
Flowers from a Surrey Garden
oil on board 75 x 75
Eas 2

Easton, Eileen Margaret 1890–1965
The Old Cedar Tree
oil on board 42.5 x 53.3
Eas 1

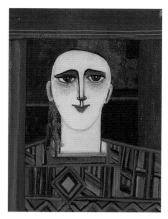

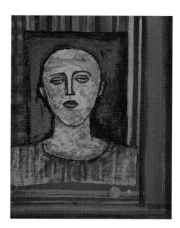

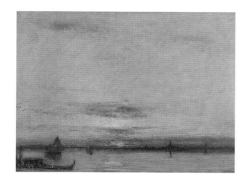

French, Kitty 1924–1989
Clown No.7
oil & textile collage on canvas 44 x 34
Frek 9

French, Kitty 1924–1989
Sad Clown
oil & canvas collage on canvas 66 x 51
Frek 8

Goodwin, Albert 1845–1932
Venice 1920
oil on board 42.8 x 57.5
Goo 4

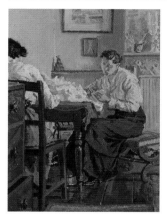

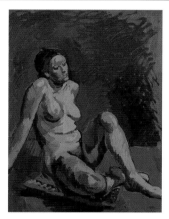

Gosse, Laura Sylvia 1881–1968
Seamstresses
oil on canvas 53.3 x 40.6
Gos 1

Grant, Duncan 1885–1978
Seated Nude
oil on canvas 77.5 x 52.0
Gra 1

Guerrier, Raymond 1920–2002
Les Martigues, Provence
oil on canvas 36.5 x 45.0
Gue 1

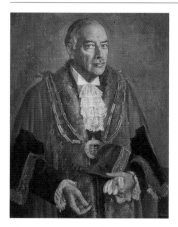

Hailstone, Bernard 1910–1987
Geoffrey Spink Bagley as Mayor of Rye 1958
oil on board 86 x 66
Hai 1

Hitchens, Ivon 1893–1979
Dark Distance 1959
oil on canvas 59 x 120
Hit 1

Hitchens, Ivon 1893–1979
Landscape, The Lake
oil on canvas 50 x 107
Hit 2

Hulk, Abraham 1813–1897
Seascape
oil on panel 17.0 x 23.5
Hul 1

Hunt, E. Aubrey 1855–1922
Cattle Watering at a River
oil on panel 20.3 x 26.8
Hun 1

Kemp, Anne 1937–1997
Woodland Stream No.3 1991
acrylic on board 59.0 x 43.5
Kem 1

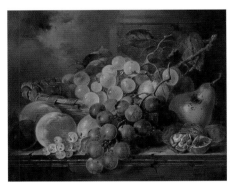

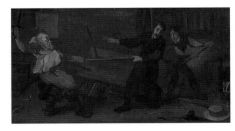

Kemp, Anne 1937–1997
Woodland Path No.1 1994
acrylic on board 59 x 44
Kem 2

Ladell, Edward 1821–1886
Basket of Fruit 1867
oil on canvas 24.0 x 29.3
Lad 1

Le Piper, Francis 1640–1698
A Scene From Hudibras, Canto I
oil on panel 22.9 x 43.2
Pipf 1

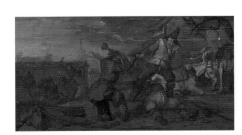

Le Piper, Francis 1640–1698
A Scene from Hudibras, Canto II
oil on panel 22.9 x 43.2
Pipf 2

Le Piper, Francis 1640–1698
A Scene from Hudibras, Canto III
oil on panel 22.9 x 43.2
Pipf 3

Low, Diana 1911–1975
A Road near the Sea
oil on board 59.7 x 69.9
Lowd 1

Low, Diana 1911–1975
Flowers in a Blue and White Jug
oil on board 43.2 x 35.6
Lowd 5

Low, Diana 1911–1975
Grandparents on the Beach
oil on board 44.5 x 59.7
Lowd 4

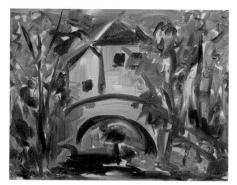

Mackechnie, Robert 1894–1975
Bridge and House
oil on board 60 x 75
Mac 2

Mackechnie, Robert 1894–1975
Rotten Wood with Blue Toadstools
oil on canvas 32.0 x 42.8
Mac 3

Mackechnie, Robert 1894–1975
San Michele, Ripaldi, Florence
oil on panel 33.5 x 23.5
Mac 7

Mackechnie, Robert 1894–1975
Self Portrait
oil on canvas 69.5 x 61.5
Mac 6

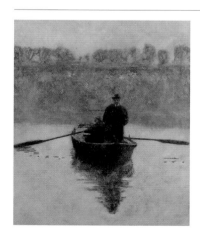

Money, Eric 1946–2003
The Ferryman
oil & gouache on board 106.7 x 70.0
Mon 1

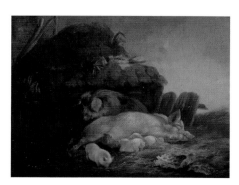

Morland, George (attributed to) 1763–1804
Litter of Pigs
oil on panel 33.0 x 42.6
Mor 1

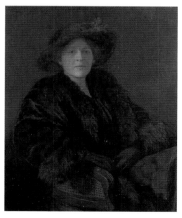

Moser, Oswald 1874–1953
Lady Dorothy D'Oyly Carte
oil on board 71 x 60
Mos 2

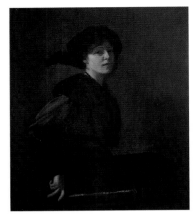

Moser, Oswald 1874–1953
Portrait of the Artist's Wife (later Madame Durand)
oil on canvas 103 x 88
Mos 3 (P)

Neer, Aert van der (attributed to)
1603–1677
Fishermen by Mooonlight
oil on panel 29.2 x 44.5
Nee 1

Padwick, Philip Hugh 1876–1958
Arundel
oil on panel 36 x 51
Pad 1

Padwick, Philip Hugh 1876–1958
Littlehampton Harbour
oil on board 29.2 x 39.4
Pad 2

Palin, William Mainwaring 1862–1947
Tree in Summer
oil on board 22 x 15
Pal 1

Richards, Ceri Geraldus 1903–1971
Pianist 1961
oil on canvas 30.5 x 34.9
Ric 1

Ruysch, Rachel (attributed to) 1664–1750
Flower Piece
oil on panel 30.5 x 22.2
Ruy 1

Sarram, Ralph de b.1930
Abstract, Aix-En-Provence 1959
oil on canvas 51.0 x 62.5
Sar 1

Stoop, Cornelius F. de 19th C
Cows and Sheep Driven by Horsemen 1859
oil on canvas 64.8 x 90.2
Sto 1

Stormont, Howard Gull 1859–1935
Rouen c.1910
oil on canvas 90 x 125
Stoh 3

Stormont, Howard Gull 1859–1935
Camber Castle 1929
oil on board 24.8 x 40.6
Stoh 1

Stormont, Howard Gull 1859–1935
Ludlow Castle 1929
oil on canvas 51.0 x 61.5
Stoh 2

Stormont, Howard Gull 1859–1935
Arundel Castle
oil on board 13.3 x 17.8
Stoh 5

Stormont, Howard Gull 1859–1935
February Morning, Rye
oil on canvas 46 x 61
Stoh 47

Stormont, Howard Gull 1859–1935
Gate into Field with Cows and Tree
oil on board 12.0 x 20.8
Stoh 43

Stormont, Howard Gull 1859–1935
Thatched Cottage
oil on board 11.5 x 21.0
Stoh 44

Stormont, Howard Gull 1859–1935
White Cottage with Figures
oil on board 12.0 x 20.5
Stoh 46

Stormont, Howard Gull 1859–1935
Wooded Valley with Hills
oil on board 11 x 20
Stoh 45

Stormont, Mary 1871–1962
A June Posy
oil on panel 30.5 x 27.9
Stom 44

Stormont, Mary 1871–1962
Autumn Flowers
oil on board 43 x 38
Stom 1

Stormont, Mary 1871–1962
Autumn Gathering
oil on board 33.7 x 26.0
Stom 10

Stormont, Mary 1871–1962
Camellias
oil on panel 26.5 x 21.3
Stom 46

Stormont, Mary 1871–1962
Daffodils and Narcissus
oil on panel 36 x 33
Stom 7

Stormont, Mary 1871–1962
Dahlias
oil on board 40.6 x 30.5
Stom 8

Stormont, Mary 1871–1962
Dahlias and Michaelmas Daisies
oil on board 35.6 x 31.8
Stom 12

Stormont, Mary 1871–1962
Flowers
oil on board 32 x 27
Stom 42

Stormont, Mary 1871–1962
Foxgloves
oil on board 42.5 x 31.5
Stom 4

Facing page: Bevan, Robert Polhill, 1865–1925, *The Cab Yard, Night* (detail), c.1909–1910, Brighton and Hove
Museums and Art Galleries, (p. 22)

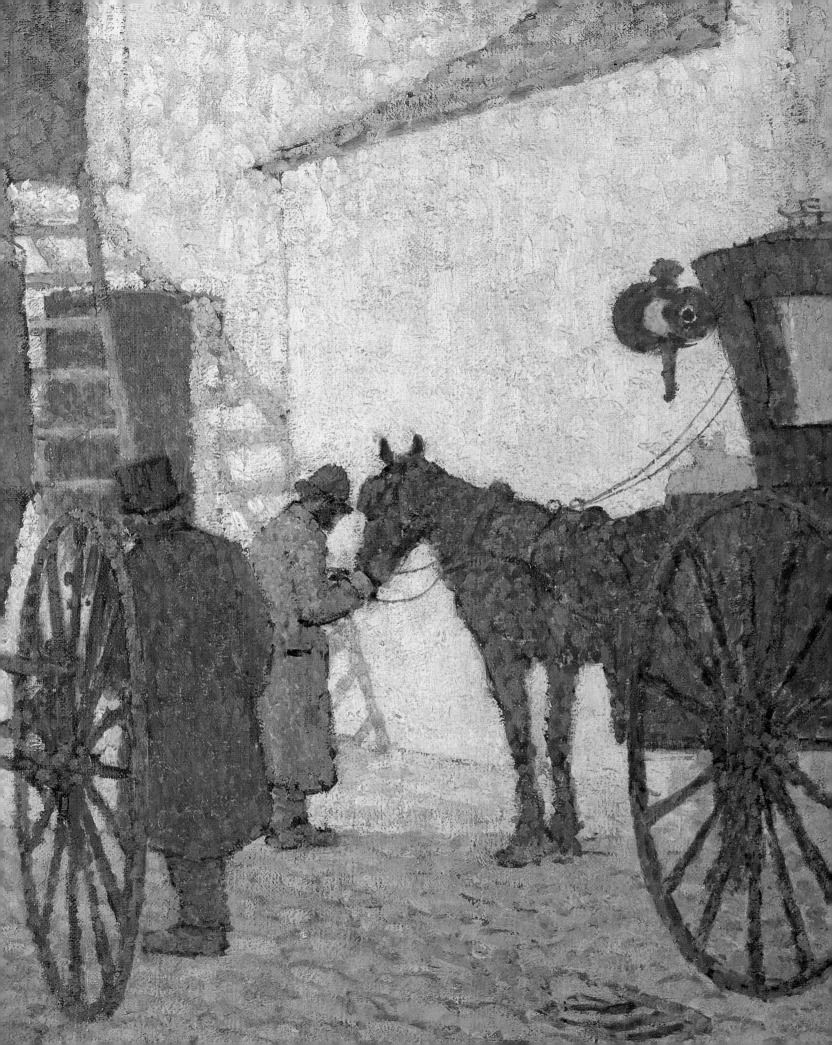

Stormont, Mary 1871–1962
Iceland Poppies
oil on board 34.5 x 41.0
Stom 11

Stormont, Mary 1871–1962
June on the Marsh
oil on panel 19.0 x 27.9
Stom 17

Stormont, Mary 1871–1962
Mermaid Street, Rye
oil on board 35.6 x 27.9
Stom 13

Stormont, Mary 1871–1962
Milking Sheep, Holland
oil on panel 15.9 x 23.5
Stom 15

Stormont, Mary 1871–1962
Mixed Roses
oil on board 38.1 x 43.2
Stom 5

Stormont, Mary 1871–1962
On the Marsh
oil on board 20.5 x 31.0
Stom 55

Stormont, Mary 1871–1962
Orchids
oil on board 29.2 x 29.2
Stom 3

Stormont, Mary 1871–1962
Romney Marsh
oil on board 24.0 x 38.3
Stom 14

Stormont, Mary 1871–1962
Rosamund
oil on panel 11.1 x 9.5
Stom 18

Stormont, Mary 1871–1962
Roses and Canterbury Bells
oil on board 43.2 x 38.1
Stom 6

Stormont, Mary 1871–1962
Roses and Pea Stems
oil on board 24.2 x 28.0
Stom 9

Stormont, Mary 1871–1962
Rye Bay
oil on board 18.5 x 27.0
Stom 53

Stormont, Mary 1871–1962
Rye from Winchelsea
oil on panel 13.5 x 23.0
Stom 45

Stormont, Mary 1871–1962
The Lime Kiln, Maldon, Essex
oil on board 20.3 x 27.9
Stom 40

Stormont, Mary 1871–1962
The Mermaid Inn, Rye
oil on board 35.6 x 27.9
Stom 16

Stormont, Mary 1871–1962
White Roses and Honeysuckle
oil on panel 38.1 x 30.5
Stom 2

Tebbutt, Lionel F. 1900–1975
Deep Water Bay, Hong Kong
oil on board 59.6 x 79.6
Teb 6

Tebbutt, Lionel F. 1900–1975
Fishing Fleet Wharf, Rye
oil on board 28.5 x 39.4
Teb 1

Tebbutt, Lionel F. 1900–1975
No Birds Sing (The Dark Wood)
oil on board 39.8 x 49.8
Teb 5

Tebbutt, Lionel F. 1900–1975
On attend le garçon
oil on board 39 x 49
Teb 4

Tebbutt, Lionel F. 1900–1975
Street Scene with Temple of Minerva, Assisi
oil on board 39 x 49
Teb3

Tebbutt, Lionel F. 1900–1975
The Yu River, Kwangsi, China
oil on board 38.6 x 49.0
Teb 7

Tebbutt, Lionel F. 1900–1975
Yacht Race at Rye Harbour
oil on board 29.8 x 39.6
Teb 2

Townsend, Kenneth 1935–2001
Fairlight
oil on canvas 56.0 x 56.5
Tow 2

**Turner, Joseph Mallord William
(school of)** 1775–1851
English Village Scene with Cattle
oil on canvas 24.8 x 31.8
Tur 1

Turpin, Louis b.1947
View from the Studio, Cabbage Field 1979
oil on canvas 100 x 94
Turl 1

Turpin, Louis b.1947
Spring Garden, Rye
oil on canvas with gold leaf 24 x 19
Turl 2

unknown artist
Hydrangeas in a Vase
oil on canvas 39 x 31
Unk 7

unknown artist
Interior with Three Figures
oil sketch on board 14.5 x 22.0
Unk 8

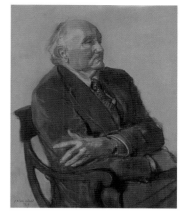

Ward, John Stanton b.1917
Patrick Dickinson 1984
oil on canvas 58.7 x 49.0
War 1 🐝

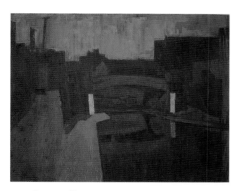

Warden, William 1908–1982
Industrial Landscape
oil on canvas 100 x 126
Warw 1

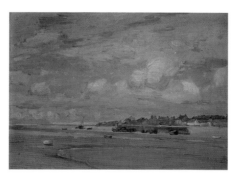

Weyden, Harry van der 1868–1956
Estuary at Etaples c.1916
oil on canvas 33.0 x 43.8
Wey 2

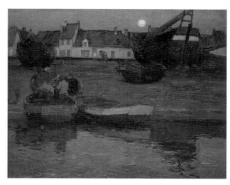

Weyden, Harry van der 1868–1956
Night Fishing at Etaples c.1916
oil on canvas 41.5 x 51.0
Wey 3

Weyden, Harry van der 1868–1956
Sailing Boats off Shore
oil on canvas 28 x 39
Wey 1

Wilson, Richard (attributed to)
1713/1714–1782
Landscape
oil on panel 36 x 29
Wil 1

Wit, Jacob de 1695–1754
Allegory of Plenty, Cherubs Playing with a Ram
oil on canvas 37 x 107
Wit 1

Yale, Brian b.1936
The Nativity Hut
oil on canvas 59.5 x 70.0
Yal 1 ❂

Rye Castle
Museum

Atkins, G.
*View of the Strand, Green Steps and the Hope
and Anchor Inn* 1888
oil on board 34.3 x 53.3
RYEYT:200.1

Danckerts, Hendrick (school of) 1625–1680
Rye 1720–1742
oil on canvas 71.0 x 90.5
RYEYT:1995.1

Davie, Leslie
Monkbretton Bridge from the Fishmarket 1949
oil on canvas 34.3 x 53.3
RYEYT:2000.04

Gales, Henry active 1856–1886
Camber Castle 1880
oil on wood panel 22.9 x 44.5
RYEYT:N276

Thorpe
The Strand, Rye 1835
oil on canvas 43.2 x 58.4
RYEYT:6.5

unknown artist
North Side of Augustinian Monastery before Alteration c.1880
oil on canvas 30.5 x 49.5
RYEYT:INV8.17

unknown artist
Rye from Fishmarket c.1910
oil on canvas 43.2 x 78.7
RYEYT:6.4

Rye Town Hall

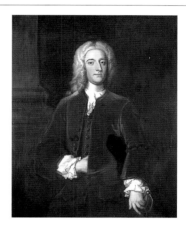

Eves, Reginald Grenville 1876–1941
Henry James (after John Singer Sargent)
oil on canvas 83.8 x 66.0
RTH01

Jervas, Charles (attributed to) c.1675–1739
Phillips Gybbon in a Brown Tunic Holding a Sword
oil on canvas 121.9 x 96.5
RTH03

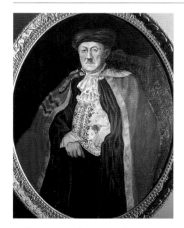

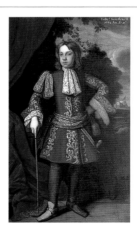

unknown artist 20th C
Joseph Adams in Mayoral Regalia
oil on board 193.0 x 119.4
RTH04

Wright, John Michael (circle of) 1617–1694
Edward Southwell Standing with a Cane in Embroidered Buff Tunic 1682
oil on canvas 152.4 x 91.4
RTH02

Seaford Museum

Astell, John
Tide Mills 1971
oil on board 22.9 x 33.0
894

Denheigst, D.
View of Church from Car Park c.1967
oil on hardboard 32.4 x 43.0
5220

Haynes
Martello Tower c.1980
oil on plywood 22.9 x 27.9
653

Hocken, Marion Grace 1922–1987
View of Buckle Pub from Cliffs 1970
oil on cardboard 24.1 x 34.3

Hutchinson, M.
View of Martello Tower and Seaford Head
1970
oil on hardboard 20 x 25
SFM07

Lane, Spencer
Seven Sisters from Seaford Beach 1970
oil on board 38.1 x 54.6
SFM12

Nash, R. A.
*View of Martello Tower, Restaurant and
Flat* 1971
oil on hardboard 44.5 x 34.3
SFM11

Robino, A.
Seaford Bay 1877
oil on canvas 30.5 x 61.0
SFM01

Robino, A.
View of Newhaven 1877
oil on canvas 38.1 x 61.0
SFM02

Sykes
Looking towards Peacehaven c.1949
oil on board 47 x 59
1720

unknown artist
Ship Portrait 'SS Seaford'
oil on card 24.1 x 48.3
SFM04

unknown artist
Ship Portrait 'SS Sussex'
oil on card laid on card 24.1 x 48.3
SFM03

Seaford Town Council

Swinstead, George Hillyard 1860–1926
The White Chalks at Seaford Head
oil on canvas 101.6 x 182.9
14

Paintings Without Reproductions

This section lists all the paintings that have not been included in the main pages of the catalogue. They were excluded as it was not possible to photograph them for this project. Additional information relating to acquisition credit lines or loan details is also included. For this reason the information below is not repeated in the Further Information section.

Brighton and Hove Museums and Art Galleries

British (English) School, *Farmyard Scene*, c.1810, 77.0 x 126.8, oil on canvas, FA000390, acquisition method unrecorded, missing at the time of photography

Cleaver, W. H?, *Napoleon Retiring from Egypt on the Muiron, 22 August 1799*, 1936, 31.3 x 41.5, oil on hardboard, FAPM090050, donation, missing at the time of photography

Durrant, Roy Turner 1925–1998, *Landscape from Cryer's Hill*, 1980, 61 x 75, oil on board, FAH1984.3, donation, missing at the time of photography

H. E. 19th C, *Chain Pier, Brighton*, 28.1 x 39.0, oil on board, FA000297, donation, missing at the time of photography

King, Gunning 1859–1940, *Black Bullock*, 1930, 20 x 29, oil on panel, FA000788, donation, missing in 1997 survey

King, Gunning 1859–1940, *Three Cows*, 1930, 20 x 29, oil on panel, FA000787, donation, missing in 1997 survey

King, Gunning 1859–1940, *A Bull*, 20.5 x 29.4, oil on panel, FA001016, donation, missing in 1997 survey

King, Gunning 1859–1940, *A Cow*, 21.1 x 26.7, oil on panel, FA001077, donation, missing in 1997 survey

King, Gunning 1859–1940, *Highland Cow*, 20.5 x 29.4, oil on panel, FA001014, donation, missing in 1997 survey

King, Gunning 1859–1940, *Reverend John Julius Hannah, Vicar of Brighton*, 66 x 51, oil on canvas, FA000972, purchase, missing at the time of photography

Monteforte, Edoardo b.1849, *A Bay on the Italian Coast*, 24.2 x 39.4, oil on board, FA000465, acquisition method unrecorded, missing at the time of photography

Rye Art Gallery

Mackechnie, Robert 1894–1975, *Movement on Red*, 35.6 x 45.1, oil, Mac 4, Mackechnie Bequest, 1990, missing May 2005, presumed lost

Moser, Oswald 1874–1953, *Lion Street, Rye*, 1929, 12.7 x 11.4, oil on panel, Mos 1, Stormont Bequest, 1962, missing May 2005, presumed lost

Stormont, Howard Gull 1859–1935, *Low Tide, Southend*, 12.1 x 19.7, oil on panel, Stoh 4, Stormont Bequest, missing May 2005, presumed lost

Stormont, Mary 1871–1962, *Harlech Castle*, 27.9 x 33.0, oil on panel, Stom 41, Stormont Bequest, 1962, missing May 2005, presumed lost

Seaford Museum

Blake, H. W., *Teashop Clifton Place*, 39.4 x 30.5, oil on board, SFM05, not available on day of photography

Leggett, Rowley, *Seafront*, 35.6 x 45.7, oil on hardboard, SFM06, not available on day of photography

Towner Art Gallery

Milner, Frederick d.1939, *An English Landscape*, 66 x 84, oil on canvas, EASTG 740, purchased, not available on day of photography

Mockford, Harold d.1932, *The Level Crossing, Pevensey*, 92 x 123, oil on canvas, EASTG 1765, purchased from the artist, not available on day of photography

Rendle, Morgan 1889–1952, *Shoreham*, 63.5 x 78.0, oil on canvas, EASTG 739, purchased from the artist, not available on day of photography

Towner, Donald Chisholm 1903–1985, *Berwick Church 1977*, 1977, 53.9 x 79.3, oil on canvas, EASTG 1623, purchased from the artist, not available on day of photography

Facing page: Bassen, Bartholomeus van, c.1590–1652, *Interior of an Imaginary Church* (detail), 1627, Brighton and Hove Museums and Art Galleries, (p. 18)

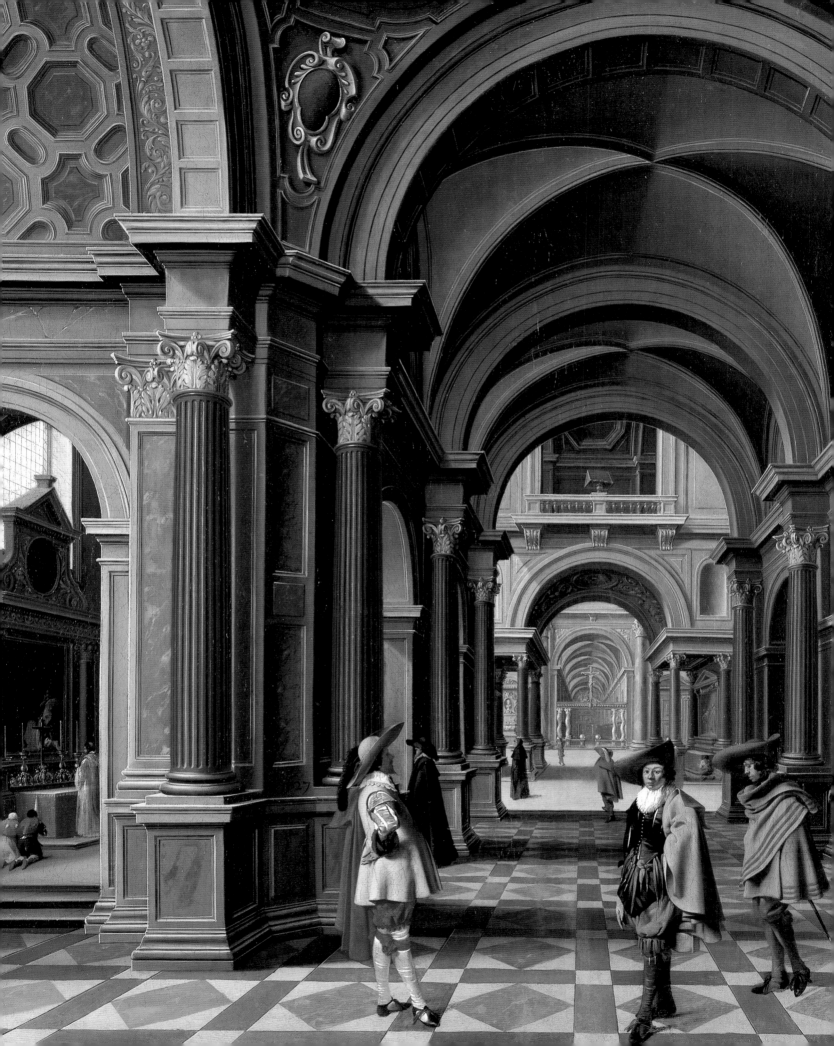

Further Information

The paintings listed in this section have additional information relating to one or more of the five categories outlined below. This extra information is only provided where it is applicable and where it exists. Paintings listed in this section are divided into their respective collections and follow the same order as in the illustrated pages of the catalogue.

I The full name of the artist if this was too long to display in the illustrated pages of the catalogue. Such cases are marked in the catalogue with a (...).

II The full title of the painting if this was too long to display in the illustrated pages of the catalogue. Such cases are marked in the catalogue with a (...).

III Acquisition information or acquisition credit lines as well as information about loans, copied from the records of the owner collection.

IV Artist copyright credit lines where the copyright owner has been traced. Exhaustive efforts have been made to locate the copyright owners of all the images included within this catalogue and to meet their requirements. Any omissions or mistakes brought to our attention will be duly attended to and corrected in future publications.

V The credit line of the lender of the transparency if the transparency has been borrowed. Bridgeman images are available subject to any relevant copyright approvals from the Bridgeman Art Library at www.bridgeman.co.uk

English Heritage, Battle Abbey

Alleyne, Francis (circle of) active 1774, *Sir Thomas Webster, First Bt?*, Christie's 1998, © English Heritage
British (English) School *William the Conqueror*, © English Heritage
British (English) School *Whistler Webster, Second Bt, Aged 15*, Christie's 1998, © English Heritage
British (English) School *A Webster in the Uniform of the Rifle Brigade*, Christie's 1998, © English Heritage
Fuller, Issac (style of) c.1606–1672, *Thomas Jordan*, Christie's 1998, © English Heritage
Gauffier, Louis 1761–1801, *Godfrey Webster, Fourth Bt*, purchased with the assistance of the National Art Collections Fund, © English Heritage
Hoppner, John 1758–1810, *Thomas Chaplin*, Christie's 1998, © English Heritage
Hoppner, John (circle of) 1758–1810, *Lady Elizabeth Webster*, Christie's 1998, © English Heritage
Hoppner, John (follower of) 1758–1810, *Charles, Fourth Duke of Richmond*, Christie's 1998, © English Heritage
Hudson, Thomas (circle of) 1701–1779, *Sir Thomas Webster, First Bt*, Christie's 1998, © English Heritage
Hudson, Thomas (circle of) 1701–1779, *Captain Edward Webster*, Christie's 1998, © English Heritage
Hudson, Thomas (circle of) 1701–1779, *Lady Martha Whistler Webster*, Christie's 1998, © English Heritage
Hudson, Thomas (circle of) 1701–1779, *Sir Whistler Webster, Second Bt*, Christie's 1998, © English Heritage
Humphry, Ozias (circle of) 1742–1810, *Lady Martha Whistler Webster*, Christie's 1998, © English Heritage
Kneller, Godfrey (circle of) 1646–1723, *Sir Godfrey Webster*, Christie's 1998, © English Heritage
Legrand, Pierre Nicolas 1758–1829, *Lady Charlotte Webster*, Christie's 1998, © English Heritage
Lely, Peter (circle of) 1618–1680, *Abigail Jordan (Later Lady Webster)*, Christie's 1998, © English Heritage
Stuart, Gilbert (follower of) 1755–1828, *Sir Godfrey Vassal Webster, Fifth Bt*, Christie's 1998, © English Heritage
Wilkins, Francis William 1800–1842, *The Battle of Hastings*, painted for the hall, © English Heritage
Wright, John Michael (follower of) 1617–1694, *Sir Thomas Webster, First Bt, Aged 3*, Christie's 1998, © English Heritage

Battle Library

Avery, Ted *A Yellow House and Pub Lining a Street in Battle*, donated to Battle Library by Mr E. C. H. Avery
Avery, Ted *View of Mount Street, Battle*, donated to Battle Library by Mr E. C. H. Avery
Avery, Ted *View of Shops in Tenterden*, donated to Battle Library by Mr E. C. H. Avery

Bexhill Museum

Burston, Samuel *Sir John Barbirolli*, gift
Graves, Charles A. 1834/1835–1918, *View from the Lawn, The Firs, Bexhill, Sussex 1891*, purchase
Graves, Charles A. 1834/1835–1918, *View from Millfield, Bexhill 1896*, purchase
Graves, Charles A. 1834/1835–1918, *High Street, Old Bexhill in 1898*, gift
Graves, Charles A. 1834/1835–1918, *View from Millfield, Bexhill 1899*, purchase
Graves, Charles A. 1834/1835–1918, *Millfield, Bexhill 1904*, purchase
Hacker, Enid *Hoad & Son Downs Mill, Bexhill-on-Sea*, gift
Hatfield, L. S. *On the 5.15pm St Pancras to St Albans (Blackout Train Scene)*, gift
A. J. *Industrial Scene*, unknown
Lowry, Laurence Stephen 1887–1976, *Old Windmill, Bexhill (Hoad's Mill)*, purchase, © the Lowry Estate
Oliver, M. *Galley Hill*, gift
Sargent, Henry 1891–1983, *Garden Scene*, unknown
unknown artist *Arthur Sawyer Brook, 'Squire of Bexhill'*
unknown artist *J. C. Thompson*

Brighton and Hove Museums and Art Galleries

Aachen, Hans von (style of) 1552–1615, *Nativity*, purchase
Adams, John Clayton 1840–1906, *On the Llugwy, North Wales*, donation
Adams, John Clayton 1840–1906, *The Meadow Pool*, donation
Adams, Norman b.1927, *The Whole: The Word*, purchase, © the artist
Aelst, Willem van 1627–after 1687, *Still Life with Carnations*, donation
Aitken, J. *Christmas Time*, donation
Aldridge, Eileen 1916–1990, *The Downs near Brighton*, donation
Allinson, Adrian Paul 1890–1959, *Winter Magic*, donation
Alma-Tadema, Lawrence 1836–1912, *The Secret*, donation
Alma-Tadema, Lawrence 1836–1912, *Courtship (The Proposal)*, donation
Alsloot, Denys van before 1573–1625/1626, *Winter Landscape with Distant Village*, donation
Amberger, Christoph c.1505–1561/1562, *Portrait of a Man*, donation
Amshewitz, John Henry 1882–1942, *Head of a Man*, donation
Amshewitz, John Henry 1882–1942, *The Revilers*, donation
Andrews, H. d.1868, *The Duke and Duchess of Marlborough Hawking at Blenheim*, donation
Andsell, Richard 1815–1885, *Portrait of a Gentleman*, donation
Annan, Dorothy 1908–1983, *Girl with an Apple*, donation
Anrooy, Anton Abraham van 1870–1949, *Rhododendrons*, donation
Appleton, Honor 1879–1951, *Poole Harbour*, donation
Armfield, Edward 1817–1896, *Disturbed at Dinner*, donation
Armfield, Edward 1817–1896, *Disturbed at Dinner (Large)*, donation
Armfield, Edward 1817–1896, *On the Watch*, donation
Armfield, Edward 1817–1896, *The Otter Hunt*, donation
Armitage, Edward 1817–1896, *Samson and the Lion*, donation
Armstrong, John b.1937, *Groyne at Hove Beach*, purchase, © the artist's estate
Ashford, William 1746–1824, *Dublin from Phoenix Park*, donation
Ashford, William 1746–1824, *Dublin Harbour from Howth*, donation
Ashton, C. H. *Pastoral Lovers*, unrecorded
Attree, J. *St Peter's Church, Brighton*, unrecorded
Aumonier, James 1832–1911, *Sketch for Sunday Evening*, donation
Austrian School *An Architectural Fantasy*, purchase
Austrian School *Study for a Painted Ceiling*, purchase
Backhuysen, Ludolf I (attributed to) 1630–1708, *Fishing Boats*, donation
Balen, Hendrik van I 1575–1632 & Brueghel, Jan the elder 1568–1625 *Pluto and Persephone*, donation
Barker, Adeline Margery b.1907, *Reverend Edward Tickner Edwardes*, donation
Barker, Benjamin II 1776–1838, *Landscape*, purchase
Barker, Benjamin II 1776–1838, *Landscape with Waterfall*, donation
Barrett, Jerry 1814–1906, *Connoisseurs Studying Sculpture*, donation
Barrett, Jerry 1814–1906, *Sheridan Assisting Miss Linley on Her Flight from Bath*, donation

Barrington, **Trend** *Hangleton Manor*, purchase

Bartlett, William H. 1858–1932, *Bound for the Island Home*, purchase

Bas, Edward le 1904–1966, *The Bedside Table*, donation

Bassen, Bartholomeus van c.1590–1652, *Interior of an Imaginary Church*, donation

Bateman, James 1893–1959, *Thames Wharf*, purchase

Battersby, Martin 1914–1982, *Oedipus and the Sphinx*, donation

Bauchant, André 1873–1958, *Paysage montagneux*, unrecorded

Baumann, Elisabeth 1819–1881, *Sunday Evening*, donation

Baynes, Thomas Mann 1794–1854, *Sake Deen Mahomed*, donation

Bazzani, Giuseppe 1690–1769, *St Margaret of Cortona*, donation

Beale, Mary (attributed to) 1633–1699, *Portrait of a Lady as St Agnes*, donation

Beard, E. 1878–1949, *Pontus et aer*, donation

Beaubrun family, (attributed to) active 16th C–17th C, *Henrietta Anne, Duchess of Orleans (1644–1670)*, donation

Beaumont, Claudio Francesco 1694–1766, *The Banquet of Alexander and Roxana*, purchase

Beaumont, George Howland 1753–1827, *Castel Gandolfo, Lake Albano*, purchase

Beavis, Richard 1824–1896, *The Shore at Scheveningen*, donation

Beechey, William 1753–1839, *William Porden*, purchase

Beers, Jan van 1852–1927, *Lady of the Directoire*, donation

Beert, Osias the elder c.1580–1624, *Still Life with Nautilus Cup, Fruit, Nuts and Wine*, donation

Beeton, W. & Hargitt, Edward 1835–1895 *Riding in Hyde Park*, donation

Begeyn, Abraham 1637/1638–1697, *Landscape with Sheep*, unrecorded

Bell, E. *Hove Town Hall Fire*, purchase

Bell, Julian b.1952, *Castle Hill on the Sussex Downs*, purchase

Bell, Vanessa 1879–1961, *The Red Dress*, unrecorded, © 1961 estate of Vanessa Bell courtesy Henrietta Garnett

Belleroche, Albert de 1864–1944, *The Servant*, donation

Bennett, E. A. *Afrikaner Farmstead on the Road to Hartebeestpoort*, donation

Bennett, E. A. *Avenue of Gum Trees, Rivonia,Transvaal*, donation

Bennett, E. A. *Native House on Road to Hartebeestpoort*, donation

Bennett, E. A. *Village Scene with Church at Centre and Surrounded by Trees*, donation

Bennett, E. A. *Woodland Scene*, donation

Bennett, James 1808–1888, *Kemptown Park from Coes Field*, unrecorded

Bennett, James 1808–1888, *The Manor House, Preston, Sussex*,

donation

Bennett, James 1808–1888, *Lover's Walk, Preston*, donation

Bennett, James 1808–1888, *The Manor House, Preston Place, Sussex*, donation

Bennett, James 1808–1888, *Hove, from the top of Holland Road*, purchase

Bennett, James 1808–1888, *Country Scene*, unrecorded

Bennett, James 1808–1888, *Poynings*, unrecorded

Bennett, James 1808–1888, *Preston Park*, donation

Bennett, James 1808–1888, *Preston Village and Manor*, purchase

Bennett, James 1808–1888, *Preston Village with the Railway*, purchase

Bennett, James 1808–1888, *Seascape*, unrecorded

Bennett, James 1808–1888, *The Pump House, Brighton, in 1825*, purchase

Bennett, James 1808–1888, *The Windmill*, unrecorded

Bennett, James 1808–1888, *View of Preston, near Brighton*, unrecorded

Berg, Adrian b.1929, *Brighton Terrace*, purchase

Bevan, Robert Polhill 1865–1925, *The Cab Yard, Night*, purchase

Bevan, Robert Polhill 1865–1925, *Rosemary la vallée*, purchase

Bindon, Jack Armfield 1910–1985, *St John's Church, Palmeira Square*, donation

Birch, Samuel John Lamorna 1869–1955, *Lingering Snows*, purchase, © Mr Adam J. Kerr

Birch, William Henry David 1895–1968, *A Sussex Panorama*, purchase

Birley, Oswald Hornby Joseph 1880–1952, *William Henry Abbey*, donation, © the artist's estate

Blaas, Eugen von 1843–1931, *Venetian Girl*, donation

Blackadder, Elizabeth V. b.1931, *Two Cats on a Kelim*, purchase, © the artist

Blake, William 1757–1827, *The Adoration of the Kings*, donation

Blanche, Jacques-Emile 1861–1942, *Still Life: Fish on a Silver Plate*, purchase, © ADAGP, Paris and DACS, London 2005

Blanche, Jacques-Emile 1861–1942, *Brighton Front*, purchase, © ADAGP, Paris and DACS, London 2005

Blanche, Jacques-Emile 1861–1942, *Black Rock, Brighton*, purchase, © ADAGP, Paris and DACS, London 2005

Blinks, Thomas 1860–1912, *Huntsmen and Hounds in a Wooded Landscape*, donation

Block, Eugène-François de 1812–1893, *The Signal*, donation

Blyth, Beatrix *Woolbridge, Dorset*, purchase

Bomberg, David 1890–1957, *Players (formerly Fiesta)*, donation, © the artist's family

Bond, William H. 1861–1918, *Old Shoreham Bridge*, donation

Bone, Herbert Alfred 1853–1931, *Mistress of the Moat*, donation

Bonheur, Rosa 1822–1899, *The Stag*, donation

Bonheur, Rosa 1822–1899, *Shepherd of the Pyrenees*, donation

Bonington, Richard Parkes 1802–1828, *Tomb in the Church of Saint Omer*, donation

Borcht, Peter van der (attributed to) c.1540–1608, *A Rest on the Flight into Egypt*, donation

Borione, Bernard Louis b.1865, *Cardinal at Coffee*, donation

Borione, Bernard Louis b.1865, *Cavalier with Mandoline*, donation

Bottomley, Albert Ernest 1873–1950, *Clay Hall Farm*, donation

Boudin, Eugène Louis (after) 1824–1898, *Trouville*, donation

Bowes, John 1899–1974, *Cliffs and Forest*, unrecorded

Boxall, William 1800–1879, *Henry Graves*, donation

Boyle, Mark b.1934, *Moorland Lake*, unrecorded

Brangwyn, Frank 1867–1956, *Queen Elizabeth Going aboard the 'Golden Hind' at Deptford*, donation, © courtesy of the artist's estate/www.bridgeman.co.uk

Brangwyn, Frank 1867–1956, *Ancona*, purchase, © courtesy of the artist's estate/www.bridgeman.co.uk

Bratby, John Randall 1928–1992, *Fishing Boat at Dungeness, RX67*, purchase, © courtesy of the artist's estate/www.bridgeman.co.uk

Breanski, Alfred de 1852–1928, *View of Burnham Beeches*, donation

Breanski, Gustave de c.1856–1898, *Seascape*, donation

Breanski, Gustave de c.1856–1898, *Seascape with Fishing Boat*

Brett, John 1830–1902, *Watergate, Cornwall*, donation

Bridges, Thomas 1871–1939, *House at Neuilly*, unrecorded

Briggs, Henry Perronet 1791/1793–1844, *The Duke of Wellington Wearing the Order of the Golden Fleece*, donation

British (English) School *Memento mori*, donation

British (English) School *Portrait of a Gentleman in a Lace Ruff*, donation

British (English) School *Portrait of a Young Man and Woman*, donation

British (English) School *Lady Elizabeth Fane*, donation

British (English) School *Oliver Cromwell*, donation

British (English) School *Man in Armour: Francis Boyle, Viscount Shannon*, donation

British (English) School *Lord Fairfax*, donation

British (English) School *Sir Anthony Shirley (1624–1683)*, donation

British (English) School *Portrait of a Woman*, donation

British (English) School *Portrait of a Man*, donation

British (English) School *Portrait of a Boy with Dog*, unrecorded

British (English) School *17th C, Henry Cavendish*, donation

British (English) School *Charles I*, donation

British (English) School *Portrait of a Young Man*, donation

British (English) School *Shepherds*, unrecorded

British (English) School *Angel and Figures by Ruins*, unrecorded

British (English) School *Italianate Landscape*, purchase

British (English) School *Portrait of a Man*, unrecorded

British (English) School *Soldier with Decapitated Head*, unrecorded

British (English) School *William IV, Prince of Orange*, donation

British (English) School *Village Scene*, unrecorded

British (English) School *Moonlit Shore with Figures*, unrecorded

British (English) School *Outskirts of a Town*, unrecorded

British (English) School *Italianate Landscape with Ruins*, donation

British (English) School *Italian Seaport*, unrecorded

British (English) School *Shepherdess and Classical Ruins*, unrecorded

British (English) School *Ecce Homo*, unrecorded

British (English) School *Woody Landscape*, donation

British (English) School *Anne of Cleves (copy of Hans Holbein the younger)*, donation

British (English) School *Diana Sleeping*, donation

British (English) School *Landscape*, unrecorded

British (English) School *Portrait of a Lady*, donation

British (English) School *The Mole' at Algiers*, donation

British (English) School *HRH George Prince of Wales*, donation

British (English) School *Landscape with Church*, donation

British (English) School *Smoker Miles*, unrecorded

British (English) School *Western Side of the Steyne, North of Castle Square, Brighthelmston*, unrecorded

British (English) School *Western Side of the Steyne, South of Castle Square, Brighthelmston*, unrecorded

British (English) School *18th C, Figures in Landscape*, unrecorded

British (English) School *18th C, Landscape*, unrecorded

British (English) School *18th C, Landscape*, unrecorded

British (English) School *18th C, Mary Western?*, donation

British (English) School *18th C, Mythological Scene*, donation

British (English) School *18th C, Rear Admiral Smith Callis*, donation

British (English) School *late 18th C, Prince Charles*, donation

British (English) School *Bramber Castle*, unrecorded

British (English) School *Castle in a Landscape*, unrecorded

British (English) School *Lake of Geneva*, donation

British (English) School *Lot Made Drunk by His Daughters*, unrecorded

British (English) School *Mounted Figure*, donation

British (English) School *Pastoral Scene*, donation

British (English) School *Peasants in a Woodland Clearing*, unrecorded

British (English) School *Seascape*, donation

British (English) School *View of a Cathedral City*, unrecorded

British (English) School *Woman in White Reading*, unrecorded

British (English) School *Woodcutters in a Forest*, unrecorded

British (English) School *Mary Tourle*, donation

British (English) School *William Stanford (1764–1841)*, donation

British (English) School *Child and Angel*, unrecorded

British (English) School *Portrait of a Law Officer*, unrecorded

British (English) School *S. Ridley*, donation

British (English) School *Brighton Beach*, unrecorded

British (English) School *Captain Samuel Brown*, unrecorded

British (English) School *Lady Mary Brown*, donation

British (English) School *Lakeland Landscape*, donation

British (English) School *Portrait of a Bather*, unrecorded

British (English) School *Seascape*, donation

British (English) School *Thomas Croesweller Junior (1788–1837)*, donation

British (English) School *Thomas Croesweller Senior, Coach Proprietor (1764–1829)*, donation

British (English) School *William Giles Senior, Town Crier*, donation

British (English) School *A Woodland Scene*, donation

British (English) School *The Old Fish Market, Brighton*, unrecorded

British (English) School *Durham*, unrecorded

British (English) School *John Ade*, unrecorded

British (English) School *Fishing Scene*, unrecorded

British (English) School *James Croesweller (1788–1837)*, donation

British (English) School *Joseph Henry Good*, purchase

British (English) School *Mrs Joseph Hemry Good*, purchase

British (English) School *Smith Hannington*, unrecorded

British (English) School *The Raising of Lazarus*, unrecorded

British (English) School *Windmill by the Coast*, unrecorded

British (English) School *Captain MacDonald as a Child, Aged 4*, donation

British (English) School *View of a Seaside Town: Rottingdean*, donation

British (English) School *Brighton Beach*, unrecorded

British (English) School *Christiana Delores MacDonald*, donation

British (English) School *Gentleman Seated*, unrecorded

British (English) School *Henry Pegg*, transfer

British (English) School *Portrait Reputed to be of Mrs Varnham*, donation

British (English) School *The Reverend James Vaughan*, unrecorded

British (English) School *Three Children*, unrecorded

British (English) School *Chain Pier*, unrecorded

British (English) School *Floating Breakwaters at Brighton*, donation

British (English) School *A Village Church*, unrecorded

British (English) School *Coastal Scene*, unrecorded

British (English) School *Garden Arbour*, donation

British (English) School *Man-O'-War at Sea*, unrecorded

British (English) School *Portrait of a Woman*, unrecorded

British (English) School *Savonarola*, donation

British (English) School *Two Arabs*, donation

British (English) School *Valley Landscape*, donation

British (English) School *William Stanford the Younger (1809–1853)*, donation

British (English) School *Brighton Viaduct*, unrecorded

British (English) School *Sir John Cordy Burrows*, donation

British (English) School *Sleeping Couple*, unrecorded

British (English) School *Thomas Lulham*, donation

British (English) School *R. Waller*, unrecorded

British (English) School *Charles Carpenter*, donation

British (English) School *Terriers with a Caged Ferret*, unrecorded

British (English) School *Jim: Yorkshire Terrier*, donation

British (English) School *Portrait of a Man*, unrecorded

British (English) School *Portrait of a Woman*, unrecorded

British (English) School *Prince Peter Kropotkin*, donation

British (English) School *Mayor Slingsby Roberts*, unrecorded

British (English) School *Portrait of a Gentleman with Bust*, unrecorded

British (English) School *Portrait of a Mayor*, unrecorded

British (English) School *Mayor Botting*, donation

British (English) School *Old Chain Pier, Brighton*, unrecorded

British (English) School *The Chain Pier*, unrecorded

British (English) School early 19th C, *Portrait of a Boy in a Red Suit*, donation

British (English) School early 19th C, *Portrait of a Man*, unrecorded

British (English) School 19th C, *Alderman W. Hallett, Mayor of Brighton (1855–1856)*, unrecorded

British (English) School 19th C, *A Lifeguardsman Attacking a Cuirassier at Waterloo*, purchase

British (English) School 19th C, *Ann Vallance*, donation

British (English) School 19th C, *Brighton Front and Chain Pier*, unrecorded

British (English) School 19th C, *Brighton Sammy the Walking Fishmonger*, donation

British (English) School 19th C, *Brighton to London Coach*, purchase

British (English) School 19th C, *Brooker Vallance*, donation

British (English) School 19th C, *Chain Pier*, unrecorded

British (English) School 19th C, *Coaching Scene*, purchase

British (English) School 19th C, *Coaching Scene*, purchase

British (English) School 19th C, *Frederick Akbar Mahomed (1849–1884)*, donation

British (English) School 19th C, *George Battcock*, unrecorded

British (English) School 19th C, *Henry Soloman*, donation

British (English) School 19th C, *James Vallance*, donation

British (English) School 19th C, *Lewis Slight*, donation

British (English) School 19th C, *Mrs Brooker Vallance*, donation

British (English) School 19th C, *Napoleon*, donation

British (English) School 19th C, *Shakespearian Characters*, donation

British (English) School 19th C, *Shakespearian Characters*, donation

British (English) School 19th C, *Shakespearian Characters*, donation

British (English) School 19th C, *Street Scene*, unrecorded

British (English) School 19th C, *Sunset by the River Amazon*, donation

British (English) School 19th C, *Village Revels*, unrecorded

British (English) School 19th C, *William Stanford the Younger (1809–1853)*, donation

British (English) School 19th C, *William IV on the Chain Pier*, unrecorded

British (English) School late 19th C, *Lord Kitchener*, unrecorded

British (English) School late 19th C, *The Chain Pier*, unrecorded

British (English) School late 19th C–early 20th C, *Interior of a Church*, unrecorded

British (English) School *Cape Hangklip, Sand Dunes Fish Hoek, Simonsberg*, donation

British (English) School *Landscape*, unrecorded

British (English) School *Portrait of a Man*, unrecorded

British (English) School *Portrait of a Mayor*, unrecorded

British (English) School *Portrait of a Dignitary*, donation

British (English) School *Alderman Sir Herbert Carden, JP*, donation

British (English) School *Flowers in a Vase*, unrecorded

British (English) School *Mrs Polson*, unrecorded

British (English) School *Portrait of a Conductor*, unrecorded

British (English) School *Riverside Scene*, unrecorded

British (English) School *W. M. Giles, the Last Town Crier*, unrecorded

British (English) School *Girl in a Flowery Hat*, unrecorded

British (English) School *Vase of Flowers*, unrecorded

British (English) School *Alderman Miss Margaret Hardy*, unrecorded

British (English) School *Woman in a Blue Dress*, unrecorded

British (English) School early 20th C, *Portrait of a Girl*, unrecorded

British (English) School 20th C, *Peasant's Hovel*, donation

British (English) School 20th C, *Poppies in a Jug*, unrecorded

British (English) School 20th C, *Seascape*, unrecorded

British (English) School 20th C, *Viscount Wolseley*, unrecorded

British (English) School *The Manor House, Hove*

British School & French School late 17th C, *Decorative Coach Panel*, donation

Bromley, W. 19th C, *Two Girls*, donation

Brooks, Marjorie 1904–1980, *Girl with Parasol*, donation

Brooks, Marjorie 1904–1980, *Seated Girl on a Beach*, donation

Brooks, Marjorie 1904–1980, *Blue Flowers*, unrecorded

Brooks, Marjorie 1904–1980, *Tea on the Lawn*, donation

Broughton, J. 19th C, *Martha Gunn Holding the Infant George IV (after John Russell)*, purchase

Brown, J. Taylor active 1893–1943, *When Dead Leaves Flicker and Fall*, purchase

Brown, Sheila Napaljarri b.1940, *Ceremonial Pole Dreaming (Witi Jukurrpa)*, © DACS 2005

Brueton, Frederick active 1882–1909, *Benjamin Lomax*, donation

Brueton, Frederick active 1882–1909, *George De Paris*, donation

Brueton, Frederick active 1882–1909, *Daniel Friend (1816–1902)*, unrecorded

Brueton, Frederick active 1882–1909, *John George Bishop*, donation

Brueton, Frederick active 1882–1909, *William Woodward, the Chartist*, donation

Bryson White, Iris 20th C, *Lychgate, St Wulfran's Church, Ovingdean*, purchase

Bulmer, Lionel 1919–1992, *The Water Meadow*, purchase

Burle Marx, Roberto 1909–1994, *Landscape*, donation

Burleigh, Averil 1883–1949, *Washerwomen*, unrecorded

Burleigh, C. H. H. 1869–1956, *Music Room of the Royal Pavilion as a Hospital for Indian Soldiers*, purchase

Burleigh, C. H. H. 1869–1956, *The Dome as an Indian Military Hospital*, purchase

Burleigh, C. H. H. 1869–1956, *Brighton Front*, donation

Burleigh, C. H. H. 1869–1956, *Portrait of an Organist*, donation

Burleigh, C. H. H. 1869–1956, *The Music Room of the Royal Pavilion*, purchase

Burleigh, C. H. H. 1869–1956, *Brighton Arts Club*, donation

Burleigh, C. H .H. 1869–1956, *Averil Burleigh Painting at 7, Wilbury Crescent*, purchase

Burleigh, C. H. H. 1869–1956, *Lieutenant Colonel S. Moens, CBE*, donation

Burleigh, C. H. H. 1869–1956, *Portrait of an Old Man*, unrecorded

Burleigh, C. H. H. 1869–1956, *The Rotunda, Royal Pavilion, Brighton*, donation

Burleigh, Veronica 1909–1998, *Self Portrait with the Artist's Parents*, donation, © the artist

Burleigh, Veronica 1909–1998, *Portrait of the Artist's Father*, donation, © the artist

Burn, Rodney Joseph 1899–1984, *The Red Lion Inn*, donation

Burrows, R. d.1855, *View on the Orwell*, donation

Busfield, Brian b.1926, *Devil's Dyke*, donation

Buss, Robert William 1804–1875, *Masters Boydell & Sidney Graves*, donation

H. C. *Remnants of the Chain Pier after Destruction*, unrecorded

H. C. *The Chain Pier*, unrecorded

Cadell, Francis Campbell Bolleau 1883–1937, *Dancer*, donation, © Cadell estate, courtesy Portland Gallery

Caffyn, Walter Wallor 1845–1898, *A Quiet Evening on the Thames near Sonning*, donation

Callow, George D. active 1856–1873, *Chain Pier, Brighton*, purchase

Calthrop, Claude Andrew 1845–1893, *In Saint Peter's*, donation

Capobianchi, Vincenzo 1836–1928, *Roman Children at Indoor Archery*, donation

Caraf 19th C, *Port*, unrecorded

Carline, Hilda Anne 1889–1950, *Elsie*, purchase, © estate of Hilda Carline, 2005. All Rights Reserved, DACS

Carlone, Carlo Innocenzo 1686–1775, *The Glorification of a Saint*, purchase

Carlone, Carlo Innocenzo (style of) 1686–1775, *Vision of Saint Anthony*, purchase

Carlone, Carlo Innocenzo (style of) 1686–1775, *Court Scene*, purchase

Carmichael, James Wilson 1800–1868, *Kemp Town from the Sea*, purchase

Carmichael, James Wilson 1800–1868, *At Anchor*, donation

Carmichael, James Wilson 1800–1868, *The Coming Storm*, donation

Carpenter, Leslie 20th C, *We Three*, purchase

Cassiers, Hendrick 1858–1944, *Winter in Amsterdam*, purchase

Cavalcanti, Emiliano di 1897–1976, *Women from Bahai*, donation

Chailloux, Robert b.1913, *Notre Dame from the Seine*, unrecorded

Chamberlin, Mason active c.1786–1826, *Water Mill*, donation

Chamberlin, William Benjamin active 1880–1934, *An Artist's Studio*, donation

Chamberlin, William Benjamin active 1880–1934, *An Interior*, donation

Chamberlin, William Benjamin active 1880–1934, *Shoreham Suspension Bridge*, donation

Champaigne, Phillippe de 1602–1674, *St Veronica's Veil*, donation

Chapman, Max b.1911, *Chinese*, purchase

Chappel, Edouard 1859–after 1936, *River Cagnes*, donation

Chappel, Edouard 1859–after 1936, *Still Life*, donation

Charles, James 1851–1906, *Apple Blossom*, purchase

Chater, Cedric 20th C, *The Cuckmere from the Beach*, purchase

Chinese School *A Bird-Seller in a Garden*, purchase

Chinese School *A Couple Drinking Tea*, original pavilion decoration

Chinese School *A Dining Scene*, original pavilion decoration

Chinese School *A Gentleman Reading on a Bed*, purchase

Chinese School *A Trio of Musicians*, purchase

Chinese School *Card Players on an Open Terrace*, original pavilion decoration

Chinese School *Domestic Interior*, purchase

Chinese School *Family Group*, purchase

Chinese School *Figures Approaching a Riverside Mansion*, original pavilion decoration

Chinese School *Glass Picture*, purchase

Chinese School *Ladies Playing Cards*, purchase

Chinese School *Musical Quartet with an American Flag*, purchase

Chinese School *Two Women Spinning*, purchase

Chinese School *Water Scene with a Distant Fortress*, original pavilion decoration

Chinese School 19th C, *Junk Sailing from Left to Right*, purchase

Chinese School 19th C, *Junk Sailing from Right to Left*, purchase

Chinese School 19th C, *Musicians*, purchase

Christie, Clyde *The Right Hon. Frances Garnet, Viscountess Wolseley*, donation

Church, Katherine b.1910, *Mary Elizabeth Church*, purchase

Churchill, Martin b.1954, *Church of the Sacred Heart*, donation

Clairmonte, Christopher b.1932, *Hove Beach*, purchase

Clark, Norman Alexander 1913–1992, *The Train Home from School*, purchase

Clarkson, William H. 1872–1944,

Floods in the Arun Valley, donation
Clausen, George 1852–1944, *The Student*, purchase, © Clausen estate
Clement Smith, Winifred b.1904, *At Newhaven*, purchase
Clint, George 1770–1854, *The Third Earl of Egremont*, donation
Clint, George (style of) 1770–1854, *The Betrothal of Princess Charlotte and Prince Leopold*, donation
Clowes, Daniel 1774–1829, *Horse and Groom*, unrecorded
Coates, George James 1869–1930, *Mrs Rae*, donation
Cobbett, W. *Beach Cottages, Hove*, donation
Cobbett, W. *Great Storm at Brighton*, unrecorded
Codina y Langlin, Victoriano 1844–1911, *Two Sides to the Question*, donation
Coecke van Aelst, Pieter the elder (attributed to) 1502–1550, *The Crucifixion*, donation
Cohen, Isaac 1884–1951, *Sir Charles Thomas Stanford in Degree Robes of DLitt, University of Wales*, donation
Cole, Chisholm 1871–1902, *The Estuary*, donation
Cole, George 1810–1883, *Morwell Rocks, on the Tamar*, donation
Cole, George 1810–1883, *Arundel at Sunset*, donation
Cole, George 1810–1883, *A Cornfield*, donation
Cole, George 1810–1883, *Landscape with Sheep*, donation
Cole, George 1810–1883, *On the Arun*, donation
Cole, George 1810–1883, *Landscape with Farm*, donation
Cole, John 1903–1975, *Almshouse Gateway*, donation
Cole, Rex Vicat 1870–1940, *The Thatched Barn*, donation
Cole, Rex Vicat 1870–1940, *The Mill*, donation
Cole, Rex Vicat 1870–1940, *Towpath Bridge*, donation
Cole, Rex Vicat 1870–1940, *Cartmel Priory*, donation
Cole, Solomon active 1845, *Portrait of a Young Girl*, donation
Collcutt, Grace Marion 1875–1954, *Firelight*, donation
Collier, John 1850–1934, *The Very Reverend John Julius Hannah*, donation
Collier, John 1850–1934, *Mrs Griffiths*, donation
Collier, John 1850–1934, *Mrs Harland Peck*, unrecorded
Collins, William 1788–1847, *Hastings*, unrecorded
Colombo, Giovanni Battista Innocenzo 1717–1793, *Diana and Endymion*, purchase
Colquhoun, Ithell 1906–1988, *The Judgement of Paris*, purchase, © the artist's estate
Colquhoun, Ithell 1906–1988, *Interior*, purchase, © the artist's estate
Colson, Jean François 1733–1803, *Portrait of a Lady*, donation
Colville, William *On the Conway*, donation

Conca, Sebastiano 1680–1764, *The Education of Dionysus*, donation
Conder, Charles 1868–1909, *Stormy Day in Brighton*, purchase
Conger, C. C. 19th C, *Portrait of a Bearded Man*, unrecorded
Constant, Jean Joseph Benjamin 1845–1902, *Stormy Sea from the Hotel Metropole*, donation
Cooper, C. *Chain Pier*, unrecorded
Cooper, C. *On the Beach at Brighton*, unrecorded
Cooper, Thomas Sidney 1803–1902, *Landscape with Cows*, donation
Cooper, Thomas Sidney 1803–1902, *Cattle*, donation
Copnall, Teresa 1882–1972, *Alderman Kingston*, donation
Coppard, C. Law active 1858–1891, *Manor House, Preston Place, Sussex*, donation
Coppard, C. Law active 1858–1891, *Wood in Autumn*, donation
Corbould, Walter Edward b.1860, *Venus and Cupid*, donation
Cornelis, Albert c.1500–1532, *The Assumption of the Virgin*, donation
Costantini, David A. *Mr Murray Marks*, donation
Cotman, Frederick George 1850–1920, *Sunset, St Ives*, donation
Cotman, Frederick George 1850–1920, *Spellbound*, donation
Cox, David the elder 1783–1859, *Landscape with Cottages*, donation
Cox, David the elder 1783–1859, *The Old Mill*, donation
Cranach, Lucas the elder 1472–1553, *Frederick III, Elector of Saxony*, donation
Cranach, Lucas the elder 1472–1553, *John I, 'The Constant', Elector of Saxony (1525–1532)*, donation
Creffield, Dennis b.1931, *Greenwich*, donation, © the artist
Creffield, Dennis b.1931, *Brighton Beach*, donation, © the artist
Creswick, Thomas 1811–1869, *Landscape with Cows*, donation
Cuming, Frederick b.1930, *Studio with Strip Light*, purchase, © the artist
Cundall, Charles Ernest 1890–1971, *Servicing a Sunderland*, donation
Cundall, Charles Ernest 1890–1971, *Marine Craft and Sunderlands*, donation
Dance-Holland, Nathaniel 1735–1811, *The Music Lesson*, donation
Danckerts, Hendrick (attributed to) 1625–1680, *The Manor House, Creswells*, donation
Darwin, Robin 1910–1974, *Ice Hockey at the Empress Hall*, donation
David, Ferdinand b.1860, *Banks of the Canal at Agen*, donation
Davis, Henry William Banks 1833–1914, *Landscape with Cattle, Morning*, donation, © the artist
Davis, Henry William Banks 1833–1914, *Landscape with Cattle, Evening*, donation
Davis, Joseph Barnard 1861–1943, *Millstream, Cotswolds*, donation
Davis, Joseph Barnard 1861–1943,

Village Sentinels, donation
Dawson, Henry 1811–1878, *Before the Storm*, donation
Dawson, Henry 1811–1878, *Landscape, River Scene*, donation
Debenham, Alison 1903–1967, *At the Fishmonger's*, purchase
De Karlowska, Stanislawa 1876–1952, *The Eyot, Richmond*, donation
Delaney, Barbara b.1941, *Spinning Red: Suspended*, purchase, © the artist
Desanges, Louis William 1822–c.1887, *Captain Pechell*, unrecorded
De Soria, Manuel Lugue *A Thaw, Sunset*, purchase
Devereux, F. 19th C, *James White, MP*, unrecorded
Diana, Giacinto 1730–1803, *St Augustine of the Flaming Heart*, purchase
Diaz de la Peña, Narcisse Virgile 1808–1876, *The Approaching Storm on the Coast near Bolougne*, unrecorded
Dicksee, John Robert 1817–1905, *The Waitress*, donation
Dicksee, Margaret Isabel 1859–1903, *The Child Handel, Discovered by His Parents*, donation
Dicksee, Thomas Francis 1819–1895, *Frederick Crace*, donation
Dickson, W. *Wide, Wild and Open to the Sea*, purchase
Diest, Willem van 1610–1673, *River Scene*, donation
Dilsey, F. *Wood Scene*, unrecorded
Dobson, William Charles Thomas 1817–1898, *Rebecca*, donation
Dodson, Sarah Paxton Ball 1847–1906, *Poppies*, donation
Dodson, Sarah Paxton Ball 1847–1906, *Malvern*, donation
Dodson, Sarah Paxton Ball 1847–1906, *Head of a Woman in a Red Cap*, donation
Dollman, John Charles 1851–1934, *The Dogs Refuge*, donation
Dollman, John Charles 1851–1934, *Thirty Pieces of Silver*, donation
Dou, Gerrit (after) 1613–1675, *The Housekeeper*, donation
Downard, Ebenezer 1830–1894, *Reading the News*, unrecorded
Downard, Ebenezer 1830–1894, *Colonel John Fawcett, First Mayor of Brighton*, donation
Downton, John 1906–1991, *Frances Witts*, donation
Drake, John P. 19th C, *William IV*, donation
Drucker, Amy J. 1873–1951, *Arab Water Carriers*, donation
Drummond, Malcolm 1880–1945, *The Stag Tavern*, purchase, © the artist's estate
Drummond, Samuel 1765–1844, *Sake Deen Mahomed*, unrecorded
Dubery, Frederick b.1926, *Beach Scene*, donation, © the artist
Dugdale, Thomas Cantrell 1880–1952, *The Good Earth*, donation
Dughet, Gaspard (attributed to) 1615–1675, *Campagna Landscape*, donation
Dughet, Gaspard (attributed to)

1615–1675, *Tivoli*, purchase
Dujardin, Karel (attributed to) 1626–1678, *Landscape*, donation
Dunlop, Ronald Ossory 1894–1973, *Cagnes sur Mer, South of France*, donation
Dunlop, Ronald Ossory 1894–1973, *Burpham, Sussex*, purchase
Dunstan, Bernard b.1920, *The Cottage Bedroom*, donation, © courtesy of the artist/www.bridgeman.co.uk
Dürer, Albrecht (after) 1471–1528, *Not This Man but Barabbas*, donation
Dutch School *Resurrection*, donation
Dutch School 16th C, *Crucifixion*, unrecorded
Dutch School *Landscape*, unrecorded
Dutch School *Still Life with Squirrel*, donation
Dutch School *Young Boy with Flowers*, unrecorded
Dutch School *Marine View*, donation
Dutch School *Marine View*, donation
Dutch School *Romantic Landscape*, unrecorded
Dutch School 17th C, *Poultry*, donation
Dutch School 17th C, *Poultry*, donation
Dutch School *Pastoral Scene*, unrecorded
Dutch School *Landscape with Mill*, donation
Dutch School *Woman with a Flute*, donation
Dutch School *Trompe l'oeil*, unrecorded
Dutch School *Fiddler in a Tavern*, unrecorded
Dyce, William 1806–1864, *Study for 'Cain'*, donation
Dyet, Alfred 19th C, *Horses in a Stable*, unrecorded
Earp, Clarence St John 1937–1989, *Apocalypse*, purchase
Earp, Clarence St John 1937–1989, *Cliffs, South Coast*, purchase
Earp, Frederick 1827–1897, *Preston Manor*, unrecorded
Earp, Frederick 1827–1897, *Downland Scene*, unrecorded
Earp, Frederick 1827–1897, *How Doth the Little Busy Bee*, donation
Earp, Henry 1831–1914, *The Village of Portslade in 1840*, purchase
Earp, Henry (attributed to) 1831–1914, *Going to Service*, unrecorded
Earp, William 19th C, *Chain Pier*, unrecorded
Eastlake, Charles Lock 1793–1865, *Coliseum*, purchase
Elsley, Arthur John 1861–1952, 1811–1891, *Ellen Benett-Stanford Riding 'Congress'*, donation
Elsley, Arthur John 1861–1952, *Pickle*, donation
Elsley, Arthur John 1861–1952, *Girl Picking Primroses*, donation
Elsley, Arthur John 1861–1952, 1811–1891, *Chu-Ki: Portrait of a Pekinese Dog*, donation

Elsley, Arthur John 1861–1952, *Quiet Afternoon*, donation
Elsley, Arthur John 1861–1952, *Crossing the Stream*, donation
Elsley, Arthur John 1861–1952, *Faithful and Fearless: Kylin*, donation
Engebrechtsz., Cornelius (circle of) c.1465–1527, *The Lamentation over the Dead Christ*, donation
Estall, William Charles 1857–1897, *Sussex Common*, unrecorded
Etty, William 1787–1849, *Arabella Morris*, donation
Etty, William 1787–1849, *Girl Touching Her Head*, donation
Eurich, Richard Ernst 1903–1992, *The Mummers*, purchase, © courtesy of the artist/www.bridgeman.co.uk
Eves, Reginald Grenville 1876–1941, *Thomas Hardy*, donation
Eves, Reginald Grenville 1876–1941, *Mr Percy Sharman*, donation
Eves, Reginald Grenville 1876–1941, *Dr Cyril Norwood*, donation
Eves, Reginald Grenville 1876–1941, *Portrait of a Young Man*, donation
Faed, Thomas 1826–1900, *The Motherless Bairn*, donation
Faed, Thomas 1826–1900, *The Waefu' Heart*, donation
Fanner, Alice Maud 1865–1930, *The Chestnut Tree*, purchase
Fanner, Alice Maud 1865–1930, *The Seaside*, donation
Fawcett, E. 20th C, *Flowers I*, unrecorded
Fawcett, Gertrude active 1916–1939, *Flowers by a Window*, unrecorded
Fawcett, Gertrude active 1916–1939, *Flowers in a Green Jug*, unrecorded
Fawcett, Gertrude active 1916–1939, *Flowers in a Vase*, unrecorded
Fawcett, Gertrude active 1916–1939, *Sunflowers*, unrecorded
Fawcett, Gertrude active 1916–1939, *Tulips and Peonies*, unrecorded
Fawcett, Gertrude active 1916–1939, *Vase of Flowers*, unrecorded
Fawkes, W. *Princess Charlotte*, donation
Fell, Sheila Mary 1931–1979, *Potato Picking at Aigle Ghyll*, purchase
Fielding, Anthony V. C. 1787–1855, *Skelwith Bridge, Ambleside*, purchase
Fildes, Luke 1844–1927, *Venetian Girl with a Flask*, donation
Fildes, Luke 1844–1927, *A Venetian Market Girl*, donation
Fisher, Mark 1841–1923, *Milking Time*, donation
Flemish (Antwerp) School early 16th C, *Mystic Marriage of St Catherine of Alexandria*, donation
Flemish School *Phillip de Monmorency, Comte de Horn*, donation
Flemish School *Rocky Landscape*, unrecorded

Flemish School *Adoration of Shepherds*, unrecorded
Flemish School early 16th C, *Portrait of a Nobleman*, donation
Flemish School *Holy Family with St Catherine of Alexandria*, donation
Flemming, Rosie Nangala b.1928, *Fire Country Dreaming (Warlukurlangu Jukurrpa)*, © DACS 2005
Floris, Emily J. *John Hannah, Vicar of Brighton*, donation
Flowers, Peter 1916–1950, *Richmond, Yorkshire*, donation
Fontebasso, Francesco (style of) 1707–1769, *The Adoration of the Magi*, purchase
Foottet, Frederick Francis 1850–1935, *Sunrise off the Dorset Coast*, donation
Forbes, Stanhope Alexander 1857–1947, *Christmas Eve*, purchase, © courtesy of the artist/ www.bridgeman.co.uk
Forbes, Stanhope Alexander 1857–1947, *Mousehole Harbour*, donation, © courtesy of the artist/ www.bridgeman.co.uk
Forbes, Stanhope Alexander 1857–1947, *Study of Violin and Bow*, donation, © courtesy of the artist/www.bridgeman.co.uk
Fox, Edward 1788–1875, *Rottingdean*, unrecorded
Fox, Edward 1788–1875, *The Town Hall, Brighton*, unrecorded
Fox, Edward 1788–1875, *Old Barn*, unrecorded
Fox, Edward 1788–1875, *Rottingdean Church*, unrecorded
Fox, Edward 1788–1875, *Brighton from the Race Hill*, donation
Fox, Edward 1788–1875, *Market Street, Brighton*, donation
Francken, Frans II 1581–1642 & Neeffs, Peeter the younger 1620–1675 *Interior of an Imaginary Cathedral*, donation
Franks-Owen, Dorothy E. 20th C, *Palace of Gold*, purchase
Fraser, John 1858–1927, *The Chain Pier, Brighton*, unrecorded
Freeth, Herbert Andrew 1912–1986, *NAAFI Counter*, donation
French School *Allegory of Homage to a Monarch*, purchase
French School *A Festival in Honour of Bacchus*, donation
French School *Satyrs*, donation
French School *Dinan from the River*, unrecorded
French School *The First Step*, unrecorded
French School 19th C, *Bonne journée*, unrecorded
French School 19th C, *Mauvaise journée*, unrecorded
Frimlargst, P. A. active 1667, *Woody Landscape with Classical Urn*, purchase
Gabain, Ethel 1883–1950, *The Nymph*, donation
Gabain, Ethel 1883–1950, *The Little Red-Haired Girl*, donation
Gaelen, Alexander van 1670–1728, *The Siege of Bonn by the Dutch Army in 1703*, donation
Gainsborough, Thomas

1727–1788, *Open Landscape at the Edge of a Wood*, donation
Gandolfi, Gaetano 1734–1802, *Christ and the Woman Taken in Adultery*, purchase
Garbeth, David 20th C, *Figures in a Park*, donation
Garrido, Leandro Ramón 1868–1909, *Study for 'His First Offence'*, purchase
Garstin, Norman 1847–1926, *Moulin de la ville, Quimperlé*, donation
Gaspari, Giovanni Paolo (attributed to) 1714–1775, *Capriccio Interior with Ruins*, purchase
Gaspari, Giovanni Paolo (attributed to) 1714–1775, *Capriccio with Statuary*, purchase
Gelder, Aert de 1645–1727, *The Marriage Contract*, donation
Gerrard, Kaff 1894–1970, *The Big Wave*, donation
Gerrard, Kaff 1894–1970, *The Cornfield by Moonlight*, donation
Gertler, Mark 1892–1939, *The Dutch Doll*, donation, © the artist's estate
Ghirlandaio, Domenico (copy after) 1449–1494, *Giovanna Tornabuoni*, donation
Gifford, Peter 19th C, *Highland Scene*, donation
Gillies, William George 1898–1973, *Still Life with Cactus*, purchase
Gilman, Harold 1876–1919, *The Coral Necklace*, donation
Ginner, Charles 1878–1952, *Leicester Square*, donation
Ginner, Charles 1878–1952, *Lancaster from Castle Hill Terrace*, donation
Ginnett, Louis 1875–1946, *Houghton Bridge*, donation
Ginnett, Louis 1875–1946, *The Coat of Many Colours*, purchase
Giordano, Luca 1634–1705, *Hercules and Omphale*, donation
Giordano, Luca 1634–1705, *The Finding of Moses*, donation
Glasson, Lancelot Myles 1894–1959, *Repose*, purchase
Glimes, P. de active 1750–1800, *Stormy Landscape with Shepherdess*, purchase
Gluckstein, Hannah 1895–1978, *The Devil's Altar*, donation, © the artist's estate
Goff, Robert Charles 1837–1922, *Farm Study*, donation
Gogin, Alma 1854–1948, *Chrysanthemums*, donation
Gogin, Alma 1854–1948, *Anemones*, donation
Gogin, Alma 1854–1948, *George, Prince of Wales (after Joshua Reynolds)*, donation
Gogin, Alma 1854–1948, *Spring in Regent's Park*, donation
Gogin, Charles 1844–1931, *Conveying Prisoners of War by 'The Spaniard'*, donation
Gogin, Charles 1844–1931, *Kingston Buci Lighthouse*, donation
Gogin, Charles 1844–1931, *My Wife Reading*, donation
Gogin, Charles 1844–1931, *Girl in*

a White Cap, donation
Gogin, Charles 1844–1931, *The Reverie*, donation
Gogin, Charles 1844–1931, *Alma Gogin*, donation
Gogin, Charles 1844–1931, *Alma Gogin*, unrecorded
Gogin, Charles 1844–1931, *Bandstand, Brighton Chain Pier*, unrecorded
Gogin, Charles 1844–1931, *Landscape at Walberton*, donation
Gogin, Charles 1844–1931, *Sussex Landscape*, donation
Gogin, Charles 1844–1931, *The Old Chain Pier*, unrecorded
Goodall, Frederick 1822–1904, *A Halt at a Brittany Well*, donation
Goodall, Frederick 1822–1904, *Palm Offering*, donation
Goodall, Frederick 1822–1904, *Sultan Hassan's School, Cairo*, donation
Goodrich, Jerome active 1829–1859, *Sir Charles Dick*, unrecorded
Goostry, Charles 19th C, *'Brandy Balls'*, donation
Gorton, Lesley-Ann b.1939, *The Earth Is Life Itself*, purchase
Gosden, Victor 20th C, *Moonlight in the Lanes*, unrecorded
Gosse, Laura Sylvia 1881–1968, *La rue Cousine, Dieppe*, purchase, © courtesy of the artist's estate/www. bridgeman.co.uk
Gowing, Lawrence 1918–1991, *Woods near Petworth*, purchase, © estate of Sir Lawrence Gowing
Grace, Alfred Fitzwalter 1844–1903, *Amberley Ferry*, donation
Grace, Alfred Fitzwalter 1844–1903, *Clayton Mills*, donation
Grace, Alfred Fitzwalter 1844–1903, *Portrait of a Man in a Dark Suit*, unrecorded
Grace, Alfred Fitzwalter 1844–1903, *Church Street, Steyning*, donation
Grace, Alfred Fitzwalter 1844–1903, *Harvest Moon*, donation
Grace, Alfred Fitzwalter 1844–1903, *Steyning*, donation
Grace, Alfred Fitzwalter 1844–1903, *Sunset near Amberley*, donation
Grace, Alfred Fitzwalter 1844–1903, *Valley of the Cuckmere*, donation
Grace, Alfred Fitzwalter 1844–1903, *Washing Barge on a Normandy River*, donation
Grace, Frances Lily active 1876–1909, *Lady Abinger*, donation
Grace, Frances Lily active 1876–1909, *Still Life*, unrecorded
Graham, Peter 1836–1921, *Coastal View with Gulls*, donation
Grant 20th C, *Kersey, Suffolk*, purchase
Grant, Duncan 1885–1978, *Painted Panel for the Music Room of the Lefevre Gallery*, purchase, © 1978 estate of Duncan Grant
Grant, Duncan 1885–1978, *The Sofa*, purchase, © 1978 estate of Duncan Grant
Grant, Duncan 1885–1978, *Landscape near Firle, Sussex*, donation, © 1978 estate of Duncan

Grant
Grant, Francis 1803–1878, *Frederick William Hervey, First Marquis of Bristol*, donation
Grant, Francis 1803–1878, *Marchioness of Bristol*, donation
Green, Josephine 20th C, *Sir John Howard*, donation
Gregory, George 19th C, *The Mull of Cantyre*, donation
Greuze, Jean-Baptiste 1725–1805, *Family Worship*, donation
Griffier, Robert 1688–1760, *Landscape with River and Ferry*, donation
Grose, Margaret 20th C, *John Otter, Mayor of Brighton*, unrecorded
Grose, Margaret 20th C, *King George V*, donation
Grose, Margaret 20th C, *Edward VIII as Prince of Wales*, donation
Grose, Margaret 20th C, *Queen Mary*, unrecorded
Guardi, Francesco (after) 1712–1793, *Fanciful View of Venice*, donation
Guardi, Francesco (after) 1712–1793, *Fanciful View of Venice*, donation
Guardi, Francesco (after) 1712–1793, *Fanciful View of Venice*, donation
Guardi, Francesco (after) 1712–1793, *Fanciful View of Venice*, donation
Guardi, Giacomo 1764–1835, *Grand Canal, Venice*, donation
Guimaraens, R. A. F. 1880–1960, *Dyke Road, Brighton*, unrecorded
Guimaraens, R. A. F. 1880–1960, *Near Russell Square, Brighton*, unrecorded
Guimaraens, R. A. F. 1880–1960, *The Corner of a Yard*, unrecorded
Guthrie, Kathleen 1905–1981, *Red Picture*, purchase
Guy, Cyril Graham active 1929–1938, *Le tonnelier*, donation
D. H. 20th C, *Woman Reclining*, unrecorded
Hacker, Arthur 1858–1919, *Flare and Flutter: Piccadilly Circus at Night*, purchase
Hacker, Arthur 1858–1919, *Daisies at Burnham*, donation
Halbique, Roger Charles 1900–1977, *Landscape in Algeria, near Algez*, donation
Halbique, Roger Charles 1900–1977, *Still Life with Watermelon*, donation
Halbique, Roger Charles 1900–1977, *The City of Ibiza from the Harbour*, donation
Halbique, Roger Charles 1900–1977, *View of the Road between St Paul de Vence and Vence*, donation
Hall, Oliver 1869–1957, *The Edge of the Forest: Autumn*, donation
Hall, Oliver 1869–1957, *Coates Common, Sussex*, purchase
Hall, W. F. 19th C, *Milking Time*, unrecorded
Hamilton, William 1751–1801, *A Scene from 'As You Like It'*, donation
Hamilton, William 1751–1801, *A Scene from 'The Tempest'*, donation

Hamme, Alexis van 1818–1875, *Poultry Seller*, donation
Harris, Edwin Lawson James 1891–1961, *Pevensey Castle*, donation
Harris, Gunner A. F. *A Manor House in France*, unrecorded
Hart, Solomon Alexander 1806–1881, *Portrait of a Man Wearing a Garter Star*, unrecorded
Harvey, Harold C. 1874–1941, *A Kitchen Interior*, purchase, © courtesy of the artist/www. bridgeman.co.uk
Harvey, Michael b.1946, *Dreadnought Garage*, unrecorded
Hayward, Alfred Robert 1875–1971, *The Morning Walk*, purchase
Helmont, Mattheus van (follower of) 1623–c.1674, *The Alchemist*, donation
Hendriks, Wybrand 1744–1831, *The Lace Maker*, donation
Hennessy, William J. 1839–1917, *Relic of the Chain Pier*, purchase
Hennessy, William J. 1839–1917, *The Woodcutter*, donation
Hepher, David b.1935, *Still Life*, purchase, missing painting, © the artist
Herkomer, Hubert von 1849–1914, *Francis John Tillstone, Town Clerk*, unrecorded
Herring, John Frederick I 1795–1865, *The Racehorse Actaeon*, donation
Hicks, Monica Leighton 20th C, *Boats off Portugal*, donation
Hilditch, George 1803–1857, *View of Hove*, purchase
Hill, Adrian Keith Graham 1895–1977, *Rain at Brighton*, donation
Hinchliff, Woodbine K. b.1874, *Chestnut Wood*, donation
Hinchliff, Woodbine K. b.1874, *Dusk in Lincoln Cathedral*, donation
Hinchliff, Woodbine K. b.1874, *Landscape with Wild Roses*, donation
Hinchliff, Woodbine K. b.1874, *Scottish Mountain Landscape*, donation
Hinchliff, Woodbine K. b.1874, *The Quince Tree*, donation
Hinchliff, Woodbine K. b.1874, *Weare Gifford*, donation
Hitchens, Ivon 1893–1979, *Forest*, purchase, © Jonathan Clark & Co
Hitchens, Ivon 1893–1979, *Pink Lily No.3*, purchase, © Jonathan Clark & Co
Hitchens, John b.1940, *Lowland Lights*, purchase, © Jonathan Clark & Co
Hodges, William (attributed to) 1744–1797, *The Inner Crater of Mauna Loa, Hawaii*, donation
Hodgkins, Frances 1869–1947, *Still Life: Eggs, Tomatoes and Mushrooms*, donation
Hogarth, William (attributed to) 1697–1764, *Portrait of a Girl*, donation
Holbein, Hans the younger (after) 1497/1498–1543, *King Henry VIII*, donation

Holbein, Hans the younger (after) 1497/1498–1543, *Bess of Hardwicke*, unrecorded

Holl, Frank 1845–1888, *Captain Henry Hill*, donation

Holl, Frank 1845–1888, *Field Marshall Lord Wolseley*, donation

Holland, James 1800–1870, *Venice*, donation

Holland, James 1800–1870, *Street in Genoa*, donation

Holst, Laurits Bernhard 1848–1934, *Madeira*, donation

Holst, Laurits Bernhard 1848–1934, *Madeira at Sunset*, donation

Holst, Laurits Bernhard 1848–1934, *The Pontinha, Madeira*, donation

Holst, Laurits Bernhard 1848–1934, *The Pontinha, Madeira*, donation

Holzhandler, Dora b.1928, *Ice Cream Parlour, Jerusalem*, donation, © courtesy of the artist/ www.bridgeman.co.uk

Hook, James Clarke 1819–1907, *Luff, Boy!*, donation

Hook, James Clarke 1819–1907, *Deep Sea Fishing*, donation

Hook, James Clarke 1819–1907, *Sailor's Wedding*, donation

Hook, James Clarke 1819–1907, *Song and Accompaniment*, donation

Hook, James Clarke 1819–1907, *The Gull Catcher*, donation

Hoppner, John 1758–1810, *John Crace*, donation

Hoppner, John 1758–1810, *Sir Henry Watkins Dashwood, Bt*, donation

Horton, James 20th C, *Still Life (after Jan Davidsz. de Heem)*, donation, © the artist

Horton, Percy Frederick 1897–1970, *Portrait of the Artist's Mother*, donation

Horton, Ronald 1902–1981, *The 'Rustler' Aground*, donation

Horton, Ronald 1902–1981, *Dick Pennifold*, donation

Howard, Ken b.1932, *Interior, South Bolton Gardens*, purchase, © courtesy of the artist/www. bridgeman.co.uk

Howes, Kenneth *Seascape*, purchase

Hubbard, Eric Hesketh 1892–1957, *A Welsh Castle*, donation

Hubbard, Eric Hesketh 1892–1957, *The Cuckmere Valley*, donation

Huchtenburgh, Jan van 1647–1733, *Battle Piece (I)*, donation

Huchtenburgh, Jan van 1647–1733, *Battle Piece (II)*, donation

Hudson, Thomas (attributed to) 1701–1779, *Mary Western*, donation

Hudson, Thomas (attributed to) 1701–1779, *Portrait of a Lady*, unrecorded

Hughes, Arthur 1832–1915, *The Swineherd*, donation

Hughes-Stanton, Herbert Edwin Pelham 1870–1937, *Corfe Castle*, purchase

Hughes-Stanton, Herbert Edwin Pelham 1870–1937, *View of*

Avignon from Villeneuve, donation

Hulk, William Frederik b.1852, *Cattle Grazing*, unrecorded

Hunter, Ian b.1939, *Table Top Nude*, purchase

Huysmans, Jacob (circle of) c.1633–1696, *Charles II*, donation

Indian School *Indian Woman*, unrecorded

Innes, James Dickson 1887–1914, *The Seine at Caudebec*, purchase

Italian (Bolognese) School 15th C–early 16th C, *A Saint*, donation

Italian School *Tobias and the Angel*, donation

Italian School *Holy Family*, donation

Italian School early 16th C, *Laura*, donation

Italian School *Mary Magdalene*, unrecorded

Italian School *A Massacre*, unrecorded

Italian School *Madonna and Child with Saints Anne and John*, unrecorded

Italian School *The Baptism of Christ*, donation

Italian School *The Drunkenness of Lot*, unrecorded

Italian School *Martyrdom of a Saint*, unrecorded

Italian School *Cleopatra*, donation

Italian School *St Jerome*, unrecorded

Italian School 17th C, *Battle Scene*, unrecorded

Italian School 17th C, *Susannah and the Elders*, unrecorded

Italian School *Head of a Saint*, unrecorded

Italian School *Battle Scene*, unrecorded

Italian School *Classical Ruins*, unrecorded

Italian School *Madonna and Child*, unrecorded

Italian School *Rome with St Peter's and Castel Sant'Angelo*, unrecorded

Italian School *Archer in a Mythical Landscape*, unrecorded

Italian School 18th C, *David and Goliath*, unrecorded

Italian School *Mary Magdalene*, unrecorded

J. W. J. *Ruins in the North of Devon*, unrecorded

M. J. *Forest Glade*, unrecorded

Jackson 19th C, *Saint Savant-Prise du Taillard*, unrecorded

Jacomb-Hood, George Percy 1857–1930, *The Garden of the Padronale, Portofino*, donation

Jacomb-Hood, George Percy 1857–1930, *Hove Beach*, purchase

Jacquet, Gustave Jean 1846–1909, *Lady with a Staff*, unrecorded

Jamieson, Alexander 1873–1937, *Dieppe Cliffs*, donation

Jamieson, Robert Kirkland 1881–1950, *A Sluice on the 'Windrush'*, purchase

Jenner, Isaac Walter 1836–1901, *Brighton Beach with Fishing Boats*, donation

Jenner, Isaac Walter 1836–1901, *Bambro' Castle, Northumberland*, donation

Jenner, Isaac Walter 1836–1901,

Fishing Boats off Brighton, donation

Jenner, Isaac Walter 1836–1901, *Sunrise: Eastern Arms of Shoreham Harbour*, donation

Jenner, Isaac Walter 1836–1901, *The Bridge, Plymouth Sound*, donation

Jervas, Charles (after) c.1675–1739, *Portrait of a Lady*, unrecorded

Joanovitch, Paul 1859–1957, *Greek Soldiers with a Woman Traitor*, donation

Johnson, Ernest Borough 1866–1949, *Portrait of a Girl*, donation

Johnson, Esther Borough 1867–1949, *Tea Table in the Garden*, donation

Jones, Christine b.1961, *Brighton Pride*, purchase

Jones, H. J. active 19th C, *The Brighton to London Coach by the Royal Albion Hotel*, unrecorded

Jones, H. J. active 19th C, *The London to Brighton Coach on the Road*, unrecorded

Jones, Robert active 1815–1835, *Chinese Scene*, donation

Jones, Robert active 1815–1835, *Chinese Scene*, donation

Jonzen, Basil 1913–1967, *Still Life*, donation

Juncker, Justus (attributed to) 1703–1767, *Interior of a Tavern*, donation

Kallstenius, Gottfried Samuel Nikolaus 1861–1943, *Fir Trees at the Coast*, purchase

Kauffmann, Angelica 1741–1807, *Penelope at Her Loom*, donation

Kauffman, Angelica 1741–1807, *Mrs Marriot*, donation

Kauffmann, Angelica 1741–1807, *Portrait of a Woman*, donation

Kessell, Mary 1914–1978, *Winter Wood*, donation

Kettle, Tilly 1735–1786, *Francis Graham*, donation

King, Gunning 1859–1940, *Hide and Seek*, donation

King, Gunning 1859–1940, *Country Scene with Haystacks and Large Tree*, donation

King, Gunning 1859–1940, *Landscape and Cloud Study*, donation

King, Gunning 1859–1940, *Mrs Hodges and Her Son*, donation

King, Gunning 1859–1940, *Cotswold Country (I)*, donation

King, Gunning 1859–1940, *Cotswold Country (II)*, donation

King, Gunning 1859–1940, *Gloucestershire Village (I)*, donation

King, Gunning 1859–1940, *Thundery Weather*, donation

King, Gunning 1859–1940, *Autumnal Trees and Farm Buildings*, donation

King, Gunning 1859–1940, *Black Cow*, donation

King, Gunning 1859–1940, *Bridge over a River*, donation

King, Gunning 1859–1940, *Brown Bull: Cow Looking Left*, donation

King, Gunning 1859–1940, *Brown Bull: Cow Looking Right*, donation

King, Gunning 1859–1940, *Brown*

Bullock, donation

King, Gunning 1859–1940, *Cow Grazing*, donation

King, Gunning 1859–1940, *Cow Lying in the Grass*, donation

King, Gunning 1859–1940, *Cow Standing*, donation

King, Gunning 1859–1940, *Forest Scene*, donation

King, Gunning 1859–1940, *Landscape Looking down into a Valley*, donation

King, Gunning 1859–1940, *Landscape with Cloudy Sky*, donation

King, Gunning 1859–1940, *Landscape with Cloudy Sky and Purple Heather*, donation

King, Gunning 1859–1940, *Landscape with Large Cloudy Sky*, donation

King, Gunning 1859–1940, *Landscape with Sun-Tinged Clouds*, donation

King, Gunning 1859–1940, *Landscape with Trees*, donation

King, Gunning 1859–1940, *Landscape with Trees and Purple Flowers*, donation

King, Gunning 1859–1940, *Mill Pond*, donation

King, Gunning 1859–1940, *Moonlight on Lake with Statues*, donation

King, Gunning 1859–1940, *Moonlight Scene with Statue*, donation

King, Gunning 1859–1940, *Pathway through the Trees*, donation

King, Gunning 1859–1940, *Pink Flowers*, donation

King, Gunning 1859–1940, *Rural Scene with Village and Church Spire*, donation

King, Gunning 1859–1940, *Sheep and Farm Workers*, donation

King, Gunning 1859–1940, *The Approach to a Village Church*, donation

King, Gunning 1859–1940, *Three Cows Grazing in a Field*, donation

King, Gunning 1859–1940, *Two Cows Grazing*, donation

King, Gunning 1859–1940, *View of Open Countryside*, donation

King, Gunning 1859–1940, *White Cow Following Brown Cow*, donation

King, Gunning 1859–1940, *Woman in Green Dress Sitting on the Grass*, donation

King, Gunning 1859–1940, *Woodland Clearing Overlooking Lower Land*, donation

King, Gunning 1859–1940, *Woodland Landscape*, donation

King, Gunning 1859–1940, *Woodland Scene*, donation

King, Gunning 1859–1940, *Woodland Scene*, donation

King, Gunning 1859–1940, *Woodland Scene on Hill*, donation

King, Gunning 1859–1940, *Wooded Scene*, donation

King, Gunning 1859–1940, *Autumn*, donation

King, Gunning 1859–1940, *Golden Spring*, donation

King, Gunning 1859–1940,

Harting, Sussex, donation

King, Gunning 1859–1940, *Kimmeridge, Dorset*, donation

King, Gunning 1859–1940, *Blue Pool*, donation

King, Gunning 1859–1940, *Evening*, donation

King, Gunning 1859–1940, *Downland*, donation

King, Gunning 1859–1940, *A Brown Cow*, donation

King, Gunning 1859–1940, *A Bull*, donation

King, Gunning 1859–1940, *A Bull*, donation

King, Gunning 1859–1940, *A Church*, donation

King, Gunning 1859–1940, *A Church and a Lady*, donation

King, Gunning 1859–1940, *A Country Scene*, donation

King, Gunning 1859–1940, *A Cow Eating*, donation

King, Gunning 1859–1940, *A Moored Boat*, donation

King, Gunning 1859–1940, *A Pig*, donation

King, Gunning 1859–1940, *A River Running through Green Fields*, donation

King, Gunning 1859–1940, *A Sheep Grazing*, donation

King, Gunning 1859–1940, *Autumnal Scene*, donation

King, Gunning 1859–1940, *A View through Trees*, donation

King, Gunning 1859–1940, *Biblical Scene*, donation

King, Gunning 1859–1940, *Blossom*, donation

King, Gunning 1859–1940, *Bull in a Field*, donation

King, Gunning 1859–1940, *Calf*, donation

King, Gunning 1859–1940, *Calf*, donation

King, Gunning 1859–1940, *Calf Drinking from Trough*, donation

King, Gunning 1859–1940, *Carol Singers*, donation

King, Gunning 1859–1940, *Cattle Heads*, donation

King, Gunning 1859–1940, *Cloudscape*, donation

King, Gunning 1859–1940, *Cloudscape*, donation

King, Gunning 1859–1940, *Cloudscape over a Hill*, donation

King, Gunning 1859–1940, *Cloudy Sky and Green Fields with Specks of Orange*, donation

King, Gunning 1859–1940, *Corfe*, donation

King, Gunning 1859–1940, *Corfe Castle*, donation

King, Gunning 1859–1940, *Country Scene*, donation

King, Gunning 1859–1940, *Country Scene with Field of Haystacks*, donation

King, Gunning 1859–1940, *Country Scene with River, Barn and House*, donation

King, Gunning 1859–1940, *Country Scene with Trees*, donation

King, Gunning 1859–1940, *Cow Grazing*, donation

King, Gunning 1859–1940, *Cow in*

1853–1885, *St Mary's Harbour, Scilly Isles*, donation

Martin, Nicholas b.1957, *The Royal Pavilion*, donation

Mason, Arnold 1885–1963, *Quai du port, Martigues*, donation

Mason, Arnold 1885–1963, *Seated Nude*, donation

Mears, George 1826–1906, *Beach Scene at Rottingdean*, purchase

Mears, George 1826–1906, *The Chain Pier*, unrecorded

Meninsky, Bernard 1891–1950, *Boy with a Cat*, purchase, © the artist's estate

Meninisky, Bernard 1891–1950, *Young Girl: Nude Study*, donation, © the artist's estate

Menzies, William A. active 1886–1911, *Louisa, Viscountess Wolseley*, donation

Merry, Godfrey active c.1883–1915, *'Dinna Ye Hear the Pipes?'*, donation

Merry, Godfrey active c.1883–1915, *The Late Captain Merry*, unrecorded

Methuen, Paul Ayshford 1886–1974, *Margaret Ware*, donation

Methuen, Paul Ayshford 1886–1974, *Pulteney Bridge, Bath, under Reconstruction*, purchase

Methuen, Paul Ayshford 1886–1974, *North Wraxall, Wiltshire*, donation

Methuen, Paul Ayshford 1886–1974, *West Kington, Wiltshire*, donation

Michieli, Andrea probably 1542–probably 1617, *Jesus Returning to His Mother after Confounding the Elders in the Temple*, purchase

Mileham, Harry Robert 1873–1957, *Miss Amy Scott*, donation

Mileham, Harry Robert 1873–1957, *In the Mirror*, donation

Millais, John Everett 1829–1896, *Non angli sed angeli*, donation

Minton, John 1917–1957, *Neville Wallis*, donation, © Royal College of Art

Mockford, Harold b.1932, *Bracken Hill*, donation, © the artist

Mockford, Harold b.1932, *Gateway to the Downs*, donation, © the artist

Mockford, Harold b.1932, *The Park*, purchase, © the artist

Mockford, Harold b.1932, *The Bridge, Hailsham*, purchase, © the artist

Mockford, Harold b.1932, *The Bandstand*, purchase, © the artist

Moira, Gerald 1867–1959, *The Sketching Party*, purchase

Molenaer, Jan Miense (after) c.1610–1668, *Tavern Scene*, donation

Molyneux, Maud active 1927–1936, *Peter*, donation

Momper, Joos de the younger (attributed to) 1564–1635, *Winter Scene*, donation

Monamy, Peter 1681–1749, *Man of War*, donation

Monnoyer, Jean-Baptiste 1636–1699, *Flower Study*, donation

Monticelli, Adolphe Joseph Thomas (attributed to)

1824–1886, *Women in a Landscape*, donation

Mor, Antonis (attributed to) 1512–1516–c.1576, *Portrait of a Man ('Memento Mori')*, donation

Morland, George 1763–1804, *Selling Carrots*, donation

Morley, Harry 1881–1943, *The Judgement of Paris*, purchase, © the artist's estate

Morley, Julia b.1917, *Palace Pier, Brighton*, purchase

Moroni, Giovanni Battista (attributed to) c.1525–1578, *Portrait of a Senator*, donation

Morris, Charles Alfred 1898–1983, *Old Town Hall, Worthing*, purchase

Moss, Sidney Dennant 1884–1946, *Adelaide Crescent, Brighton*, purchase

Mostaert, Jan (attributed to) c.1475–1555/1556, *Christ Crowned with Thorns ('Ecce Homo')*, donation

Moynihan, Rodrigo 1910–1990, *Self Portrait*, donation, © the artist's estate

Müller, William James 1812–1845, *A Street in Cairo*, donation

Müller, William James 1812–1845, *Slave Market*, donation

Müller, William James 1812–1845, *The Opium Seller*, donation

Müller, William James 1812–1845, *Welsh Scene*, donation

Munnings, Alfred James 1878–1959, *The Shady Grove*, purchase

Munnings, Alfred James 1878–1959, *Landscape with Cow*, donation

Murray, Graham 20th C, *Failford Bridge*, donation

Napper, John b.1916, *Chantry Mill Pond*, purchase, © the artist's estate

Nash, Frederick 1782–1856, *Shoreham Harbour*, donation

Nash, Paul 1889–1946, *Granary*, purchase, © the artist's estate

Nash, Thomas Saunders 1891–1968, *Figures in a Park*, unrecorded, © the artist's estate

Nasmyth, Alexander 1758–1840, *Wooded Landscape*, donation

Nasmyth, Patrick 1787–1831, *Landscape with River and Cottage*, donation

Nasmyth, Patrick 1787–1831, *Landscape*, donation

Nasmyth, Patrick 1787–1831, *Landscape*, donation

Neeffs, Peeter the elder (school of) c.1578–1656–1661, *Interior of a Church*, donation

Neer, Aert van der 1603–1677, *Skating on a Frozen River*, donation

Nevinson, Christopher 1889–1946, *French Landscape*, donation, © courtesy of the artist's estate/www.bridgeman.co.uk

Newman, Ian b.1953, *Still Life*, donation

Newton, Algernon Cecil 1880–1968, *Paddington Basin*, purchase

Nibbs, Richard Henry 1816–1893, *Queen Victoria Landing at Brighton*, unrecorded

Nibbs, Richard Henry 1816–1893, *'HMS Vengeance' at Spithead*, donation

Nibbs, Richard Henry 1816–1893, *Seaford Head, Sussex*, donation

Nibbs, Richard Henry 1816–1893, *Stanmer Park*, donation

Nibbs, Richard Henry 1816–1893, *Guildhall*, unrecorded

Nibbs, Richard Henry 1816–1893, *Cloisters, Canterbury Cathedral*, donation

Nibbs, Richard Henry 1816–1893, *Dutch Boats Leaving Harbour in a Breeze*, donation

Nibbs, Richard Henry 1816–1893, *Shoreham*, donation

Nibbs, Richard Henry 1816–1893, *Shipping on the Medway*, donation

Nibbs, Richard Henry 1816–1893, *Climping Church*, donation

Nibbs, Richard Henry 1816–1893, *Cross Channel Steamer 'Belfast' off Brighton*, purchase

Nibbs, Richard Henry 1816–1893, *Frederic Chatfield*, unrecorded

Nibbs, Richard Henry 1816–1893, *Martello Tower*, purchase

Nibbs, Richard Henry 1816–1893, *Near Lancing, Sussex*, donation

Nibbs, Richard Henry 1816–1893, *Near Midhurst, Sussex*, donation

Nibbs, Richard Henry 1816–1893, *Old Drawbridge on the Ouse at Barcombe*, donation

Nibbs, Richard Henry 1816–1893, *Old Grammar School, Steyning*, donation

Nibbs, Richard Henry 1816–1893, *Ote Hall, Wivelsfield*, donation

Nibbs, Richard Henry 1816–1893, *St Mary's Chichester*, donation

Nibbs, Richard Henry 1816–1893, *The Crypt at Eastbourne*, donation

Nicholls, Bertram 1883–1974, *Riverside Town*, purchase

Nicholson, Ben 1894–1982, *Cumberland Farm*, donation, © Angela Verren-Taunt 2005. All rights reserved, DACS

Nicholson, Winifred 1893–1981, *Still Life by a Window*, purchase

Niemann, Edmund John 1813–1876, *Woody Lane*, donation

Niemann, Edmund John 1813–1876, *Richmond, Yorkshire*, purchase

Nolan, Sidney 1917–1992, *Landscape*, purchase, © courtesy of the artist's estate/www.bridgeman.co.uk

Northcote, James 1746–1831, *John Reeve as 'Henry Alias' in 'One, Two, Three, Four, Five'*, donation

Nowell, Arthur Trevethin 1861–1940, *Queen Mary*, donation

Nowell, Arthur Trevethin 1861–1940, *King George V*, donation

Oakes, Frederick active 1866–1870, *Portrait of the Artist*, donation

Oakes, Frederick active 1866–1870, *Selena Oakes*, donation

Oakley, Thornton 1881–1953, *Old and New Brighton*, purchase

O'Connor, James Arthur 1792–1841, *Worthing Beach*, donation

O'Connor, James Arthur (attributed to) 1792–1841, *Landscape*, donation

Olitski, Jules b.1922, *Open Option*, donation, © Jules Olitski/ Vaga,

New York/ DACS, London 2005

Opie, John 1761–1807, *Mrs Mary Chatfield*, donation

Organ, Robert b.1933, *Portraits and Self Portraits, the Uffculme Children*, purchase

Orley, Bernaert van (attributed to) c.1492–1541, *Balthazar*, donation

Orpen, William 1878–1931, *Sir Charles Thomas-Stanford*, donation

Orrente, Pedro (style of) c.1580–1645, *St John the Baptist as a Child*, donation

Os, Georgius Jacobus Johnannes van 1782–1861, *Vase of Flowers*, donation

Osborne, Cecil 1909–1996, *Sunday Morning, Farringdon Road*, donation

Owen, Samuel 1768–1857, *Windmill and Brick Kiln on Riverside*, purchase

Owen, William 1769–1825, *Portrait of an Old Lady*, donation

Padwick, Philip Hugh 1876–1958, *Sussex Hills*, purchase

Padwick, Philip Hugh 1876–1958, *Bridge at Arundel*, purchase

Padwick, Philip Hugh 1876–1958, *Quayside at Low Tide*, purchase

Padwick, Philip Hugh 1876–1958, *The Sussex Weald*, donation

Padwick, Philip Hugh 1876–1958, *View near Pulborough*, donation

Pagano, Michele c.1697–1732, *Landscape with Ruinous House*, donation

Pagano, Michele c.1697–1732, *Rocky Landscape*, donation

Panini, Giovanni Paolo (attributed to) c.1692–1765, *The Forum, Rome*, donation

Parez, Joseph active 1823–1836, *Sir David Scott*, unrecorded

Park, John Anthony 1880–1962, *Fishing Boats on the Sands*, donation

Park, John Anthony 1880–1962, *Monday Morning*, donation

Parkin, Molly b.1932, *New York, Evening*, unrecorded

Parkinson, Gerald b.1926, *English Farm*, purchase

Parrott, William 1813–after 1875, *The Negro Boat Builder*, donation

Parsons, Arthur Wilde 1854–1931, *Queen Elizabeth Passing down the Avon in 1574*, donation

Paterson, Emily Murray 1855–1934, *Cortile, Doge's Palace*, donation

Paterson, Emily Murray 1855–1934, *Pink Roses*, donation

Patinir, Joachim (attributed to) c.1480–before 1524, *Building the Tower of Babel*, donation

Paye, Richard Morton 1750–c.1821, *Angel*, unrecorded

Paye, Richard Morton 1750–c.1821, *Children Playing*, unrecorded

Paye, Richard Morton 1750–c.1821, *Girl with Her Hands Folded*, unrecorded

Paynter, David 1900–1975, *L'après-midi*, donation

Pearson, Mary Martha 1799–1871, *Mrs Otho Manners*, donation

Pellegrini, Giovanni Antonio 1675–1741, *Philip of Macedonia Checking the Anger of Alexander*, purchase

Penley, Aaron Edwin 1807–1870, *Aldrington Basin*, donation

Penley, Aaron Edwin 1807–1870, *The Music Room, Royal Pavilion: The Grand Re-Opening Ball*, unrecorded

Peploe, Samuel John 1871–1935, *The Yellow Jug*, donation, © courtesy of the artist's estate/www.bridgeman.co.uk

Pether, Abraham 1756–1812, *The Shepherd*, donation

Pether, Abraham 1756–1812, *Moonlit Landscape with River*, donation

Pether, Abraham 1756–1812, *Moonlit Scene*, donation

Pether, Henry (style of) active 1828–1865, *Moonlit Landscape*, donation

Pether, Henry (style of) active 1828–1865, *Moonlit Scene*, unrecorded

Pether, Henry (style of) active 1828–1865, *Moonlit Scene*, unrecorded

Philipson, Robin 1916–1992, *Altar II*, purchase

Phillip, John 1817–1867, *The Fortune Teller*, donation

Phillip, John 1817–1867, *In the Garden, Seville*, donation

Phillip, John 1817–1867, *Breakfast in the Highlands*, donation

Phillips, Thomas 1770–1845, *Mr Barratt*, donation

Philpot, Glyn Warren 1884–1937, *Mrs Basil Fothergill and Her Two Daughters*, donation, © the artist's estate

Philpot, Glyn Warren 1884–1937, *Journey of the Spirit*, donation, © the artist's estate

Philpot, Glyn Warren 1884–1937, *The Angel of the Annunciation*, donation, © the artist's estate

Philpot, Glyn Warren 1884–1937, *Miss Gwendoline Cleaver*, donation, © the artist's estate

Philpot, Glyn Warren 1884–1937, *Mrs Woolmer*, donation, © the artist's estate

Philpot, Glyn Warren 1884–1937, *Acrobats Waiting to Rehearse*, donation, © the artist's estate

Philpot, Glyn Warren 1884–1937, *Melancholy Negro*, donation, © the artist's estate

Philpot, Glyn Warren 1884–1937, *Negro Thinking of Heaven*, donation, © the artist's estate

Philpot, Leonard Daniel 1877–1973, *The Canyon*, purchase

Piltz, Otto 1864–1910, *The Sunday School*, donation

Pine, Robert Edge 1742–1788, *Captain William Baillie*, donation

Piper, W. F. *The Evening Meal*, donation

Pissarro, Lucien 1863–1944, *The Hills from Hayfield Green*, donation, © the artist's estate

Pissarro, Lucien 1863–1944, *Le Cabanon, le Lavandou*, donation, © the artist's estate

Thorshov, purchase

Thornhill, James 1675–1734, *Olympian Scene*, purchase

Tintoretto, Domenico (after) 1560–1635, *Crucifixion*, donation

Todd, Arthur Ralph Middleton 1891–1966, *The Artist's Mother*, donation

Toorenvliet, Jacob c.1635–1719, *The Dentist*, donation

Torrance, James 1859–1916, *Primrose Hill*, donation

Trangmar, T. *Old Unicorn Inn, North Street*, donation

Travis, Walter 1888–1962, *Mayor Ernest Marsh*, donation

Tryon, Wyndham J. 1883–1942, *Spanish Landscape*, donation

Tuke, Henry Scott 1858–1929, *Miss Muriel Lubbock*, donation

Tuson, George E. c.1820–1880, *Sir John Cordy Burrows, Mayor of Brighton*, donation

Tyler, Philip b.1964, *Daedalus Weeps*, donation

Tyler, Philip b.1964, *Shadow Dreams*, donation

Tyler, Philip b.1964, *Wrestlers*, donation

unknown artist *Nativity*, unrecorded

unknown artist 18th C, *Saint*, unrecorded

C. V. 19th C, *Busy Bee Boat at Shoreham*, unrecorded

Velde, Esaias van de I 1587–1630, *A Boat Moored before a Walled Farm*, donation

Velde, Esaias van de I (circle of) 1587–1630, *English Men-O'-War near the Coast*, donation

Verner, Ida 1850–1937, *J. W. Lister, Borough Librarian and Curator*, donation

Verner, Ida 1850–1937, *Isolde Menges*, donation

Verner, Ida 1850–1937, *Self Portrait*, donation

Verner, Ida 1850–1937, *Self Portrait*, donation

Verner, Ida 1850–1937, *'Thy Will Be Done' Study of a Lady in Oils*, donation

Veronese, Paolo (after) 1528–1588, *The Family of Darius before Alexander*, unrecorded

Veronese, Paolo (studio of) 1528–1588, *The Centurion of Capernaum*, purchase

Veronese, Paolo (studio of) 1528–1588, *Europa and the Bull*, purchase

Victors, Jan 1619–after 1676, *Jacob's Deception*, donation

Vivarini, Bartolomeo (school of) d. after 1500, *Madonna and Child with Cherubs*, donation

Von Kamptz, Fritz 1817–1901, *William Woodward, the Chartist*, donation

W. W. *Lewes Coach on the Road*, unrecorded

Wadsworth, Edward Alexander 1889–1949, *Light Sections*, purchase, © estate of Edward Wadsworth 2005. All Rights Reserved DACS

Walker, Ethel 1861–1951, *Portrait of a Woman*, purchase, © courtesy

of the artist's estate/www. bridgeman.co.uk

Walker, Ethel 1861–1951, *The Miniature*, purchase, © courtesy of the artist's estate/www.bridgeman. co.uk

Wallace, Robin 1879–1952, *Waterloo Bridge*, donation

Wallace, Robin 1879–1952, *Landscape*, donation

Walton, John Whitehead active 1831–1885, *Frederick William Hervey, First Marquess of Bristol*, donation

Ward, James 1769–1859, *Duckweeds*, purchase

Ward, Richard b.1957, *Untitled*, donation

Warren, William White 1832–1915, *Chain Pier, Brighton*, donation

Warrington, Ellen active 1931–1939, *Cineraria*, donation

Watson, Harry 1871–1936, *Woodland Scene, Sussex*, purchase

Watson, Robert active 1899–1920, *Highland Sheep*, donation

Watteau, Jean-Antoine (after) 1684–1721, *Fête galante: Conversation Piece*, donation

Way, Emily C. active 1886–1907, *Ellen Benett-Stanford*, donation

Webb, James c.1825–1895 & **Earl, George** active 1856–1883 *Brighton from the West Pier*, purchase

Weenix, Jan Baptist 1621–1660/1661, *Shipping in Harbour*, donation

Weigall, Henry 1829–1925, *Alderman Sir John Ewart*, donation

Weigall, Henry 1829–1925, *Sir John George Blaker and Family*, donation

Weight, Carel Victor Morlais 1908–1997, *Cold Day, Schönbrunn*, donation, © the estate of the artist

Weight, Carel Victor Morlais 1908–1997, *Jane I*, purchase, © the estate of the artist

Weight, Carel Victor Morlais 1908–1997, *Dialogue*, purchase, © the estate of the artist

Weight, Carel Victor Morlais 1908–1997, *American Girl and Doll*, purchase, © the estate of the artist

Weller, Norma b.1932, *Frederick Alexander*, donation

Weller, Norma b.1932, *Fire Cavern*, purchase

Wetherbee, George Faulkner 1851–1920, *Oenone Forsaken*, donation

Wheatley, Francis 1747–1801, *Mother and Child*, donation

Wheatley, Francis 1747–1801, *The Encampment at Brighton, Scotland*, purchase

Whistler, Reginald John 1905–1944, *HRH the Prince Regent Awakening the Spirit of Brighton*, purchase, © estate of Rex Whistler 2005. All Rights Reserved DACS

Whistler, Reginald John 1905–1944, *King George IV*, donation, © estate of Rex Whistler 2005. All Rights Reserved DACS

Whiting, Frederic 1874–1962, *Girl*

in a Green Jersey, donation

Whiting, Frederic 1874–1962, *The Professional*, purchase

Whittle, Thomas active c.1854–1895, *Nutfield Village*, donation

Wilkie, David (after) 1785–1841, *Grace before Meat*, donation

Williams, Alfred Walter 1824–1905, *On the Cumberland Fells*, donation

Williams, E. W. 19th C, *John Cordwell*, unrecorded

Williams, John Edgar active 1846–1883, *Alderman David Smith, Mayor of Brighton*, donation

Williams, J. M. *Mounted Figure with Hounds*, donation

Williams, Terrick 1860–1936, *Seaweed Gatherers*, purchase

Williams, William 1808–1895, *Cader Idris*, donation

Williamson, James active 1868–1889, *Silver Birches, Hassocks Gate*, donation

Williamson, James active 1868–1889, *Silver Brook, Hassocks Gate*, donation

Wilson, Benjamin 1721–1788, *Dr Richard Russell, FRS*, donation

Wilson, Margaret Evangeline b.1890, *Mrs Blackman*, donation

Wilson, Richard 1713/1714–1782, *River View with Figures on the Bank*, donation

Wilson, Richard (after) 1713/1714–1782, *Landscape with Lake and Figures*, purchase

Wilson, Richard (after) 1713/1714–1782, *Figures by a Lake*, unrecorded

Wilson, Richard (after) 1713/1714–1782, *Italian Landscape*, purchase

Wilson, Richard (circle of) 1713/1714–1782, *Landscape with River*, unrecorded

Wilson, Richard (follower) 1713/1714–1782, *Landscape*, donation

Wingate, James Lawton 1846–1924, *The Flock*, donation

Wivell, Abraham Junior active 1840–1865, *Mrs Rotton, neé Charlotte S. Barton*, donation

Wolf-Ferrari, Teodoro 1878–1945, *Lo spitz di mezzodì da Brusa Adaz a Zolno Alto*, purchase

Wolgemut, Michael (studio of) 1434/1437–1519, *Triptych with the Nativity and Saints (inner panels)*, 55.9 x 18.3, 56.2 x 47.0, 55.9 x 18.3, donation

Wolgemut, Michael (studio of) 1434/1437–1519, *Triptych with the Nativity and Saints (outer panels)*, donation

Wood, Christopher 1901–1930, *Girl in a Cloche Hat*, purchase

Wood, Christopher 1901–1930, *Seated Nude*, donation

Woods, Henry 1846–1921, *Street in Venetia*, donation

Wouwerman, Philips (attributed to) 1619–1668, *Battle Scene*, donation

Wright, Joseph of Derby 1734–1797, *Catherine Sophia Macauley*, donation

Wright (née Dawson), Patricia

Vaughan b.1925, *Vincent Lloyd on Blythe Hill, South London, with Kent Hills beyond*, purchase

Wyndham, Richard 1896–1948, *Winter Landscape*, donation

Wyndham, Richard 1896–1948, *Tickerage Mill*, donation

Yarber, Robert b.1948, *False Dawn*, donation

Yates, Fred b.1922, *Saturday Afternoon*, purchase

Yates, Fred b.1922, *Shoreham Power Station*, purchase

Yates, Norman b.1923, *Three Flags*, donation

Yhap, Laetitia b.1941, *Paul Helping His Brother Doug, and Scoby, Will and Saxon*, purchase, © the artist

Ziem, Félix François Georges Philibert 1821–1911, *The Doge's Palace, Venice*, donation

Ziem, Félix François Georges Philibert 1821–1911, *Venetian Scene: Gondolas and Sailing Boats*, donation

Zinkeisen, Anna Katrina 1901–1976, *Brighton in the Regency*, donation

Zinkeisen, Anna Katrina 1901–1976, *King George IV*, donation

Zoffany, Johann 1733–1810, *John Maddison*, donation

Zuccarelli, Franco 1702–1788, *Pastoral Scene with Cowherds*, donation

Zuccarelli, Franco 1702–1788, *Pastoral Scene with Goatherds*, donation

The Aldrich Collection, University of Brighton

Bucher, Mayo b.1963, *J. S. B.*, gift from the artist

Bucher, Mayo b.1963, *Red Over Black*, purchased by Foundation Fund

Burke, Patrick *Five Figures on Red Ground*, purchased by Foundation Fund

Burke, Patrick *Red Night*, purchased by Foundation Fund

Burton, Simon b.1973, *Garden Furniture*, purchased by University of Brighton, © the artist

Burton, Simon b.1973, *Naples*, purchased by University of Brighton, © the artist

Clements, Keith 1931–2003, *Estranged*, on loan from artist, Keith Clements, © the artist's estate

Clements, Keith 1931–2003, *Pecking Order*, on loan from the artist, Keith Clements, © the artist's estate

Creffield, Dennis b.1931, *Still Life with Bread and Jug*, © the artist

Daniels, Harvey b.1936, *Zigzag*, gift from the artist, © courtesy of the artist/www.bridgeman.co.uk

Davie, Alan b.1920, *Crazy Ikon (op. no. 258)*, gift from the artist, © the artist

Davie, Alan b.1920, *Egg Filler*, on loan from the artist, Alan Davie, © the artist

Davie, Alan b.1920, *Wheels for the*

Sweet Life, on loan from the artist, Alan Davie, © the artist

Davie, Alan b.1920, *Woodpecker's Choice*, on loan from the artist, Alan Davie, © the artist

Davie, Alan b.1920, *See You in Heaven*, on loan from the artist, Alan Davie, © the artist

Gillespie, Paula *Mists of Memories No.2*, purchased by Foundation Fund

Gregory, Patricia *The Meeting*, purchased by University of Brighton

Gregory, Patricia *The Meeting*, purchased by University of Brighton

Griffiths, Michael b.1951, *Suspension*, gift from the artist

Horton, Ronald 1902–1981, *Shoreham Harbour*, presented by Mrs M. Horton

Imai, Yasuo *White Chrysanthemum*, purchased by Foundation Fund

Imai, Yasuo *Yellow Chrysanthemum*, purchased by Foundation Fund

Imai, Yasuo *Morning Glory*, purchased fby Foundation Fund

Kam Kow, Choong *Earth Mood 2*, gift from the artist

Kemmenor, James *One of the Faces*, purchased from Nuffield Exhibition

Martin, Leigh b.1964, *M. Matissée in Nice*, purchased from Nuffield Exhibition

Martin, Leigh b.1964, *M. Matissée in Nice*, purchased from Nuffield Exhibition

Martin, Leigh b.1964, *M. Matissée in Nice*, purchased from Nuffield Exhibition

Martin, Leigh b.1964, *M. Matissée in Nice*, purchased from Nuffield Exhibition

McKendry, Kenneth *Robin Plummer*, purchased by University of Brighton

McKendry, Kenneth *Michael Aldrich*, purchased by University of Brighton

McKendry, Kenneth *Professor Geoffrey Hall, CBE*, purchased by University of Brighton

McKendry, Kenneth *Professor John Vernon Lord*, gift from Michael Aldrich

Mooney, Martin b.1960, *Dark Orange Still Life*

Neiland, Brendan b.1941, *Brighton*, University of Brighton commission

Neiland, Brendan b.1941, *Aldrich Library*, gift from Michael Aldrich

O'Connor, Lisa b.1965, *Abstract*, purchased by Foundation Fund

O'Connor, Lisa b.1965, *White, Green, Yellow Abstract*, purchased by Foundation Fund

Plummer, Robin b.1931, *Sea View No.2*, donated by Margret Polmer

Rice, Brian b.1936, *Kalender*, purchased by Foundation Fund

Spanyol, Jessica *Part of a Triptych*, purchased from ADH Degree Show

Spanyol, Jessica *Part of a Triptych*,

purchased from ADH Degree Show

Spanyol, Jessica *Part of a Triptych*, purchased from ADH Degree Show

Stevens, Christopher b.1961, *Two Women*, purchased by University of Brighton

Udagawa, Norito *TRIPLE X–2*, gift from the artist

Wilson, Tony b.1944, *Study for a Wall*, purchased by Foundation Fund

Wilson, Tony b.1944, *Lost Letter*, purchased by Foundation Fund

University of Sussex

Akolo, Jimo b.1935, *Hausa Drummer*

Akolo, Jimo b.1935, *Hausa Procession*

Akolo, Jimo b.1935, *Northern Horsemen*

Bradley, Martin b.1931, *Zen*

Chevallier, Annette b.1944, *'Geometric Shapes'*, © the artist

Child, St John active from 1960s, *Cayley's Flying Machine*

Child, St John active from 1960s, *Untitled*

Child, St John active from 1960s, *Woodlands*

Child, St John active from 1960s, *Knights of the Flying Circus*

Clements, Keith 1931–2003, *The Painter's Wife with Cat*, © the artist's estate

Clements, Keith 1931–2003, *Revolutionary Study*, © the artist's estate

Clements, Keith 1931–2003, *Sir Denys Wilkinson*, © the artist's estate

Cook, Bill *Study of Dancing Children*

Cook, Bill *Study of Leaves*

Creffield, Dennis b.1931, *July Evening, Brighton*, © the artist

Daghani, Arnold 1909–1985, *'Abstract Multicoloured Lines'*, © Arnold Daghani Trust

Daghani, Arnold 1909–1985, *Abstract Geometric Shapes*, © Arnold Daghani Trust

Daghani, Arnold 1909–1985, *George Enescu: 'Rumanian Rhapsody'*, © Arnold Daghani Trust

Daghani, Arnold 1909–1985, *III*, © Arnold Daghani Trust

Daghani, Arnold 1909–1985, *Abstract with Fish on Red Background*, © Arnold Daghani Trust

Daghani, Arnold 1909–1985, *Townscape*, © Arnold Daghani Trust

Daghani, Arnold 1909–1985, *Coin de la vieille ville de Vence*, © Arnold Daghani Trust

Daghani, Arnold 1909–1985, *VII*, © Arnold Daghani Trust

Daghani, Arnold 1909–1985, *Shadowy Face*, © Arnold Daghani Trust

Daghani, Arnold 1909–1985, *'Two Female Portraits on Dark Background'*, © Arnold Daghani Trust

Daghani, Arnold 1909–1985, *Cyclists*, © Arnold Daghani Trust

Daghani, Arnold 1909–1985, *Hommage à Jean-François Millet (Les glaneuses)*, © Arnold Daghani Trust

Ferguson, Pauline *'Three Square Shapes'*

Fox, J. *'Ships'*

Frey, Barbara 20th C, *Engineering Theme, Greens and White*

Ginloud, Colin 20th C, *Painting in Black, Grey and White*

Gladwell, Rodney 1928–1979, *Flowers in Vase*

Gladwell, Rodney 1928–1979, *'Cottages'*

Gung, Zhu *Sir Leslie Fielding*

Hesse, Lebrecht *Market Woman in Ghana*

Hitchens, Ivon 1893–1979, *Day's Rest, Day's Work (Polyptych)*, © Jonathan Clark & Co

H. K. *Unknown*

Leukiwicz 20th C, *Francesca and Death*

Marle, Judith *Passing through*

Martin, Kingsley 1897–1969, *Downland Scene from the Artist's Garden*

McHugh, Christopher *The Sea, The Sea, The Sea*

Organ, Bryan b.1935, *Lord Shawcross Seated*

Oxtoby, David b.1938, *Explosion (Flash)*

Oxtoby, David b.1938, *Ya Ya (Burst)*

Pibias *Self Portrait as St Anthony*

Ribeiro, Lancelot b.1933, *Bombay*

Salvendy, Frieda 1887–1965, *Fishermen in Boat, Italy*

Salvendy, Frieda 1887–1965, *Market Scene at Mihalovce*

Salvendy, Frieda 1887–1965, *Anemones and Magnolia in Vase*

Salvendy, Frieda 1887–1965, *Girl with Doll*

Salvendy, Frieda 1887–1965, *Gladioli in Vase*

Salvendy, Frieda 1887–1965, *Still Life: Fruit and Anemones*

Salvendy, Frieda 1887–1965, *Tulips in Vase*

Sebree, Charles 1914–1985, *Blue Drinker*

Shields, Barbara b.1922, *Still Life, Rose and Lemons*, © the artist

unknown artist late 18th C, *Philadelphi, Daughter of Sir John Dixon Dyke Baronet, 1790*

unknown artist late 19th C, *The Brighton Chain Pier (after Joseph Mallord William Turner)*

unknown artist 20th C, *Artist's Studio*

Upton, John b.1933, *Christ's Entry into Brighton*, © the artist

Upton, John b.1933, *And She Was the Princess*, © the artist

Upton, John b.1933, *Nude with Mirror*, © the artist

Wheatley, Grace *Lord Fulton of Falmer*

Yassin, Assad b.1911, *Black and White African Scene*

Ditchling Museum

Cobbam, Rose *Mrs Parkinson*, given by Mrs Tomsett to Ditchling Museum on 9th May 1988

Elms, G. D. *Ditchling*, given by Reverend K. Jefferies to Ditchling Museum on 14th November 1988

Ginnett, Louis 1875–1946, *The Picnic*, loan but being gifted

Ginnett, Louis 1875–1946, *Portrait*, loan but being gifted

Ginnett, Louis 1875–1946, *A June Interior*, loan but being gifted

Ginnett, Louis 1875–1946, *Amy Sawyer*, loan, 2009 but will be renewed

Ginnett, Louis 1875–1946, *Boy's Head*, loan but being gifted

Ginnett, Louis 1875–1946, *Cathedral Facade*, loan but being gifted

Ginnett, Louis 1875–1946, *Child in Green Cape*, loan but being gifted

Ginnett, Louis 1875–1946, *Female Nude*, loan but being gifted

Ginnett, Louis 1875–1946, *Four Trees and a Building*, loan but being gifted

Ginnett, Louis 1875–1946, *Hampstead Heath*, given by Jean Clarke 7.9.1994

Ginnett, Louis 1875–1946, *Head of Unknown Lady*, loan but being gifted

Ginnett, Louis 1875–1946, *Lady with a Blue-Brimmed Hat*, loan but being gifted

Ginnett, Louis 1875–1946, *Little Venice*, loan but being gifted

Ginnett, Louis 1875–1946, *Mary*, loan but being gifted

Ginnett, Louis 1875–1946, *Mary*, loan but being gifted

Ginnett, Louis 1875–1946, *Mary*, loan but being gifted

Ginnett, Louis 1875–1946, *Mary Ginnett*, loan but being gifted

Ginnett, Louis 1875–1946, *Mary Sitting in a Wood*, loan but being gifted

Ginnett, Louis 1875–1946, *Mary under Sunshade*, loan but being gifted

Ginnett, Louis 1875–1946, *Portrait of a Lady*, loan but being gifted

Ginnett, Louis 1875–1946, *Portrait of a Man*

Ginnett, Louis 1875–1946, *Portrait of an Unknown Girl*, loan but being gifted

Ginnett, Louis 1875–1946, *Ruined Castle*, loan but being gifted

Ginnett, Louis 1875–1946, *Ruins*, loan but being gifted

Ginnett, Louis 1875–1946, *Seascape*, loan but being gifted

Ginnett, Louis 1875–1946, *Seashore*, loan but being gifted

Ginnett, Louis 1875–1946, *The Picture Book*, loan but being gifted

Ginnett, Louis 1875–1946, *The Secret Bather*, loan but being gifted

Ginnett, Louis 1875–1946, *Unknown Lady*, loan but being gifted

Hucker, R. *Court Farm*, given by Mrs Hucker to Ditchling Museum on 10th December 1996

Incledon, Marjorie 1891–1973, *Etchingham, Sussex*, given by Mrs Creed to Ditchling Museum on 26th May 1989

Incledon, Marjorie 1891–1973, *Free Range*, given by Mrs Creed to Ditchling Museum on 26th May 1989

Incledon, Marjorie 1891–1973, *Sussex Wood*, given by Mrs Creed to Ditchling Museum on 26th May 1989

Jones, David 1895–1974, *Madonna and Child in a Landscape*, purchased by Ditchling Museum trustees, friends and grants from the V&A, NACF, the Pilgrim Trust and private donations on the 9th Janurary 2002, © trustees of the David Jones estate

Knight, Charles 1901–1990, *Mountain Waters*, loan, Febuary 2009 but will be renewed, © the artist's estate

Pepler, Clare *Kilbride Family*, loan, January 2009 but will be renewed

Rawlins, Ethel Louise active c.1900–1962, *7 High Street*, given by Ditchling Village Hall management committee to Ditchling Museum on 26th May 1989

unknown artist *Oldland Mill*, given by Ditchling Village Hall management committee to Ditchling Museum on 26th May 1989

Towner Art Gallery

Adkins, Harriette S. active 1906–1914, *Tide up at Bosham*, purchased from the artist

Adkins, Harriette S. active 1906–1914, *Roofs of Horsham Stone*, bequest of the artist

Adkins, Harriette S. active 1906–1914, *A Bit of Brighton*, purchased from the artist

Adkins, Harriette S. active 1906–1914, *Stacks*, purchased from the artist

Aken, Joseph van c.1699–1749, *The Music Party*, the Irene Law bequest

Allsopp, Judith b.1943, *Number Ten*, donation

Alma-Tadema, Lawrence 1836–1912, *Negro Head*, the Sylvia Gosse gift

Andrews, Elizabeth d.1978, *Annie*, donated by the artist

Andrews, Elizabeth d.1978, *Portrait*, purchased

Andrews, Elizabeth d.1978, *Still Life*, purchased from the artist

Armstrong, James b.1946, *Mansion Hotel, Spring Arrives*, purchased

Barker, Kit 1916–1988, *Cornish Coast*, acquired with the assistance of the Gulbenkian Fund, © the artist's estate

Barratt, Krome 1924–1990, *Fenland*, purchased

Barry, Francis b.1965, *On Land*, purchased

Bassano, Francesco II (attributed to) 1549–1592, *Nativity Scene: The Adoration of the Shepherds*, unknown

Bassingthwaighte, Lewis b.1928, *Interior with Children*, acquired with the assistance of the Gulbenkian Fund

Batty, Joyce *Seges est ubi troia fuit*, purchased

Baynes, Keith 1887–1977, *Still Life*, the Port gift

Bell, Quentin 1910–1996, *Bishop Bell*, the Miss Jean Batters bequest, © the artist's estate

Bell, Trevor b.1930, *Summer Painting 1959*, purchased, © the artist

Bell, Vanessa 1879–1961, *8 Fitzroy Street*, purchased, © 1961 estate of Vanessa Bell courtesy Henrietta Garnett

Benecke, Margaret d.1962, *Composition: Eastbourne 1935*, gift of Elizabeth Andrews

Benecke, Margaret d.1962, *Entrance to Saffrons*, gift of Elizabeth Andrews

Benecke, Margaret d.1962, *Glacier Forms*, gift of Elizabeth Andrews

Benecke, Margaret d.1962, *Interior with Figure*, purchased from the artist

Benecke, Margaret d.1962, *Interior with Two Figures*, purchased from the artist

Benecke, Margaret d.1962, *Manor Gardens, Autumn*, unknown

Benecke, Margaret d.1962, *Roofs, Upperton Gardens*, gift of Elizabeth Andrews

Bennett, John active 1827–1850, *Eastbourne*, purchased, on loan to Eastbourne Borough Council, Town Hall

Benney, Ernset Alfred Sallis 1894–1966, *Tarring Neville in April*, purchased from the artist

Berchem, Nicolaes 1620–1683, *Landscape with Animals*, donated by Elizabeth Andrews

Birch, David 1895–1968, *On Pevensey Marshes*, unknown

Birley, Oswald Hornby Joseph 1880–1952, *Alderman Arthur Edward Rush, JP, Mayor (1938–1943)*, presented by public subscription, on loan to Eastbourne Borough Council, Town Hall, © the artist's estate

Birley, Oswald Hornby Joseph 1880–1952, *Colonel W. A. Cardwell, Master of Eastbourne Foxhounds (1895–1910) and Mayor of Eastbourne (1886–1887)*, unknown, on loan to Eastbourne Borough Council, Town Hall, © the artist's estate

Blamey, Norman Charles 1914–1999, *Stripes*, bicentenary gift of the Royal Academy of Arts

Bles, Herri met de c.1510–after 1550, *Madonna and Child in a Landscape with St Christopher and St Anthony the Great (Triptych)*, the Irene Law bequest

Bles, Herri met de c.1510–after 1550, *Madonna and Child in a Landscape with St Christopher and*

St Anthony the Great (Triptych), the Irene Law bequest

Bles, Herri met de c.1510–after 1550, Madonna and Child in a Landscape with St Christopher and St Anthony the Great (Triptych), the Irene Law bequest

Blow, Sandra b.1925, Painting 1962, acquired with the assistance of the Victoria & Albert Museum purchase Grant Fund and the Gulbenkian Fund, © the artist

Blum, E. The Captive Sky, unknown

Bomberg, David 1890–1957, Kitty, the Artist's Sister, gift of Mrs J. Newmark, © the artist's family

Bomberg, David 1890–1957, Jim 1943, gift, presented in memory of David Bomberg by Mr & Mrs J. Newmark, through the Contemporary Art Society, © the artist's family

Bonner, George b.1924, Rye Harbour, purchased

Bonner, George b.1924, Fable, unknown

Bonner, George b.1924, Journey into Time I, gift of the artist

Bonner, George b.1924, Journey into Time II, gift of the artist

Borrow, William Henry 1840–1905, Eastbourne, purchased

Boshier, Derek b.1937, Vista City, purchased

Boswell, James 1906–1971, The Southern Edge, purchased, © Ruth Boswell

Bowen, Denis b.1921, Bronze Barrier, donated by the artist

Bradshaw, Gordon Landscape, purchased from the artist

Brett, B. active c.1841–1918, Fishermen's Huts, the Crumbles, Eastbourne, bequest of Mr Frank Coleman, on loan to Eastbourne Borough Council, Town Hall

British (English) School 19th C, Lieutenant Colonel Jarvis, unknown

British (English) School 20th C, Boats in Harbour

British (English) School 20th C, The Football Match, unknown

Broughton, Kevin b.1962, Dialogue I, purchased

Brouwer, Adriaen (circle of) 1605/1606–1638, Pastoral Scene with Children and Animals, unknown

Bruford, Marjorie Frances b.1902, In the Flower Field, purchased from the artist

Calkin, Lance 1859–1936, Alderman Sir Charles O'Brien Harding, JP, MRCS, LRCP, Honorary Freeman (Admitted 1919), Mayor of Eastbourne (1903, 1916, 1917, 1918 and 1919), presented by public subscription, on loan to Eastbourne Borough Council, Town Hall

Callam, Edward 1904–1980, Canal Wharf near Tring, unknown

Callow, William 1812–1908, Coastal Scene, Fishermen Unloading Their Catch, unknown

Camp, Jeffery b.1923, Beachy Head, White Windswept Prospect, acquired with the assistance of South East Arts, © the artist

Camp, Jeffery b.1923, Bluebells, purchased, © the artist

Carter, Bernard Arthur Ruston (Sam) b.1909, Nude on Blue, bicentenary gift of the Royal Academy of Arts

Cecconi, Lorenzo 1863–1947, Italian Interior with Two Figures, the Towner bequest

Charlton, Mervyn b.1945, Prospero's Island, purchased, © the artist

Chubb, Shirley b.1959, Inequality, purchased

Clarke, Thomas Flowerday active c.1930–1960, On Brighton Beach, donation

Clarkson, William H. 1872–1944, A Downland Park, purchased from the artist

Cole, John 1903–1975, Priory Farm with St Philip Neri, Arundel, purchased from the artist

Cole, Rex Vicat 1870–1940, Brooks of Bramber (Bramber Meadows), purchased from the artist

Collings, Albert Henry 1858–1947, Alderman Henry William Keay, JP, Mayor (1893–1894, 1898–1901 & 1906–1908), presented by public subscription, on loan to Eastbourne Borough Council, Town Hall

Collins, Cecil 1908–1989, Dawn Invocation, bequest of Mrs Elisabeth Collins through the National Art Collections Fund

Colquhoun, Robert 1914–1962, Woman and Goat, purchased, © courtesy of the artist's estate/www.bridgeman.co.uk

Cooper, Thomas Sidney 1803–1902, Cattle and Sheep, the Towner bequest

Couch, Christopher b.1946, Preliminary Sketch for 'Saturday', purchased

Coutts-Smith, Kenneth b.1929, Painting, donated by the artist

Crozier, William b.1930, Landscape No.14, purchased

Cuming, Frederick b.1930, Studio, Early Morning, the Royal Academy of Arts bicentenary presentation, © the artist

Cumming, James b.1922, Paraffin Carrier, purchased from the artist, © the artist's estate

Cuthbert, Alan 1931–1995, EV from MSI, purchased

Dane, Clemence 1888–1965, View of Midhurst, the Sir Edward Marsch bequest, through the Contemporary Art Society

Darragh, Stephen Untitled, purchased, on loan to Community Alcohol Team Project, Eastbourne

Darragh, Stephen Untitled, purchased, on loan to Community Alcohol Team Project, Eastbourne

Davie, Alan b.1920, Sea Gate, acquired with the assistance of the Gulbenkian Fund, © the artist

Dawson, Henry 1811–1878, The Bird Trap, the Towner bequest

de Grey, Roger 1918–1995, Beckley Hill, Kent, acquired with the assistance of the Victoria & Albert

Museum purchase Grant Fund

De Karlowska, Stanislawa 1876–1952, Barrage Balloons, gift of Mr & Mrs Baty

Denny, Robyn b.1930, Night out, purchased, acquired with the assistance of Friends of the Towner and CAS, © the artist

Denny, Robyn b.1930, Apart (Here and Then Series), purchased, © the artist

Dickson, Jennifer b.1936, Crucifixion, purchased from the artist

Dobson, S. Zebra Crossing, unknown

Douglas-Thompson, Marguerite 20th C, Search, gift of Mrs J. Newmark

Downing, Nigel b.1964, Follow through, commissioned/purchased from the artist

Duncan, Edward 1803–1882, Arundel Castle, unknown

Dunlop, Ronald Ossory 1894–1973, September Landscape, acquired with the assistance of the Victoria & Albert Museum purchase Grant Fund, on loan to Eastbourne Borough Council, Town Hall

Dunlop, Ronald Ossory 1894–1973, The Arun at Pulborough, purchased from the artist

Dunlop, Ronald Ossory 1894–1973, The Thames at Lambeth, purchased

Dutton, Chris Reverend Thomas Pitman, Vicar of Eastbourne, presented to the Borough by public subscription, on loan to Eastbourne Borough Council, Town Hall

Erici (Cherry), K. Flower, donated by Mr Silvanus Nicol

Erici (Cherry), K. Still Life, donated by Mr Silvanus Nicol

Etchells, Frederick 1886–1973, A Group of Figures, the Sir Edward Marsch bequest through the Contemporary Art Society

Evans, Merlyn Oliver 1910–1973, The Orchestra Pit, Covent Garden, acquired with the assistance of the Gulbenkian Fund

Eves, Reginald Grenville 1876–1941, Portrait of the Artist's Mother, donated by the artist

Eves, Reginal Grenville 1876–1941, Mrs W. P. H. Pollock, gift of the artist

Eves, Reginald Grenville 1876–1941, Thomas Hardy, gift of the artist

Eyton, Anthony John Plowden b.1923, Pitgliano III, the Royal Academy of Arts bicentenary Presentation, © courtesy of the artist/www.bridgeman.co.uk

Farthing, Stephen b.1950, Louis XIV Rigaud, gift of the Contemporary Art Society

Farthing, Stephen b.1950, Monument to a Musician, purchased

Feiler, Paul b.1918, Eastbourne Front from the Pier, purchased, © the artist

Fell, Sheila Mary 1931–1979, Misty

Evening, Cumberland, acquired with the assistance of the Victoria & Albert Museum purchase Grant Fund and the Department of Education & Science

Fenton, F. M. The River, gift of the artist

Fenton, F. M. The Siesta, donated by the artist

Fielding, Brian 1933–1987, Partsong No.4, acquired with the assistance of the Contemporary Art Society and the Friends of the Towner, © the artist's estate

Finn, Doreen b. c.1905, Abstract, gift of the artist, from long loan

Finn, Doreen b. c.1905, Adventure, donated by Mrs Marjorie Gibb

Finn, Doreen b.1905, Aggression, gift of the artist, from long loan

Finn, Doreen b.1905, Camouflage, gift of the artist, from long loan

Finn, Doreen b. c.1905, Crescendo, gift of the artist, from long loan

Finn, Doreen b. c.1905, From a Landscape, gift of the artist

Finn, Doreen b. c.1905, Landscape, unknown

Finn, Doreen b. c.1905, No.9, gift of the artist

Finn, Doreen b. c.1905, No.17, gift of the artist

Finn, Doreen b. c.1905, Painting, gift of the artist

Finn, Doreen b. c.1905, The Gorseway, gift of the artist

Finn, Doreen b. c.1905, Untitled, gift of the artist, from long loan

Finn, Doreen b. c.1905, Untitled, gift of the artist, from long loan

Finn, Doreen b. c.1905, Untitled, gift of the artist

Finn, Doreen b. c.1905, Untitled, gift of the artist

Finn, Doreen b. c.1905, Untitled, gift of the artist, from long loan

Finn, Doreen b. c.1905, Untitled, gift of the artist

Fisher, Mark 1841–1923, Pevensey Castle, presented to the Corporartion of Eastbourne by Mrs Galloway, on loan to Eastbourne Borough Council, Town Hall

Fisher, Myrta 1917–1999, Table with Lamp, Mug and Bowl, purchased from the artist

Flint, Geoffrey b.1919, Cruciform II, purchased from the artist

Follis, Beatrice Flowers II, purchased from the artist

Gales, Henry 1856–1886, G. A. Wallis, First Mayor of Eastbourne, gift of Miss J. M. Holman

Gales, Henry active 1856–1886, HRH Princess Alice, Daughter of Queen Victoria, gift of the Hospitals Authority

Gales, Henry active 1856–1886, Reproduction of Portrait of G. A. Wallis, First Mayor of Eastbourne, unknown, on loan to Eastbourne Borough Council, Town Hall

Gales, Henry active 1856–1886, Alderman James Arthur Skinner, bequest of Mrs M. M. T. Holt

Gales, Henry active 1856–1886,

The First Mayor, Aldermen and Clerk of the Borough of Eastbourne (1883–1884), unknown, on loan to Eastbourne Borough Council, Town Hall

Garwood, Tirzah 1908–1951, Hornet with Wild Roses, purchased from the artist, © the estate of Tirzah Garwood 2005. All Rights Reserved DACS

Garwood, Tirzah 1908–1951, Orchid Hunters in Brazil, purchased from the artist, © the estate of Tirzah Garwood 2005. All Rights Reserved DACS

Gear, William 1915–1997, Composition Blue Centre, acquired with assistance of the V&A purchase Grant Fund, the National Art Collections Fund and the Friends of the Towner, © the artist's estate

Gear, William 1915–1997, Winter Landscape, purchased, © the artist's estate

Gear, Willam 1915–1997, Landscape Composition, gift of Mrs Gill Sargeant, © the artist's estate

Gear, William 1915–1997, Untitled, gift of Mr Paul Harris, © the artist's estate

Gear, William 1915–1997, Vertical Feature, September 1961, acquired with the assistance of the Gulbenkian Fund, © the artist's estate

Geeraerts, Marcus the elder (attributed to) c.1520–before 1604, Portrait of a Lady, the Irene Law bequest

Gerrard, Kaff 1894–1970, Sussex Landscape, gift of Prof. A. H. Gerrard

Gibb, Harry Phelan 1870–1948, Paysage, the Lucy Carrington Wertheim bequest

Gibb, Harry Phelan 1870–1948, Group of Nude Women Bathers, the Lucy Carrington Wertheim bequest

Gibb, Harry Phelan 1870–1948, Three Graces, unknown

Gibb, Harry Phelan 1870–1948, Rose Nudes, the Lucy Carrington Wertheim bequest

Gibb, Harry Phelan 1870–1948, Six Nudes in Landscape, the Lucy Carrington Wertheim bequest

Gibb, Harry Phelan 1870–1948, Rose Nudes in Landscape, the Lucy Carrington Wertheim bequest

Gibb, Harry Phelan 1870–1948, Study of Four Women, the Lucy Carrington Wertheim bequest

Gladwell, Rodney 1928–1979, Night Voyage, the Lucy Carrington Wertheim bequest

Gladwell, Rodney 1928–1979, Chrysanthemums, the Lucy Carrington Wertheim bequest

Gladwell, Rodney 1928–1979, Abstract Head, the Lucy Carrington Wertheim bequest

Gladwell, Rodney 1928–1979, This is a Life Created, Flowing Spirit I Am Much, the Lucy Carrington Wertheim bequest

Gladwell, Rodney 1928–1979, Half-Length Male Nude, unknown

Gladwell, Rodney 1928–1979,

Male Figures
Gladwell, Rodney 1928–1979, *Mushrooms*, the Lucy Carrington Wertheim bequest
Glogan, Jeremy *Untitled*, purchased
Gogin, Charles 1844–1931, *Avard's Farm, Walberton*, donated by the artist's widow
Gommon, David 1913–1987, *Music Hall*, the Lucy Carrington Wertheim bequest
Goodall, Frederick 1822–1904, *Gypsy Encampment*, the Towner bequest
Goodman, Gary b.1959, *Double Portrait of Teresa with Tilda and Tintin*, purchased, © the artist
Gosse, Laura Sylvia 1881–1968, *Grande patisserie, Place Nationale, Dieppe*, purchased from the artist, © courtesy of the artist's estate/ www.bridgeman.co.uk
Gosse, Laura Sylvia 1881–1968, *The Column, Aix-en-Provence*, the Sylvia Gosse gift, © courtesy of the artist's estate/www.bridgeman. co.uk
Graham, George 1881–1949, *Hastings Beach with Sailing Boats*, unknown
Grant, Duncan 1885–1978, *Study for a Portrait of Bishop Bell*, acquired from the artist's estate, from long loan, © 1978 estate of Duncan Grant
Grant, Duncan 1885–1978, *The Glade, Firle Park*, purchased from the artist, © 1978 estate of Duncan Grant
Grant, Duncan 1885–1978, *Still Life*, purchased from the artist, © 1978 estate of Duncan Grant
Grant, Keith b.1930, *Pyramid Peak IV*, purchased
Griffiths, Hugh b.1916, *Early Spring, Distant View of Battle and Telham Mills*, purchased from the artist
Griffiths, Hugh b.1916, *Landscape*
Griffiths, Hugh b.1916, *Flowering Thorn*, purchased from the artist, on loan to EDEAL, Eastbourne
Griffiths, Joy b.1919, *City Crossroads*, purchased from the artist
Griffiths, Joy b.1919, *A Branch of Blossom*, unknown
Guy, G. G. d.1978, *Fishing Station, Eastbourne*, gift of Mr Guy
Hacker, Arthur 1858–1919, *Alderman J. A. Skinner, Mayor of Eastbourne (1895–1897)*, presented by to the town of Eastbourne public subscription, on loan to Eastbourne Borough Council, Town Hall
Hall, Kenneth 1913–1947, *Buckingham Palace from the Mall*, the Lucy Carrington Wertheim bequest
Hall, Kenneth 1913–1947, *Cap d'Ail*, the Lucy Carrington Wertheim bequest
Hall, Kenneth 1913–1947, *Trafalgar Square*, the Lucy Carrington Wertheim bequest
Hall, Oliver 1869–1957, *Burton Park, Sussex*, purchased

Haynes-Williams, John 1836–1908, *Salle ovale, Fontainbleau*, bequest of Miss D. Haynes Williams
Hayter, Stanley William 1901–1988, *Coast of Erehwon*, acquired with the assistance of the Gulbenkian Fund and the Victoria & Albert Museum purchase Grant Fund
Haywood, Ann b.1931, *Roof Tops in Snow*, the Port gift
Hemming, Adrian b.1945, *Arizona Ridge*, purchased, © the artist
Henry, George F. 1858–1943, *Landscape*, unknown
Herring, John Frederick I 1795–1865, *The Blacksmiths*, the Towner bequest
Herring, John Frederick I 1795–1865, *Cattle and Ducks*, the Port gift
Herring, John Frederick I 1795–1865, *Farm Scene with Cart Horses*, the Towner bequest
Herring, John Frederick I 1795–1865, *Study of the Horse B. G., West Australian Winner of the Derby and St Leger 1853*, unknown
Hider, Frank c.1861–1933, *Splash Point, Eastbourne 1894*, gift
Hilton, Roger 1911–1975, *Painting, May 1961*, acquired with the assistance of the Gulbenkian Fund, © the artist's estate
Hitchens, Ivon 1893–1979, *Evening Sky over Hills*, gift of the Contemporary Art Society, © Jonathan Clark & Co
Hitchens, John b.1940, *Duncton Down in Shadow*, purchased, © Jonathan Clark & Co
Hodgkins, Frances 1869–1947, *Cedric Morris (Man with Macaw)*, the Lucy Carrington Wertheim bequest
Hodgkins, Frances 1869–1947, *Flatford Mill*, the Lucy Carrington Wertheim bequest
Hodgkins, Frances 1869–1947, *Still Life*, the Lucy Carrington Wertheim bequest
Holles, Annelise b.1963, *Recollections: Dressing Table*, purchased
Holles, Annelise b.1963, *Recollections: Mirror*, purchased
Holloway, Rachel *The Horn Chair*, purchased
Holt, Pamela *Wild Daffodils*, the Royal Academy of Arts Biecentenary presentation
Horton, Percy Frederick 1897–1970, *Village in Luberon*, the Royal Academy of Arts Bicentenary presentation
Howard, Charles Houghton 1899–1978, *Painting 61–62 No.3*, acquired with the assistance of the Victoria & Albert Museum purchase Grant Fund and the Gulbenkian Fund
Hubbard, Eric Hesketh 1892–1957, *Rye*
Hubbard, Eric Hesketh 1892–1957, *Snow at Litlington*, donation, on loan to East Sussex County Council, Westfield House, Lewes
Hubbard, John b.1931, *Water

Painting: Sandbanks, purchased, © the artist
Hudson, Thomas (school of) 1701–1779, *The Hon. Mrs Plummer*, the Irene Law bequest, on loan to East Sussex County Council, Westfield House, Lewes
Hugonin, James b.1950, *Study for Untitled IV*, presented by the Contemporary Art Society, 2000, in memory of Nancy Balfour, OBE, © the artist
Huysmans, Jacob (attributed to) c.1633–1696, *Arcadian Landscape with Shepherd and Other Pastoral Figures in Background*, the Irene Law bequest, on loan to Eastbourne Borough Council, Town Hall
Hyman, Timothy b.1946, *The Procession (Sandown Race Course)*, purchased, © the artist
Innes, Callum b.1962, *Exposed Painting, Cadmium Orange*, acquired in partnership with the Contemporary Art Society and Arts Council of England as part of the Collections Scheme. Funded by the Contemporary Art Society, the Friends of the Towner, Eastbourne Borough Council, Towner Contemporary Art Fund Committee and donations
Jackowski, Andrzej b.1947, *Downfalling*, purchased, © the artist
Jacob, Alexandre 1876–1972, *Misty Morning*, bequest of Enid Dyer
Jagger, Charles Sargeant 1885–1934, *Alderman Lieutenant Colonel Roland Vaughan Gwynne, DSO, DL, JP, Mayor of Eastbourne (1928–1931)*, presented by public subscription
Jagger, Charles Sargeant 1885–1934, *Alderman Miss Alice Hudson, JP, Mayor of Eastbourne (1925–1928 & 1943–1945)*, presented by public subscription, on loan to Eastbourne Borough Council, Town Hall
James, Louis b.1920, *Suburban Landscape*, purchased from the artist
Jefferson, Anna b.1965, *On the Pier*, purchased, © the artist
Jensen, Michael *Amen*, purchased from the artist
Johnson, Nick b.1941, *Lurcher*, purchased, © the artist
Jones, David 1895–1974, *Sea View*, acquired with the assistance of MGC/V&A purchase Grant Fund, the National Art Collections Fund, and the Friends of the Towner, © trustees of the David Jones estate
Jones, Olwen b.1945, *Cucumber Plants*, purchased from the artist
Jones, Thomas 1742–1803, *Coast Scene with Approaching Storm*, acquired with assistance of the National Art Collections Fund, Resource/V&A purchase Grant Fund and the Friends of the Towner
Kirk, S. G. *Eastbourne Town Hall*, purchased
Kneller, Godfrey (studio of) 1646–1723, *Portrait of a Man*, gift,

condition: credit as anonymous, on loan to Michelham Priory, Hailsham, on loan to Michelham Priory, Hailsham
Knight, Charles 1901–1990, *Ditchling Beacon*, purchased from the artist, © the artist's estate
Knight, John William Buxton 1842/1843–1908, *Cousin Annie*, gift of Daphne Oliver
Knight, Keith b.1946, *Spectral Bands*, purchased
Knight, Loxton 1905–1993, *Birling Gap*, donated by Harold Head Esq.
Knight, Loxton 1905–1993, *Seven Sisters*, donated by Harold Head Esq.
Kolle, Helmut 1899–1931, *Boy with Bird*, the Lucy Carrington Wertheim bequest
Kolle, Helmut 1899–1931, *Bullfight*, the Lucy Carrington Wertheim bequest
Kulkarni, Lara Nita b.1967, *Untitled*, purchased
Lake, John Gascoyne 1903–1975, *An Eastbourne Garden (A Garden in the Provinces)*, purchased from the artist
Lancaster, Mark b.1938, *Diet*, acquired with the assistance of the Friends of the Towner, © the artist
Lander, Rachel b.1971, *Under the Rose*, purchased
La Thangue, Henry Herbert 1859–1929, *Portrait of a Young Girl*, purchased
Lawrenson, Edward Louis 1868–1940, *The Last Sussex Team*, acquired with the assistance of the Victoria & Albert Museum purchase Grant Fund, on loan to East Sussex County Council, Westfield House, Lewes
Le Brun, Christopher b.1951, *Painting, February 1982*, gift of the Contemporary Art Society, © the artist
Lessore, Thérèse 1884–1945, *Walcot Church, Bath*, gift of the Sickert Trust, © the artist's estate
Lewis, Gomer b.1921, *Untitled*, purchased
Lewis, Gomer b.1921, *Forest*, purchased from the artist
Littlejohn, William b.1929, *Night Window*, the Royal Academy bicentenary presentation
Lloyd, Thomas James 1849–1910, *Milk for the Calves*, the Towner bequest
Lloyd, Walker Stuart active 1875–1913, *The Ferry*, unknown
Loftus, Barbara b.1946, *Unanswered Call*, purchased, © the artist
Lord, Sarah b.1964, *Western Wind*, purchased, © the artist
Lord, Sarah b.1964, *Harbour*, purchased, © the artist
Low, Diana 1911–1975, *Still Life with Brown Jug*, purchased
Lucas, Caroline Byng c.1886–1967, *Admiral Lucas VC as a Young Man*, purchased
Lumsden, Bryan *Interior with Plant*, purchased from the artist
MacBryde, Robert 1913–1966, *A Vegetable Still Life*, purchased

MacLagan, Philip Douglas 1901–1971, *Bramber, from the South Downs*, donation, on loan to Eastbourne Borough Council, Town Hall
Magill, Elizabeth b.1959, *Overhead 3*, purchased by the Contemporary Art Society Special Collection Scheme on behalf of the Towner Art Gallery, with funds from the Arts Council Lottery, on loan to Ikon Gallery, Birmingham/ Milton Keynes Gallery/ Baltic, Gateshead, © the artist
Mann, Alexander 1853–1908, *On the Berkshire Downs*, unknown
Manson, James Bolivar 1879–1945, *Edith Matthews, née Meredith*, gift of Miss Mary Manson
Manson, James Bolivar 1879–1945, *S. F. Markham Esq.*, gift of Miss Mary Manson
March, Maria Elizabeth *The Parish Church, Eastbourne*, purchased from the artist
Marston, Freda 1895–1949, *Flood the Amberley*, purchased from the artist
Martin, Nicholas b.1957, *Impasse III*, purchased
Martin, Nicholas b.1957, *Untitled*, purchased
McCaffrey, Angela b.1962, *Connoisseur of Charlatan*, purchased, © the artist
McCaffrey, John b.1961, *Information is Power*, purchased, © the artist
McClure, David 1926–1998, *Horsemen and Icons*, purchased from the artist
McKeever, Ian b.1946, *Door Painting No.10*, purchased in partnership with the Contemporary Art Society and Arts Council of England as part of the Collections Scheme. Funded by the Contemporary Art Society, the Friends of the Towner, Eastbourne Borough Council, Towner Contemporary Art Fund and donations
Medley, Robert b.1905, *Figures in Movement*, acquired with the assistance of the Gulbenkian Fund
Meninsky, Bernard 1891–1950, *Landscape*, purchased, © the artist's estate
Meo, Gaetano 1849–1925, *Arundel Castle, Looking from the Back of the Railway Station*, donated by Miss Meo
Miller, Robert b.1910, *Eastbourne Front*, purchased, on loan to EDEAL, Eastbourne
Mills, Clive b.1964, *Untitled*, purchased
Minton, John 1917–1957, *Spanish Village*, acquired with the assistance of the Victoria & Albert Museum purchase Grant Fund, © Royal College of Art
Mockford, Harold b.1932, *Eastbourne*, purchased from the artist, © the artist
Mockford, Harold b.1932, *Chalk Pit in the Downs*, gift from long loan, © the artist

Mockford, Harold b.1932, *The Little Park (Motcombe Park)*, gift of Daphen Oliver, © the artist

Mockford, Harold b.1932, *Cars at Birling Gap*, gift of Mrs Hoyer, © the artist

Mockford, Harold b.1932, *Runner on the Downs*, gift of Mrs J. Newmark, © the artist

Mockford, Harold b.1932, *The Level Crossing (Crossing between Hailsham/ Stonecross)*, purchased from the artist, © the artist

Mockford, Harold b.1932, *The Windbreak*, acquired with the assistance of the Victoria & Albert Museum purchase Grant Fund, © the artist

Mockford, Harold b.1932, *The Sick Man*, donated by the artist in memory of his father, © the artist

Mockford, Harold b.1932, *When the Lights Come on*, acquired with the assistance of the MGC/V&A purchase Grant Fund, on loan to East Sussex County Council, Westfield House, Lewes, © the artist

Mockford, Harold b.1932, *Belle toute*, purchased from the artist, © the artist

Mockford, Harold b.1932, *Bon Voyage Sardinia Vera*, gift of Hilary Lane, © the artist

Monnington, Walter Thomas 1902–1976, *Design on Route 5*, donated by the artist, © the artist's estate

Morris, Cedric Lockwood 1889–1982, *Herstmonceux Church*, gift of R. A. Bevan Esq., © trustees of Cedric Morris estate/foundation

Morris, Cedric Lockwood 1889–1982, *Proud Lilies*, bequest of Miss Monica Graham Young, © trustees of Cedric Morris estate/foundation

Mortimer, John Hamilton 1740–1779, *Self Portrait in Character*, acquired with the assistance of the National Art Collections Fund

Mortimer, John Hamilton 1740–1779, *Mary, Second Wife of Reverend Henry Lushington, DD*, gift of Miss Davies Gilbert

Mortimer, John Hamilton 1740–1779, *Reverend Henry Lushington, DD*, gift of Miss Davies Gilbert

Müller, William James 1812–1845, *The Temple of Theseus*, the Towner bequest

Mundy, Henry b.1919, *Enclosed 1960*, acquired with the assistance of the Victoria & Albert Museum purchase Grant Fund, © the artist

Munnings, Alfred James 1878–1959, *Beach Scene*, purchased

Murray, David 1849–1933, *Fittleworth*, purchased

Murray, David 1849–1933, *Ludlow Castle*, the Towner bequest

Murray, David 1849–1933, *Music by the Lake*, gift of T. Crompton Peatfield Esq.

Murray, David 1849–1933, *Remains of Bygone Days*, gift of T. Crompton Peatfield Esq.

Murray, David 1849–1933, *Springtime in the Woods*, gift of T. Crompton Peatfield Esq.

Musscher, Michiel van (attributed to) 1645–1705, *The Hope Family of Rotterdam*, the Irene Law bequest

Mytens, Daniel I (after) c.1590–before 1648, *Portrait of a Man thought to be Viscount Falkland*, the Irene Law bequest, on loan to East Sussex County Council, Westfield House, Lewes

Narbeth, William Arthur 1893–1961, *Marar Waterfall*, donated by Mrs E. J. Hill

Nash, John Northcote 1893–1977, *Disused Canal, Wormingfold*, the Miss Jean Batters bequest, © artistic Trustee of estate of John Nash

Newton, William John 1785–1869, *Scottish Child and Dog*, the Port gift

Nibbs, Richard Henry 1816–1893, *Pevensey, Showing a Soldier in the Uniform of the North Pevensey Legion Raised by Lord Sheffield in 1803*, unknown

Nicholls, Bertram 1883–1974, *Lancing Chapel*, purchased

Nicholson, William 1872–1949, *Judd's Farm*, acquired with the assistance of the MGC/V&A purchase Grant Fund, National Art Collections Fund and the Friends of the Towner, © Elizabeth Banks

O'Connor, John 1830–1889, *Dawn near East Coast*, the Miss Jean Batters bequest

O'Neil, Henry Nelson 1817–1880, *Portrait of a Girl*, the Port gift

Orrock, James 1829–1913, *Showery Weather*, the Towner bequest

Owen, Mary *The Backwater, Weymouth*, unknown

Oxlade, Roy b.1929, *Blue Flowers*, purchased, © the artist

Oxtoby, David b.1938, *That's Alright*, purchased

Pace, Percy Currall active 1898–1936, *Victoria Drive*, purchased

Palmer, Garrick b.1933, *Lazarus Raised from the Dead*, purchased from the artist

Palmer, Rozanne b.1932, *Wood Burning Stove*, purchased

Parker, Frederick H. A. d.1904, *Wish Tower, Eastbourne*, purchased

Parsons, Christine c.1912/1914, *Three Jars*, purchased from the artist

Pasmore, Victor 1909–1998, *Study of a Cast of a Child's Head*, the Miss Winifred Pasmore bequest

Pasmore, Victor 1909–1998, *The Front at Seaford*, the Miss Winifred Pasmore bequest

Pasmore, Victor 1909–1998, *Carnations in a Glass Vase*, the Miss Winifred Pasmore bequest

Pasmore, Victor 1909–1998, *Mother and Florence*, the Miss Winifred Pasmore bequest

Payen, Sally b.1964, *The Blue River*, purchased

Pears, Charles 1873–1958, *Beachy Head, Moonlight*, purchased

Plumb, John b.1927, *New Bamboo 1961*, acquired with the assistance of the Friends of the Towner, ©

the artist

Preece, Patricia 1894–1966, *Girl in Yellow Dress*, gift of Mr Saxon Sidney-Turner, © 2005. All Rights Reserved DACS

Preece, Patricia 1894–1966, *In a Cottage*, gift of Mr Saxon Sidney-Turner, © 2005. All Rights Reserved DACS

Quigley, Peter *Flint Lines II*, purchased from the artist

Reeve-Fowkes, David *Fields near Rievaulx, Yorkshire*, purchased from the artist

Reitlinger, Gerald 1900–1978, *Still Life with Prawns*, the Syliva Gosse gift

Riboulet, Jacques M. b.1930, *Screaming Cliffs*, purchased

Richards, Ceri Geraldus 1903–1971, *Poissons d'or*, acquired with the assistance of the Gulbenkian Fund and the Victoria & Albert Museum purchase Grant Fund, © estate of Ceri Richards 2005. All Rights Reserved DACS

Rivers, Leopold 1852–1905, *On the River Cuckmere*, gift, on loan to East Sussex County Council, Westfield House, Lewes

Robertson, Tom 1850–1947, *Moonrise on the Loire*, purchased

Rodmell, Ilsa b.1898, *Chase (The Hunt)*, the Lucy Carrington Wertheim bequest

Salby *View of a Bridge*, unknown

Scott, William George 1913–1989, *Blue on Blue*, presented by Contemporary Art Society, 2000, in memory of Nancy Balfour, OBE

Seabrooke, Elliot 1886–1950, *Landscape*, purchased from the artist

Seabrooke, Elliot 1886–1950, *Trees and Red Gate*, purchased from the artist

Shayer, William 1788–1879, *Shore Scene with Figures*, the Towner bequest

Sheldon-Williams, Inglis active 1902–1945, *Farm Wagon, Exceat*, purchased

Sheldon-Williams, Inglis active 1902–1945, *Oxen with Wagon*, purchased

Shepherd, Dominic b.1966, *The Secret Language of Insects*, purchased

Sickert, Walter Richard 1860–1942, *The Poet and His Muse*, the Sylvia Gosse gift, © estate of Walter R. Sickert 2005. All Rights Reserved DACS

Sigrist, Anthony *Rift*, gift

Smith, George 1829–1901, *The Auction*, the Towner bequest

Smith, George 1829–1901, *The Launch*, the Towner bequest

Smith, Jack b.1928, *Central Disturbance*, purchased, © the artist

Smith, Matthew Arnold Bracy 1879–1959, *Seated Female Nude*, acquired with the assistance of the Victoria & Albert Museum purchase Grant Fund, © the artist's estate

Smythe, Canon *Chalk Pit, Sussex*, donated by the artist's family

Snyders, Frans (attributed to) 1579–1657, *Still Life: Fruit, Vegetables and Game on a Table*, the Irene Law bequest

Spear, Ruskin 1911–1990, *Woman Ironing*, gift through the NACF, © courtesy of the artist's estate/www. bridgeman.co.uk

Spear, Ruskin 1911–1990, *Spring in Hammersmith*, gift, © courtesy of the artist's estate/www. bridgeman.co.uk

Spencer, Charles Neame active 1896–1917, *On the South Coast*, purchased from the artist

Steadman, J. T. active 1884–1911, *Portrait of an Old Lady Holding Her Spectacles*

Stevens, Christopher b.1961, *Two Trunked Elephants*, purchased

Stockley, Henry 1892–1982, *Flight into Egypt*, the Lucy Carrington Wertheim bequest

Stockley, Henry 1892–1982, *Through the Trees, Hyde Park*, the Lucy Carrington Wertheim bequest

Stockley, Henry 1892–1982, *Evelyn Laye in Hyde Park*, the Lucy Carrington Wertheim bequest

Stockley, Henry 1892–1982, *Girl and Dogs*

Stott, Edward 1859–1918, *Lambing Time*, the Cecil French bequest

Stott, Edward 1859–1918, *Saturday Night*, the Cecil French bequest

Street, Evelyn active 1950s–1960s, *Still Life*, purchased from the artist

Strutt, Alfred William 1856–1924, *Pot Luck*, the Towner bequest

Swanwick, Joseph Harold 1866–1929, *Alfriston*, purchased

Swanwick, Joseph Harold 1866–1929, *Oxen Ploughing, South Downs*, purchased

Tennant, John F. 1796–1872, *View of Martello Towers near Bexhill, Looking towards Beachy Head*, acquired with the assistance of the Victoria & Albert Museum purchase Grant Fund, the National Art Collections Fund and the Friends of the Towner

Tennant, John F. 1796–1872 & Herring, John Frederick I 1795–1865 *Resting at Plough*, gift, on loan to Eastbourne Borough Council, Town Hall

Thompson, Estelle b.1960, *Winterlude*, purchased, on loan to Community Alcohol Team Project, Eastbourne, © the artist

Thorpe, L. *Study of a Man Wearing a Felt Hat*

Tindle, David b.1932, *Beach Scene*, the Miss Jean Batters gift, © the artist

Tindle, David b.1932, *Beach '61*, the Miss Jean Batters bequest, © the artist

Towner, Donald Chisholm 1903–1985, *The Pool of London, 1935*, purchased, © the artist's estate

Towner, Donald Chisholm 1903–1985, *Church Row Gardens, Spring*, gift of the artist, © the artist's estate

Townsend, Kenneth 1935–2001, *Tregarthen*, purchased from the artist

Townsend, William 1909–1973, *Sundance Canyon*, acquired with the assistance of the Gulbenkian Fund

Townshend, Jo b.1967, *Shoreline*, purchased, © the artist

Trevelyan, Julian 1910–1989, *Durance Valley*, purchased

Trollope, Roy b.1933, *Falling*, purchased, © the artist

Turpin, Louis b.1947, *Patchwork*, purchased, © the artist

unknown artist *At Full Sail*

unknown artist *Ginger Jar and Mandarins*, unknown

unknown artist *Still Life with Bottle, Melon and Teapot*, unknown

unknown artist *Three Tone, White to Cream*, unknown

unknown artist *Time for the Leaves to Tumble*, purchased

Unsworth, Peter b.1937, *Evening Bowls*, acquired with the assistance of the Victoria & Albert Museum purchase Grant Fund

Urquhart, Murray McNeel Caird 1880–1972, *Rye*, purchased

Vaughan, John Keith 1912–1977, *Standing Figure*, gift of the Contemporary Art Society, © the estate of Keith Vaughan 2005. All Rights Reserved DACS

Velde, Peter van den 1634–after 1687, *Dutch Men O'War in a Squall off a Coastal Town*, the Irene Law bequest

Velde, Willem van de II (style of) 1633–1707, *Storm and Shipwreck (British and Dutch Men O'War Floundering in a Gale off a Rocky Coast)*, unknown

Virtue, John b.1947, *Landscape No.82*

Virtue, John b.1947, *Landscape 268*

Wadsworth, Edward Alexander 1889–1949, *Bronze Ballet*, acquired with the assistance of the V&A purchase Grant Fund, © estate of Edward Wadsworth 2005. All Rights Reserved DACS

Wallis, Alfred 1855–1942, *Sailing Ship*, the Lucy Carrington Wertheim bequest

Wallis, Alfred 1855–1942, *Steamer*, the Lucy Carrington Wertheim bequest

Wallis, Alfred 1855–1942, *Three Ships*, the Lucy Carrington Wertheim bequest

Wallis, Alfred 1855–1942, *White Sails*, the Lucy Carrington Wertheim bequest

Ward, John *All Night Café*, unknown

Ward, John *The Reverend Dr Lushington*, purchased

Warden, William 1908–1982, *East Beach, Hastings*, purchased from the artist

Ware, William b.1915, *Battersea*, purchased

Webb, James c.1825–1895, *Seascape*, donated by Mr E. V. White MA, LLB

Weight, Carel Victor Morlais 1908–1997, *The Old Woman in the Garden No.2*, acquired with the assistance of the National Art Collections Fund and the Victoria

& Albert Museum purchase Grant Fund, © the estate of the artist
West, C. H. *Old Town, Eastbourne*, purchased from the artist
Wheatley, John 1892–1955, *The Darlings*, the Sylvia Gosse gift
Wheeler, Charles 1892–1974, *Windswept Snow on Frozen Pond*, the Miss Jean Batters bequest
Whelpton, Gertrude 1867–1963, *Alderman Morrison, Mayor of Eastbourne (1889–1892)*, donated by Miss A. M. Morrison
White, B. D. F. *Royal Welsh Agricultural Society Show*, purchased
White, Ethelbert 1891–1972, *Sussex Landscape*, purchased, © the Ethelbert White estate
Whitten, Philip John b.1922, *Puerto Pollensa, Majorca*, gift
Wicksman, Anca b.1964, *Bishop's Meadow*, purchased, © the artist
Williams, Bruce b.1962, *Sea View I*, purchased, © the artist
Wimperis, Edmund d.1946, *Forest Row, Sussex, the Golf Course*, gift of Lady Nash
Wood, Christopher 1901–1930, *Fair at Neuilly*, the Lucy Carrington Wertheim bequest
Wood, Christopher 1901–1930, *Constant Lambert*, the Lucy Carrington Wertheim bequest
Wood, Christopher 1901–1930, *French Crab Boat, Tréboul*, the Lucy Carrington Wertheim bequest
Wood, Christopher 1901–1930, *PZ 134*, the Lucy Carrington Wertheim bequest
Wood, Christopher 1901–1930, *Conversation Piece*, the Lucy Carrington Wertheim bequest
Wood, Christopher 1901–1930, *Girl on a Chair (Figure for a Screen)*, the Lucy Carrington Wertheim bequest
Wood, Christopher 1901–1930, *Paris under Snow*, the Lucy Carrington Wertheim bequest
Wootton, Frank 1914–1998, *Windover in Winter, Alciston, January*, purchased
Wootton, Kenneth Edwin c.1892–1974, *Brian*
Wootton, Kenneth Edwin c.1892–1974, *Mrs K .E. Wootton*, gift of Mynie Wootton
Wright, Joseph of Derby 1734–1797, *River Landscape*, the Irene Law bequest
Wynter, Bryan 1915–1975, *Red Spoor 1960*, acquired with the assistance of the Victoria & Albert Museum purchase Grant Fund, © estate of Bryan Wynter 2005. All Rights Reserved, DACS
Yhap, Laetitia b.1941, *Paul Carrying Robin Huss Accompanied by His Dog Saxon*, purchased, © the artist

Michelham Priory

Elder, Dorothy 20thC, *Red Oxen of Sussex*, donation
Gardiner, A. *Michelham Priory and Gatehouse*, donation

Hayward, Arthur 1889–1971, *Michelham Priory with Moat (South Aspect of Michelham)*, donation
Hayward, Arthur 1889–1971, *Michelham Priory with Moat*, donation
Swanwick, Joseph Harold 1866–1929, *Horses at Wilmington (Priory Farmyard)*, indefinite anonymous loan
unknown artist 19th C, *William Lambe of Wilmington*, donation
unknown artist *The Gatehouse and Moat at Michelham Priory*, donation

Conquest Hospital

Braven, Angela *Hastings Old Town Beach*, loan from the artist
Brine, John b.1920, *Abstract Series 2*, loan from the artist
Khanna, Balraj b.1940, *Sussex by the Sea*, © the artist
Oxley, Nigel b.1949, *Holidays*, loan from the artist, © Nigel Oxley
unknown artist *Hastings Fishing Beach*
unknown artist *Hastings Pier (Triptych)*, loan from West Hill Boys Club
unknown artist *Hastings Pier (Triptych)*, loan from West Hill Boys Club
unknown artist *Hastings Pier (Triptych)*, loan from West Hill Boys Club

Hastings Fishermen's Museum

Austen *Shackleton's 'Endurance' in the Antarctic Ice*, given to the museum in 1994
Borrow, William Henry 1840–1905, *East Cliff and Fishing Vessels*, permanent loan from Hastings Museum and Art Gallery
Borrow, William Henry 1840–1905, *Fishermen on the Stade*, on permanent loan from the Winkle Club since March 1964, given by Mrs Norman Strickland to the Winkle Club in 1963
Borrow, William Henry 1840–1905, *A Good Catch*, on permanent loan from Hastings Museum and Art Gallery from 25th July 2002
Borrow, William Henry 1840–1905, *Coming Ashore*, on permanent loan from the Winkle Club since March 1964, given by Mrs Norman Strickland to the Winkle Club in 1963
Borrow, William Henry 1840–1905, *Fishing Boat at Sea*, on permanent loan from Hastings Museum and Art Gallery from 25th July 2002
Brown, Tom *Sailing Boat*, given to Hastings Fishermen's Museum in 1956
Burwood, George Vemply c.1845–1917, *Seascape, Fishing Boats by Moonlight*, given by unknown to Hastings Fishermen's Museum
Garrod, L *Quiet Morning*, given

by Mr and Mrs E. K. Wright to Hastings Fishermen's Museum on 26th December 1995
Harding, James Duffield 1798–1863, *Hastings Luggers on the Beach*, given by unknown to Hastings Museum and Art Gallery between 1956 and 1994, permanent loan from Hastings Museum and Art Gallery
Maurice *Sunset over the Stade*, given to the museum in 2002
Moore, Jean *The Lifeboat 'Fairlight' at Sea*, presented to the Hastings branch of the RNLI by Mrs J. Moore
Moore, Jean *Fleet in Mourning*, given by Jean Moore to Hastings Fishermen's Museum on 29th June 2001
Moore, Jean *The Stade*, given by Jean Moore to Hastings Fishermen's Museum in 2003
Moore, Jean *Fishermen's Boat Race, Hastings*, given by Mrs M. Fairchild to Hastings Fishermen's Museum on 8th January 1998
Schofield, James (attributed to) *The Stade and Fishing Boat K52*, given by the family of Mr and Mrs Benjamin James Smith to Hastings Fishermen's Museum after 1956
Sheppard *Looking West from Rye*, given to the museum in 2002
Shore, Stephen *Among the Net Sheds of Old Hastings*, given by Miss Routh to Hastings Fishermen's Museum between 1961 and 1994
Smith, E. Blackstone *The Stade, 1839*, given by unknown to Hastings Fishermen's Museum between 1956 and 1994
Strickland, William Francis d.2000, *East Hill from Harbour Arm*, given by William Strickland to Hastings Fishermen's Museum in 1992
Strickland, William Francis d.2000, *Hastings Fishermen's Museum*, property of Hastings Fishermen's Museum since 7th October 1999
Turner, J. C. J. late 20th C, *Beaching a Pink in Heavy Weather (copy of Edward William Cooke)*, given by Roy Farnborough to Hastings Fishermen's Museum in 1991
unknown artist *Sailing Vessel off Hastings*, given to Hastings Museum and Art Gallery after 1956 by unknown, permanent loan from Hastings Museum and Art Gallery
unknown artist 19th C *Boat and Two Fishermen*, given by unknown to Hastings Fishermen's Museum between 1956 and 1994
unknown artist *Old Fisherman with White Beard Smoking a Pipe*, given by unknown to Hastings Fishermen's Museum on 7th January 2004
unknown artist *Hastings Fishing Boat RX10*, given by unknown to Hastings Fishermen's Museum between 1956 and 1994
unknown artist *Charles and Robert RX266*, given by S. Peak to

Hastings Fishermen's Museum on 4th October 1999
unknown artist *The Presentation of the Golden Winkle to Winston Churchill, 7th September 1955*, given to the museum in 1994, permanent loan from Hastings Town Council
unknown artist *Biddy Stonham*, given by Mr Philcox to Hastings Fishermen's Museum
unknown artist *RX94 Industry Coming Ashore*, given by Jo Adams to Hastings Fishermen's Museum between 1956 and 1994
White *Mizpah RX135*, given to the museum in 1994
Yhap, Laetitia b.1941, *Fishermen on Hastings Beach*, on loan from Summerfields Sports Centre, Hastings, permanent loan from Summerfields Sports Centre, © the artist

Hastings Library

Armitage, Edward 1817–1896, *A Dream of Fair Women (Diptych)*
Armitage, Edward 1817–1896, *A Dream of Fair Women (Diptych)*
Crozier, Philip b.1947, *The Fish Wife*

Hastings Museum and Art Gallery

Aglio, Agostino Maria 1777–1857, *Entrance to Hastings from London Road*, gift from Mr Clifford Howes
Aglio, Agostino Maria 1777–1857, *Hastings from the London Road*, acquired in 1946
Armitage, Edward 1817–1896, *Ladies and Swans*, gift from Miss N. Armitage, 1959
Badham, Edward Leslie 1873–1944, *Autumn Sunshine, Bourne Walk, Hastings*, donation by the artist
Baines, Dick b. 1940, *East Hill Passage*, gift from Vicat Cole Fund, 1968
Baines, Dick b. 1940, *Hastings 1066–1966*, gift from Went Tree Trust, 1968
Baines, Dick b. 1940, *The Sun Inn, Tackleway*, gift from Vicat Cole Fund, 1968
Baines, Dick b. 1940, *Prospect Place*, gift from Went Tree Trust, 1968
Bas, Edward le 1904–1966, *The Lighthouse, Rye Harbour*, gift from Contemporary Art Society, Sir Edward Marsh Bequest, 1954
Baynes, Keith 1887–1977, *Still Life*, gift from General D. Horsfield
Baynes, Keith 1887–1977, *View of Lisbon from Almeria*, gift from the Went Tree Trust in 1986
Beere, Thomas Handsford 1874–1953, *April*, purchased from 'Invitation Exhibition', 1952
Beere, Thomas Handsford 1874–1953, *Landscape*, purchased from family who owned artist's former house, 1969
Berchem, Nicolaes (after)

1620–1683, *Italian Landscape*, gift from Mr G. W. Foxon
Bird, A. *After the Storm, Hastings*, gift from Miss E. Connold, 1981
Blackmore, Edward 1898–1983, *Blackfoot Indians, Montana*, gift from E. H. Blackmore, 1983
Blackmore, Edward 1898–1983, *The Supreme Appeal (from the sculpture by Cyrus Edwin Dallin)*, gift from Edward Blackmore, 1983
Blackmore, Edward 1898–1983, *Chief Oskenonton*, gift from Edward Blackmore, 1983
Blackmore, Edward 1898–1983, *Sitting Bull*, gift from Edward Blackmore, 1983
Bland, Emily Beatrice 1864–1951, *Building the Rick*, gift from Contemporary Art Society, 1952
Bodichon, Barbara Leigh Smith 1827–1891, *Sarrzet*, bequest by Matilda Betham Edwards
Bond, Arnold 1905–1990, *Bicycle with Boat*, gift from Mrs Julie Longbottom
Bond, Arnold 1905–1990, *Clog Clamp, Holland*, gift from Mrs Julie Longbottom
Bond, Arnold 1905–1990, *Cornfield, Sevenoaks*, gift from Mrs Julie Longbottom
Borrow, William Henry 1840–1905, *Galley Hill*, gift from Reverend F. G. Marriott, 1955
Borrow, William Henry 1840–1905, *Hastings Beach*, gift from T. Knox Shaw, 1957
Borrow, William Henry 1840–1905, *Hastings from the Sea*, purchased by Went Tree Trust, 1981
Borrow, William Henry 1840–1905, *Hastings from Torfield*, gift from Mr G. N. Herington
Borrow, William Henry 1840–1905, *Fairlight Glen*, gift from T. Knox Shaw, 1957
Borrow, William Henry 1840–1905, *Hastings from the East Cliff*, gift from Went Tree Trust
Borrow, William Henry 1840–1905, *Hastings Beach*, purchased from Fanny Borrow, 1955
Borrow, William Henry 1840–1905, *Hastings Beach Looking East to Pelham Crescent*, bequest from Kathleen Crowhurst, 1991
Borrow, William Henry 1840–1905, *Rye*, gift from Mrs C. Howes, 1956
Borrow, William Henry 1840–1905, *View across Priory Valley to the Castle*, given by Roger and Geoffrey Munn in memory of their mother, Marion Munn née Hollingsworth who inherited the picture from her parents
Borrow, William Henry 1840–1905, *Sea Piece*, donation by pupil of the artist
Borrow, William Henry 1840–1905, *Study for 'The Harvest of the Sea'*, purchased from Fanny Borrow, the artist's daughter, 1955
Borrow, William Henry 1840–1905, *Ruins of Old Ore Church*, purchased from Howes Bookshop, 1972

Hyde

Lancaster, Richard Hume 1773–1853, *Marine Parade, Hastings*, presented to the Mayor and Corporation of Hastings by Arthur Du Cros MP to commemorate the visit of the Lord Mayor and Sheriffs of London in 1908

Lancha, P. *Councillor D. W. Wilshin, MBE, JP, Mayor (1962–1967)*, gift from G. S. Dicker

Lansdell, Avril *Ecclesbourne Cliff, Hastings*, gift from the artist

Lansdell, Avril *The Broken Boat*, gift from the artist

Leggat, Douglas James *Councillor Alan Stace, Mayor (1981–1983)*

Lessore, Thérèse 1884–1945, *The Daredevils*, purchase from Harry Lucy's sale by Went Tree Trust, 13 October 1983, © the artist's estate

Lewis, F. Howard *HM Queen Elizabeth II in Coronation Robes (after Herbert James Gunn)*, purchased from Vicat Cole Bequest, 1960

Lilley, E. P. *A Bazaar*, gift from Miss Dalton

Lilley, E. P. *Marshland*, gift from Miss Dalton

Lilley, E. P. *Summer Meadow*, gift from Miss Dalton

Lilley, E. P. *The Butcher's Boy*, gift from Miss Dalton

Lines, Vincent Henry 1909–1968, *Hastings from John's Place*, purchased by Brassey Fund from Vincent Lines Memorial Trust

W. J. M. *Hollington Church in the Wood*, gift from G. H. Kenwood, 1949

Maitland, J. *The Railway Embankment in 1866*, gift from Miss E. Evans

Marks, Margaret 1899–1990, *Net Shops at Rock-a-Nore*, gift from Mr Harold Marks

Mazzoni, Sebastiano c.1611–1678, *Study for the Sacrifice of Jephthah*, unknown

Meadows, Arthur Joseph 1843–1907, *Hastings Beach*, gift from Hastings and St Leonards Museum Association

Mears, George 1826–1906, *The Steam Ship 'Carrick Castle'*, transferred from Hastings Town Hall by orders of Watch Committee, July 1937

Methuen, Paul Ayshford 1886–1974, *Number 3, St James Street, Bath*, purchased from Invitation Exhibition, 1952

Mitchell, John Campbell 1865–1922, *Clearing after Rain*, donation by A. E. Anderson

Moss, Sidney Dennant 1884–1946, *Harmony (Cattle Watering, Pevensey)*, gift from Went Tree Trust

Moss, William George active 1814–1838, *Rescue at Hastings*, gift from the Went Tree Trust and V&A/Museums and Galleries Comission Purchase Grant Fund, 1994

Moss, William George active 1814–1838, *Hastings Town Hall*, purchased by the Went Tree Trust

Murray, David 1849–1933, *The Fairy Glen*, per executor Sir Edwin Cooper

Neave, Alice Headley 1903–1977, *Children Returning to School, Battle*, purchased from artist's exhibition in art gallery

Neave, Alice Headley 1903–1977, *Smokey Afternoon, Ore*, purchased from Went Tree Trust in 1974

Neave, Alice Headley 1903–1977, *Tree in Winter, Tunbridge Wells*, gift from Dr Summers and Mrs M. Cranleigh

Panini, Giovanni Paolo c.1692–1765, *Classical Ruins*, bequest by Rev. L. B. Bartleet

Parkin, Thomas 1845–1932, *Bulverhythe, St Leonards on Sea*, donation by the artist

Parkin, Thomas 1845–1932, *The Bull Inn, Bulverhythe*, gift from Captain and Mrs Parkin

Parks, W. J. *View from All Saints*, gift from Mrs N. P. Bardin and Miss E. N. Wright

Patry, Edward 1856–1940, *Major Cyril Davenport*, gift from Mrs Patry in 1942

Pavey, A . J. *Vincent Lines*, purchased

Pellegrin, V. *Lifeboat House*, purchased from Mr J. Taylor, 1981 by V&A Purchase Grant Fund and Went Tree Trust

Pellegrin, V. *The East Hill Well*, purchased from Mr J. Taylor, 1981 by V&A Purchase Grant Fund and Went Tree Trust

Pether, Henry active 1828–1865, *Off Tilbury, Shipping on the Thames in Moonlight*, purchased from Mr Rix, Hastings in 1927

Pike, Leonard W. 1887–1959, *Autumn in the Wye Valley*, gift from Mrs Pike

Porter, W. *Hon. Mrs Freeman Thomas*

Powell, Charles Martin 1775–1824, *Hastings*, gift from Mrs Sayer-Milward

Powell, Joseph 1796–c.1834, *Dutch Man of War and Frigate*, gift from Mrs Reay in 1937

Pratt, Leonard *Vincent Lines*, gift from the artist

Prout, Margaret Fisher 1875–1963, *Blossom Time*, gift from Went Tree Trust, 1951

Quick, Horace Edward d.1966, *The Old Lady*, gift from Miss Quick

Rankle, Alan b.1952, *Marine Court, St Leonards*, gift from the artist, 1989

Ray, Edith 1905–c.1989, *Ebb Tide, Cleddau, Pembrokeshire*, bequest from Miss Ray

Ray, Edith 1905–c.1989, *Gatigues, Provence*, bequest from Miss Ray

Ray, Edith 1905–c.1989, *Old Mill, Winchelsea*, bequest from Miss Ray

Ray, Edith 1905–c.1989, *Rye Harbour, Sussex*, bequest from Miss Ray

Read, Arthur Rigden b.1879, *September Sunshine*, bequest of Charles A. Baxter

Reni, Guido (after) 1575–1642, *Head of Christ*, gift from Miss M.

E. Leyster

Richardson, Bob b.1928, *Trek to Birch Lake, out of Cabano, Quebec*, gift from the artist

Roberts, Arthur Spencer 1920–1997, *'HMS Corunna' and 'Agincourt' at Hastings during the Coronation Celebrations*, gift from Councillor Sims Hilditch, 1955

Romagnoli, Angiolo *Augustus Hare*, bequeathed by the sitter

Roussel, Theodore 1847–1926, *Parkland in Summer*, purchased from Spira

Rubens, Peter Paul (school of) 1577–1640, *Rubens*, gift from Mrs Dawson

Shannon, James Jebusa 1862–1923, *Miss D. L. Smith*, bequest from Miss D. L. Smith, the sitter

Sharp, Dorothea 1874–1955, *By the Lakeside*, bequest from Violet Vicat Cole, 1955

Sharp, Dorothea 1874–1955, *Children on a Hillside*, bequest from Violet Vicat Cole, 1955

Shayer, William 1788–1879, *Carthorses and Rustics by a Stream*, gift from Colonel T. Bartlet Hornblower

Shee, Martin Archer 1769–1850, *Lieutenant Colonel Sir Henry Vassal Webster*, gift from Miss Kathleen Webster, granddaughter of the sitter

Sickert, Walter Richard 1860–1942, *Signor de Rossi*, gift from Went Tree Trust, © Estate of Walter R. Sickert 2005. All Rights Reserved DACS

Smith, E. Blackstone *The Oil Stove*, gift from Contemporary Art Society, 1957

Stallard, Constance b.1870, *Jerusalem from Mount Scopus*, gift from Constance Stallard in 1943

Strickland, William Francis d.2000, *Old St Helen's Church*, gift from Mr W. F. Strickield

Strickland, William Francis d.2000, *The Last Over*, purchased by Went Tree Trust from East Sussex Arts Club Exhibition, 1989

Strickland, William Francis d.2000, *Darwell Reservoir*, gift from the artist, 1991

Strickland, William Francis d.2000, *Engine Houses, Brede Pumping Station*, gift from the artist, 1991

Strickland, William Francis d.2000, *Tangye Engine at Brede Pumping Station*, gift from the artist, 1991

Strickland, William Francis d.2000, *Evening at Rye*, gift from J. M. Baines

Strij, Abraham van 1753–1826, *Dutch Girl and Boy on House Doorstep*, gift from Ernest Edward Cook through the National Art Collections Fund, 1955

Strutt, Alfred William 1856–1924, *Temptation in the Wilderness*, donation by artist's son

Thorpe, John 1813–1897, *The Rope Walk*, gift from G. A. Herington

Townsend, Kenneth 1935–2001, *Fieldmark*, purchased by Went Tree

Trust from artist's widow

unknown artist *Poacher in a Wood*, unknown

unknown artist *William Phillips Lamb, Mayor of Rye in His Robes as a Baron of the Cinque Ports*, unknown, on loan to National Trust, Lamb House, Rye

unknown artist *The Schooner 'London' Built at Chester in 1827*, gift from Mrs Marjory Watts, 1983

unknown artist *Reverend Thomas Vores as a Young Man*, gift from Mrs G. M. Dillmore in 1932

unknown artist *Marianne Barnfather Eagles in Middle Age*

unknown artist *William Barnfather Eagles in Middle Age*, gift from Mrs E. Hooke, 1980

unknown artist *The Reverend Thomas Vores*

unknown artist *View of Old Town from above All Saints Church*, gift from Mrs V. Farmer, 1987

unknown artist *Edwin Bradnam in Mayoral Robes*, gift from J. R. Jackson, 1977

unknown artist *Copy of Diamond Jubilee Portrait of Queen Victoria*, gift to the Mayor and Burgesses of Hastings from Highbury School for Old Boys, 1908

unknown artist early 19th C, *John Goldsworthy Shorter, Mayor of Hastings*, gift from Mrs Luthwaite, 1972

unknown artist *E. D. Compton MA, Headmaster of Summerfields School (1903–1928)*, gift from Colonel Haig, 1966

unknown artist *Biddy the Tubman*, purchased through the Brassey Fund from Mr Kent Taylor, 1979

unknown artist *James Burton (1761–1837), Founder of St Leonards*, gift from Miss C. M. Pott, great-granddaughter of sitter, 1952

Urquhart, Murray McNeel Caird 1880–1972, *Alderman Arthur Blackman*

Warden, William 1908–1982, *The Gate*, gift from Mr G. M. Grant

Weight, Carel Victor Morlais 1908–1997, *Holland Walk*, purchased from Museum Invitation Exhibition, 1954, © the estate of the artist

West, Samuel c.1810–after 1867, *Marianne Barnfather Eagles as a Young Woman*, gift from Mrs E. Hooke, 1980

West, Samuel c.1810–after 1867, *William Barnfather Eagles as a Young Man*, gift from Mrs E. Hooke, 1980

West, Samuel (attributed to) c.1810–after 1867, *James Breeds Junior*, gift from Mrs Elizabeth Massy, 1993

Williams, Ina Sheldon 1876–1955, *Oxen Ploughing, the Cuckmere*, purchased from the artist

Williams, Ina Sheldon 1876–1955, *Sussex Oxen and Hayricks*, purchased by Brassey fund from Miss Eve Sheldon Williams, 1973

Williams, Terrick 1860–1936, *The Harbour at Mevagissey, Cornwall*, purchased from the sale of the late

E. W. Amoore, 1952

Williams, Walter 1835–1906, *Hastings Beach*, donation by Mrs Crewdson

Williams, Walter 1835–1906, *Misty Morning, Old Hastings*, gift from Mr C. Howes, 1956

Williamson, J. active 1850–1919, *German Lifeboat U118 Stranded at Hastings Beach*, gift from G. S. Gildersleeve

Williamson, William Henry 1820–1883, *Shipping off Dover*, gift from Colonel T. Bartlett Hornblower in 1933

Wright, Macer active 1893–1919, *Man with White Hair and Beard Holding Papers*

Wright, Macer active 1893–1919, *Unidentified Mayor (Possibly Alderman Mitchell)*

Yale, W. *Copeland Plaque, Rough Day, off Bexhill*

Yale, W. *Copeland Plaque, View off Hastings*, purchased by the Went Tree Trust from Sotheby's, Belgravia

Yhap, Laetitia b.1941, *The Boat*, purchased through Museums and Galleries Commission/ Victoria and Albert Museum Purchase Grant Fund and Went Tree Trust in 1991, © the artist

Zermati, Jules 1875–1925, *A Pinch of Snuff*, gift from Miss N. Armitage, 1959

Charleston

Bagenal, Barbara 1891–1984, *Menton*, gift

Barne, George Hume b.1882, *Still Life with Strawberries*, gift

Bas, Edward le 1904–1966, *Snow Scene*, gift

Baynes, Keith 1887–1977, *Landscape*, gift

Baynes, Keith 1887–1977, *Still Life of White Roses*, gift

Baynes, Keith 1887–1977, *Still Life with Books, Lamp and Jug of Flowers*, gift

Baynes, Keith 1887–1977, *Still Life, Flowers in a Jug*, gift

Bell, Quentin 1910–1996, *Pots et citron (copy of Pablo Picasso)*, gift, © the artist's estate

Bell, Vanessa 1879–1961, *Cornish Cottage*, gift, © 1961 estate of Vanessa Bell courtesy Henrietta Garnett

Bell, Vanessa 1879–1961, *Julian Asleep*, gift, © 1961 estate of Vanessa Bell courtesy Henrietta Garnett

Bell, Vanessa 1879–1961, *Julian Bell*, gift, © 1961 estate of Vanessa Bell courtesy Henrietta Garnett

Bell, Vanessa 1879–1961, *Saxon Sydney-Turner at the Piano*, bequest, © 1961 estate of Vanessa Bell courtesy Henrietta Garnett

Bell, Vanessa 1879–1961, *Three Branches in a Jar*, gift, © 1961 estate of Vanessa Bell courtesy Henrietta Garnett

Bell, Vanessa 1879–1961, *Landscape with Buildings*, gift, ©

1961 estate of Vanessa Bell courtesy Henrietta Garnett

Bell, Vanessa 1879–1961, *Two Figures*, gift, © 1961 estate of Vanessa Bell courtesy Henrietta Garnett

Bell, Vanessa 1879–1961, *Landscape*, gift, © 1961 estate of Vanessa Bell courtesy Henrietta Garnett

Bell, Vanessa 1879–1961, *The Pond at Charleston*, gift, © 1961 estate of Vanessa Bell courtesy Henrietta Garnett

Bell, Vanessa 1879–1961, *Head of Quentin Bell*, gift, © 1961 estate of Vanessa Bell courtesy Henrietta Garnett

Bell, Vanessa 1879–1961, *The Harbour, St Tropez*, gift, © 1961 estate of Vanessa Bell courtesy Henrietta Garnett

Bell, Vanessa 1879–1961, *St Catherine (copy of Raphael)*, gift, © 1961 estate of Vanessa Bell courtesy Henrietta Garnett

Bell, Vanessa 1879–1961, *Colonna Madonna (copy of Raphael)*, gift, © 1961 estate of Vanessa Bell courtesy Henrietta Garnett

Bell, Vanessa 1879–1961, *Lady Strachey*, gift, © 1961 estate of Vanessa Bell courtesy Henrietta Garnett

Bell, Vanessa 1879–1961, *Baie de la reine*, gift, © 1961 estate of Vanessa Bell courtesy Henrietta Garnett

Bell, Vanessa 1879–1961, *Angelica Bell*, gift, © 1961 estate of Vanessa Bell courtesy Henrietta Garnett

Bell, Vanessa 1879–1961, *Still Life, Polyanthus in Vase*, gift, © 1961 estate of Vanessa Bell courtesy Henrietta Garnett

Bell, Vanessa 1879–1961, *A Girl Reading*, bequest, © 1961 estate of Vanessa Bell courtesy Henrietta Garnett

Bell, Vanessa 1879–1961, *Portrait of a Lady (copy of Willem Drost)*, gift, © 1961 estate of Vanessa Bell courtesy Henrietta Garnett

Bell, Vanessa 1879–1961, *Queue at Lewes*, gift, © 1961 estate of Vanessa Bell courtesy Henrietta Garnett

Bell, Vanessa 1879–1961, *The Forum, Rome*, gift, © 1961 estate of Vanessa Bell courtesy Henrietta Garnett

Bell, Vanessa 1879–1961, *The Weaver*, gift, © 1961 estate of Vanessa Bell courtesy Henrietta Garnett

Bell, Vanessa 1879–1961, *Newhaven Lighthouse*, © 1961 estate of Vanessa Bell courtesy Henrietta Garnett

Bell, Vanessa 1879–1961, *Chattie Salaman*, gift, © 1961 estate of Vanessa Bell courtesy Henrietta Garnett

Bell, Vanessa 1879–1961, *The Kitchen at Charleston*, gift, © 1961 estate of Vanessa Bell courtesy Henrietta Garnett

Bell, Vanessa 1879–1961, *A Sussex Barn*, gift, © 1961 estate of Vanessa Bell courtesy Henrietta Garnett

Bell, Vanessa 1879–1961, *Still Life of Pears and Everlasting Flowers*, gift, © 1961 estate of Vanessa Bell courtesy Henrietta Garnett

Bell, Vanessa 1879–1961, *Still Life of Plums*, gift, © 1961 estate of Vanessa Bell courtesy Henrietta Garnett

Bell, Vanessa 1879–1961, *Still Life with Plaster Head*, gift, © 1961 estate of Vanessa Bell courtesy Henrietta Garnett

Bell, Vanessa 1879–1961, *The Duomo in Lucca*, gift, © 1961 estate of Vanessa Bell courtesy Henrietta Garnett

Bell, Vanessa 1879–1961, *Charleston*, purchased, © 1961 estate of Vanessa Bell courtesy Henrietta Garnett

Bell, Vanessa 1879–1961, *Olivier Bell*, gift, © 1961 estate of Vanessa Bell courtesy Henrietta Garnett

Bell, Vanessa 1879–1961, *Poissy le Pont (copy of Maurice de Vlaminck)*, gift, © 1961 estate of Vanessa Bell courtesy Henrietta Garnett

Bell, Vanessa 1879–1961, *The Bridge at Auxerre*, © 1961 estate of Vanessa Bell courtesy Henrietta Garnett

Bell, Vanessa 1879–1961, *Dorothy Bussy at La Souco*, gift, © 1961 estate of Vanessa Bell courtesy Henrietta Garnett

Bell, Vanessa 1879–1961, *Henrietta Garnett*, gift, © 1961 estate of Vanessa Bell courtesy Henrietta Garnett

Bell, Vanessa 1879–1961, *West Pier, Brighton*, gift, © 1961 estate of Vanessa Bell courtesy Henrietta Garnett

Bell, Vanessa 1879–1961, *Julian Bell*, © 1961 estate of Vanessa Bell courtesy Henrietta Garnett

Bell, Vanessa 1879–1961, *Julian Bell*, gift, © 1961 estate of Vanessa Bell courtesy Henrietta Garnett

Bell, Vanessa 1879–1961, *Self Portrait*, gift, © 1961 estate of Vanessa Bell courtesy Henrietta Garnett

Bell, Vanessa 1879–1961, *Angelica Garnett and Her Four Daughters*, gift, © 1961 estate of Vanessa Bell courtesy Henrietta Garnett

Bell, Vanessa 1879–1961, *Still Life of Flowers*, gift

Bergen, George 1903–1984, *Chimney Pot and Window*, gift

Bergen, George 1903–1984, *Painting of a Group of Buildings*, gift

Bergen, George 1903–1984, *A London Street*, gift

Bergen, George 1903–1984, *The Policeman*, gift

Bergen, George 1903–1984, *East End Pub*, gift

Bergen, George 1903–1984, *Peñiscola*, gift

de Grey, Roger 1918–1995, *Eleanor*, gift, © S. T. de Grey

Doucet, Henri 1883–1915, *Julian Bell*, gift

Dufferin, Lindy *Still Life of Flowers in a Vase*, gift

Etchells, Frederick 1886–1973, *The Entry into Jerusalem*, gift

Etchells, Jessie 1892–1933, *The Opera Box*, gift

Etchells, Jessie 1892–1933, *Three Figures*, gift

Friesz, Othon 1879–1949, *Apple and Pear*, gift, © ADAGP, Paris and DACS, London 2005

Friesz, Othon 1879–1949, *Landscape*, gift, © ADAGP, Paris and DACS, London 2005

Fry, Roger Eliot 1866–1934, *Flooded Valley*, gift

Fry, Roger Eliot 1866–1934, *Mediterranean Port, La Ciotat*, gift

Fry, Roger Eliot 1866–1934, *The Healing of the Wounded Man of Lerida*, gift

Fry, Roger Eliot 1866–1934, *French Landscape with House*, gift

Fry, Roger Eliot 1866–1934, *Landscape in Provence*, gift

Garnett, Angelica b.1918, *Still Life with Poppies*, gift

Garnett, Angelica b.1918, *The Hock Bottle*, gift

Garnett, Angelica b.1918, *Abstract*, gift

Gerbaud, Abel 1888–1954, *Harbour, St Jean-de-Luz*, gift

Grant, Duncan 1885–1978, *Village Street*, gift, © 1978 estate of Duncan Grant

Grant, Duncan 1885–1978, *The Duke of Urbino (copy of Piero della Francesca)*, purchased, © 1978 estate of Duncan Grant

Grant, Duncan 1885–1978, *Arcadian Scene*, gift, © 1978 estate of Duncan Grant

Grant, Duncan 1885–1978, *Self Portrait in a Turban*, purchased, © 1978 estate of Duncan Grant

Grant, Duncan 1885–1978, *Adrian Stephen*, gift, © 1978 estate of Duncan Grant

Grant, Duncan 1885–1978, *Adrian Stephen*, gift, © 1978 estate of Duncan Grant

Grant, Duncan 1885–1978, *Self Portrait*, gift, © 1978 estate of Duncan Grant

Grant, Duncan 1885–1978, *Lytton Strachey*, bequest, © 1978 estate of Duncan Grant

Grant, Duncan 1885–1978, *Vanessa Bell in a Red Headscarf*, gift, © 1978 estate of Duncan Grant

Grant, Duncan 1885–1978, *Ethel Grant*, © 1978 estate of Duncan Grant

Grant, Duncan 1885–1978, *Quentin Bell as a Boy*, gift, © 1978 estate of Duncan Grant

Grant, Duncan 1885–1978, *A Prancing Horse*, gift, © 1978 estate of Duncan Grant

Grant, Duncan 1885–1978, *Lady Strachey*, gift, © 1978 estate of Duncan Grant

Grant, Duncan 1885–1978, *Julian Bell Writing*, gift, © 1978 estate of Duncan Grant

Grant, Duncan 1885–1978, *Still Life with Tea Pot*, bequest, © 1978 estate of Duncan Grant

Grant, Duncan 1885–1978, *Helen Anrep in Turkish Costume*, gift, © 1978 estate of Duncan Grant

Grant, Duncan 1885–1978, *Julian Bell Reading*, gift, © 1978 estate of Duncan Grant

Grant, Duncan 1885–1978, *Still Life*, gift, © 1978 estate of Duncan Grant

Grant, Duncan 1885–1978, *Spanish Dancer*, gift, © 1978 estate of Duncan Grant

Grant, Duncan 1885–1978, *Music Room Panel*, bequest, © 1978 estate of Duncan Grant

Grant, Duncan 1885–1978, *The Cat, Opussyquinusque*, gift, © 1978 estate of Duncan Grant

Grant, Duncan 1885–1978, *Standing Male Nude, Study of Tony Asserati*, gift, © 1978 estate of Duncan Grant

Grant, Duncan 1885–1978, *Still Life with Apples*, gift, © 1978 estate of Duncan Grant

Grant, Duncan 1885–1978, *Still Life with Staffordshire Figure and Wine Bottle*, gift, © 1978 estate of Duncan Grant

Grant, Duncan 1885–1978, *Helen Anrep in the Dining Room at Charleston*, gift, © 1978 estate of Duncan Grant

Grant, Duncan 1885–1978, *Paul Roche Reclining*, gift, © 1978 estate of Duncan Grant

Grant, Duncan 1885–1978, *Oliver Strachey*, gift, © 1978 estate of Duncan Grant

Grant, Duncan 1885–1978, *Lucca*, gift, © 1978 estate of Duncan Grant

Grant, Duncan 1885–1978, *Helen Anrep*, gift, © 1978 estate of Duncan Grant

Grant, Duncan 1885–1978, *The Pond at Charleston in Winter*, gift, © 1978 estate of Duncan Grant

Grant, Duncan 1885–1978, *Edward le Bas Decorating a Pot*, gift, © 1978 estate of Duncan Grant

Grant, Duncan 1885–1978, *Flowers in front of a Window*, bequest, © 1978 estate of Duncan Grant

Grant, Duncan 1885–1978, *The Barns from the Garden*, gift, © 1978 estate of Duncan Grant

Grant, Duncan 1885–1978, *Vanessa Bell Painting at La Souco*, gift, © 1978 estate of Duncan Grant

Grant, Duncan 1885–1978, *Nerissa in a White Blouse*, gift, © 1978 estate of Duncan Grant

Grant, Duncan 1885–1978, *Walled Garden at Charleston*, gift, © 1978 estate of Duncan Grant

Grant, Duncan 1885–1978, *Tony Haines*, gift, © 1978 estate of Duncan Grant

Halicka, Alice 1895–1975, *Man Standing beside Seated Woman*, gift

Hayden, Henri 1883–1970, *Still Life of Fruit*, gift, © ADAGP, Paris and DACS, London 2005

Hill, Derek b.1916, *Duncan Grant*, gift

Lloyd, Katherine Constance active from early 1920s, *Still Life with Fan*, gift

Marchand, Jean Hippolyte 1883–1940, *Still Life with Fruit and Flower Pot*, gift

O'Conor, Roderic 1860–1940, *Flowers*, gift

Pitchforth, Roland Vivian 1895–1982, *Landscape*, gift

Porter, Frederick James 1883–1944, *On the Arun*, gift

Richard, Edouard b.1883, *Still Life of Three Fish on a Plate*, gift

Roy, Pierre 1880–1950, *Fairy Pipe*, gift, © ADAGP, Paris and DACS, London 2005

Shone, Richard b.1948, *Virginia Woolf*, gift

Sickert, Walter Richard 1860–1942, *One of Madame Villain's Sons*, purchased, © estate of Walter R. Sickert 2005. All Rights Reserved DACS

Smith, Matthew Arnold Bracy 1879–1959, *Flowers*, gift

Thomas, Margaret b.1916, *The Captain of the Hockey Team*, gift, © the artist

unknown artist *Still Life with Vegetables*, gift

unknown artist *Still Life of Fruit with Decanters and Glasses*, gift

unknown artist 18th C, *Carnival Figure*, gift

unknown artist *Mother and Child*, gift

unknown artist *Young Girl in a Landscape*

unknown artist *Young Woman in a Landscape*, gift

unknown artist *Two Girls in a Landscape*, gift

unknown artist 19th C, *Portrait of a Young Woman*, gift

unknown artist *Ancient Urn and Bible*, gift

unknown artist *Still Life of Roman Pottery*, gift

unknown artist *Connoisseur*, gift

unknown artist *Chickens and Mother Hen*, gift

unknown artist *Victor Pasmore*, gift

unknown artist *Landscape*

unknown artist *Landscape*

unknown artist *Still Life*, gift

unknown artist *Tea Things (copy of Vanessa Bell)*, gift, © 1961 estate of Vanessa Bell courtesy Henrietta Garnett

Watson, Elizabeth 1906–1955, *The Garden*, gift

Watts, George Frederick 1817–1904, *Julia Stephen*, gift

Wolfe, Edward 1897–1982, *Still Life with Omega Cat*, gift

Wolfe, Edward 1897–1982, *Willows at Charleston*, bequest

East Sussex Record Office

Jervas, Charles (circle of) c.1675–1739, *The Reverend Peter Baker MA of Mayfield Place, Vicar of Mayfield (1671–1730)*, given by Isobel Pike to East Sussex County Council in 1994

Lambert, James I (after) 1725–1788, *Lewes Old Bridge, 1781*, gift

Murray, Thomas (attributed to)

1663–1734, *Marthanna, Daughter of Robert Baker of Middle House, Wife of Peter Baker (c.1675–1731)*, given by Isobel Pike to East Sussex County Council in 1994

unknown artist *Marthanna Baker?(1639–1693), Daughter of Samuel Cole, Wife of Robert Baker*, given by Isobel Pike to East Sussex County Council in 1994

unknown artist *Robert Baker of Middle House, Mayfield (1635–1714)*, given by Isobel Pike to East Sussex County Council in 1994

unknown artist *Ruth, Daughter of Peter Farnden, Wife of John Baker of Mayfield Place (1643–1724), Died 1691*, given by Isobel Pike to East Sussex County Council in 1994

Lewes Castle and Museum

Adams, Elinor Proby 1885–1945, *Cottage at Slindon, Sussex, opposite the Village Club*, gift to Sussex Archaeological Society

Archer, Archibald active 1810–1845, *Charles Wille*, gift to Sussex Archaeological Society 8/11/1979

Blackie, Agnes J. d.c.1961, *Sussex Shepherd*, bequest to Sussex Archaeological Society February 1962

Cook, Eric Trayler c.1896–1978, *Clymping, Sussex*, gift to Sussex Archaeological Society 25/5/1983

Cook, Eric Trayler c.1896–1978, *Martello Tower*, gift to Sussex Archaeological Society 25/5/1983

Cook, Eric Trayler c.1896–1978, *Pevensey*, gift to Sussex Archaeological Society 25/5/1983

Cook, Eric Trayler c.1896–1978, *Ypres Tower, Rye 1930*, gift to Sussex Archaeological Society 25/5/1983

Cook, Eric Trayler c.1896–1978, *Rodmell Church*, gift to Sussex Archaeological Society 25/5/1983

Cook, Eric Trayler c.1896–1978, *Bexhill Church*, gift to Sussex Archaeological Society 25/5/1983

Cook, Eric Trayler c.1896–1978, *Litlington Church*, gift to Sussex Archaeological Society 25/5/1983

Cook, Eric Trayler c.1896–1978, *Heart of Bognor*, gift to Sussex Archaeological Society 25/5/1983

Cook, Eric Trayler c.1896–1978, *North End House, Rottingdean, Burne Jones's House*, gift to Sussex Archaeological Society 25/5/1983

Cook, Eric Trayler c.1896–1978, *St Mary A…m, near Bognor*, gift to Sussex Archaeological Society 25/5/1983

Cook, Eric Trayler c.1896–1978, *Telscombe Church (St Laurence) near Rottingdean (Saltdean), Sussex*, gift to Sussex Archaeological Society 25/5/1983

Cook, Eric Trayler c.1896–1978, *Burne Jones's House, Rottingdean*, gift to Sussex Archaeological Society 25/5/1983

Cook, Eric Trayler c.1896–1978, *Field Place near Horsham*, gift to Sussex Archaeological Society

25/5/1983

Cook, Eric Trayler c.1896–1978, *Blake's Cottage, Felpham near Bognor, Sussex*, gift to Sussex Archaeological Society 25/5/1983

Cook, Eric Trayler c.1896–1978, *Eight Acres, Ancton*, gift to Sussex Archaeological Society 25/5/1983

Cook, Eric Trayler c.1896–1978, *The Medieval Chapel at Bailiff's Court near Clymping, Sussex 1279*, gift to Sussex Archaeological Society 25/5/1983

Cook, Eric Trayler c.1896–1978, *Chichester*, gift to Sussex Archaeological Society 25/5/1983

Cook, Eric Trayler c.1896–1978, *Chichester Close 1950*, gift to Sussex Archaeological Society 25/5/1983

Cook, Eric Trayler c.1896–1978, *Church Square, Rye*, gift to Sussex Archaeological Society 25/5/1983

Cook, Eric Trayler c.1896–1978, *Mermaid Inn, Rye 1953, Whitsun*, gift to Sussex Archaeological Society 25/5/1983

Cook, Eric Trayler c.1896–1978, *Playden Church, near Rye*, gift to Sussex Archaeological Society 25/5/1983

Cook, Eric Trayler c.1896–1978, *West Street, Rye*, gift to Sussex Archaeological Society 25/5/1983

Cook, Eric Trayler c.1896–1978, *Hangleton, near Brighton*, gift to Sussex Archaeological Society 25/5/1983

Elvin *Black Lion Hotel, Patcham*, gift to Sussex Archaeological Society 1985

Farmer, Kathleen active 1925–1940, *Chain Pier, Brighton, 4 December 1896*, gift to Sussex Archaeological Society

Forestier, Amédée 1854–1930, *A Centurian on the March*, gift to Sussex Archaeological Society

Forestier, Amédée 1854–1930, *Italic Bronze Age Warriors on the March*, gift to Sussex Archaeological Society

Forestier, Amédée 1854–1930, *Roman Standard-Bearer*, gift to Sussex Archaeological Society

Forestier, Amédée 1854–1930, *Roman Trumpeter*, gift to Sussex Archaeological Society

Garnett, Eve 1900–1991, *Lewes Gasworks from South Street*, gift to Sussex Archaeological Society July 1997

Henwood, Thomas (attributed to) 1797–1861, *Male Portrait*, gift to Sussex Archaeological Society

Henwood, Thomas (attributed to) 1797–1861, *Mrs Edward Minshall*, gift to Sussex Archaeological Society

Lambert, James I 1725–1788, *James Lambert*, bequest to Sussex Archaeological Society 1944

Lambert, James II 1742–1799, *James Lambert, Junior*, gift to Sussex Archaeological Society 1910

Lonsdale, James 1777–1839, *John Ellman*, gift to Sussex Archaeological Society

Riviere, Briton 1840–1920, *Old Woman Lighting Tinder*, gift to

Sussex Archaeological Society 1956

Roods, Thomas active 1833–1867, *Charles Ade*, gift to Sussex Archaeological Society 1977

Roods, Thomas (attributed to) active 1833–1867, *Catherine Sarah Ade*, gift to Sussex Archaeological Society 1983

Roods, Thomas (attributed to) active 1833–1867, *John Stephen Ade*, gift to Sussex Archaeological Society 1983

Roods, Thomas (attributed to) active 1833–1867, *Martha Ade*, gift to Sussex Archaeological Society 1983

Tennant, John F. (attributed to) 1796–1872, *Mountfield Court, Battle*, gift to Sussex Archaeological Society September 1908

unknown artist *First Peal, Rang July 27, 1770*, gift to Sussex Archaeological Society 1946

unknown artist *Dr T. White*, gift to Sussex Archaeological Society August 1966

unknown artist *John Morris*, gift to Sussex Archaeological Society 8/11/1979

unknown artist *Portrait of a Clerical Gentleman*, gift to Sussex Archaeological Society 1956

unknown artist *Portrait of an Elderly Woman*, gift to Sussex Archaeological Society 1956

unknown artist *Portrait of a Gentleman*, gift to Sussex Archaeological Society

unknown artist *Ann Morris*, gift to Sussex Archaeological Society 8/11/1979

unknown artist *Female Portrait*, gift to Sussex Archaeological Society

unknown artist *Malling Hill Lewes, c.1840*, gift to Sussex Archaeological Society

unknown artist *James Pelling*, gift to Sussex Archaeological Society April 1962

unknown artist *Mr William Inkpen*, gift to Sussex Archaeological Society 1980

unknown artist *Portrait of a Gentleman*, gift to Sussex Archaeological Society

unknown artist *The Avalanche at Lewes, 1836*, gift to Sussex Archaeological Society 1924

unknown artist *Thomas Paine*, gift to Sussex Archaeological Society 1944

Williams, John Edgar active 1846–1883, *Mark Anthony Lower*, gift to Sussex Archaeological Society 1927

Williamson, J. active 1850–1919, *St Clement's Church*, gift to Sussex Archaeological Society

Lewes District Council

Chambers *Sailing Ship 'Tamarind' Being Towed into Portsmouth*
R. F. *Cottages and Fishermen on the Coast of Fife*
Halswelle, Keeley 1832–1891, *Wittenham Clumps*

Sussex Archaeological Society 1956

Lewes Town Hall

Dollman, John Charles 1851–1934, *Ditchling Beacon*, presented by Captain Guy Dollman, 1936
Gabell, I. E. *Sussex Weald in Winter*
Hardy early 20th C, *Battle of Lewes, 14 May 1264*, presented by Alderman George Holman JP, 1913
Keyser, Nicaise de 1813–1887, *Syrian Chief*, presented by M. S. Blaker Esq.
Keyser, Nicaise de 1813–1887, *Syrian Chief*, presented by M. S. Blaker Esq.
Smith, Gabell 1861–1934, *Southease*, presented by Mrs E. Dendy, 1935
unknown artist *Wynne E. Baxter Esq. First Mayor of Lewes (1881–1882)*, presented by the Worshipful Company of Gold and Silver Wyre Drawings to their Clerk Wynne E. Baxter Esq. First Mayor of Lewes (1881–1882)
unknown artist 20th C, *Alderman George Holman JP*
unknown artist *Audrey Wimble*
unknown artist *John Baxter, Invented Colour Printing in 1820s*
unknown artist *John Baxter's Son*
unknown artist *Nehemiah Wimble*
unknown artist *Portrait of a Woman**
unknown artist *The Protestant Reformers*, presented by Thomas Header White

Victoria Hospital

Bell, Julian b.1952, *View of Lewes*
Hawkins, Irene *Flowers in White Jug*
Winkworth, Jackie 1925–1992, *Apollonia, Siphnos*
Winkworth, Jackie 1925–1992, *Church, Seriphos, Greece*
Winkworth, Jackie 1925–1992, *Cineraria*
Winkworth, Jackie 1925–1992, *Fortress at Rethimno, Crete*
Winkworth, Jackie 1925–1992, *View from the Terrace, St Mawes*

Westfield House

Holl, Frank 1845–1888, *Henry Thomas Pelham (1804–1886), Earl of Chichester, Lord Lieutenant of Sussex*
Niemann, Edmund H. 1841–1910, *Lewes from Chapel Hill*
unknown artist *John George Dodson (1825–1897), Baron Monk Bretton, First Chairman of East Sussex County Council*

Rye Art Gallery

Bagley, Geoffrey Spink 1901–1992, *Rye Harbour*, donated by Friends of Rye Art Gallery, 2000
Banting, John 1902–1972, *Startled Bird*, donated by Mrs Hawkins

Barnard, Margaret 1898–1992, *Boat in the Bay*, donated by the artist, 1982
Barnard, Margaret 1898–1992, *Island and Storm*, donated by the artist, 1982
Barnard, Margaret 1898–1992, *Rocks and Waves*, donated by the artist, 1982
Barnard, Margaret 1898–1992, *The Spell*, donated by the artist, 1982
Barnard, Margaret 1898–1992, *White House in Sunshine, Ravello*, donated by the artist, 1982
Barnard, Margaret 1898–1992, *White Rock, Sutherland*, donated by the artist, 1982
Barnard, Margaret 1898–1992, *90th Birthday*, donated by the artist, 1982
Baynes, Keith 1887–1977, *Meursault*, donated by the artist, 1970
Bell, Vanessa 1879–1961, *A Bridge, Paris*, donated by Keith Baynes 1970, © 1961 estate of Vanessa Bell courtesy Henrietta Garnett
British (English) School 17th C, *Portrait of a Cleric*, Stormont Bequest, 1962
British (English) School 19th C, *A Horse in Stable*, Stormont Bequest, 1962
Buchanan, George F. 1800–1864, *River Scene with Boat*, Stormont Bequest, 1962
Coates, George James 1869–1930, *Mary Stormont*, Stormont Bequest, 1962
Cohen, Alfred 1920–2001, *Man at Ease*, donated by The Friends of Rye Art Gallery and the V&A Museum Grant Fund, 1977
Crew, David b.1948, *Rye Symposium*, donated by Peter Temple, 1976
Crook, Pamela b.1945, *Artist and Model*, donated by Osma Jones, 2004, © courtesy of the artist/www.bridgeman.co.uk
Daniel, Henry b.1900, *Mary Stormont*, Stormont Bequest, 1962
Downie, John P. 1871–1945, *Landscape*, Stormont Bequest, 1962
Druce, Elsie 1880–1965, *Spring Cleaning at the Lime Street Studio*, Stormont Bequest, 1962
Druce, Elsie 1880–1965, *Woodland*, Stormont Bequest, 1962
Dutch School 17th C, *Flower Study No.1*, Stormont Bequest, 1962
Dutch School 17th C, *Flower Study No.2*, Stormont Bequest, 1962
Dutch School 18th C, *Sailing Barge on River*, Stormont Bequest, 1962
Easton, Eileen Margaret 1890–1965, *Flowers from a Surrey Garden*, Easton Bequest
Easton, Eileen Margaret 1890–1965, *The Old Cedar Tree*, Easton Bequest
French, Kitty 1924–1989, *Clown No.7*, permanent loan by Rye Society of Artists, 1998
French, Kitty 1924–1989, *Sad Clown*, permanent loan by Rye Society of Artists, 1996
Goodwin, Albert 1845–1932,

Venice, Easton Bequest

Gosse, Laura Sylvia 1881–1968, *Seamstresses*, donated by Mrs Barbara Bagenal in memory of Roger Senhouse, 1971, © courtesy of the artist's estate/www.bridgeman.co.uk

Grant, Duncan 1885–1978, *Seated Nude*, donated by The Friends of Rye Gallery and V&A Museum Grant Fund, 1971, © 1978 estate of Duncan Grant

Guerrier, Raymond 1920–2002, *Les Martigues, Provence*, donated by the Contemporary Art Society

Hailstone, Bernard 1910–1987, *Geoffrey Spink Bagley as Mayor of Rye*, donated by Rosemary Bagley in memory of her husband, 1997

Hitchens, Ivon 1893–1979, *Dark Distance*, long-term loan from Contemporary Art Society, © Jonathan Clark & Co

Hitchens, Ivon 1893–1979, *Landscape, The Lake*, long-term loan from Contemporary Art Society, © Jonathan Clark & Co

Hulk, Abraham 1813–1897, *Seascape*, Stormont Bequest, 1962

Hunt, E. Aubrey 1855–1922, *Cattle Watering at a River*, Stormont Bequest, 1962

Kemp, Anne 1937–1997, *Woodland Stream No.3*, donated by Bernard Kemp in memory of the artist, 1998

Kemp, Anne 1937–1997, *Woodland Path No.1*, donated by Bernard Kemp in memory of the artist, 1998

Ladell, Edward 1821–1886, *Basket of Fruit*, Stormont Bequest, 1962

Le Piper, Francis 1640–1698, *A Scene From Hudibras, Canto I*, Stormont Bequest, 1962

Le Piper, Francis 1640–1698, *A Scene from Hudibras, Canto II*, Stormont Bequest, 1962

Le Piper, Francis 1640–1698, *A Scene from Hudibras, Canto III*, Stormont Bequest, 1962

Low, Diana 1911–1975, *A Road near the Sea*, Collard Bequest, 1978

Low, Diana 1911–1975, *Flowers in a Blue and White Jug*, Collard Bequest, 1978

Low, Diana 1911–1975, *Grandparents on the Beach*, Collard Bequest, 1978

Mackechnie, Robert 1894–1975, *Bridge and House*, Mackechnie Bequest, 1990

Mackechnie, Robert 1894–1975, *Rotten Wood with Blue Toadstools*, Mackechnie Bequest, 1990

Mackechnie, Robert 1894–1975, *San Michele, Ripaldi, Florence*, Mackechnie Bequest, 1990

Mackechnie, Robert 1894–1975, *Self Portrait*, Mackechnie Bequest, 1990

Money, Eric 1946–2003, *The Ferryman*, donated by the Friends of Rye Art Gallery, 1982

Morland, George (attributed to) 1763–1804, *Litter of Pigs*, Stormont Bequest, 1962

Moser, Oswald 1874–1953, *Lady Dorothy D'Oyly Carte*, donated by

Mrs Jennings, 1971

Moser, Oswald 1874–1953, *Portrait of the Artist's Wife (later Madame Durand)*, permanent loan by Frances Catt

Neer, Aert van der (attributed to) 1603–1677, *Fishermen by Moonlight*, Stormont Bequest, 1962

Padwick, Philip Hugh 1876–1958, *Arundel*, bequest of Mrs Doris Phillips, 1979

Padwick, Philip Hugh 1876–1958, *Littlehampton Harbour*, bequest of Mrs Doris Phillips, 1979

Palin, William Mainwaring 1862–1947, *Tree in Summer*, Stormont Bequest, 1962

Richards, Ceri Geraldus 1903–1971, *Pianist*, bequest of Mrs A. Rickman, 1979, © estate of Ceri Richards 2005. All Rights Reserved DACS

Ruysch, Rachel (attributed to) 1664–1750, *Flower Piece*, Stormont Bequest, 1962

Sarram, Ralph de b.1930, *Abstract, Aix-En-Provence*, donated by the artist

Stoop, Cornelius F. de 19th C, *Cows and Sheep Driven by Horsemen*, Stormont Bequest, 1962

Stormont, Howard Gull 1859–1935, *Rouen*, Stormont Bequest, 1962

Stormont, Howard Gull 1859–1935, *Camber Castle*, Stormont Bequest, 1962

Stormont, Howard Gull 1859–1935, *Ludlow Castle*, Stormont Bequest, 1962

Stormont, Howard Gull 1859–1935, *Arundel Castle*, Stormont Bequest, 1962

Stormont, Howard Gull 1859–1935, *February Morning, Rye*, donated by Mary Stormont

Stormont, Howard Gull 1859–1935, *Gate into Field with Cows and Tree*, Stormont Bequest, 1962

Stormont, Howard Gull 1859–1935, *Thatched Cottage*, Stormont Bequest, 1962

Stormont, Howard Gull 1859–1935, *White Cottage with Figures*, Stormont Bequest, 1962

Stormont, Howard Gull 1859–1935, *Wooded Valley with Hills*, Stormont Bequest, 1962

Stormont, Mary 1871–1962, *A June Posy*, Stormont Bequest, 1962

Stormont, Mary 1871–1962, *Autumn Flowers*, Stormont Bequest, 1962

Stormont, Mary 1871–1962, *Autumn Gathering*, Stormont Bequest, 1962

Stormont, Mary 1871–1962, *Camellias*, Stormont Bequest, 1962

Stormont, Mary 1871–1962, *Daffodils and Narcissus*, Stormont Bequest, 1962

Stormont, Mary 1871–1962, *Dahlias*, Stormont Bequest, 1962

Stormont, Mary 1871–1962, *Dahlias and Michaelmas Daisies*, Stormont Bequest, 1962

Stormont, Mary 1871–1962, *Flowers*, Stormont Bequest, 1962

Stormont, Mary 1871–1962, *Foxgloves*, Stormont Bequest, 1962

Stormont, Mary 1871–1962, *Iceland Poppies*, Stormont Bequest, 1962

Stormont, Mary 1871–1962, *June on the Marsh*, Stormont Bequest, 1962

Stormont, Mary 1871–1962, *Mermaid Street, Rye*, Stormont Bequest, 1962

Stormont, Mary 1871–1962, *Milking Sheep, Holland*, Stormont Bequest, 1962

Stormont, Mary 1871–1962, *Mixed Roses*, Stormont Bequest, 1962

Stormont, Mary 1871–1962, *On the Marsh*, Stormont Bequest, 1962

Stormont, Mary 1871–1962, *Orchids*, Stormont Bequest, 1962

Stormont, Mary 1871–1962, *Romney Marsh*, Stormont Bequest, 1962

Stormont, Mary 1871–1962, *Rosamund*, Stormont Bequest, 1962

Stormont, Mary 1871–1962, *Roses and Canterbury Bells*, Stormont Bequest, 1962

Stormont, Mary 1871–1962, *Roses and Pea Stems*, Stormont Bequest, 1962

Stormont, Mary 1871–1962, *Rye Bay*, Stormont Bequest, 1962

Stormont, Mary 1871–1962, *Rye from Winchelsea*, Stormont Bequest, 1962

Stormont, Mary 1871–1962, *The Lime Kiln, Maldon, Essex*, Stormont Bequest, 1962

Stormont, Mary 1871–1962, *The Mermaid Inn, Rye*, Stormont Bequest, 1962

Stormont, Mary 1871–1962, *White Roses and Honeysuckle*, Stormont Bequest, 1962

Tebbutt, Lionel F. 1900–1975, *Deep Water Bay, Hong Kong*, donated by Mrs Florence Tebbutt, 1985

Tebbutt, Lionel F. 1900–1975, *Fishing Fleet Wharf, Rye*, donated by Mrs Florence Tebbutt, 1985

Tebbutt, Lionel F. 1900–1975, *No Birds Sing (The Dark Wood)*, donated by Mrs Florence Tebbutt, 1985

Tebbutt, Lionel F. 1900–1975, *On attend le garçon*, donated by Mrs Florence Tebbutt, 1985

Tebbutt, Lionel F. 1900–1975, *Street Scene with Temple of Minerva, Assisi*, donated by Mrs Florence Tebbutt, 1985

Tebbutt, Lionel F. 1900–1975, *The Yu River, Kwangsi, China*, donated by Mrs Florence Tebbutt, 1985

Tebbutt, Lionel F. 1900–1975, *Yacht Race at Rye Harbour*, donated by Mrs Florence Tebbutt, 1985

Townsend, Kenneth 1935–2001, *Fairlight*, donated by Rye Society of Artists, 2002

Turner, Joseph Mallord William (school of) 1775–1851, *English Village Scene with Cattle*, Stormont Bequest, 1962

Turpin, Louis b.1947, *View from the Studio, Cabbage Field*, donated by the Friends of Rye Art Gallery,

1979, © the artist

Turpin, Louis b.1947, *Spring Garden, Rye*, donated by Osma Jones, 2004, © the artist

unknown artist *Hydrangeas in a Vase*, probably Stormont Bequest, 1962

unknown artist *Interior with Three Figures*, probably Stormont Bequest, 1962

Ward, John Stanton b.1917, *Patrick Dickinson*, donated by National Art Collections Fund and the Friends of Rye Art Gallery, 1984, © courtesy of the artist/www.bridgeman.co.uk

Warden, William 1908–1982, *Industrial Landscape*, donated by The Friends of Rye Art Gallery and SE Arts Association, 1984

Weyden, Harry van der 1868–1956, *Estuary at Etaples*, donated by Dr C. Sotheby Pitcher in memory of his parents, local artists, Neville Sotheby Pitcher, RSMA and Florence Mary Sotheby Pitcher, 1990

Weyden, Harry van der 1868–1956, *Night Fishing at Etaples*, donated by Dr C. Sotheby Pitcher in memory of his parents, local artists, Neville Sotheby Pitcher, RSMA and Florence Mary Sotheby Pitcher, 1990

Weyden, Harry van der 1868–1956, *Sailing Boats off Shore*, Stormont Bequest, 1962

Wilson, Richard (attributed to) 1713/1714–1782, *Landscape*, Stormont Bequest, 1962

Wit, Jacob de 1695–1754, *Allegory of Plenty, Cherubs Playing with a Ram*, Stormont Bequest, 1962

Yale, Brian b.1936, *The Nativity Hut*, donated by the artist in memory of Derek Jarman, 1994, © courtesy of the artist/www.bridgeman.co.uk

Rye Castle Museum

Atkins, G. *View of the Strand, Green Steps and the Hope and Anchor Inn*, gift from Mrs Anne Sheppard

Danckerts, Hendrick (school of) 1625–1680, *Rye*, purchased from Philips, Son and Neale, 1995

Davie, Leslie *Monkbretton Bridge from the Fishmarket*, given by Miss Janet Davie to the Museum, 2000

Gales, Henry active 1856–1886, *Camber Castle*, gift by Miss D. F. R Gale to the Museum

Thorpe *The Strand, Rye*, gift from Mr J. Gasson to the Museum, 1928

unknown artist *North Side of Augustinian Monastery before Alteration*, unknown

unknown artist *Rye from Fishmarket*, gift from Mr J. Gasson to the Museum, 1928

Rye Town Hall

Eves, Reginald Grenville 1876–1941, *Henry James (after John*

Singer Sargent), bequeathed to Rye Town Hall

Jervas, Charles (attributed to) c.1675–1739, *Phillips Gybbon in a Brown Tunic Holding a Sword*, bequeathed to Rye Town Hall

unknown artist 20th C, *Joseph Adams in Mayoral Regalia*, bequeathed to Rye Town Hall

Wright, John Michael (circle of) 1617–1694, *Edward Southwell Standing with a Cane in Embroidered Buff Tunic*, bequeathed to Rye Town Hall

Seaford Museum

Astell, John *Tide Mills*

Denheigst, D. *View of Church from Car Park*

Haynes *Martello Tower*

Hocken, Marion Grace 1922–1987, *View of Buckle Pub from Cliffs*

Hutchinson, M. *View of Martello Tower and Seaford Head*

Lane, Spencer *Seven Sisters from Seaford Beach*

Nash, R. A. *View of Martello Tower, Restaurant and Flat*

Robino, A. *Seaford Bay*

Robino, A. *View of Newhaven*

Sykes *Looking towards Peacehaven*

unknown artist *Ship Portrait 'SS Seaford'*

unknown artist *Ship Portrait 'SS Sussex'*

Seaford Town Council

Swinstead, George Hillyard 1860–1926, *The White Chalks at Seaford Head*, donated to the people of Seaford

Collection Addresses

Battle

English Heritage, Battle Abbey
High Street, Battle TN33 0AD
Telephone 01424 775705

Battle Library
7 Market Square, Battle TN33 0XA
Telephone 01424 772250

Bexhill on Sea

Bexhill Museum
Egerton Road, Bexhill on Sea TN39 3HL
Telephone 01424 787950

Brighton

Brighton and Hove Museums and Art Galleries:

Brighton Museum and Art Gallery
Royal Pavilion Gardens, Brighton BN1 1EE
Telephone 01273 290900

Hove Museum and Art Gallery
19 New Church Road, Hove BN3 4AB
Telephone 01273 290200

Preston Manor
Preston Drove, Brighton BN1 6SD
Telephone 01273 292770

The Royal Pavilion
Brighton BN1 1EE
Telephone 01273 290900

The Aldrich Collection, University of Brighton
Grand Parade, Brighton BN2 0JY
Telephone 01273 643012

University of Sussex
Special Collections, The Library, Brighton BN1 9QL
Telephone 01273 678157

Ditchling

Ditchling Museum
Church Lane, Ditchling BN6 8TB
Telephone 01273 844744

Eastbourne

Towner Art Gallery
High Street, Old Town, Eastbourne BN20 8BB
Telephone 01323 417961

Hailsham

Michelham Priory
Upper Dicker, Hailsham BN27 3QS
Telephone 01323 844224

Hastings

Conquest Hospital
Arts in Healthcare, St Anne's House, 729 The Ridge,
St Leonards on Sea TN37 7PT
Telephone 01424 755470

Hastings Fishermen's Museum
Rock-a-Nore Road, Hastings TN34 3DW
Telephone 01424 461446

Hastings Library
Brassey Institute, 13 Claremont, Hastings TN34 1HE
Telephone 01424 420501

Hastings Museum and Art Gallery:

Hastings Museum and Art Gallery
Johns Place, Bohemia Road, Hastings TN34 1ET
Telephone 01424 781155

Hastings Old Town Hall Museum
High Street, Old Town, Hastings TN34 1EW
Telephone 01424 781166

Lewes

Charleston
Firle, Lewes BN8 6LL
Telephone 01323 811626

East Sussex Record Office
The Maltings, Castle Precincts, Lewes BN7 1YT
Telephone 01273 482349

Lewes Castle and Museum
169 High Street, Lewes BN7 1YE
Telephone 01273 486290

Lewes District Council
32 High Street, Lewes BN7 2LX
Telephone 01273 471600

Lewes Town Hall
High Street, Lewes BN7 2QS
Telephone 01273 471469

Victoria Hospital
Nevill Road, Lewes BN7 1PE
Telephone 01273 474153

Westfield House
St Anne's Crescent, Lewes BN7 1RJ
Telephone 01273 481000

Rye

Rye Art Gallery
Stormont Studio, Ockman Lane, East Street,
Rye TN31 7JY
Telephone 01797 223218

Rye Castle Museum
3 East Street, Rye TN31 7JY
Telephone 01797 226728

Rye Town Hall
Rye TN31 7LA
Telephone 01797 223902

Seaford

Seaford Museum
c/o Tourist Information Centre
25 Clinton Place, Seaford BN25 1NP
Telephone 01323 898222

Seaford Town Council
Hurdis House, 10 Broad Street,
Seaford BN25 1ND
Telephone 01323 894870

Index of Artists

In this catalogue, artists' names and the spelling of their names follow the preferred presentation of the name in the Getty Union List of Artist Names (ULAN) as of February 2004, if the artist is listed in ULAN.

The page numbers next to each artist's name below direct readers to paintings that are by the artist; are attributed to the artist; or, in a few cases, are more loosely related to the artist being, for example, 'after', 'the circle of' or copies of a painting by the artist. The precise relationship between the artist and the painting is listed in the catalogue.